Photography

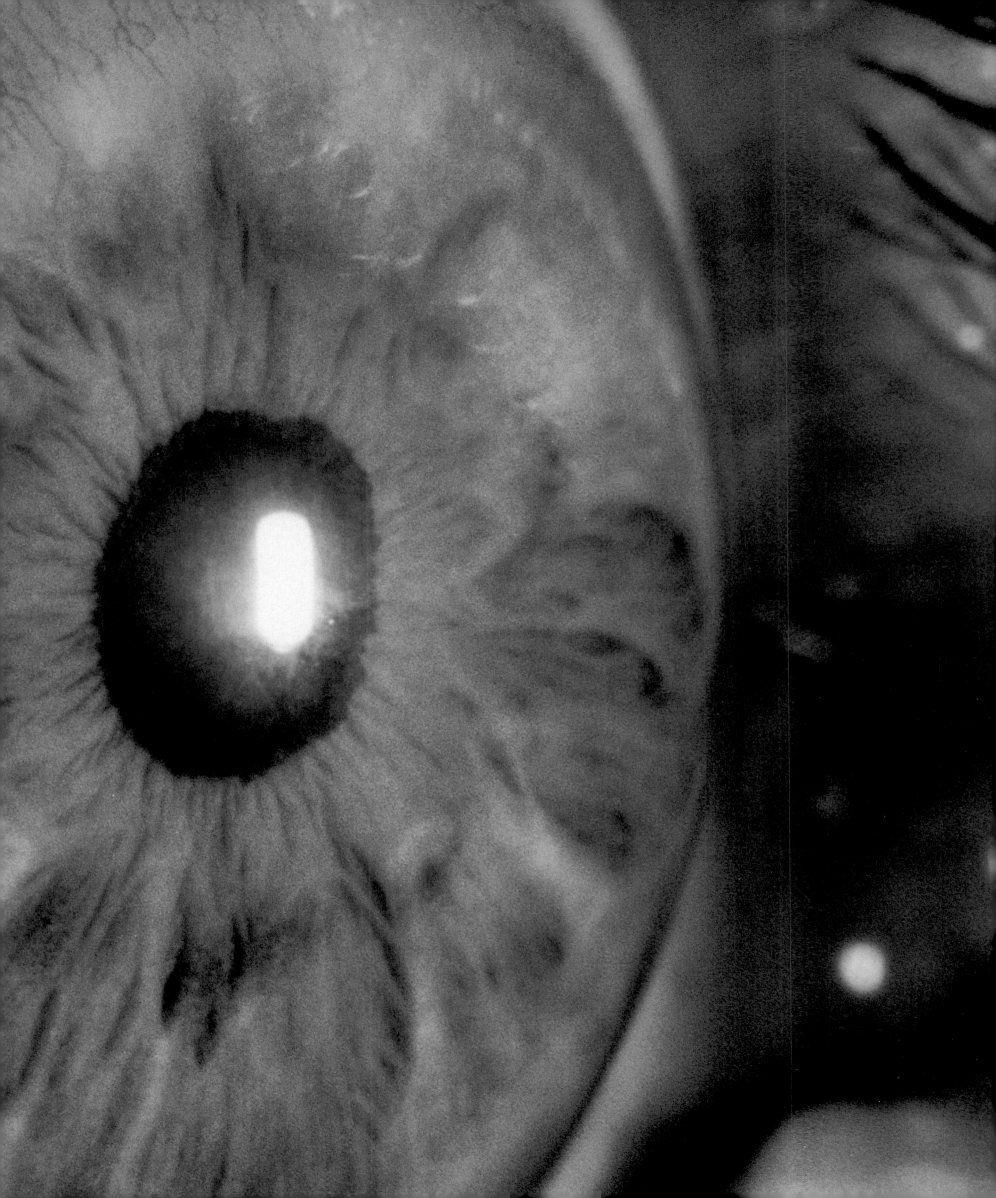

Photography
Index I

Frontispiece: André Thijssen

All images in this book have been reproduced with the knowledge and prior consent of the artists concerned and no responsibility is accepted by publisher or printer for any infringement of copyright or otherwise, arising from the contents of this publication.

Every effort has been made to ensure that the credits and information for each work included in this Index are correct. Sometimes errors of omission or commission may occur. For this the publisher is most regretful, but hereby must disclaim any liability.

© Page One The Bookshop Pte Ltd
 Block 4 Pasir Panjang Road
 #08-33 Alexandra Distripark
 Singapore 118491
 Tel: (65) 274-3188
 Fax: (65) 274-1833

Distributed worldwide (except Asia) by:

© Könemann Verlagsgesellschaft mbH
 Bonner Straße 126
 D-50968 Köln
 Germany

Distributed in Asia by:

Page One The Bookshop Pte Ltd
Block 4 Pasir Panjang Road
#08-33 Alexandra Distripark
Singapore 118491

Edited and designed by Peter Feierabend, Berlin
Layout by K.C. Sin, Singapore
Colour separation by Imago Publishing Ltd., Thame
Printed by LeeFung-Asco Printers, Hong Kong
Printed in China
ISBN 981-00-6325-3

Contents · Inhalt · Sommaire · Indice

Portrait	8
Sports	104
Fashion	128
Children	164
Animals	182
Food	202
Landscapes	214
Transport	254
Still Life	274
Artist Index	307

Foreword

In today's world, visual perception determines our modes of communication and has become the most important channel of information for humankind. Technological advance has produced new mediums for the conveyance of visual information which have penetrated all areas of our lives. Increasing quality and quantity make it ever more difficult to create unusual forms and attract the attention of the beholder.

Wit and imagination, creativity and succinctness are vital for the success of visual communication. Those working in this field know that only few artists can meet these demands.

With its indexes, Page One Publishing has set itself the goal of creating a forum for internationally up-and-coming photographers, typographers, architects, graphic designers and illustrators, enabling these artists to introduce examples of their work to a broad public. The observer is presented with an impressive array of varied styles, techniques and work methods. The inclusion of the artist's address at the end of each respective index allows the reader to form contacts with the artist.

This volume on photography is the fourth in this series and features sections on topics as diverse as People, Animals, Fashion, Food, Sports and Landscapes.

This index with its fascinating photographs is not only a treasure trove for future patrons and clients; it also furnishes the photography enthusiast with a wealth of ideas. The index also serves to promote communication and exchange of information between individual artists.

We would like to express our special thanks to all those who have helped to make this index a unique illustrative work.

Vorwort

In der heutigen Zeit bestimmt die visuelle Wahrnehmung unsere Kommunikation und ist zum wichtigsten Informationskanal für den Menschen geworden. Der technische Fortschritt hat neue Medien zur Übermittlung visueller Informationen hervorgebracht, die in allen Bereichen unseres Lebens Einzug genommen haben. Durch deren steigende Qualität und Quantität wird es immer schwieriger, Außergewöhnliches zu schaffen und Aufmerksamkeit zu erregen.

Witz und Phantasie, Kreativität und Prägnanz sind für die erfolgreiche visuelle Umsetzung unbedingt erforderlich. Diejenigen, die in Bereichen der Kommunikation tätig sind, werden wissen, daß nur wenige diesen Anforderungen gerecht werden.

Page One Publishing hat es sich mit seinen Indexen zum Ziel gesetzt, international aufstrebenden Photographen, Typographen, Architekten, Grafikdesignern und Illustratoren ein Forum zu schaffen, indem der Verlag den Künstlern ermöglicht, sich mit ihren Arbeiten exemplarisch einem breiten Publikum vorzustellen. Dem Betrachter werden so die unterschiedlichsten Stilrichtungen, Arbeitsweisen und Techniken eindrucksvoll vermittelt. Durch die Angabe der Adressen der einzelnen Künstler am Ende eines jeden Indexes hat er zudem auch die Möglichkeit, mit ihnen in Kontakt zu treten.

Der vorliegende Band zum Thema Photographie ist der vierte in dieser Reihe und gliedert sich in so vielfältige Bereiche wie People, Animals, Fashion, Food, Sports und Landscapes.

Dieser Index mit seinen faszinierenden Photographien ist nicht nur eine Fundgrube für mögliche Auftraggeber, sondern bietet auch dem photographisch interessierten Betrachter eine Fülle von Anregungen. Nicht zuletzt fördert der Index auch die Kommunikation und den Austausch zwischen den Künstlern selbst.

Unser besonderer Dank gilt allen Mitwirkenden, die diesen Index zu einem einzigartigen Bildband gemacht haben.

Préface

De nos jours, la perception visuelle détermine la communication, elle est devenue le principal canal informatif de l'homme. Le progrès technique a permis l'émergence de nouveaux médias chargés de transmettre ces informations visuelles, médias qui ont pénétré tous les domaines de la vie. Mais leur qualité et leur quantité allant s'accroissant, il est de plus en plus difficile de créer l'extraordinaire et d'attirer l'attention.

L'humour et l'imagination, la créativité et la justesse sont absolument nécessaires pour réussir toute transposition visuelle. Or ceux qui exercent dans le domaine de la communication savent bien que rares sont les individus qui répondent à ces exigences.

Avec ses index, Page One Publishing s'est fixé pour objectif de réunir en un forum, des photographes, typographes, architectes, graphistes et illustrateurs qui ambitionnent une carrière internationale. L'éditeur offre à ces artistes la possibilité de présenter des exemples de leur travail au grand public. Le but est de montrer de manière captivante des orientations stylistiques, des méthodes et techniques de travail. L'adresse des divers artistes figurant à la fin de chaque index, le lecteur aura la possibilité d'entrer en contact avec eux.

Ce volume consacré à la photographie est le quatrième de la collection, il s'articule en plusieurs domaines tels que People, Animals, Fashion, Food, Sports et Landscapes.

Cet index et ses photos fascinantes représentent non seulement une mine d'or pour d'éventuels commanditaires, mais peut être une source d'inspiration pour les lecteurs qui s'intéressent à la photographie. Qui plus est, il encouragera aussi la communication et les échanges entre artistes.

Nous tenons à remercier toutes les personnes qui ont contribué à faire de cet ouvrage un album unique en son genre.

Prólogo

En el mundo actual, nuestra comunicación está determinada por la percepción visual: ésta se ha convertido en el canal de información más importante para el hombre. El progreso técnico ha generado nuevos medios para transmitir informaciones visuales, que se han introducido en todos los ámbitos de nuestra vida. Al crecer su calidad y cantidad, cada vez es más difícil crear algo fuera de lo común y despertar la atención.

Gracia e imaginación, creatividad y concisión son absolutamente necesarias para conseguir éxito en la transformación visual. Quienes trabajan en los sectores de la comunicación sabrán que sólo pocos están en condiciones de cumplir estas exigencias.

Con sus índices, Page One Publishing se ha propuesto crear un foro para fotógrafos, tipógrafos, arquitectos, diseñadores gráficos e ilustradores, emergentes internacionalmente, haciendo posible la editorial que los artistas se presenten a un público amplio con ejemplos de sus trabajos. De este modo, el observador obtiene una amplia visión de conjunto sobre los más diferentes estilos, modos de trabajo y técnicas. Al ofrecer las direcciones de los artistas al final de cada índice, tiene además la posibilidad de ponerse en contacto con ellos.

El presente volumen, sobre el tema de la fotografía, es el cuarto de esta serie y se divide en sectores tan variados como People, Animals, Fashion, Food, Sports y Landscapes.

Este índice, con sus fascinantes fotografías, no sólo es un filón para clientes potenciales, sino que también ofrece toda una serie de ideas para el observador interesado por la fotografía. El índice ofrece también comunicación e intercambio entre los artistas mismos.

Deseamos expresar nuestro especial agradecimiento a todos los que han colaborado para hacer de este índice un volumen ilustrado único.

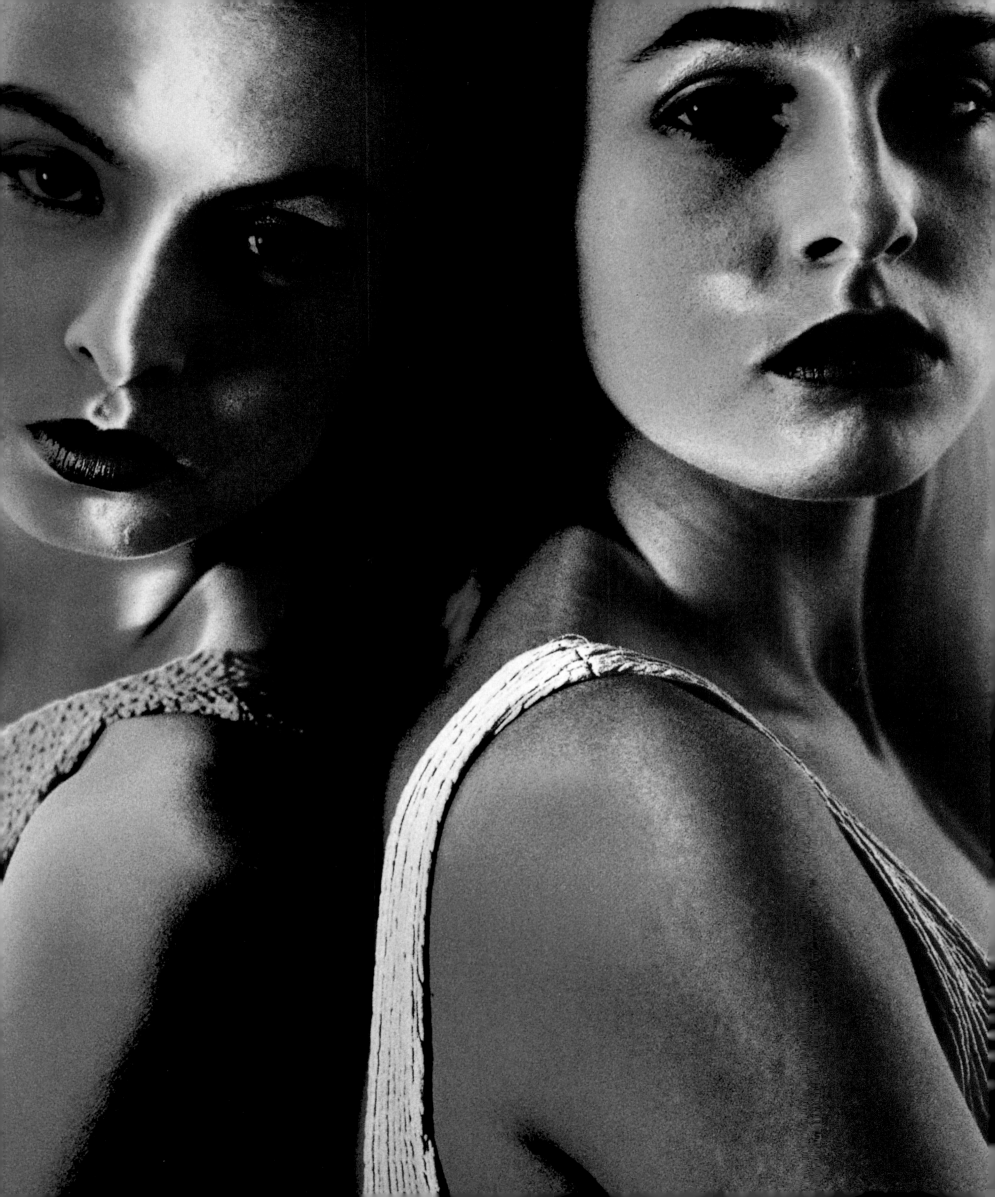

P O R T R A I T

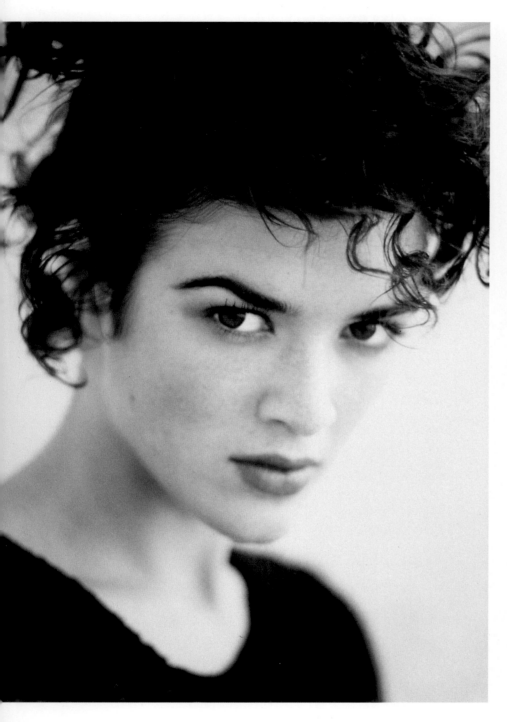

Karin Knoblich

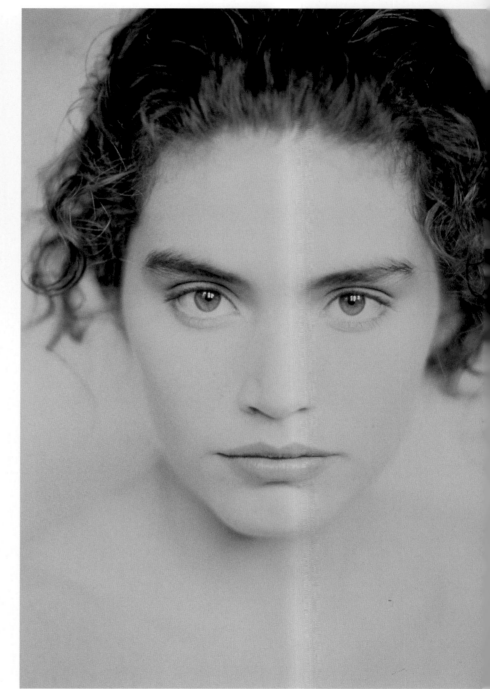

Jutta Klee

◁◁ Jonnie Miles

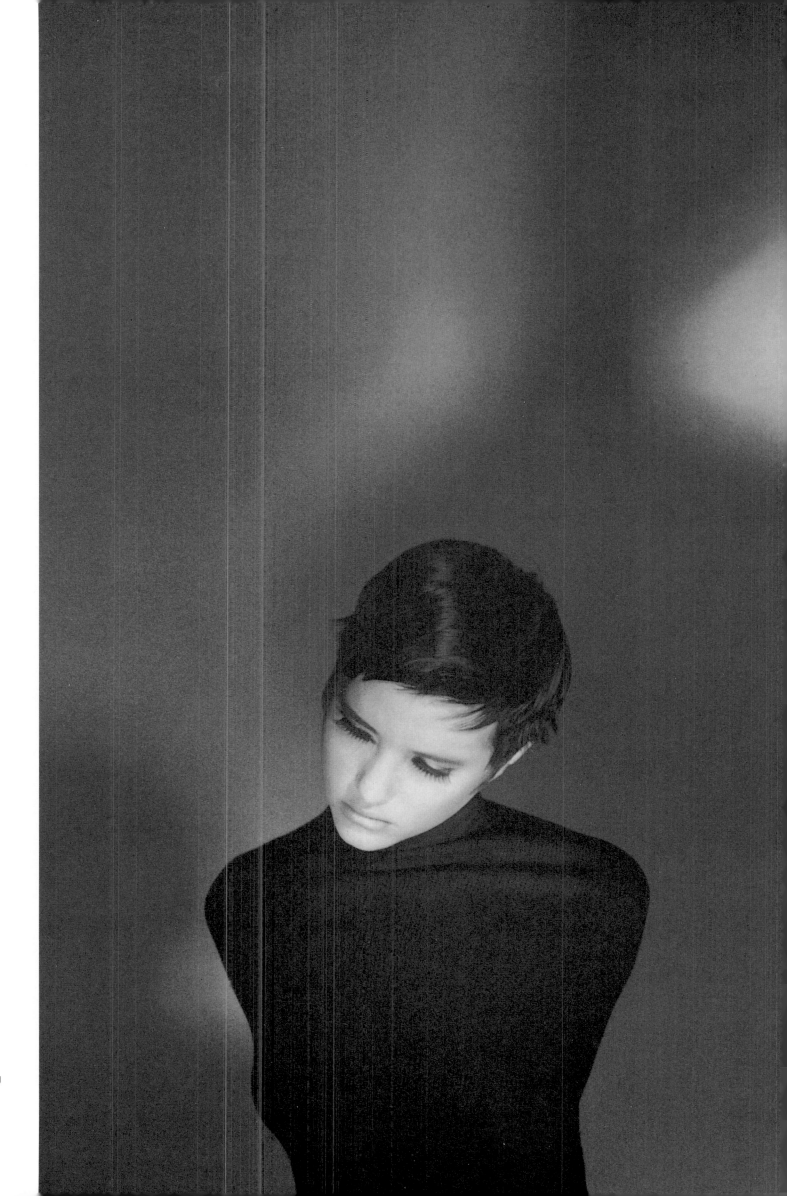

Ringo Tang

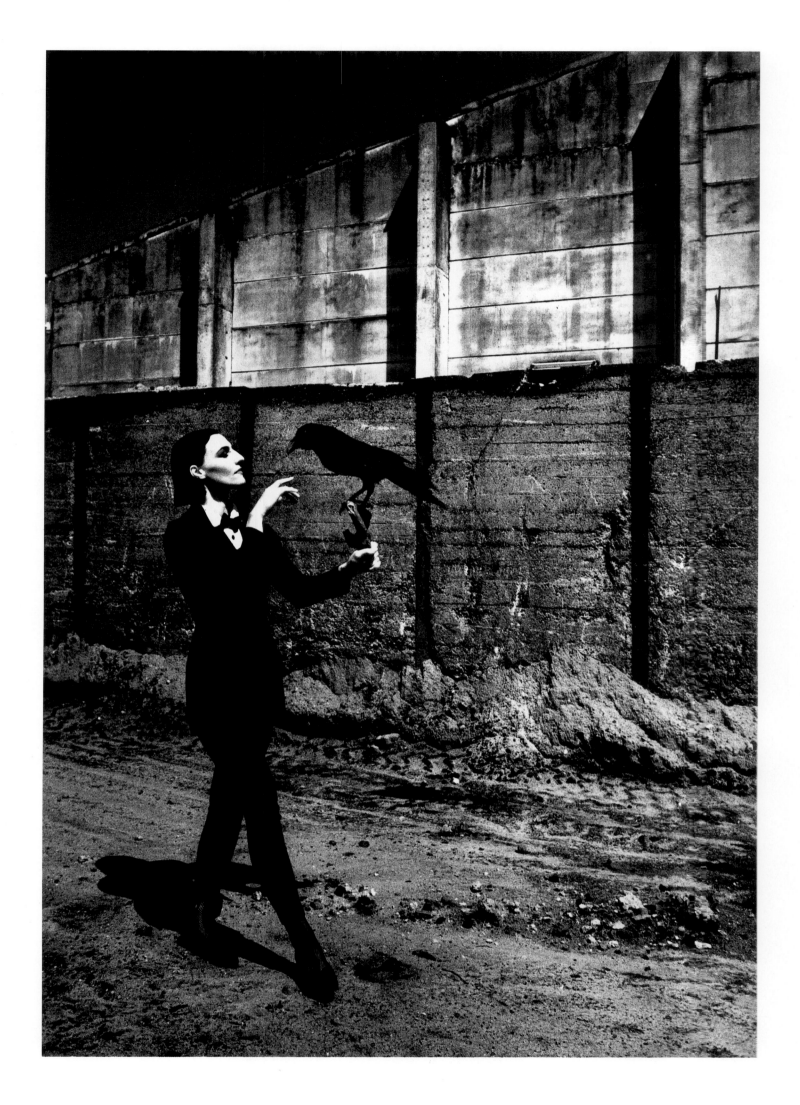

PORTRAIT 12

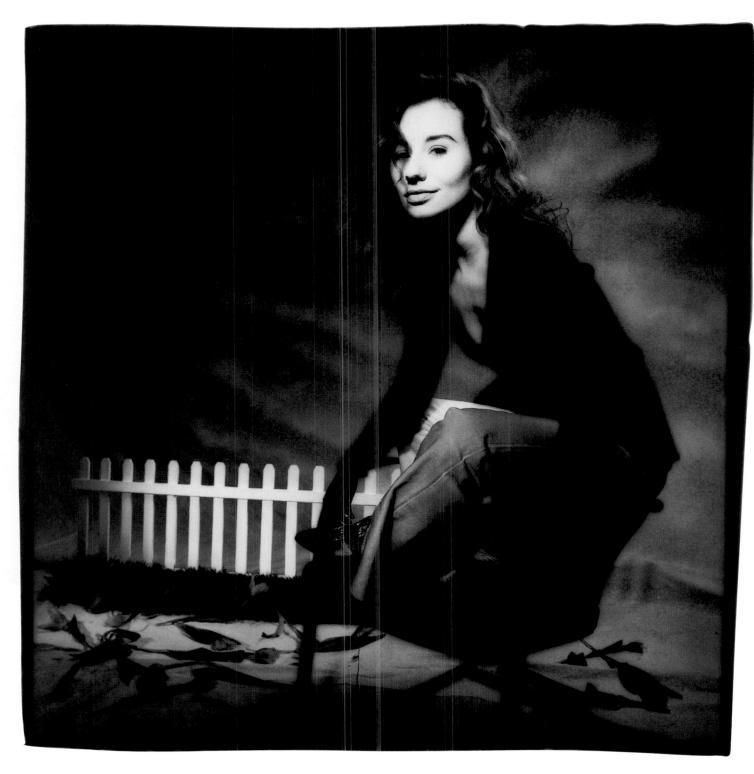

Karen Miller, *Tori Amos*

Manfred Koetter

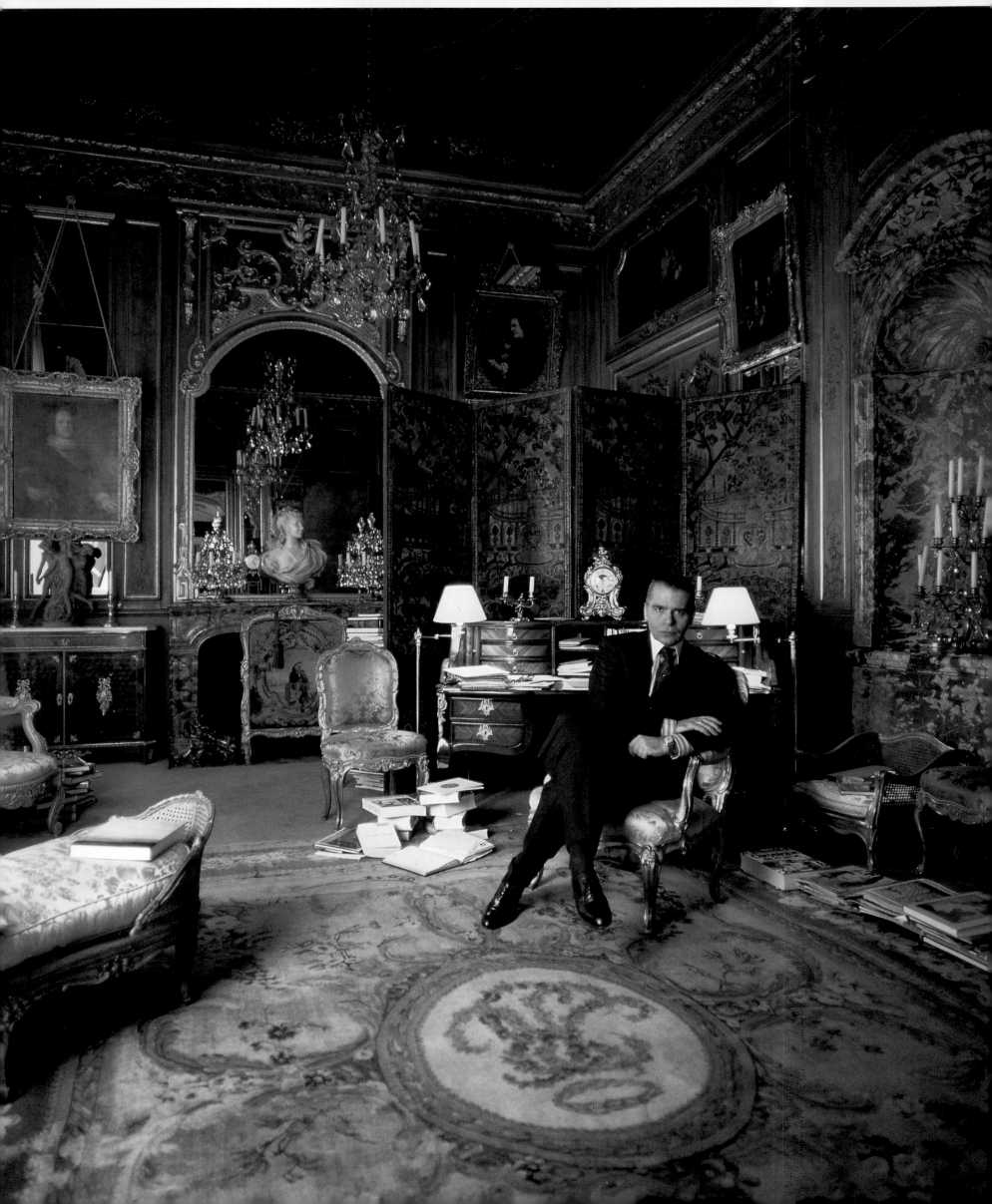

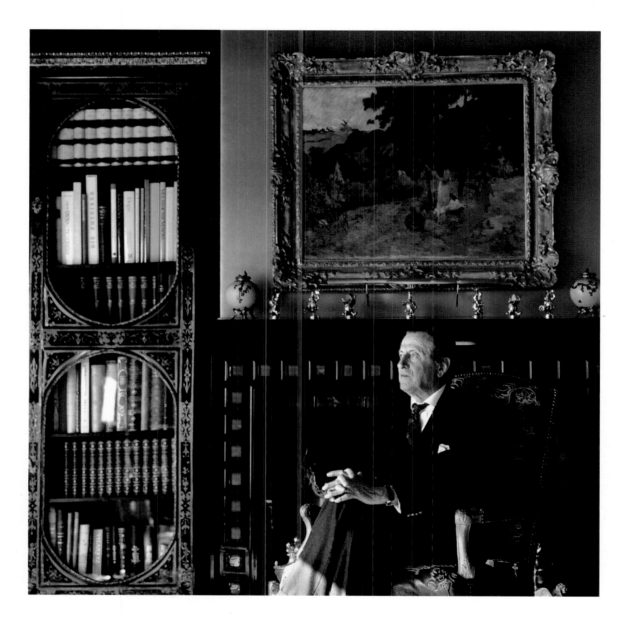

Lisa Bogdan, *Baron Heinrich Thyssen-Bornemisza*

Helmut Claus, *Karl Lagerfeld*

Todd Haiman

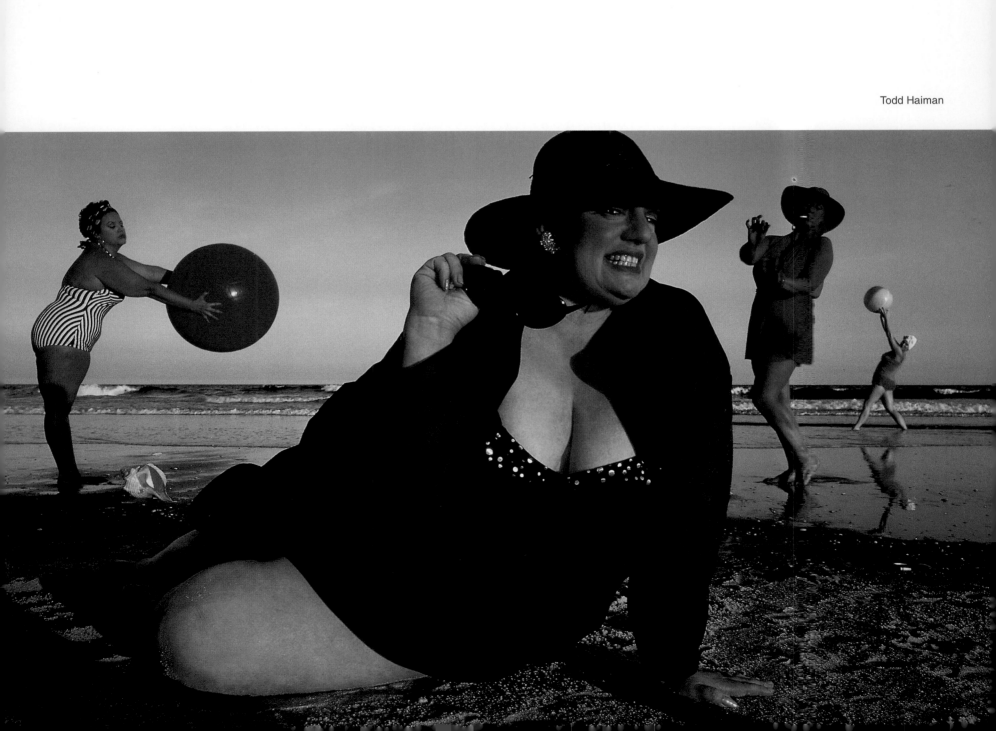

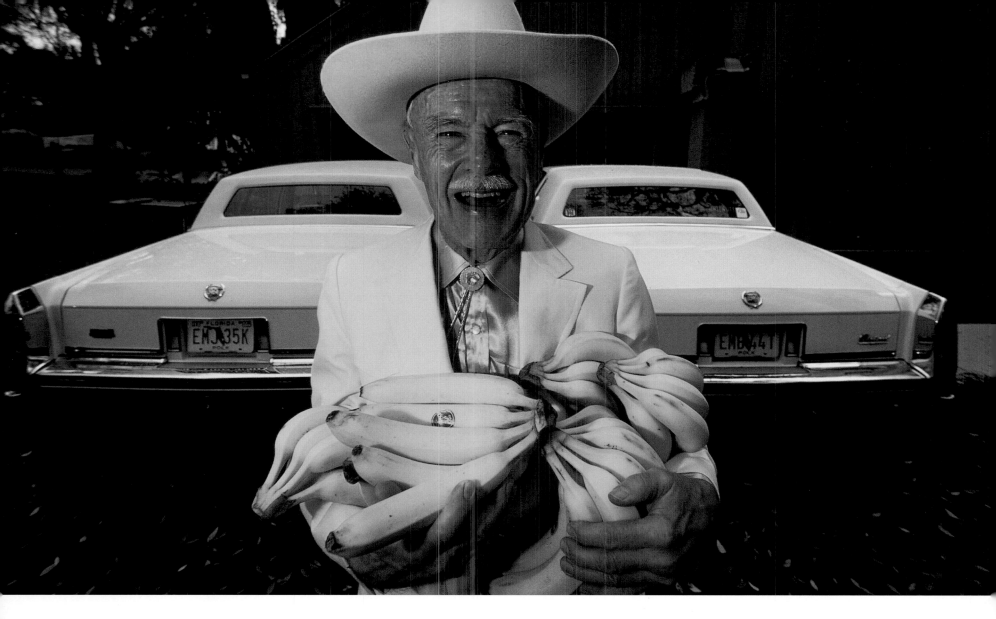

Mark Gamba

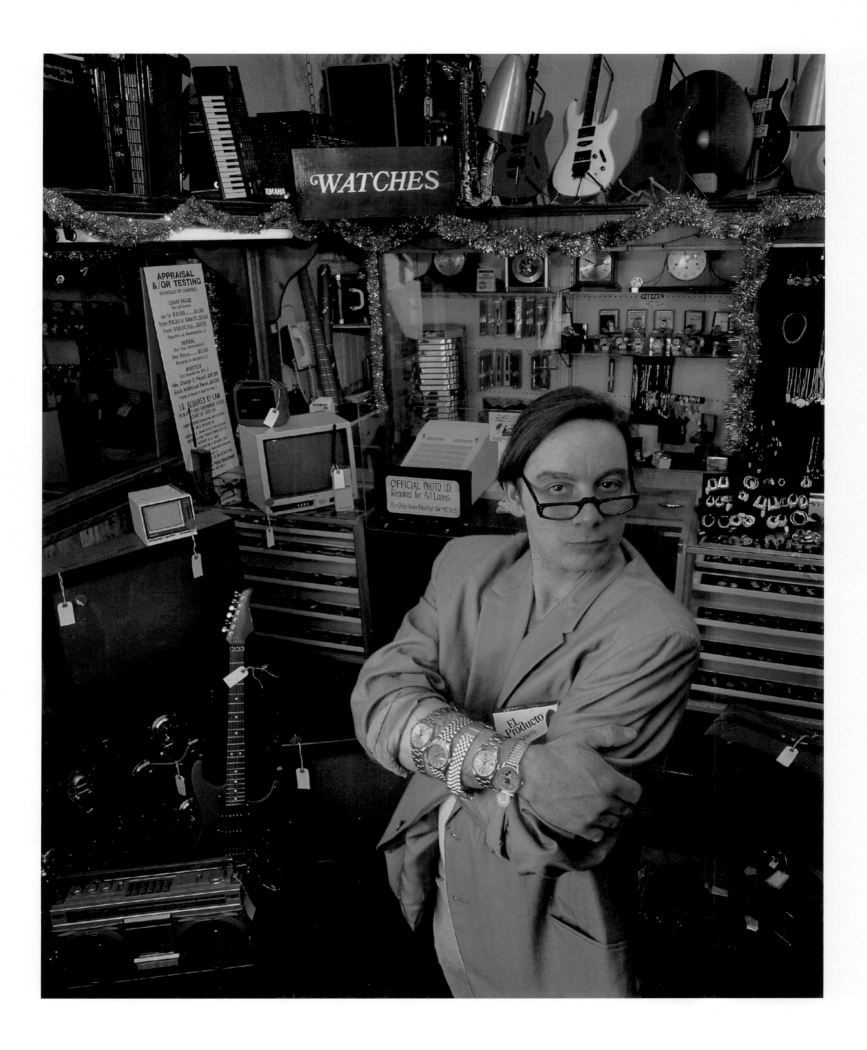

Steve Marsel

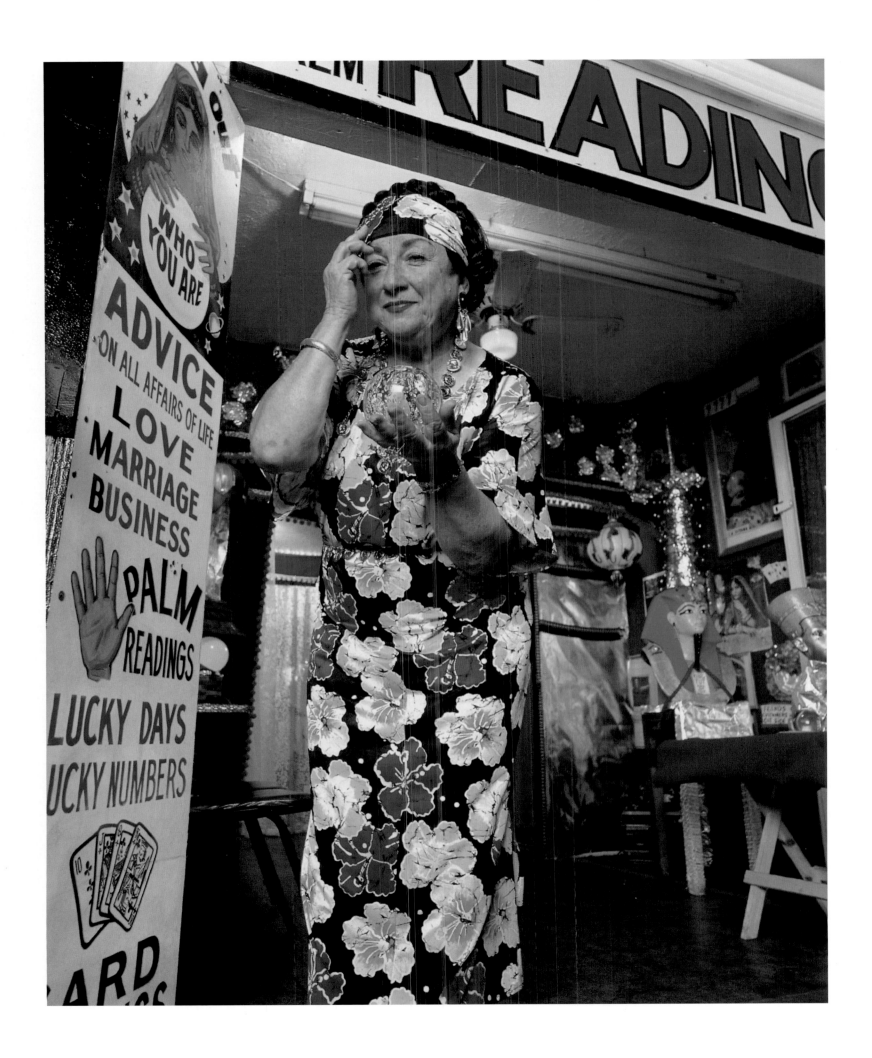

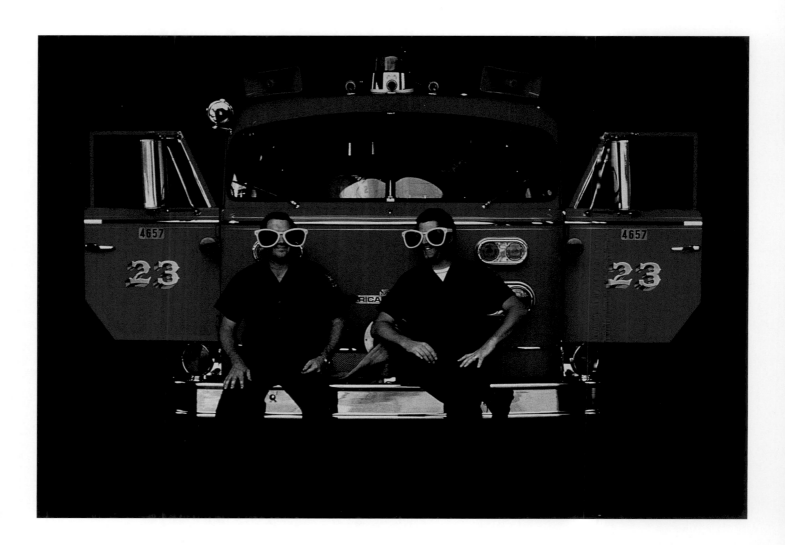

Gordon Baer

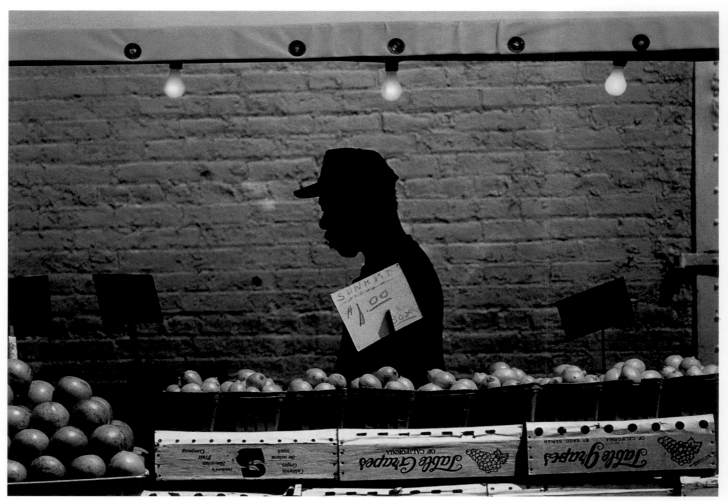

Gordon Baer

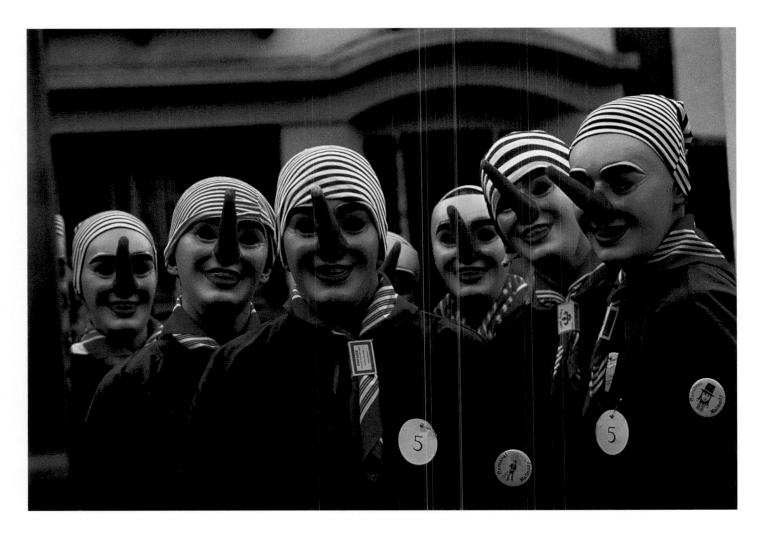

Manfred Wirtz

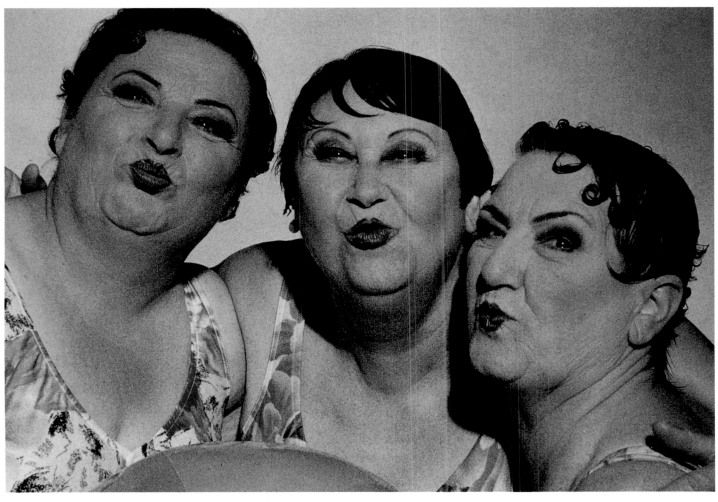

Michael Kremer

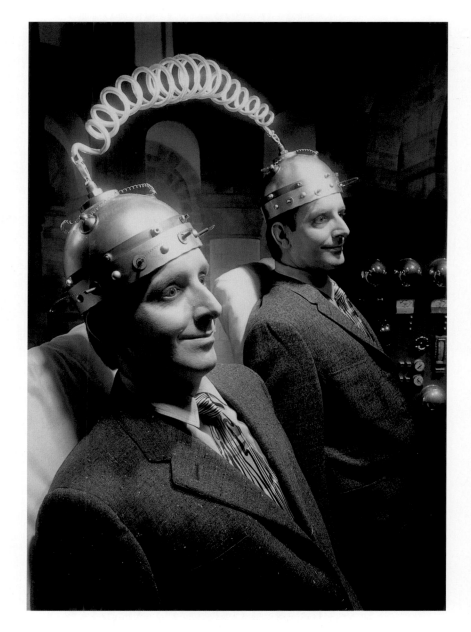

Michael Kremer

Jock McDonald

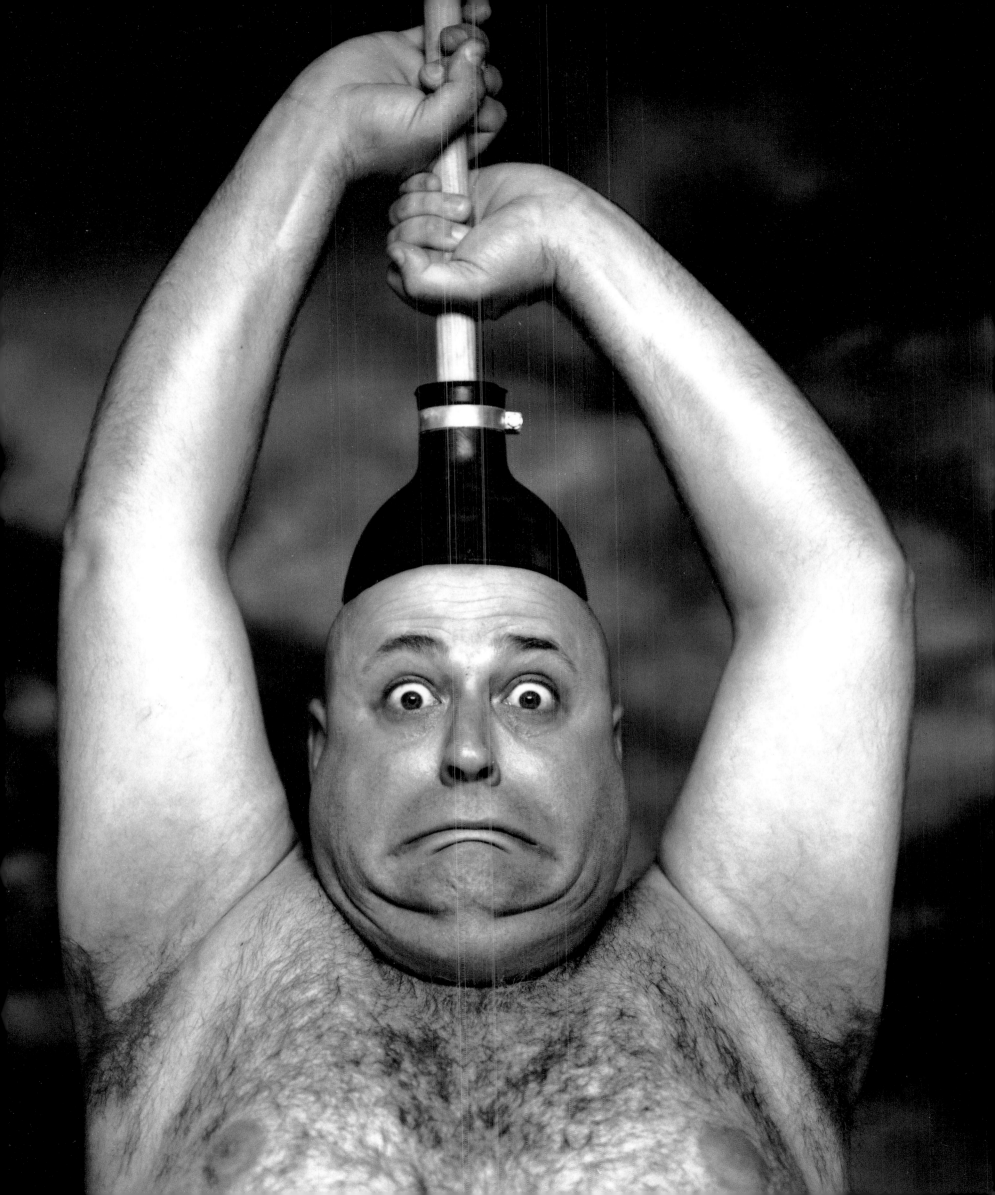

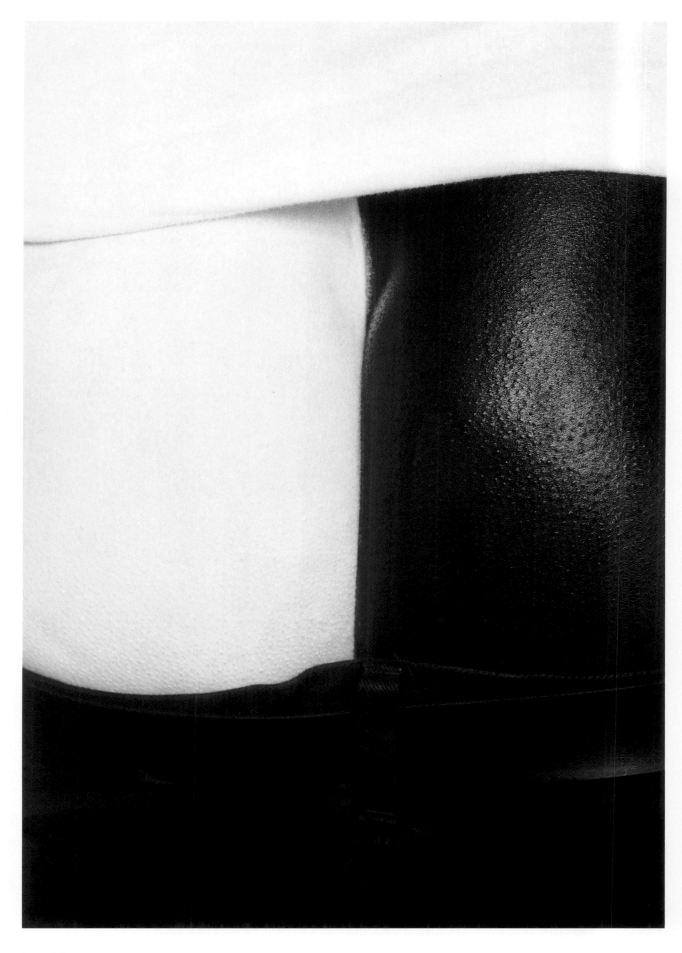

Peter Adler

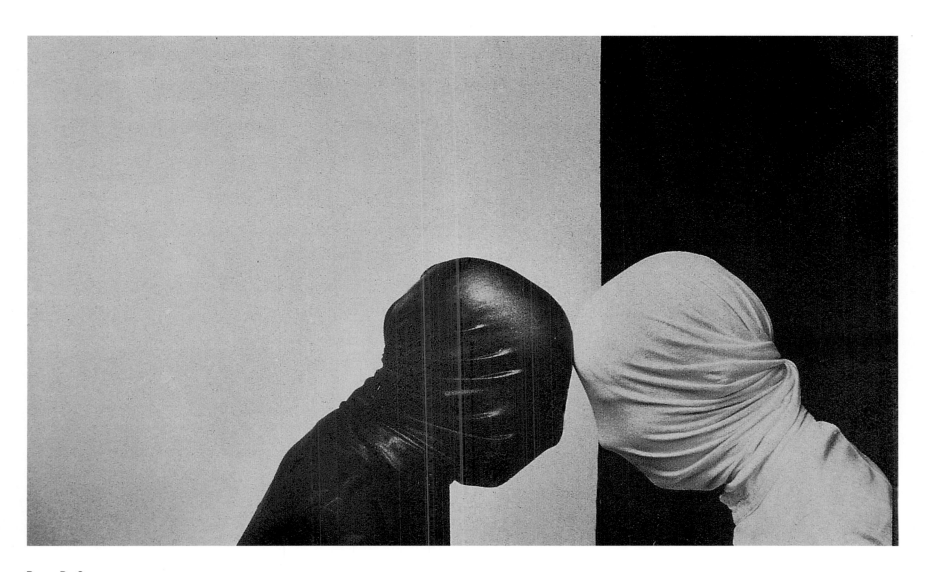

Benny De Grove

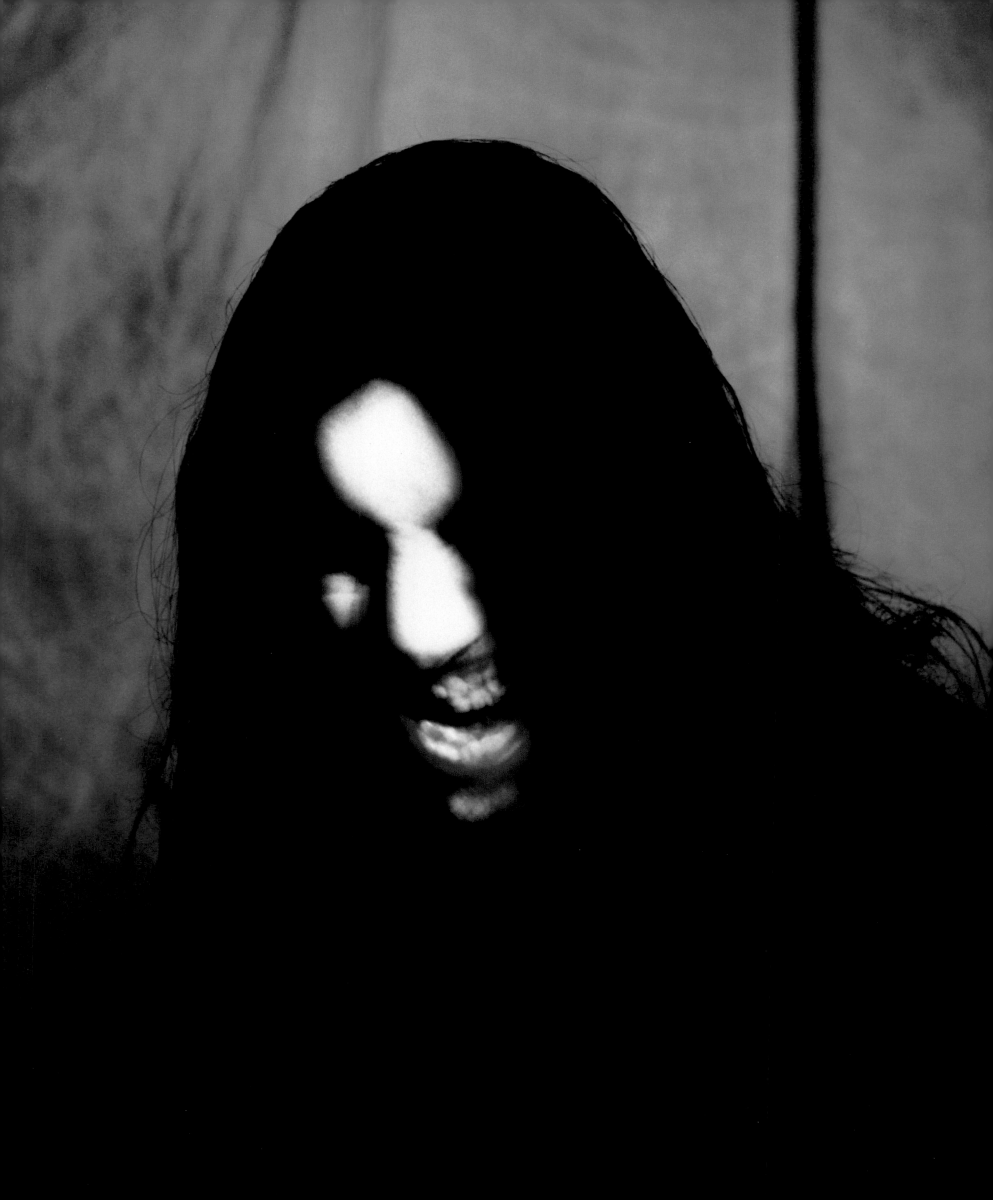

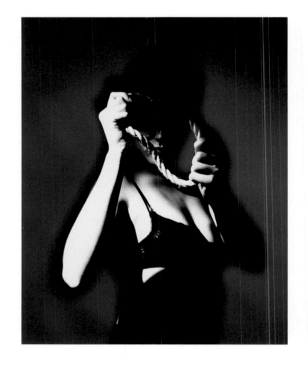
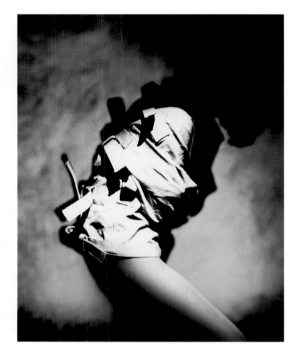
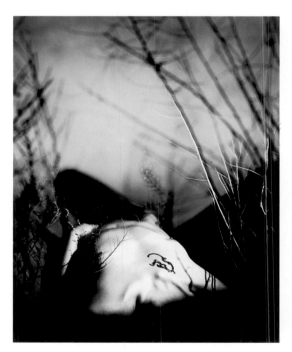
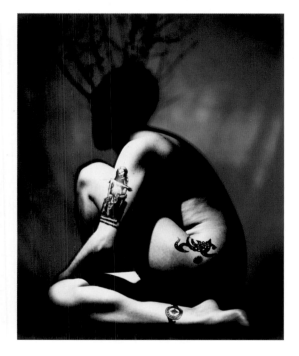

Dale May

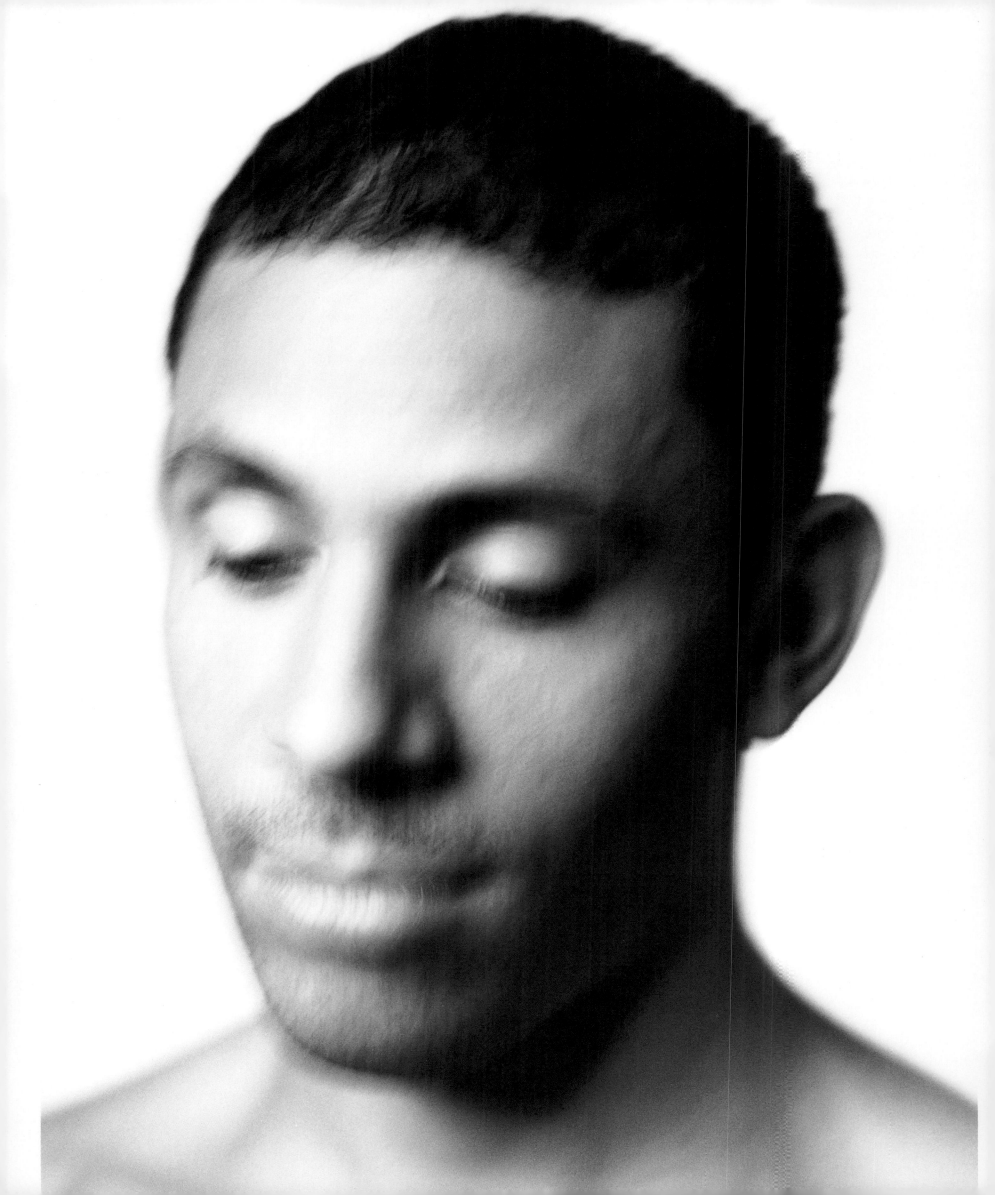

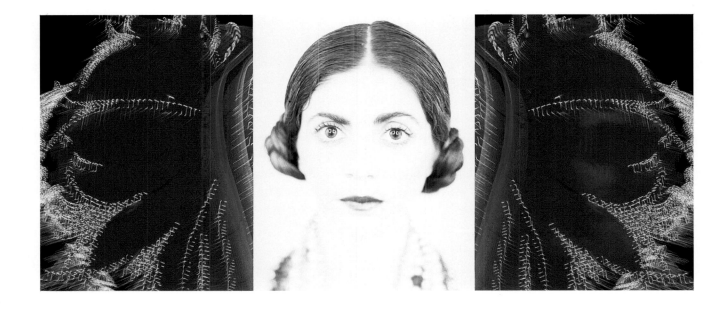

Peter Medilek

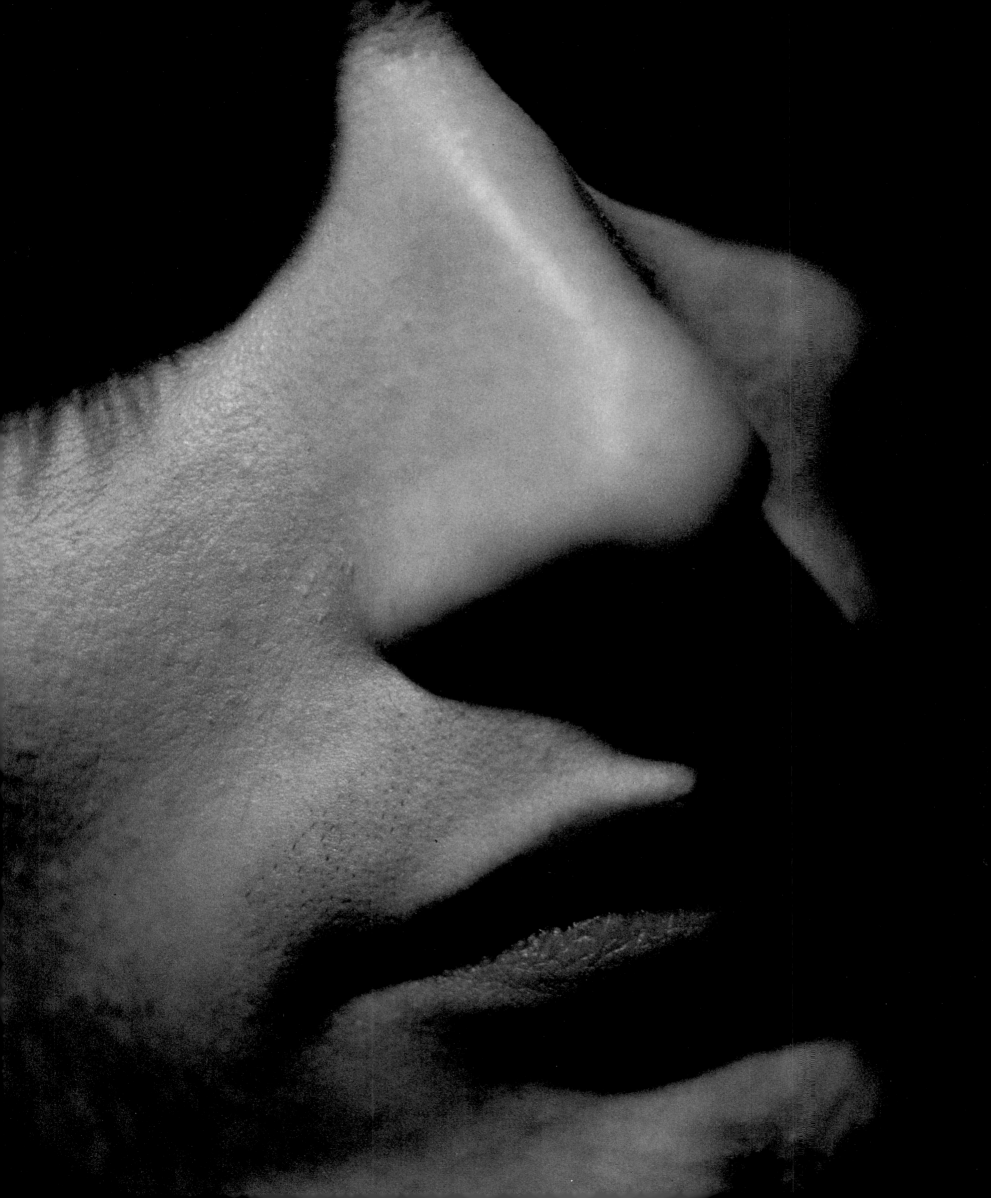

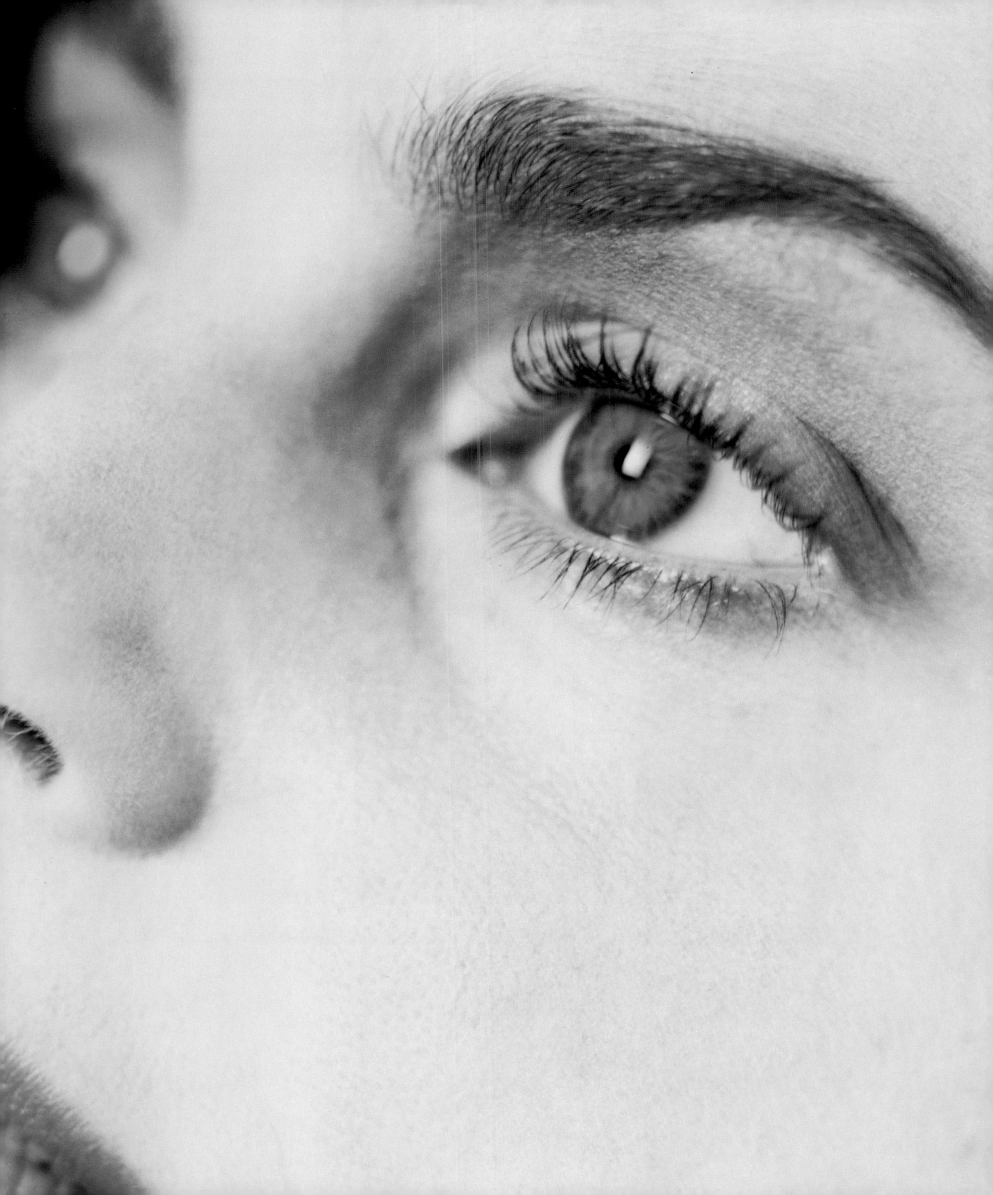

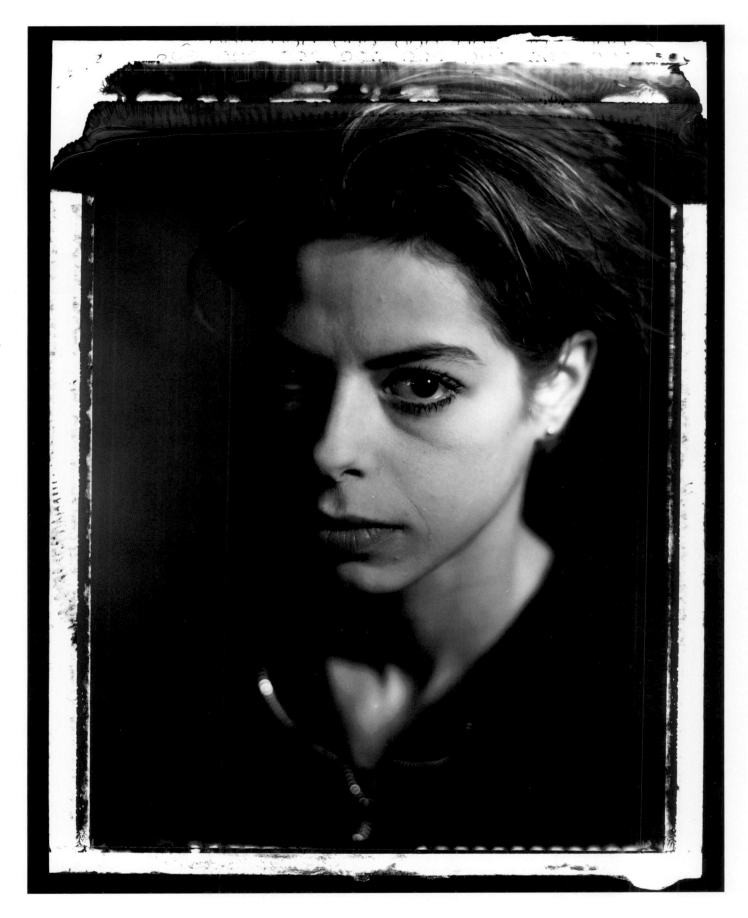

Jürgen Schulzki

◁ Craig Cutler

◁◁ Karin Kohlberg

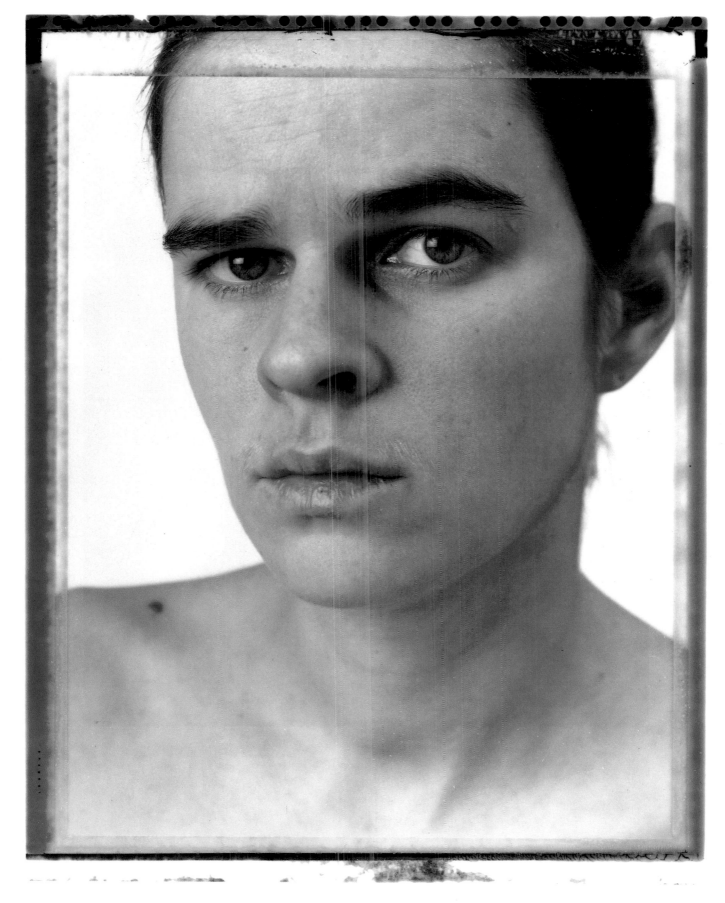

Saša Fuis

Rieder & Walsh Photography

Christian Vogt

▷▷Benno Thoma

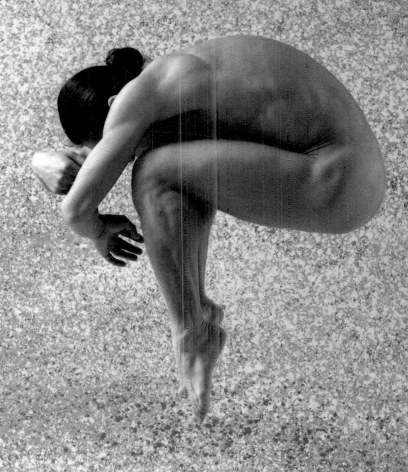

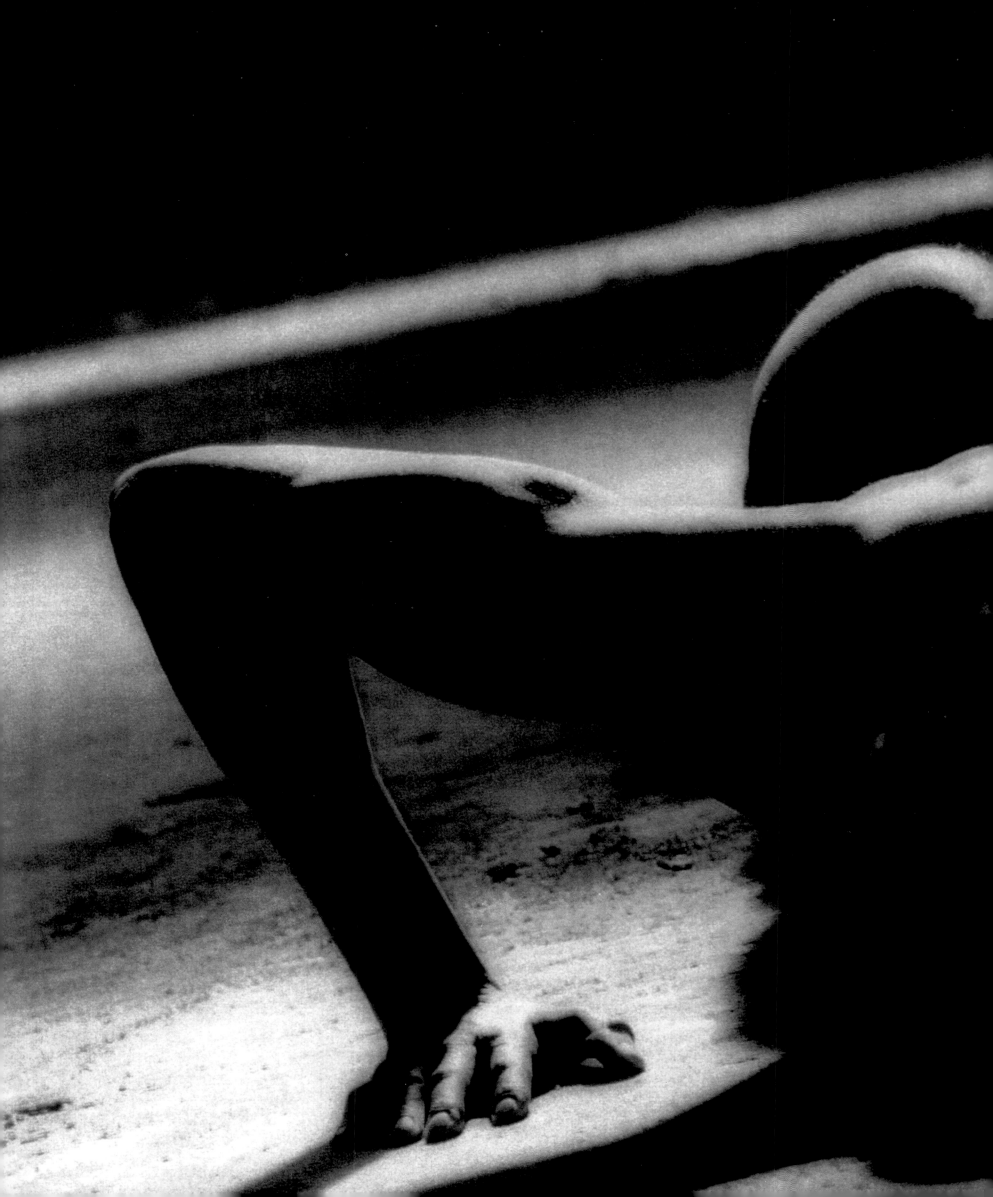

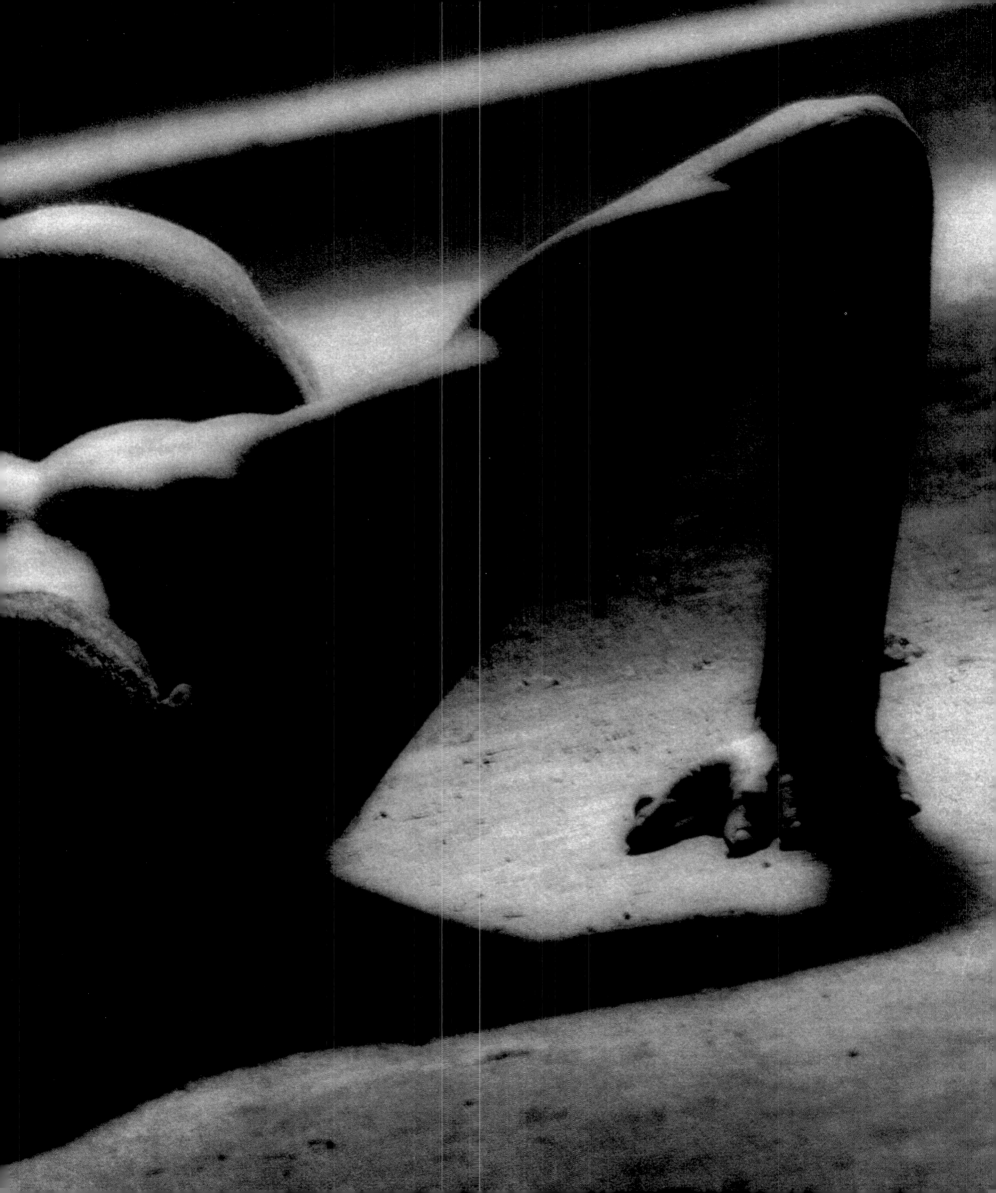

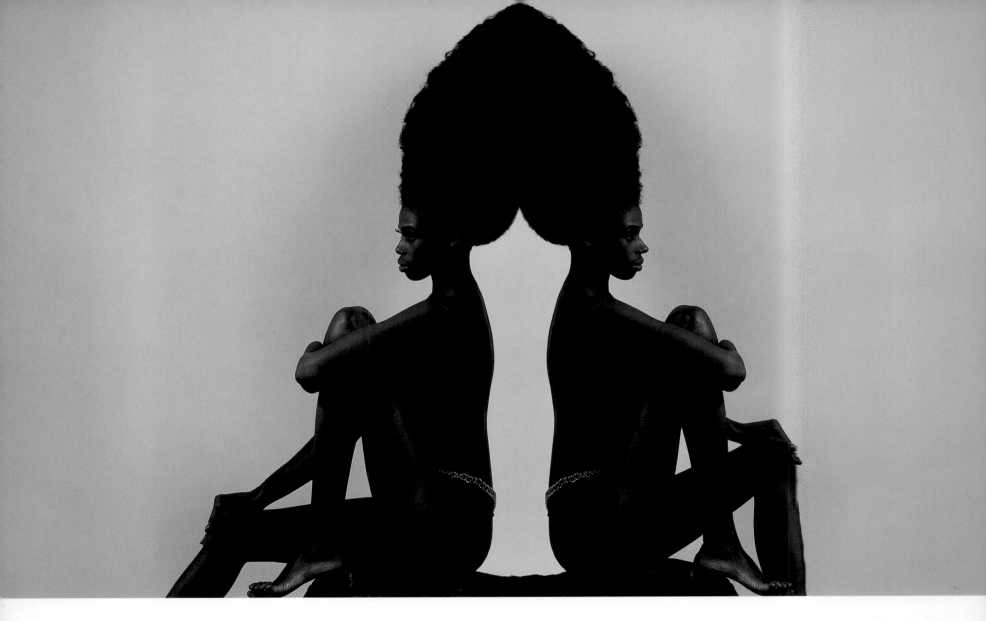

Foton Co., Ltd

Max Schulz

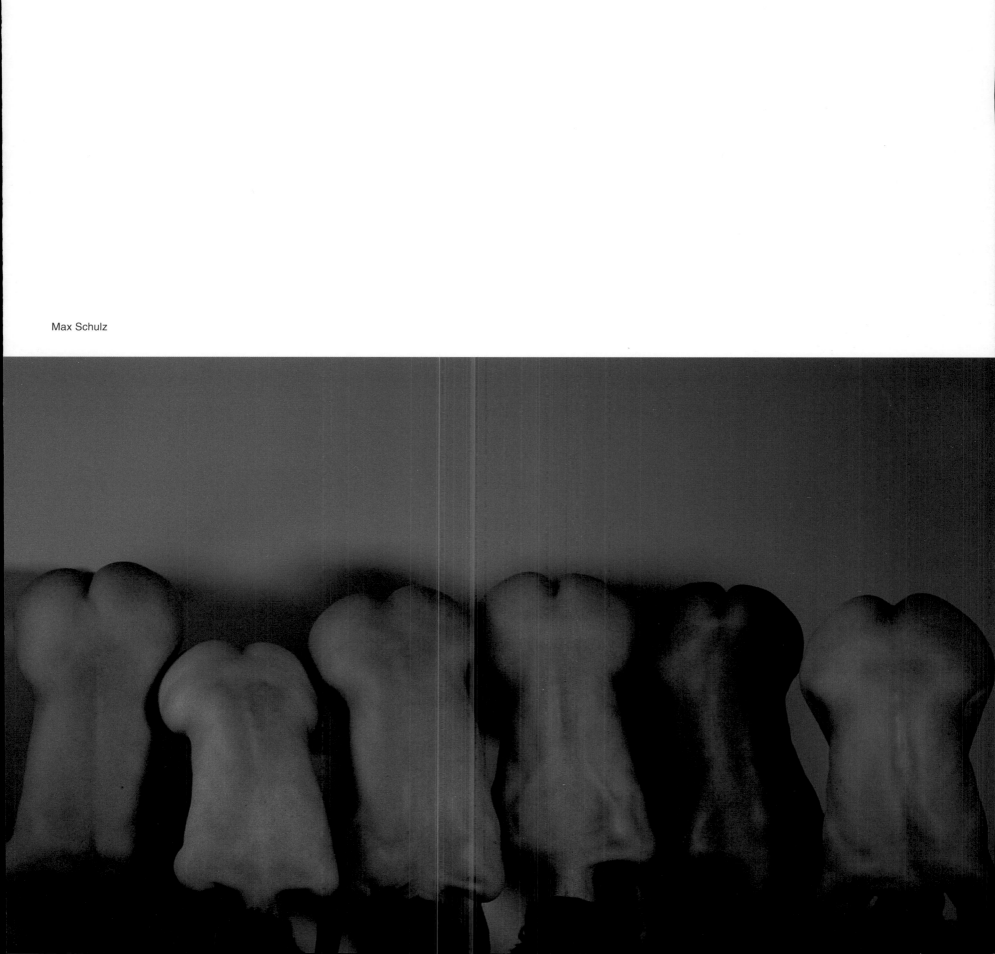

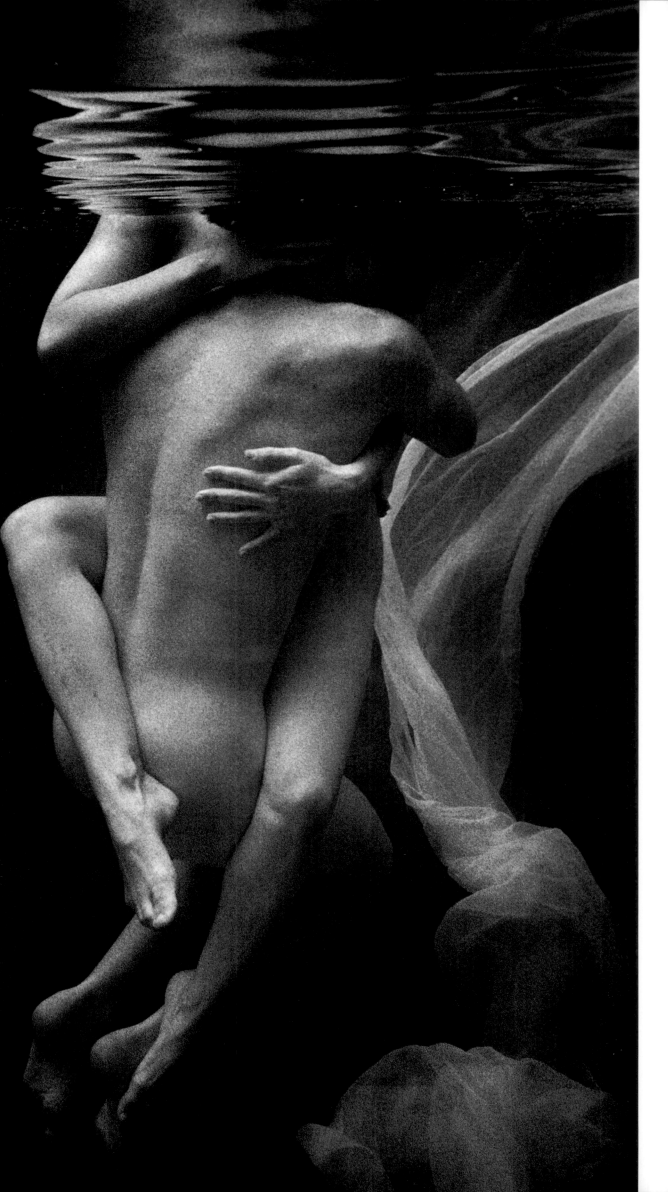

Christina Hope

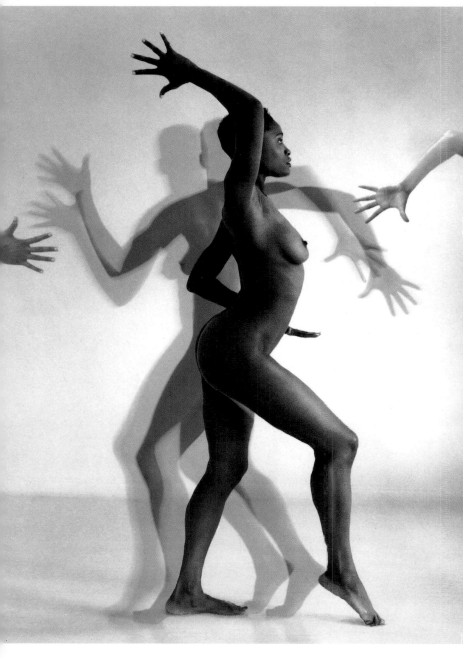

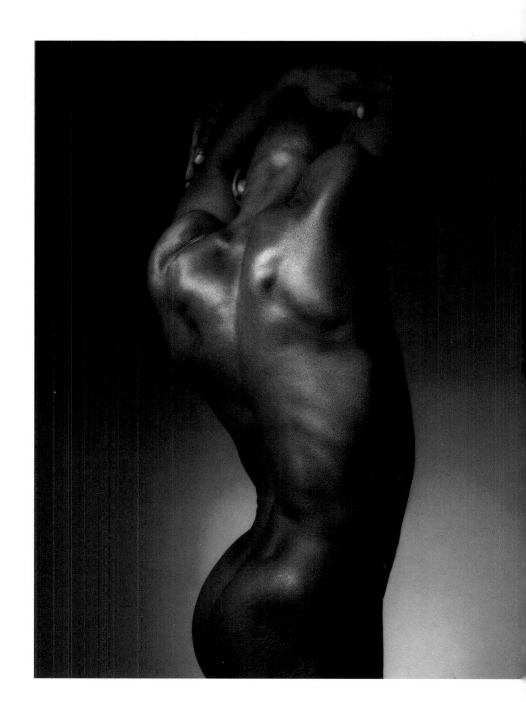

John Chan

E.R. Malmström

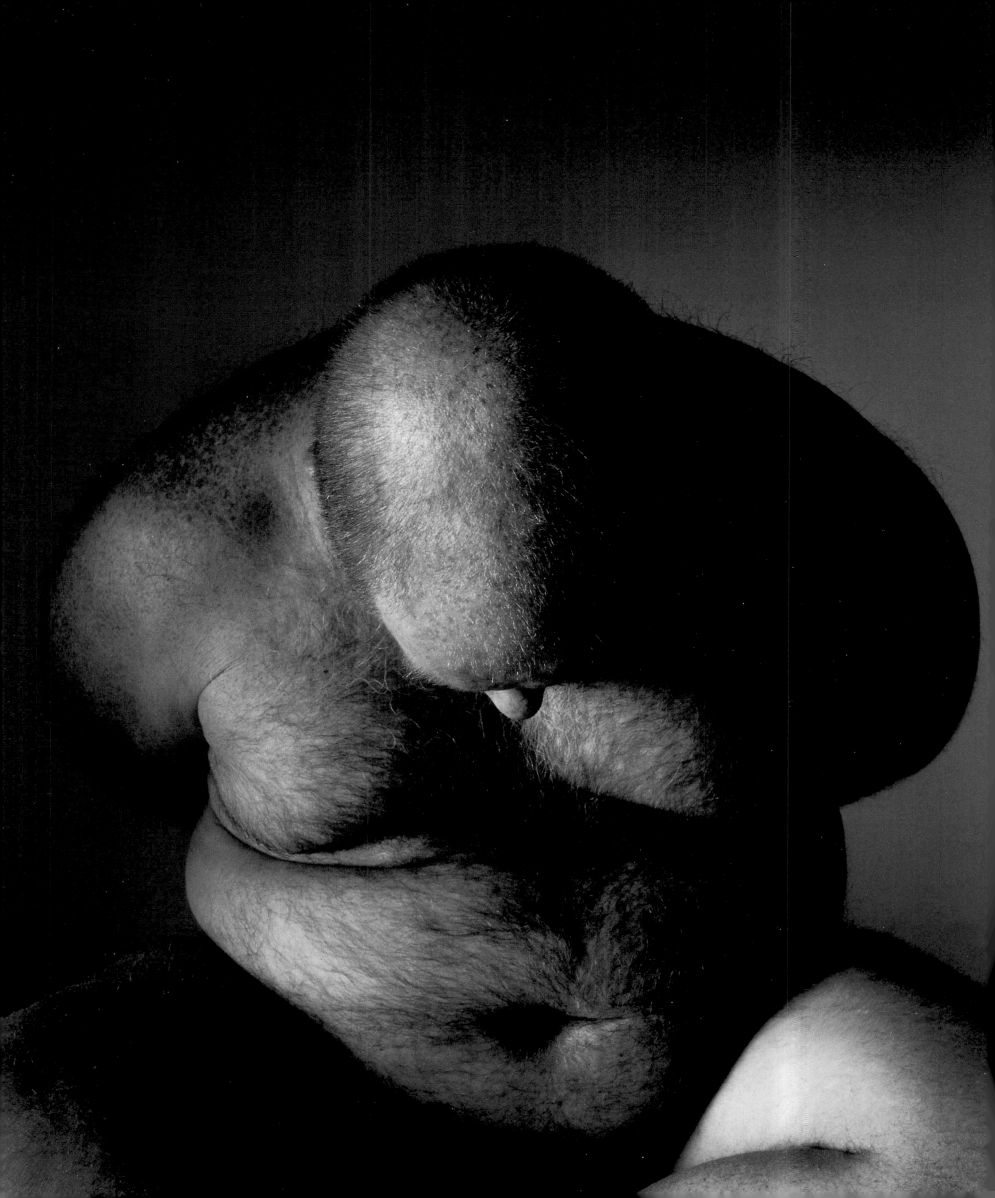

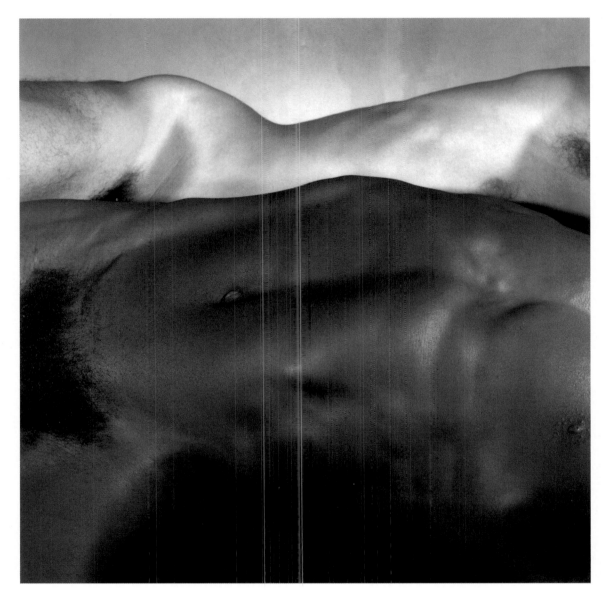

E.R. Malmström

Max Schulz

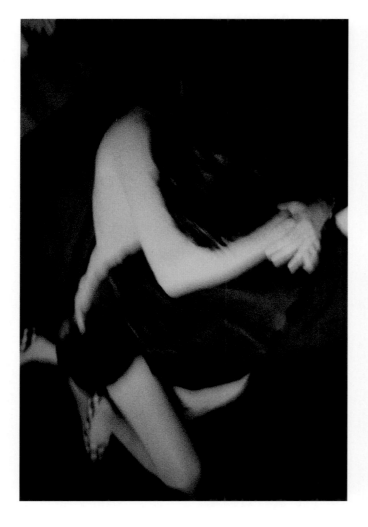

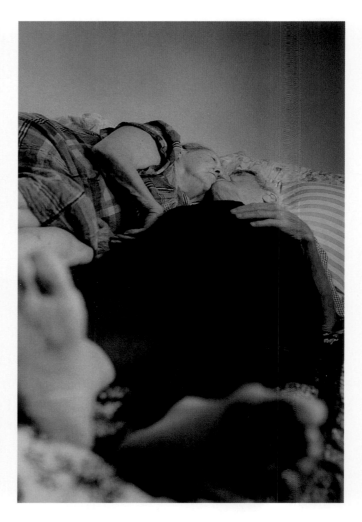

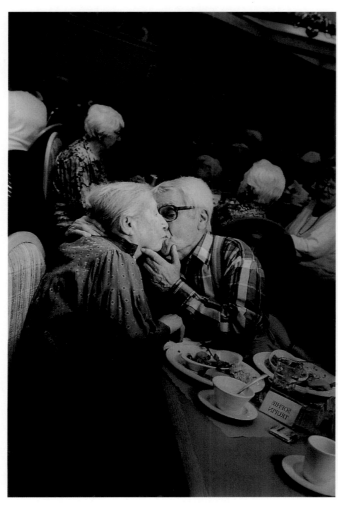

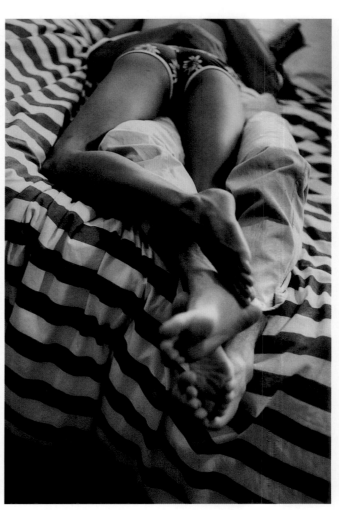

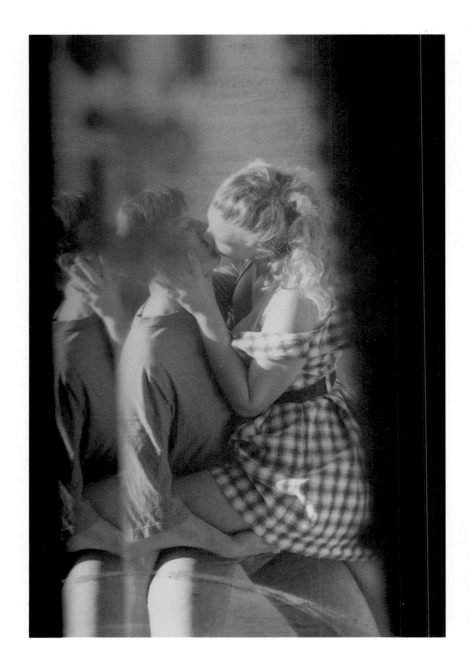

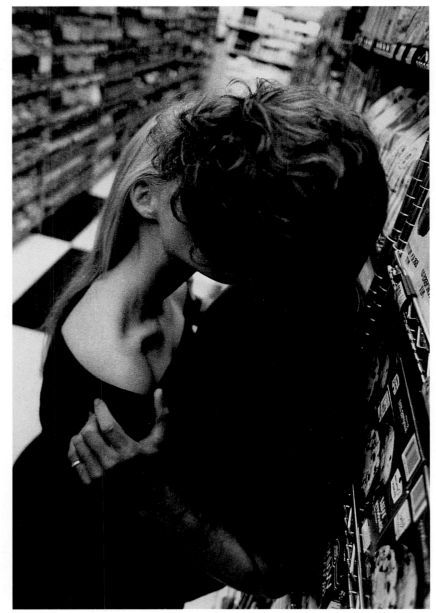

Stephanie Rausser

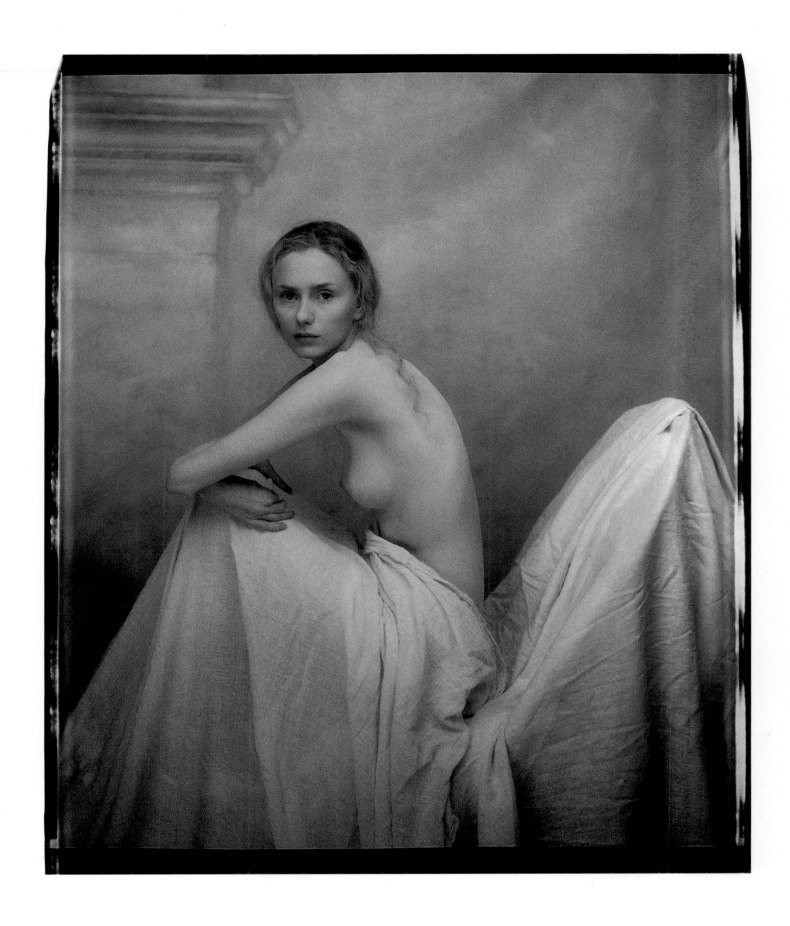

Joyce Tenneson

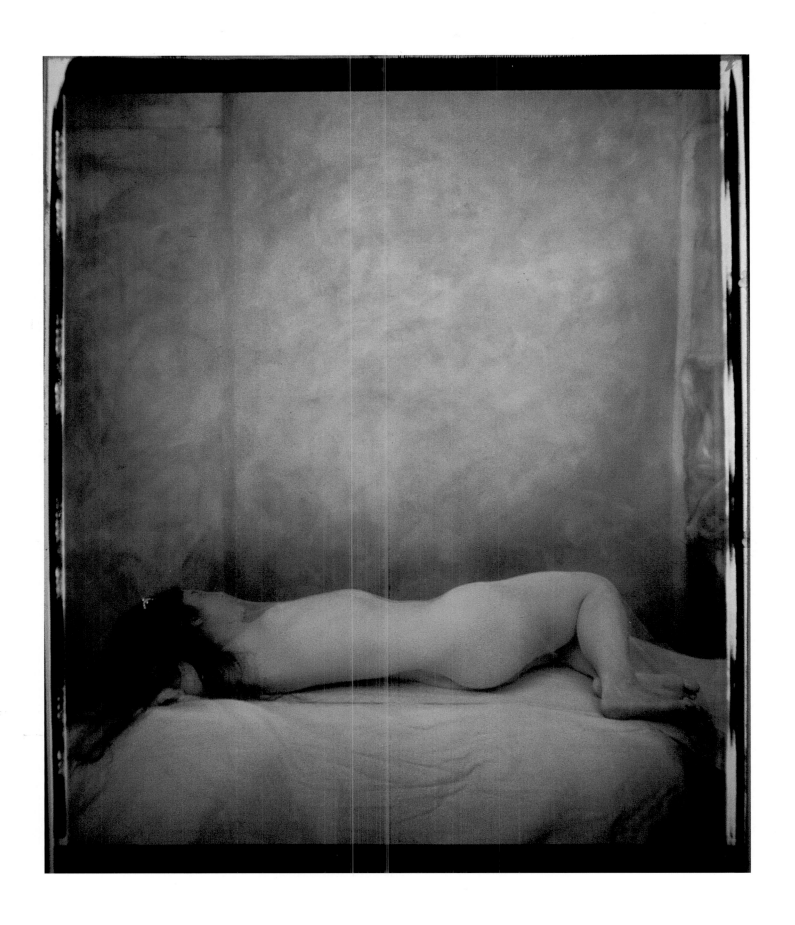

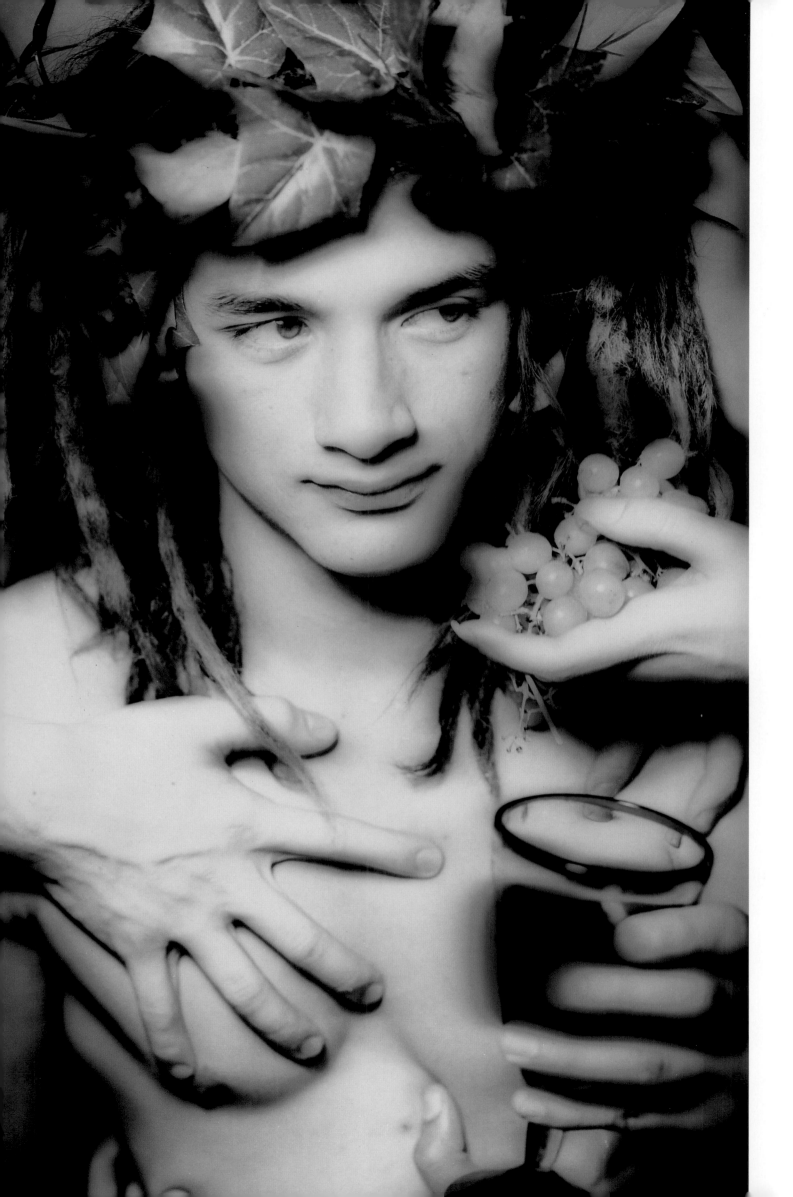

Kim Stringfellow

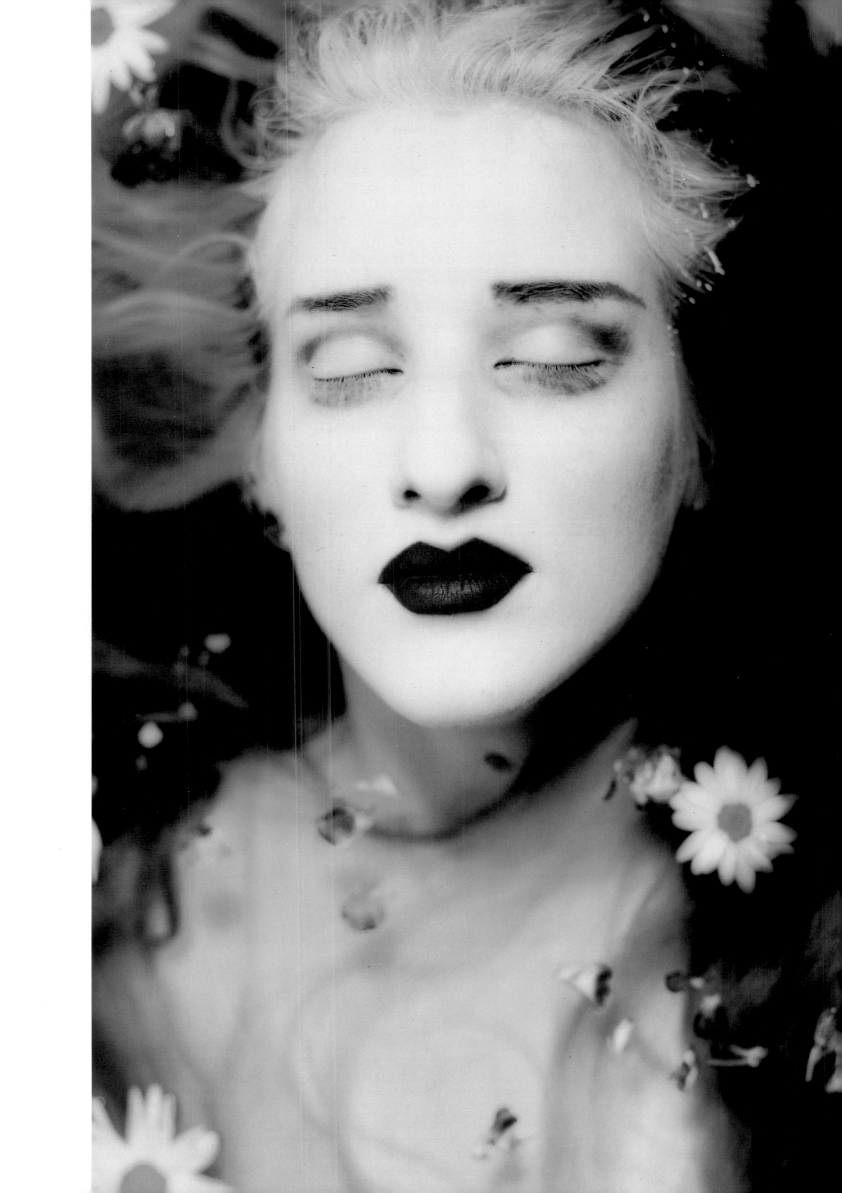

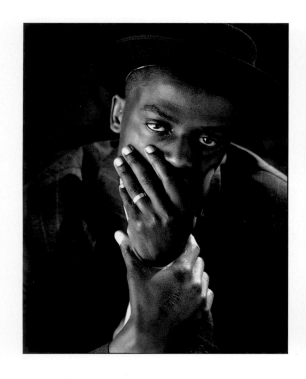
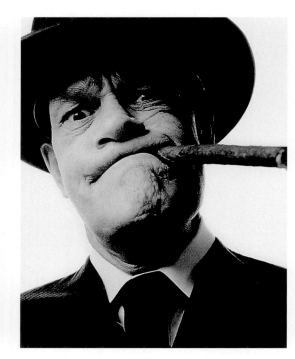
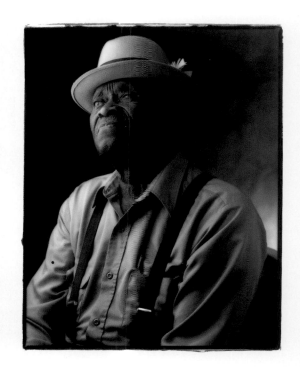

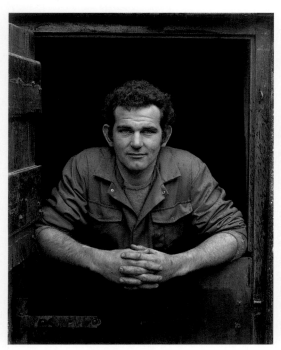
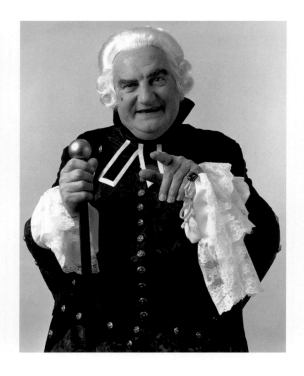
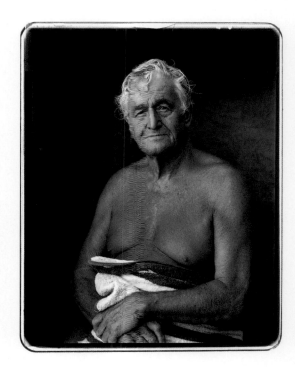

Paul Hampton

Bruce Nicoll

Michael Kremer

Robert Millard

David Powers

Bruce Nicoll

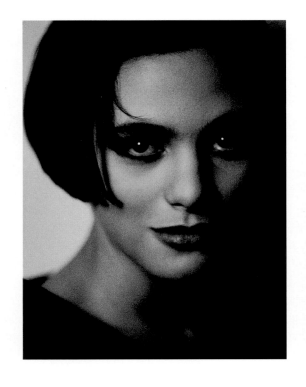
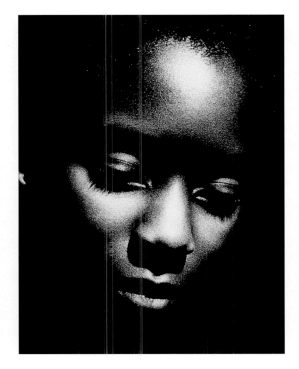
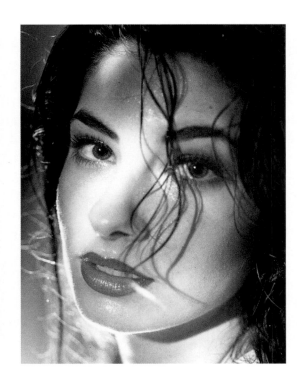

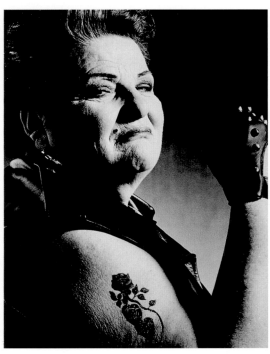
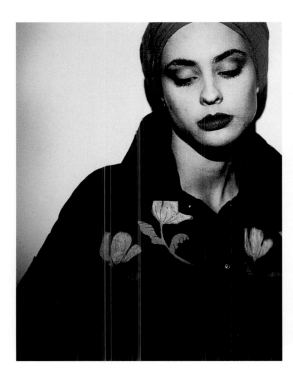
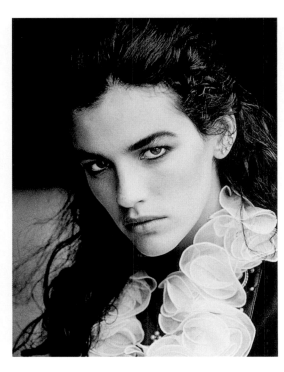

Elke Hesser

Michael Kremer

Elke Hesser

Jonnie Miles

Mike Horseman

Karin Knoblich

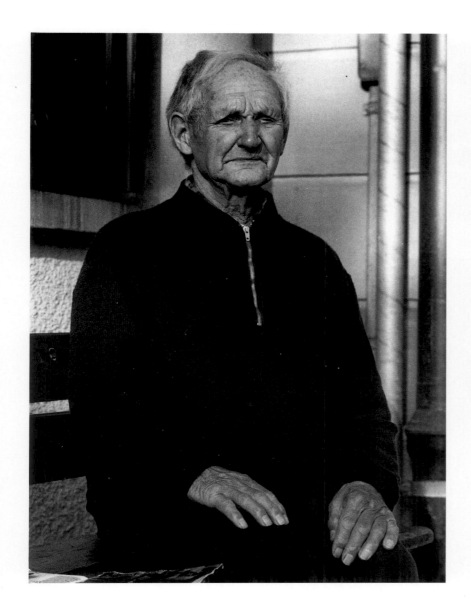

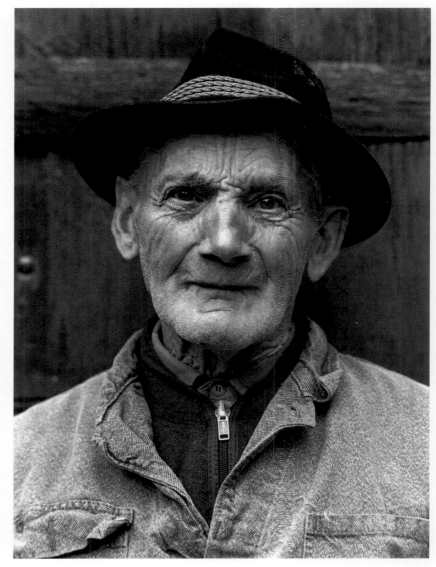

Friedrich K. Rumpf

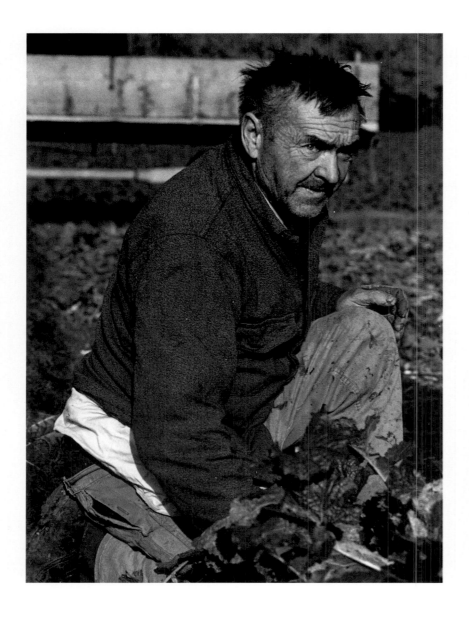

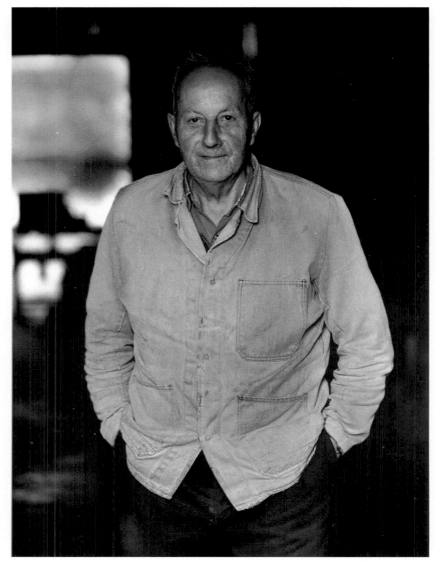

Jacko Vasilev ▷

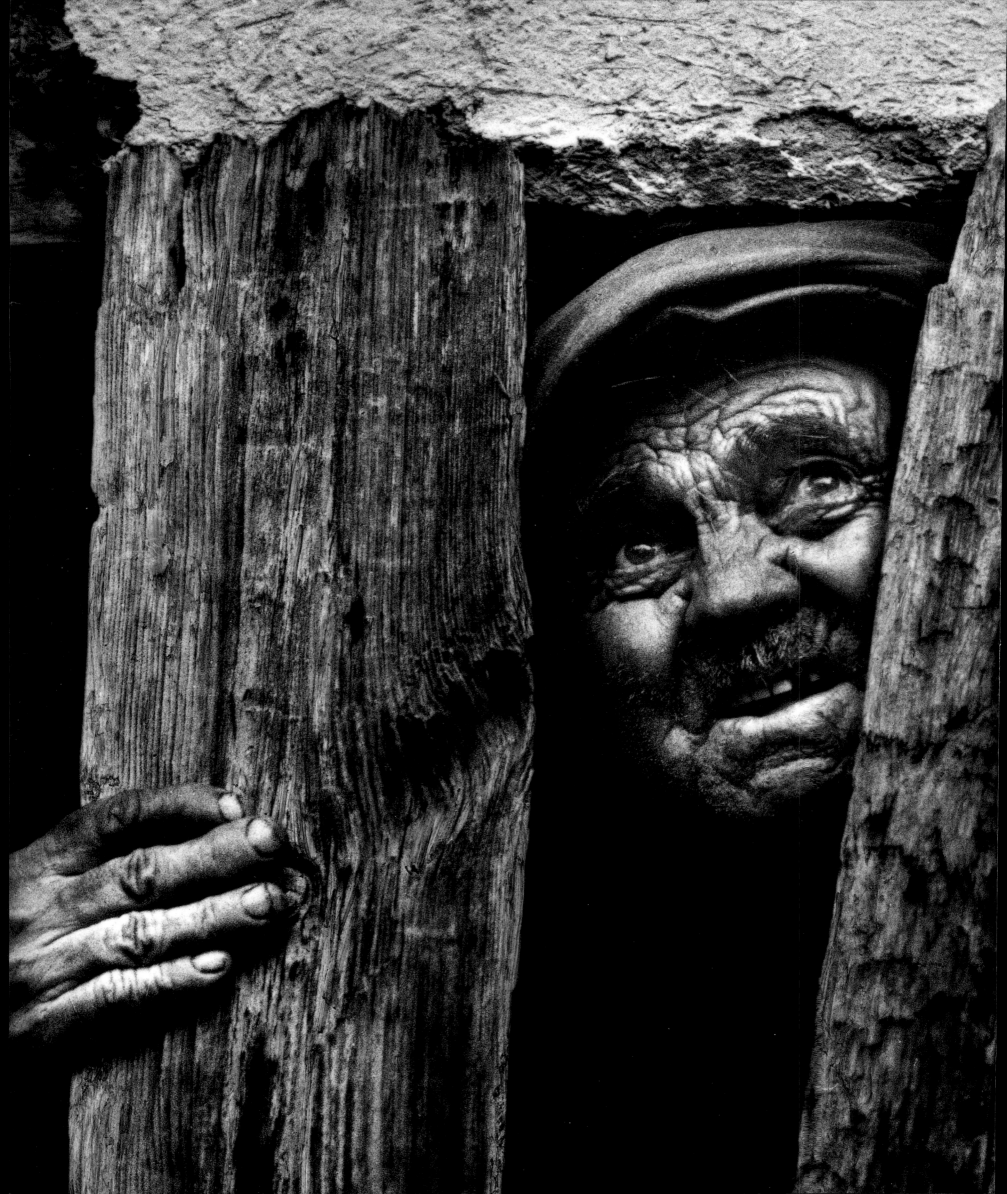

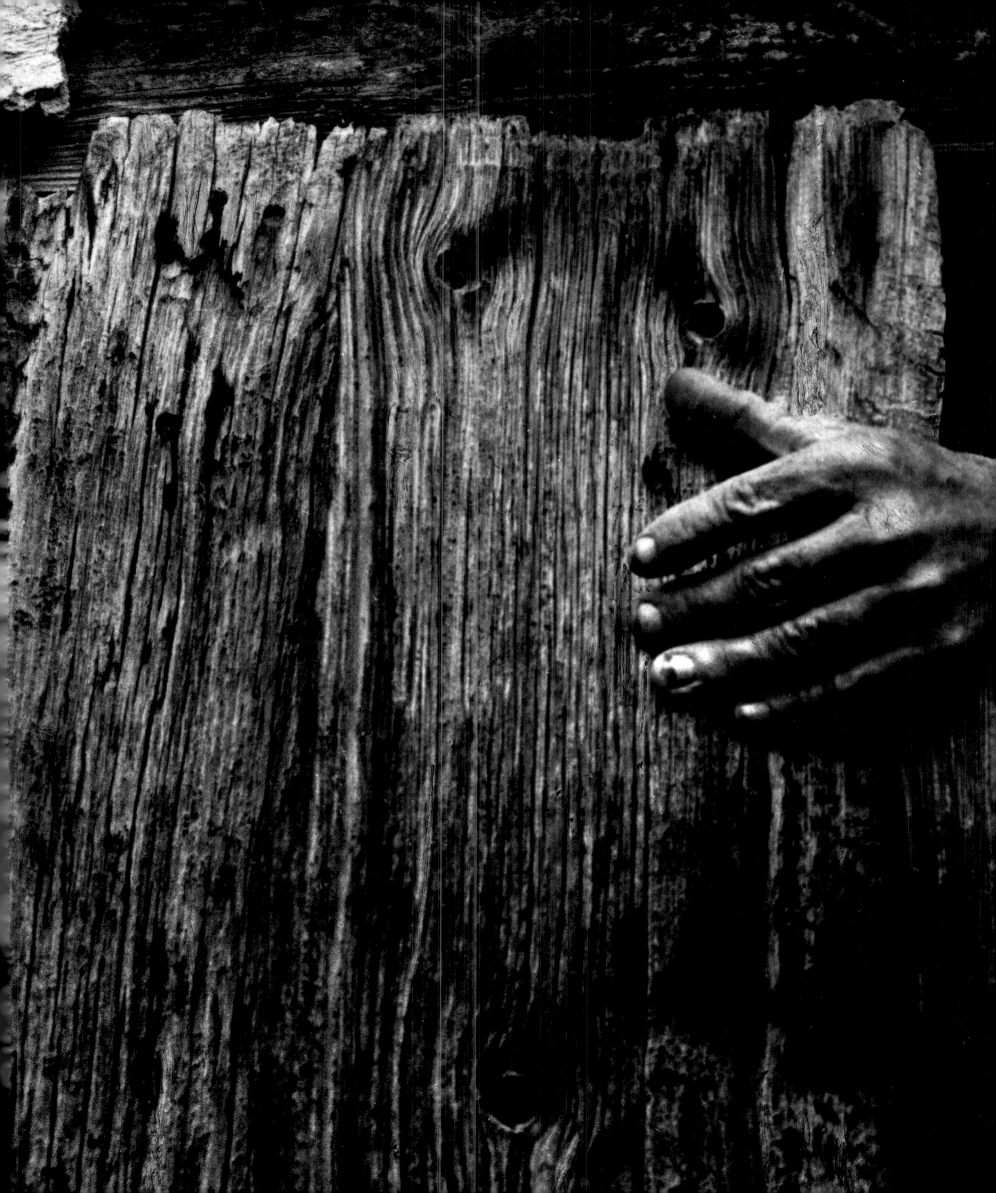

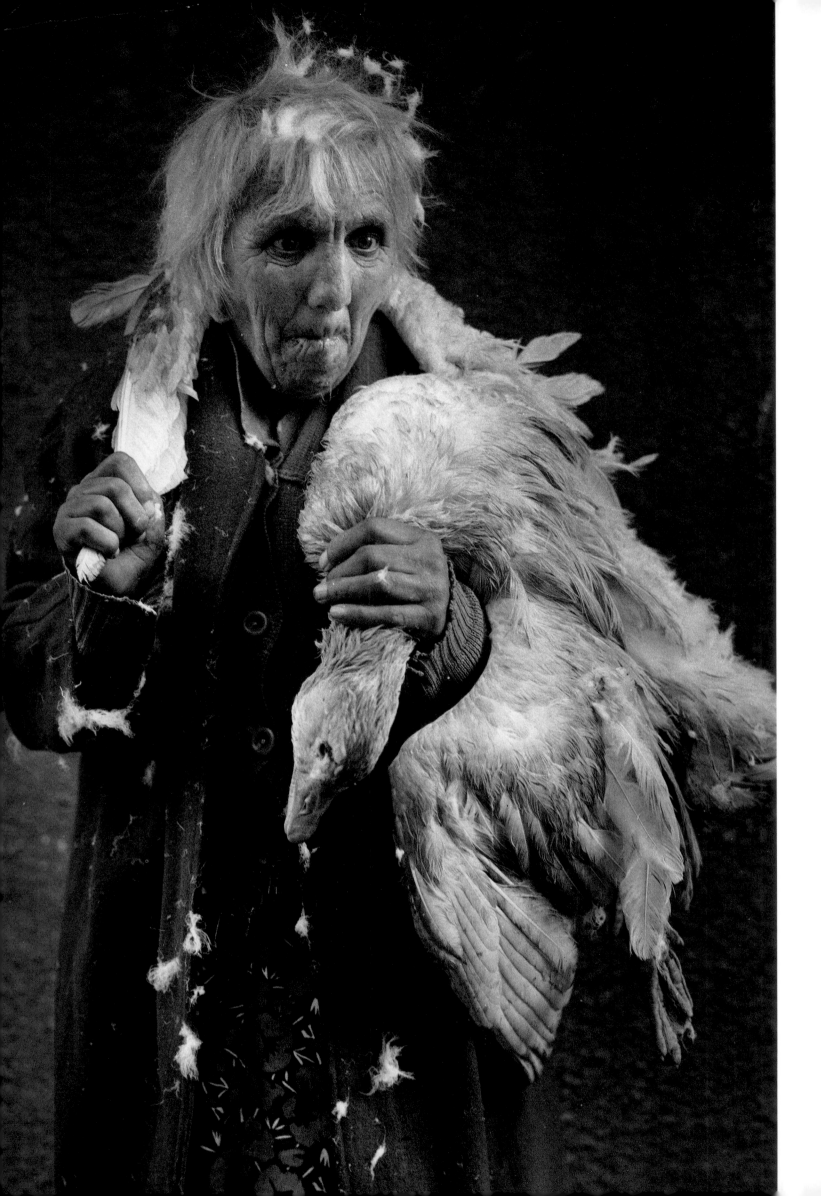

Jacko Vasilev

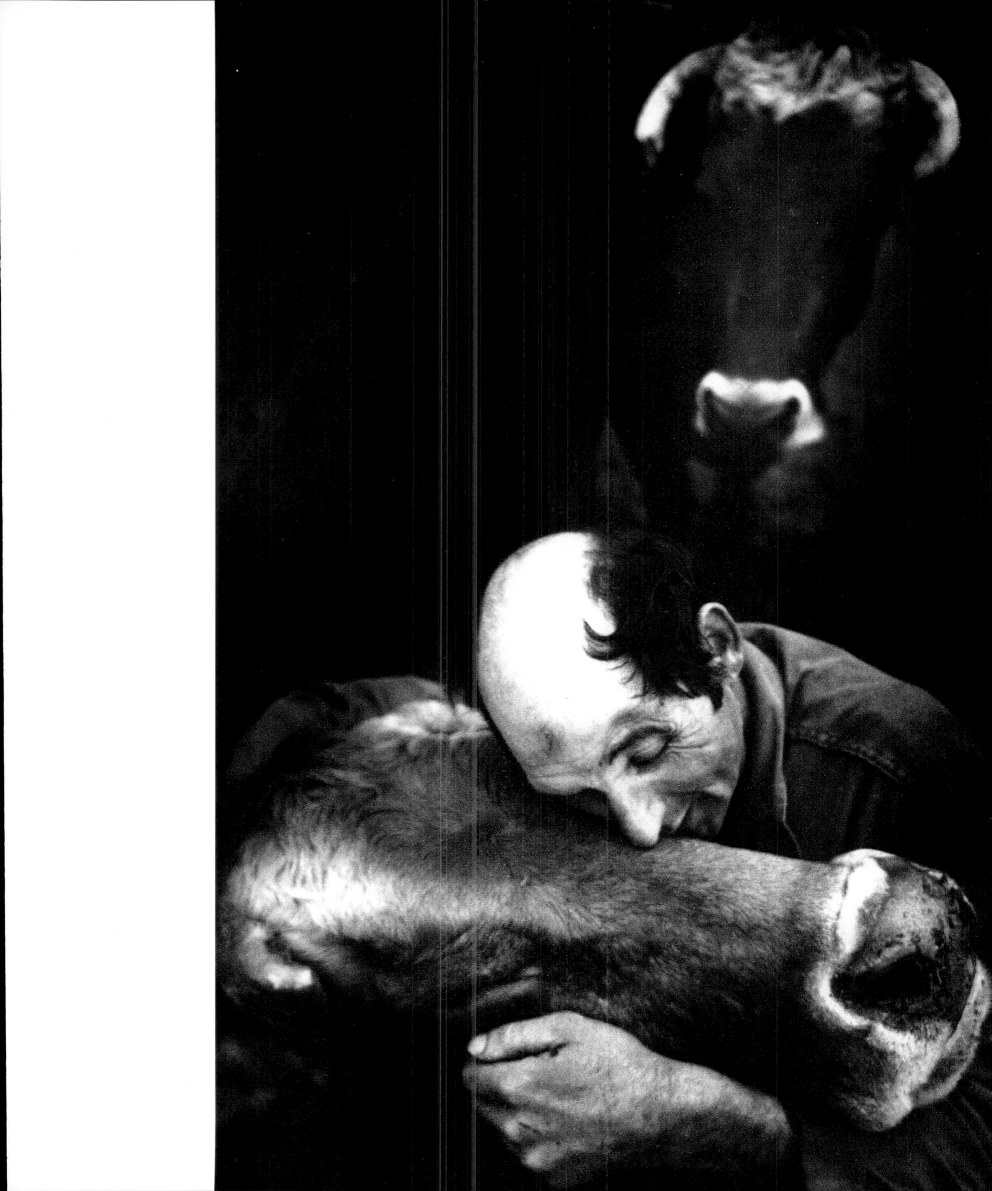

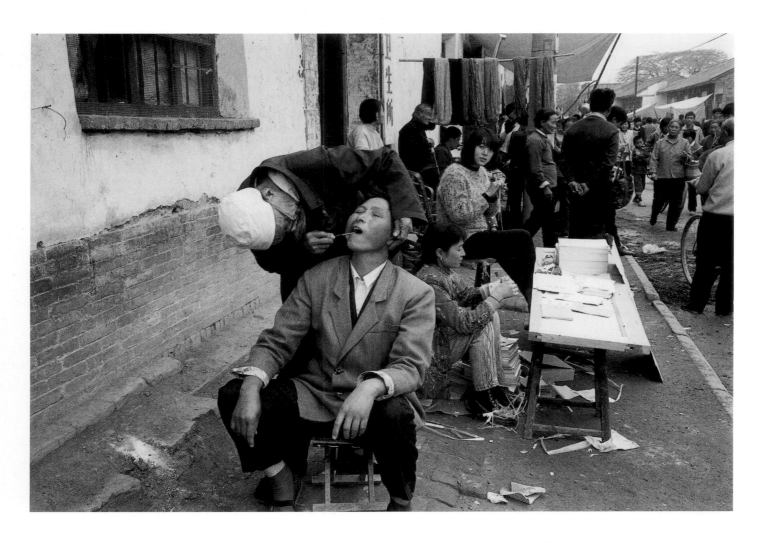

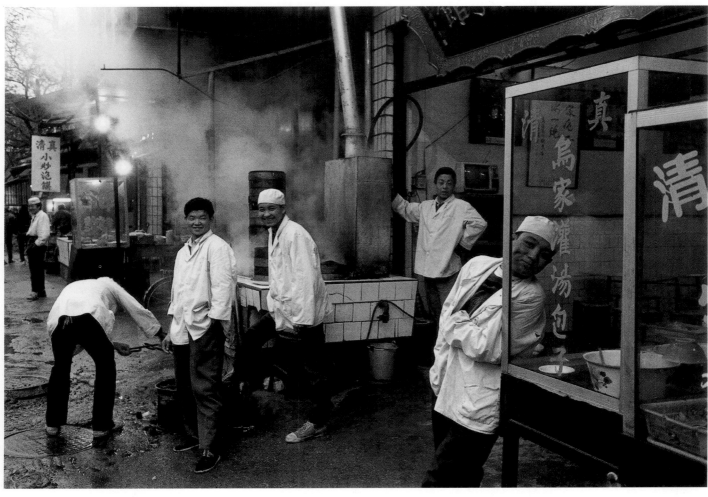

Mark Gisler

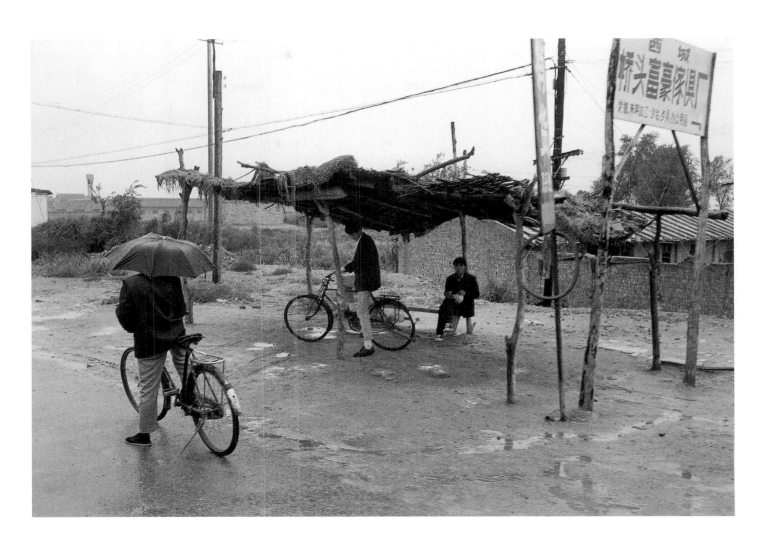

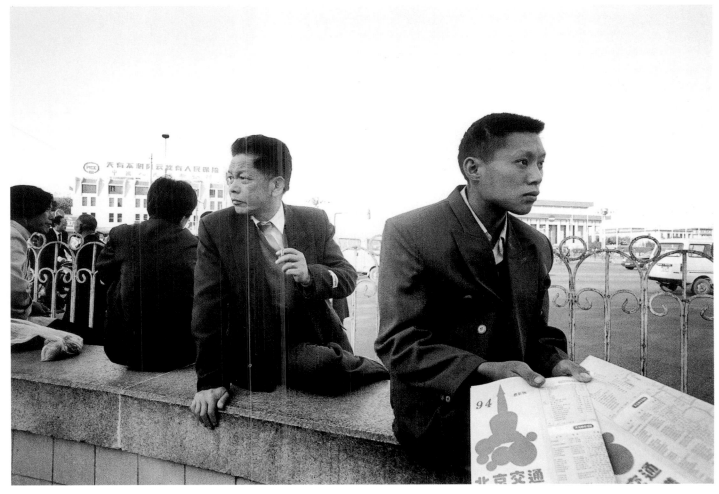

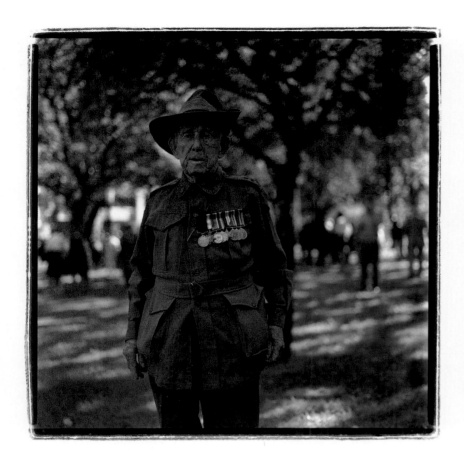

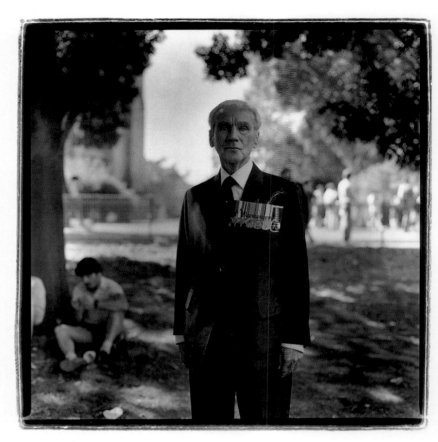

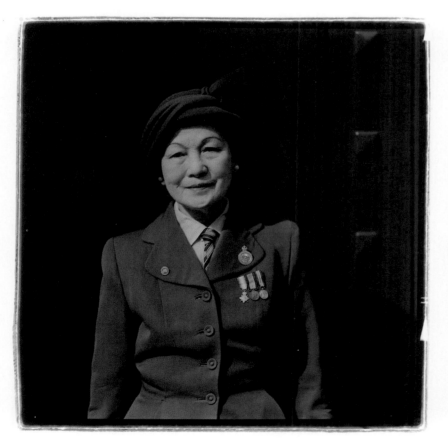

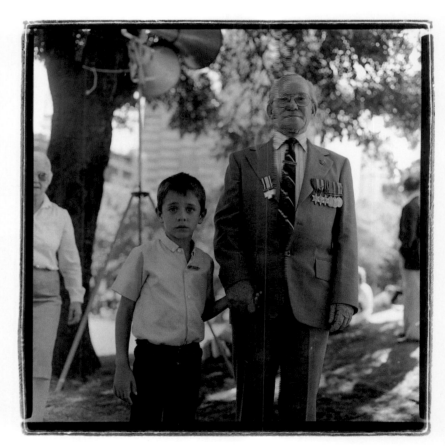

Nik Mandakis

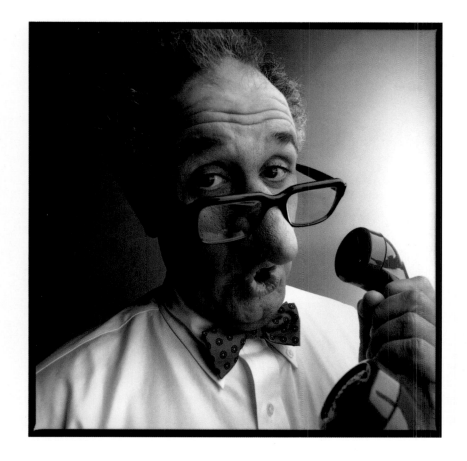

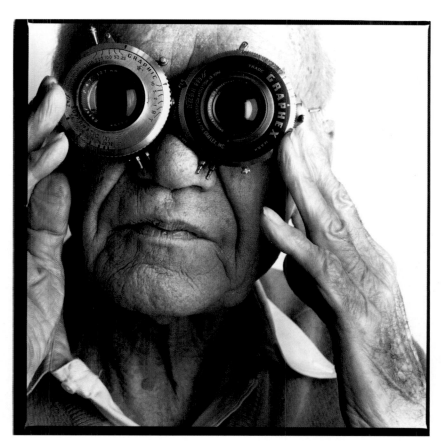

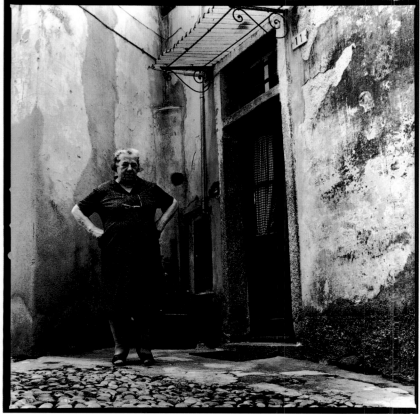

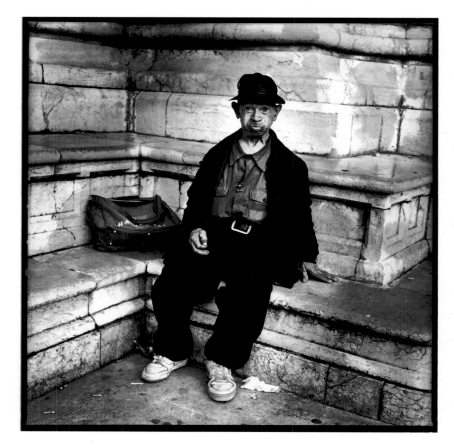

Jock McDonald

Fjodor Cyriel Buis

Jock McDonald

Fjodor Cyriel Buis

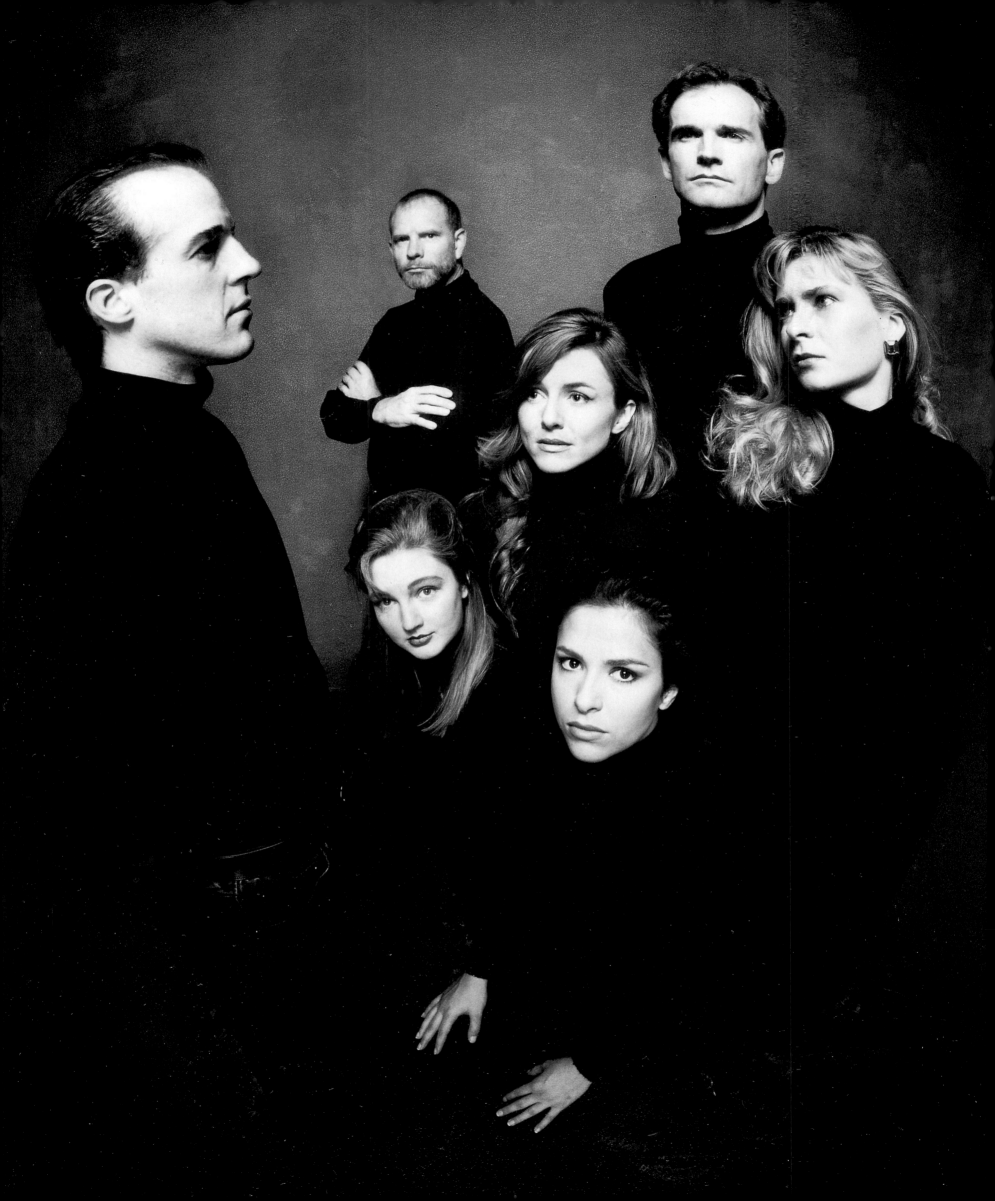

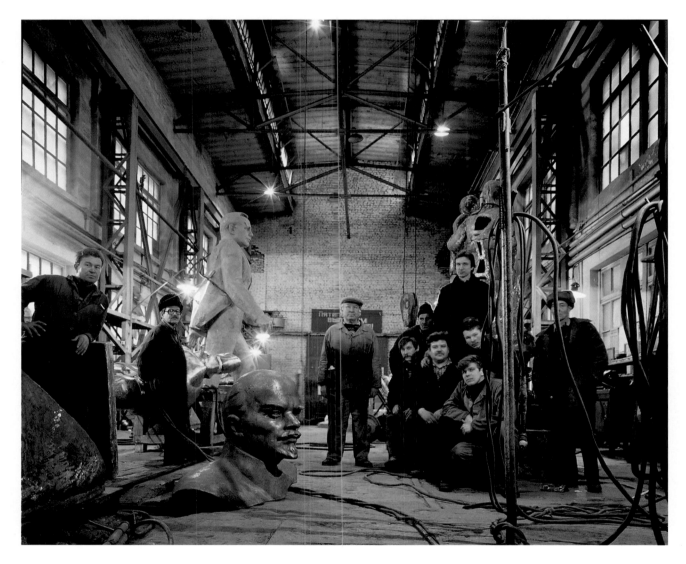

Anno Pieterse

Ed Freeman

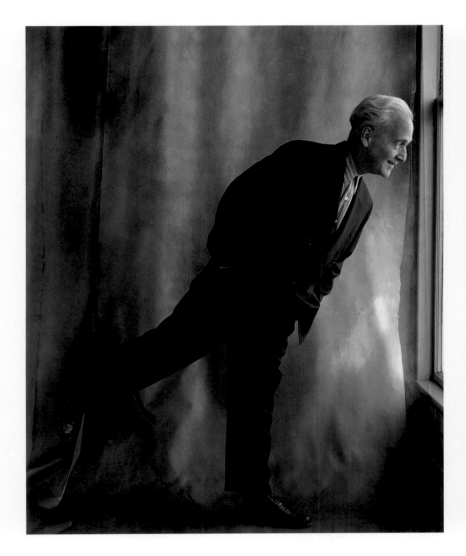

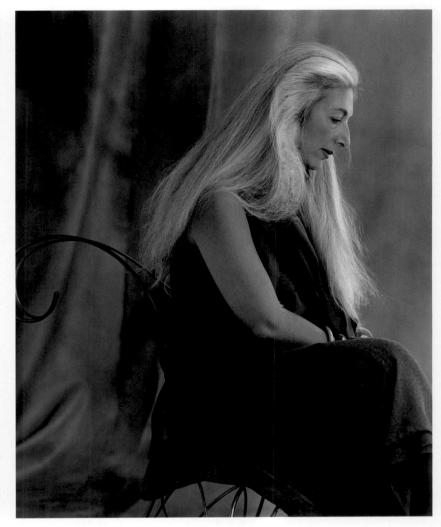

Alen MacWeeney, *Robert Reitzfeld*

Alen MacWeeney, *Marina Kaufman*

Alen MacWeeney, *John Lone*

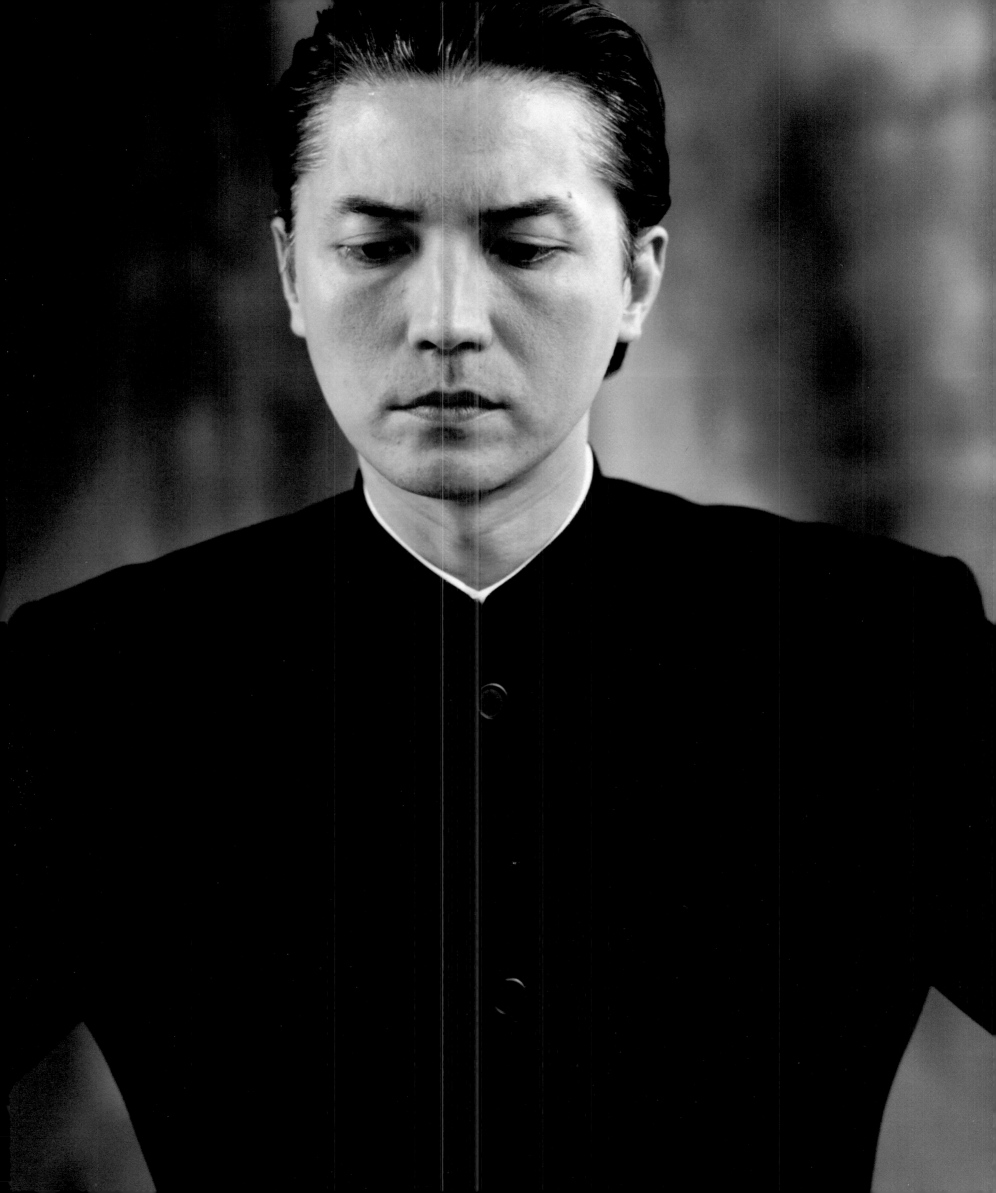

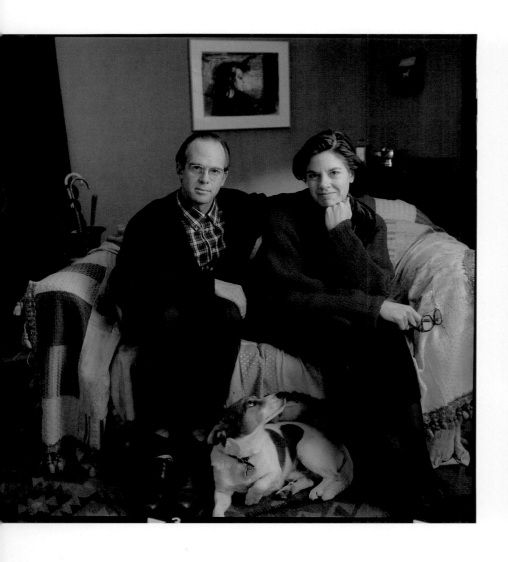

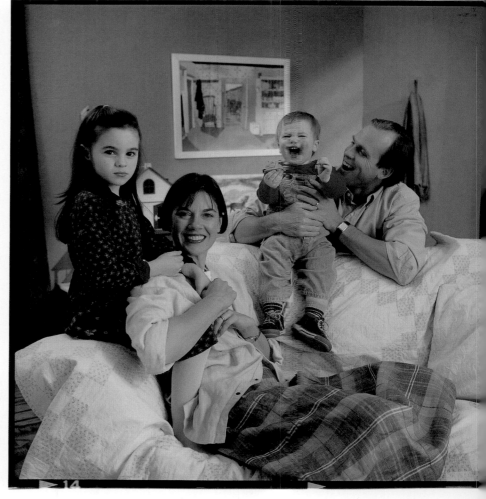

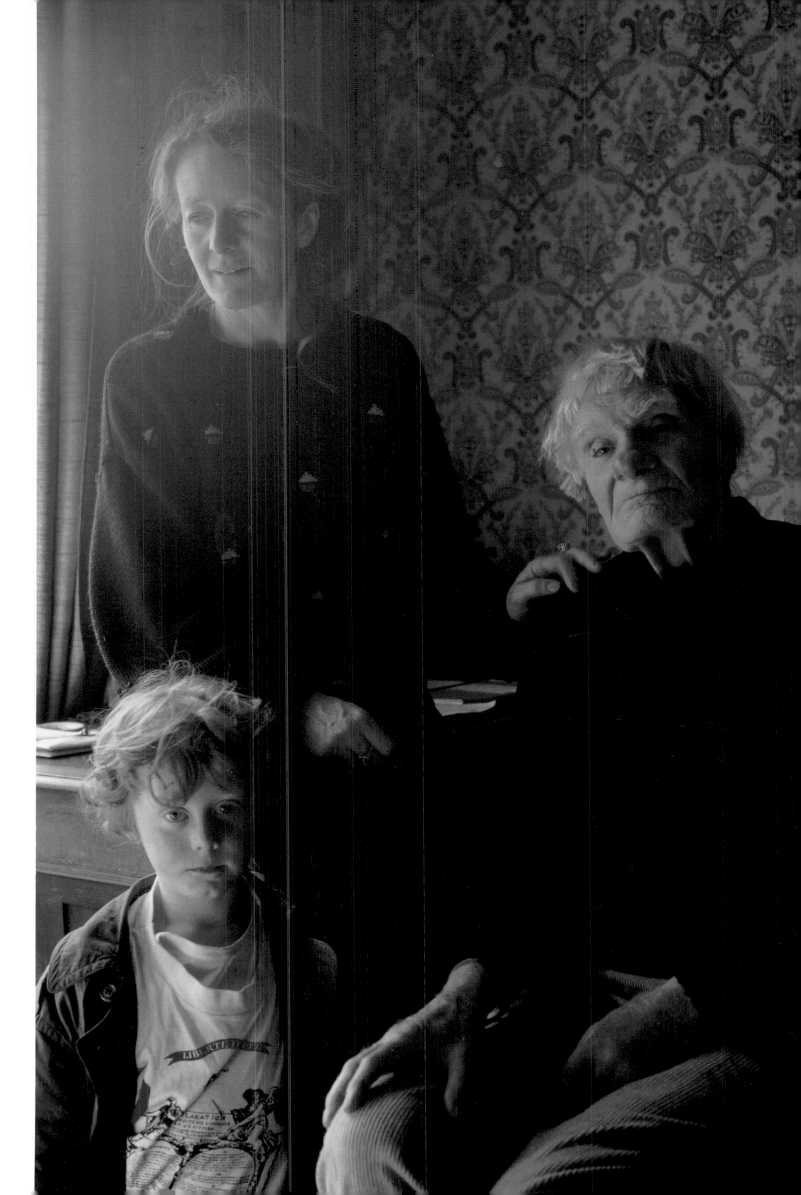

Alen MacWeeney

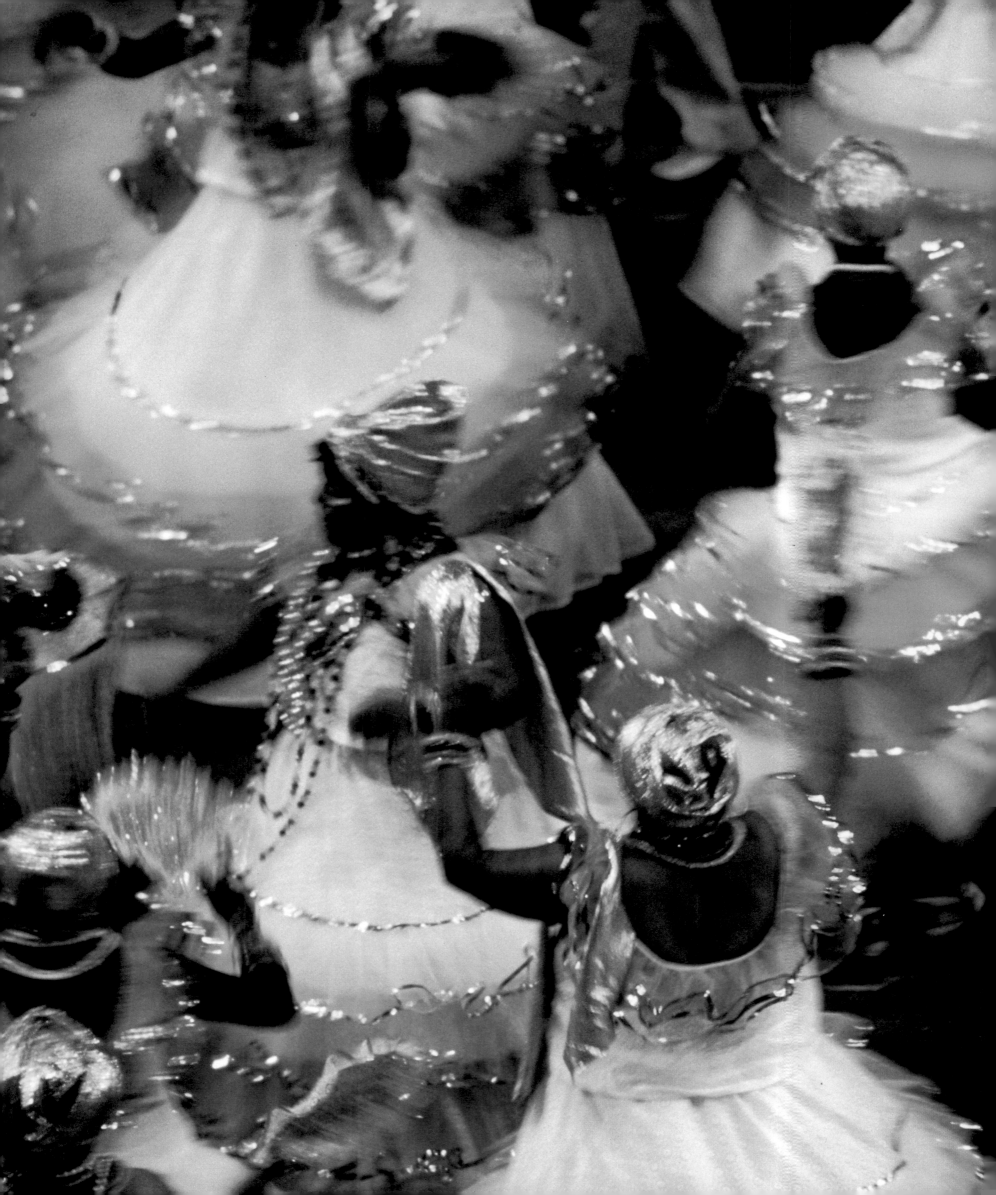

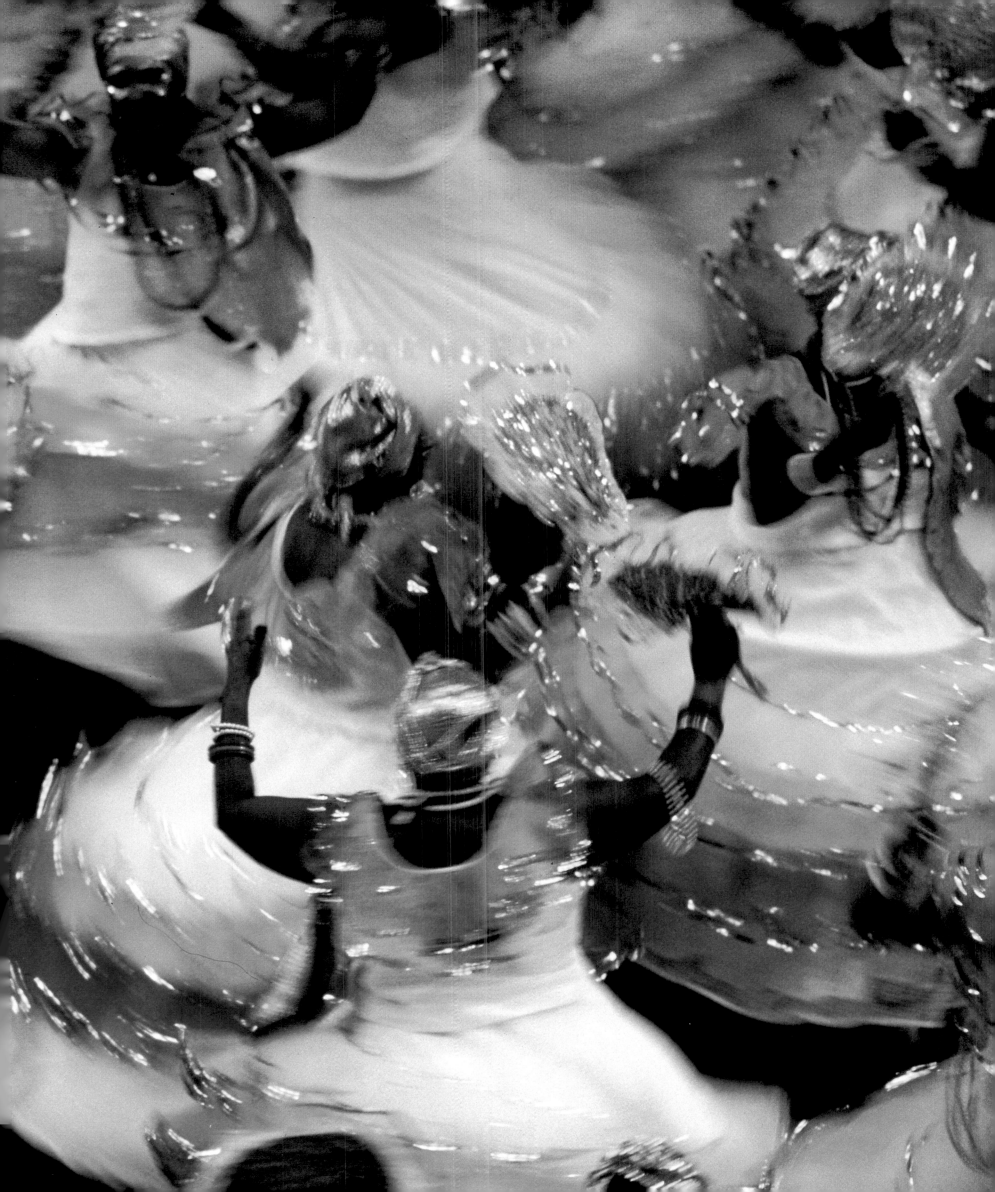

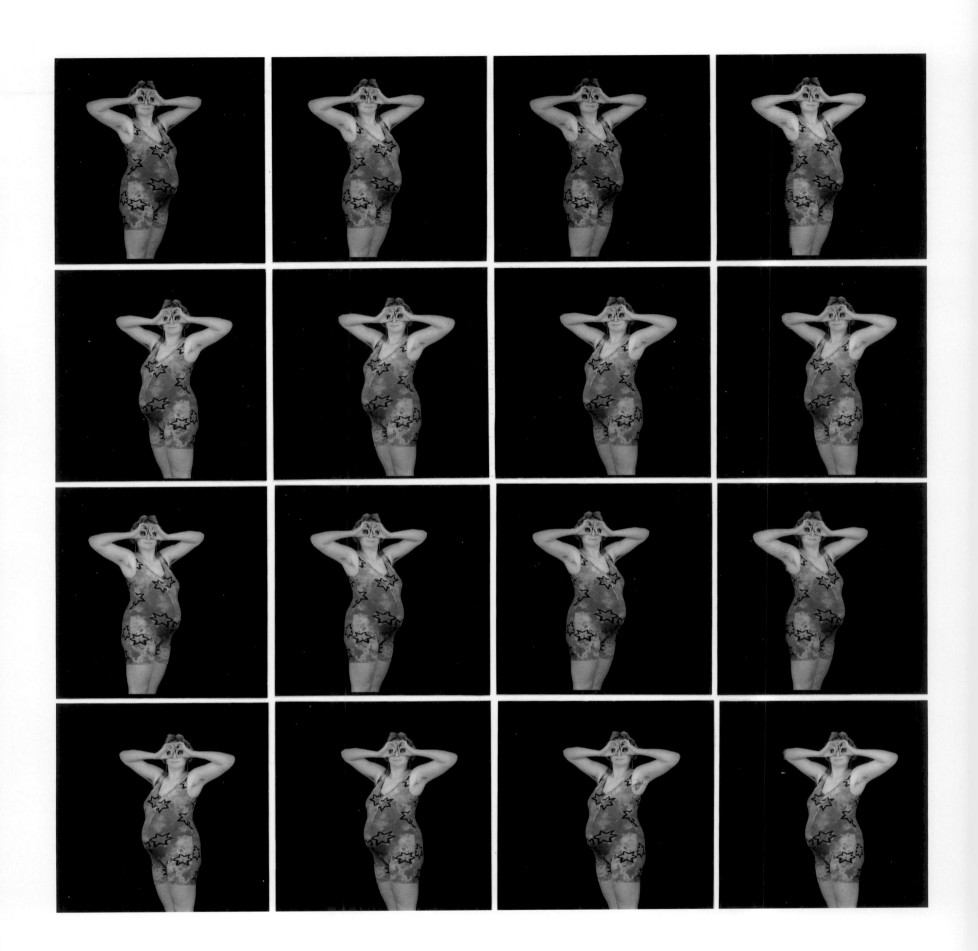

Pascale Jansen

◁ Mark Gamba

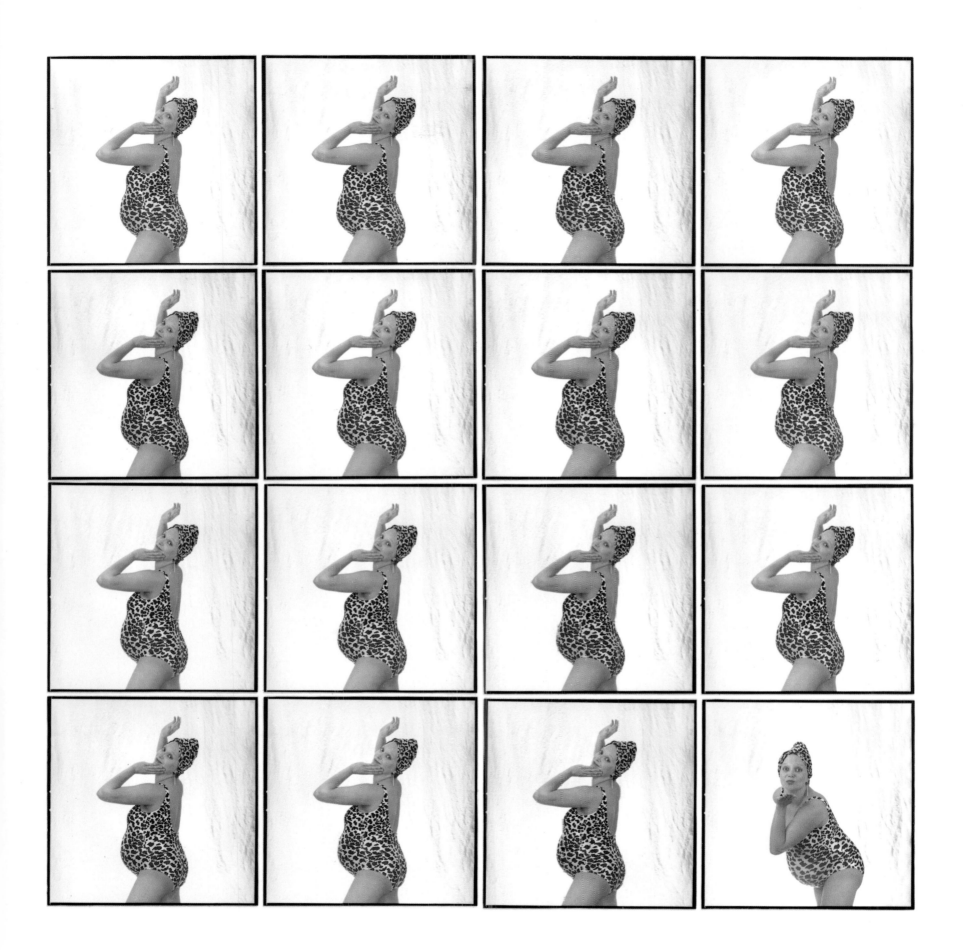

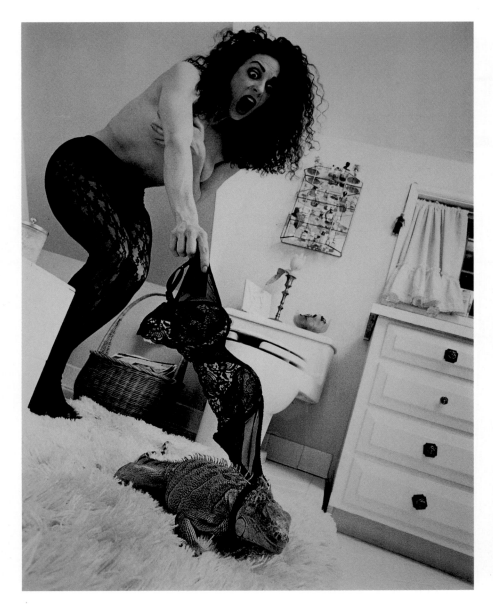

Fred George

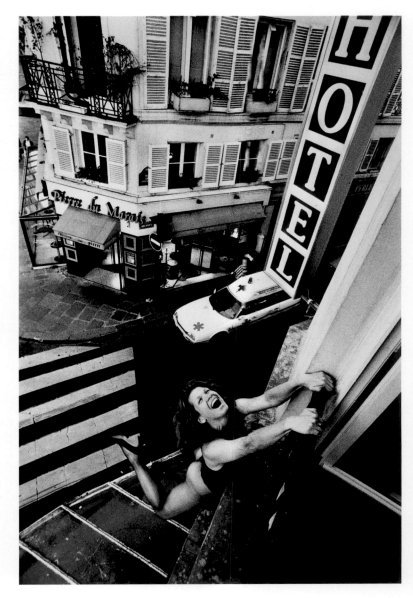

Fred George

Klaus-Peter Nordmann

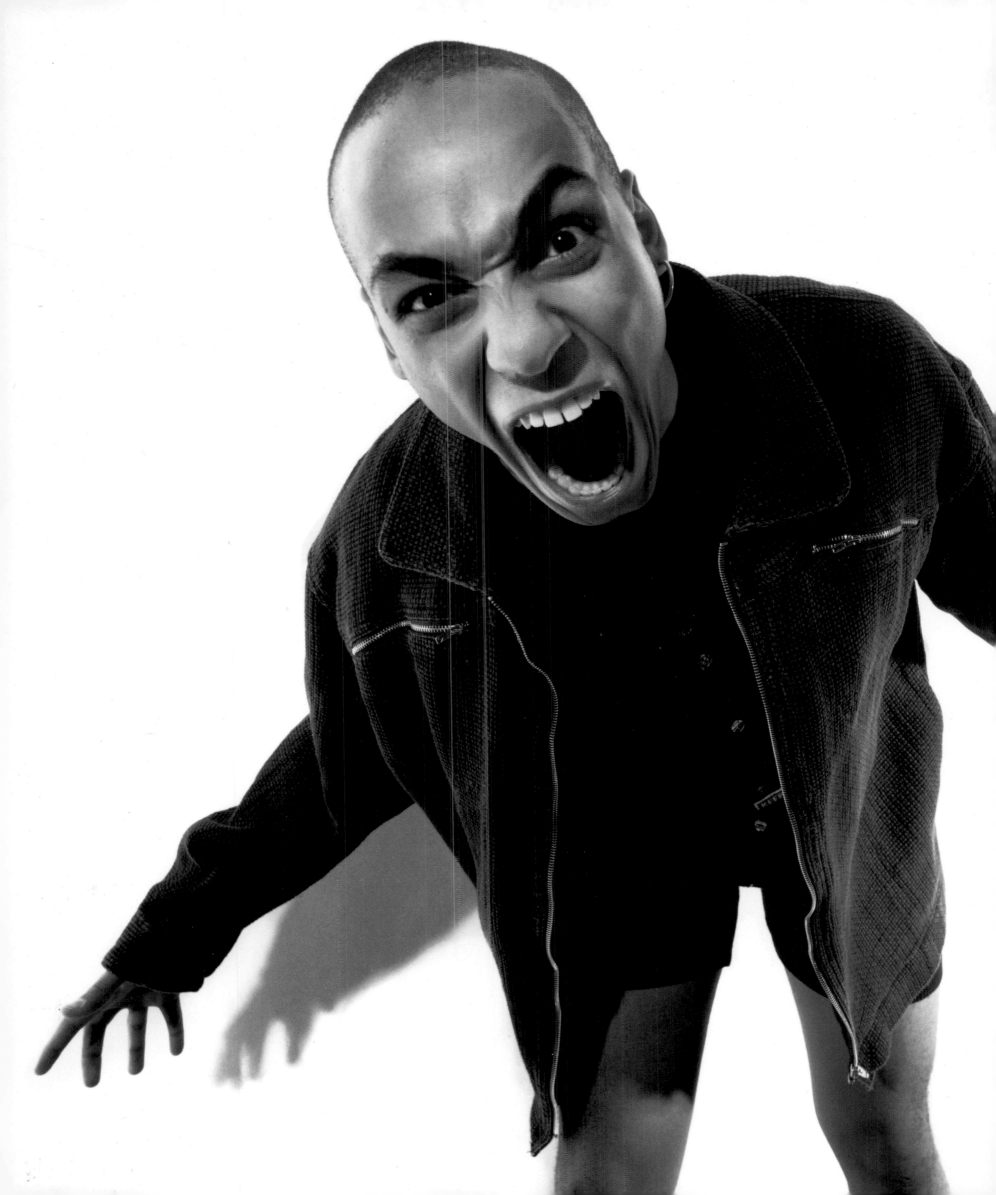

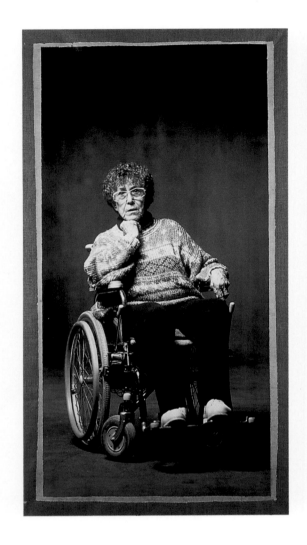
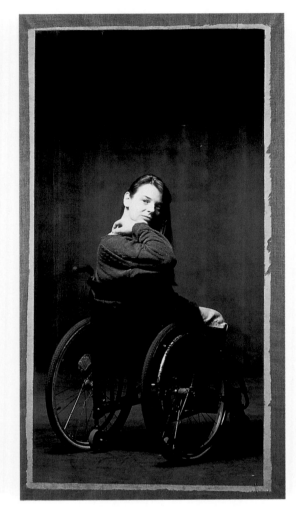
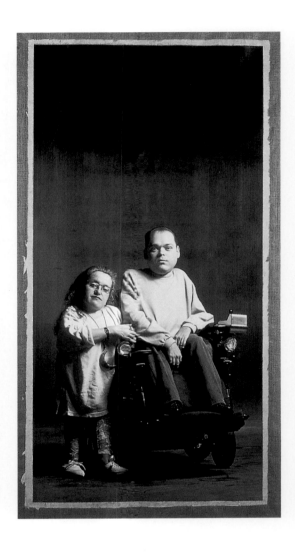

Ruprecht Stempell & Oliver Schmauch

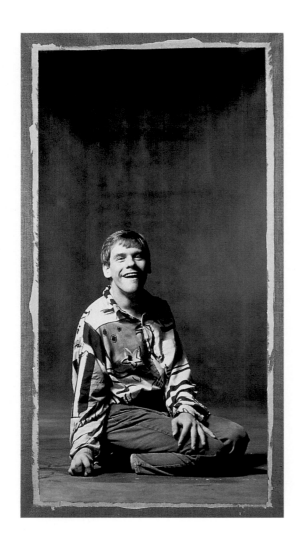
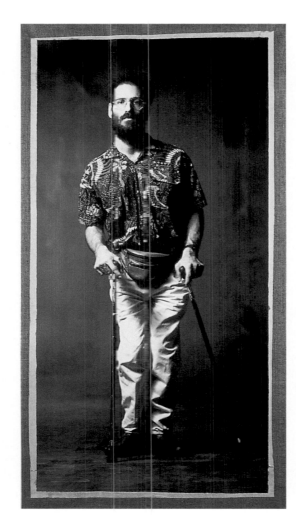
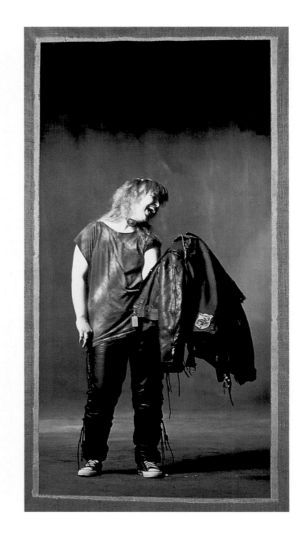

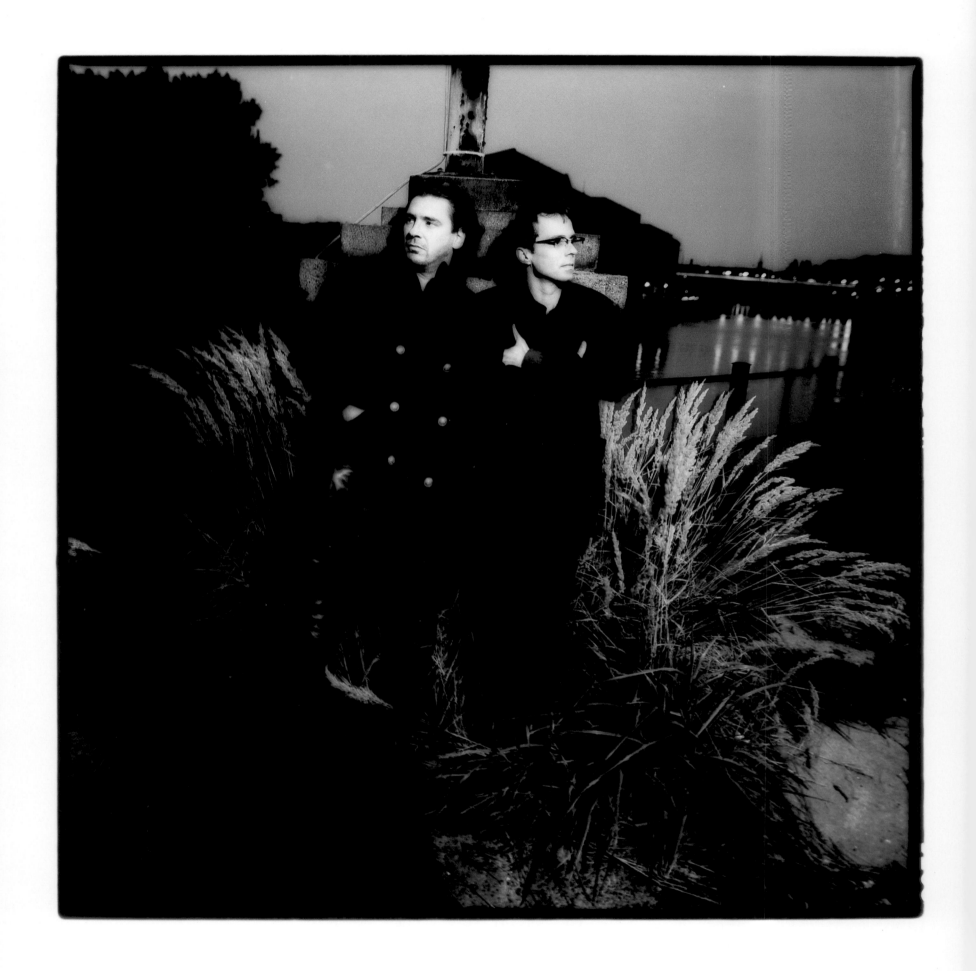

Thorsten Eichhorst

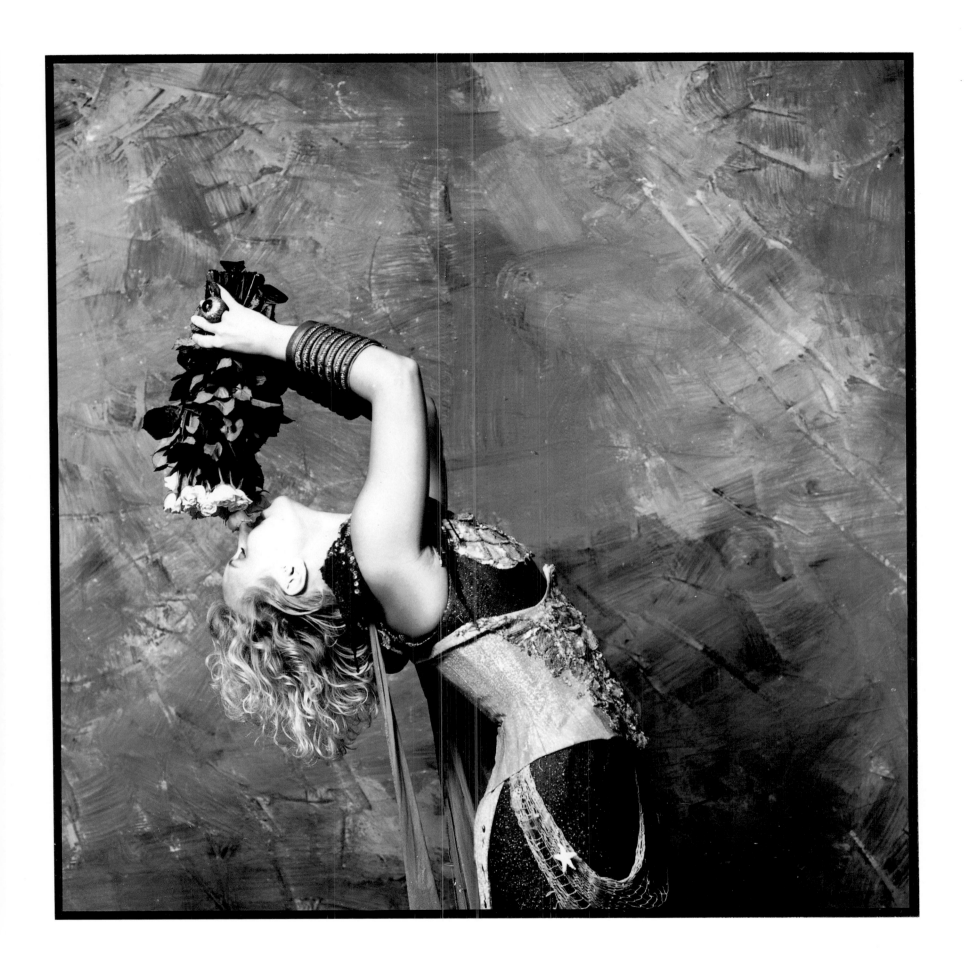

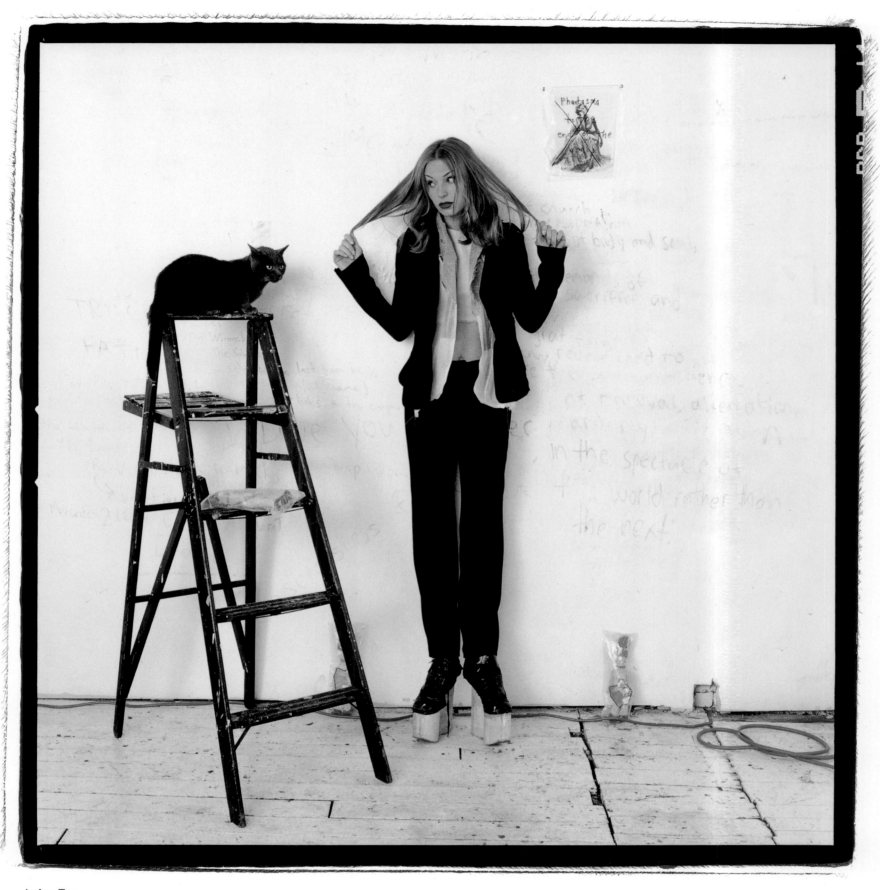

Jo Ann Toy

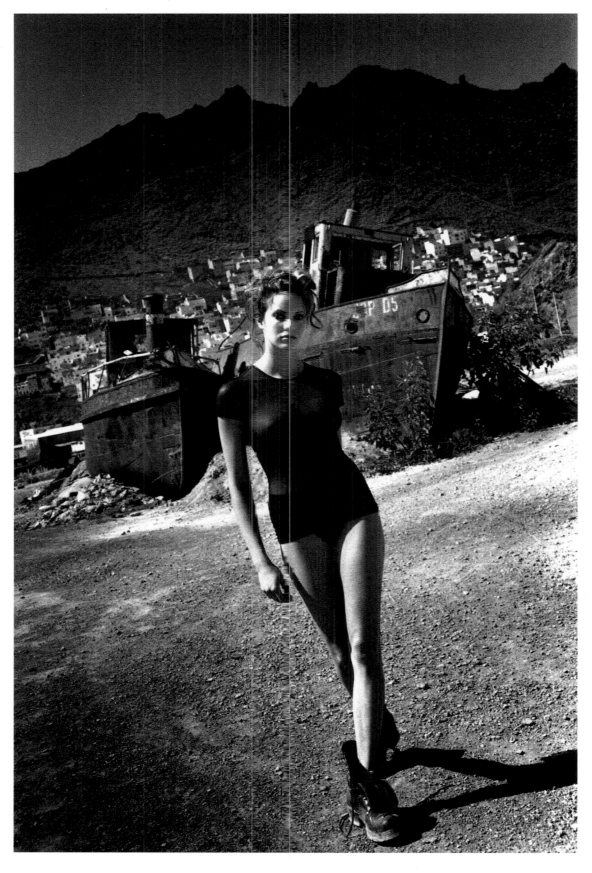

Klaus-Peter Nordmann

Katie Gray ▷

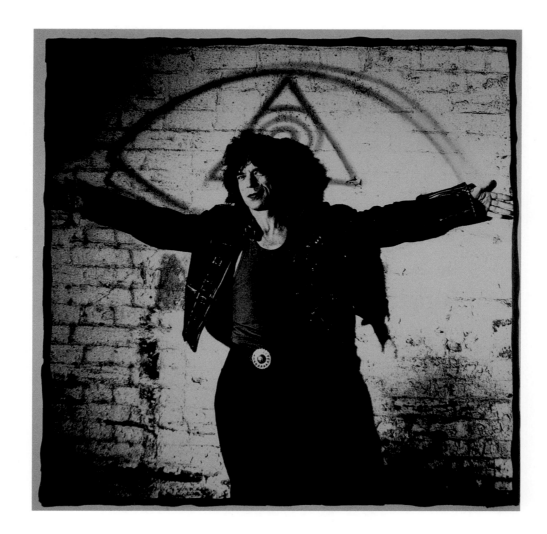

Tim Dry, *Mick Jagger*

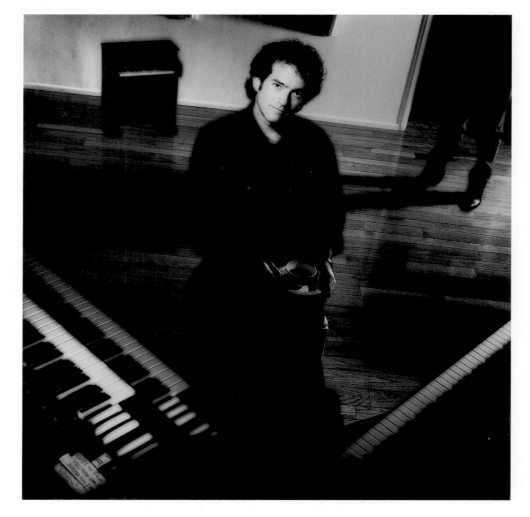

Karen Miller, *Benmont Tench/ Tom Petty's Heartbreakers*

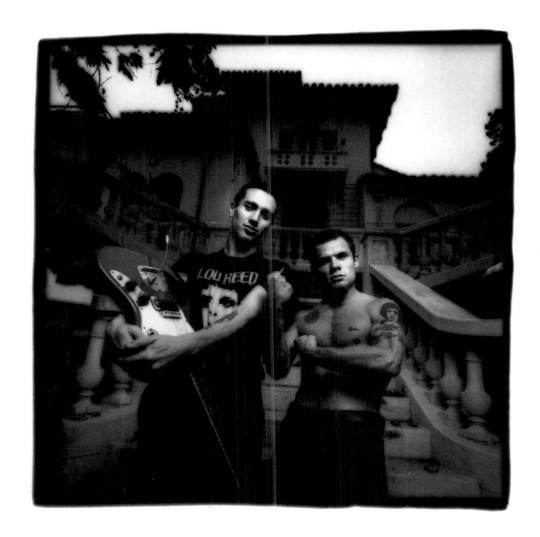

Karen Miller, *Red Hot Chili Peppers*

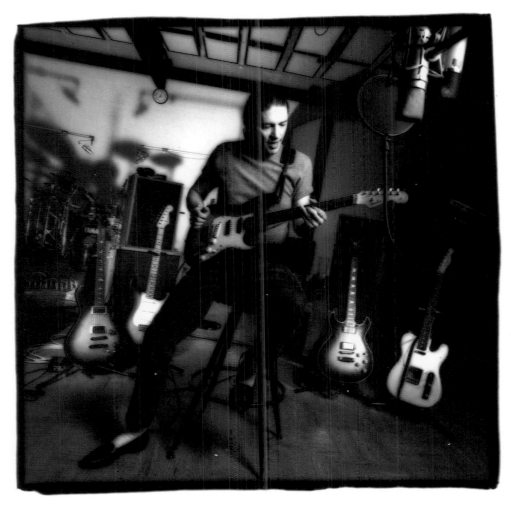

Karen Miller, *Robben Ford*

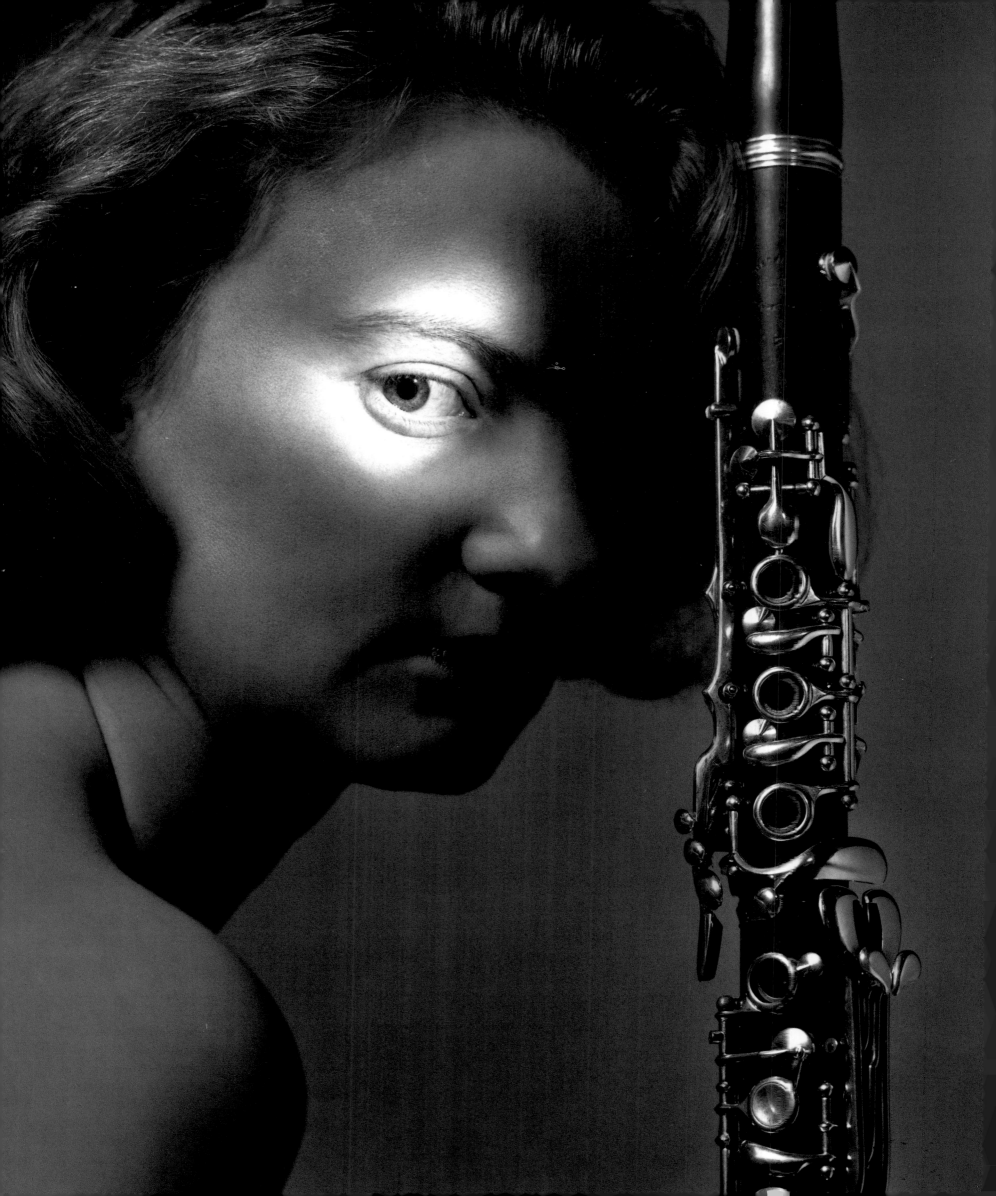

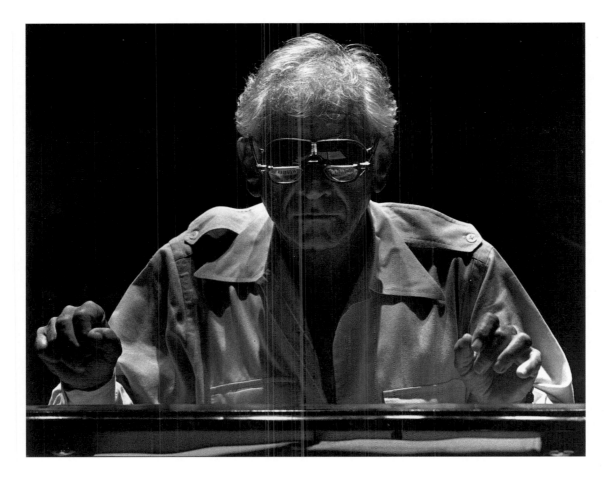

Robert Millard, *Leonard Bernstein*

Serge Cohen, *Sabine Meyer*

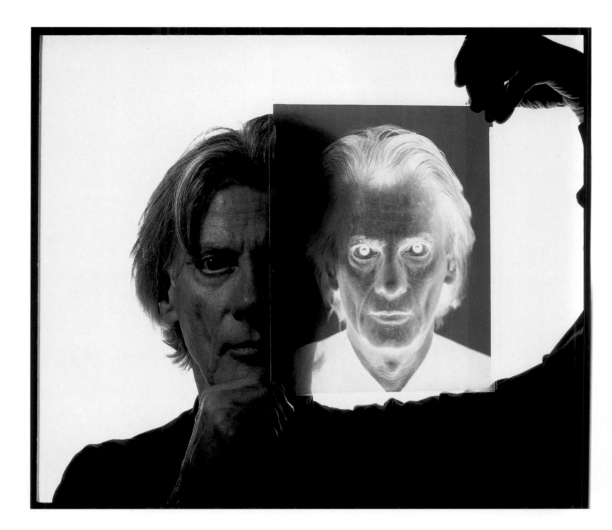

Serge Cohen, *Richard Avedon*

Serge Cohen, *Ignaz Bubis*

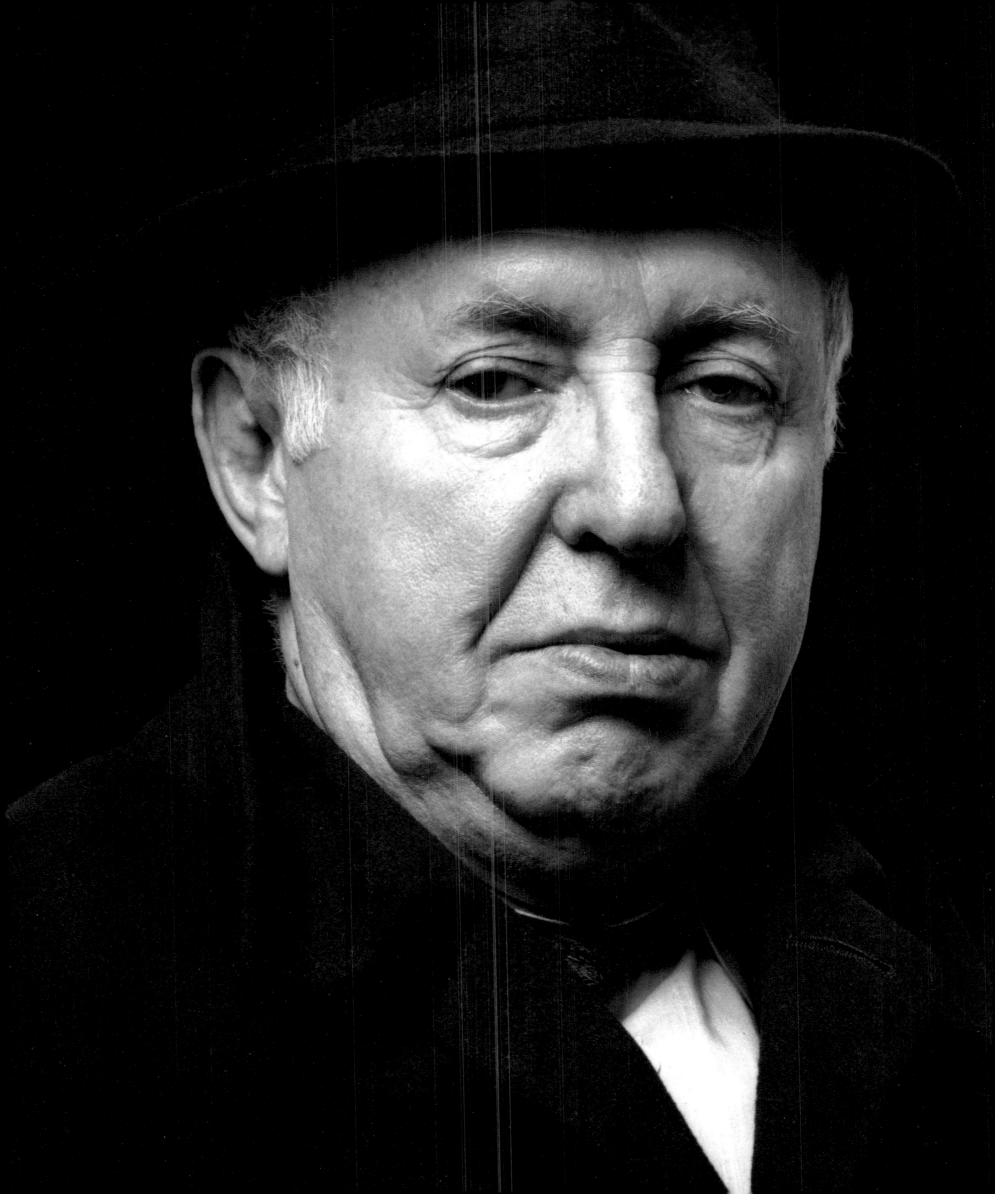

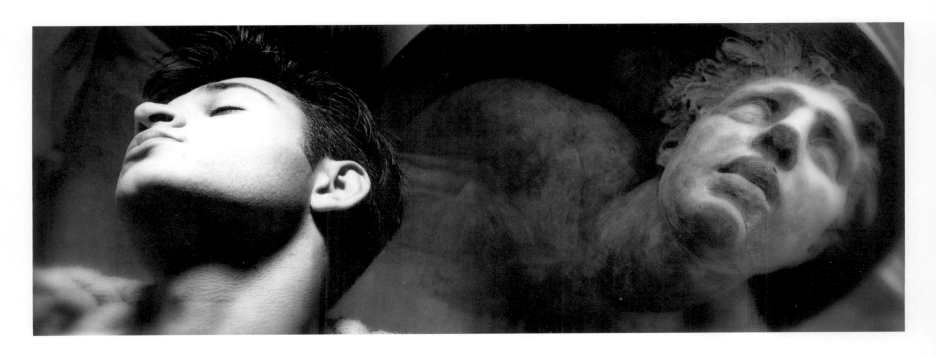

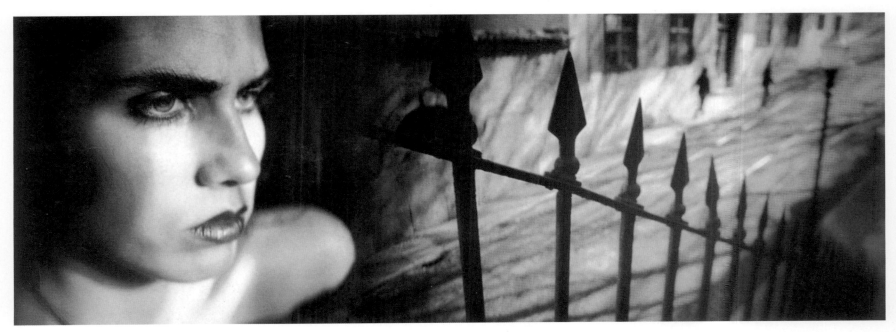

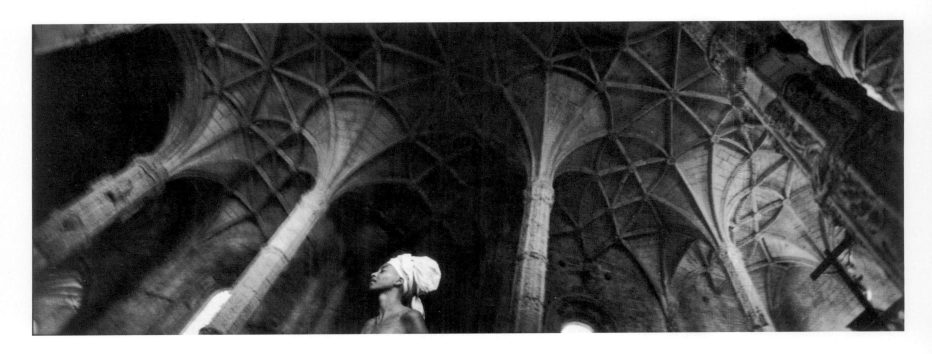

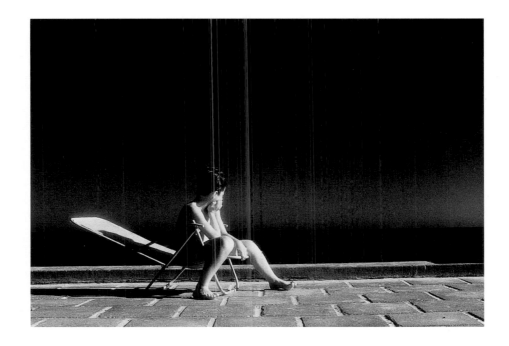

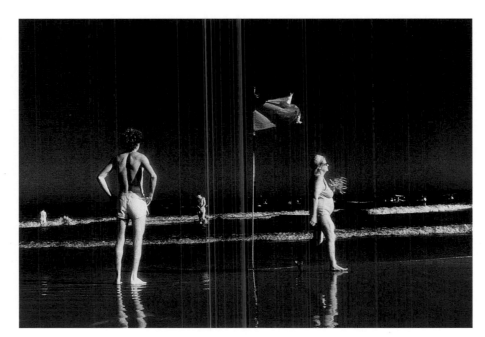

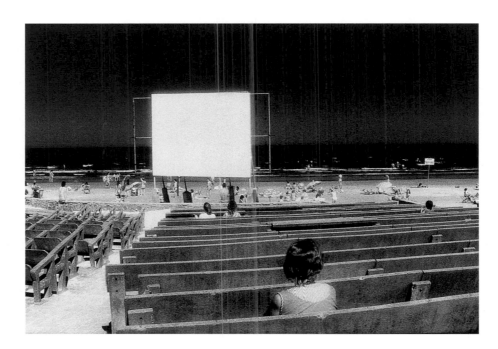

Richard Ivey

Marcelo Isarrualde

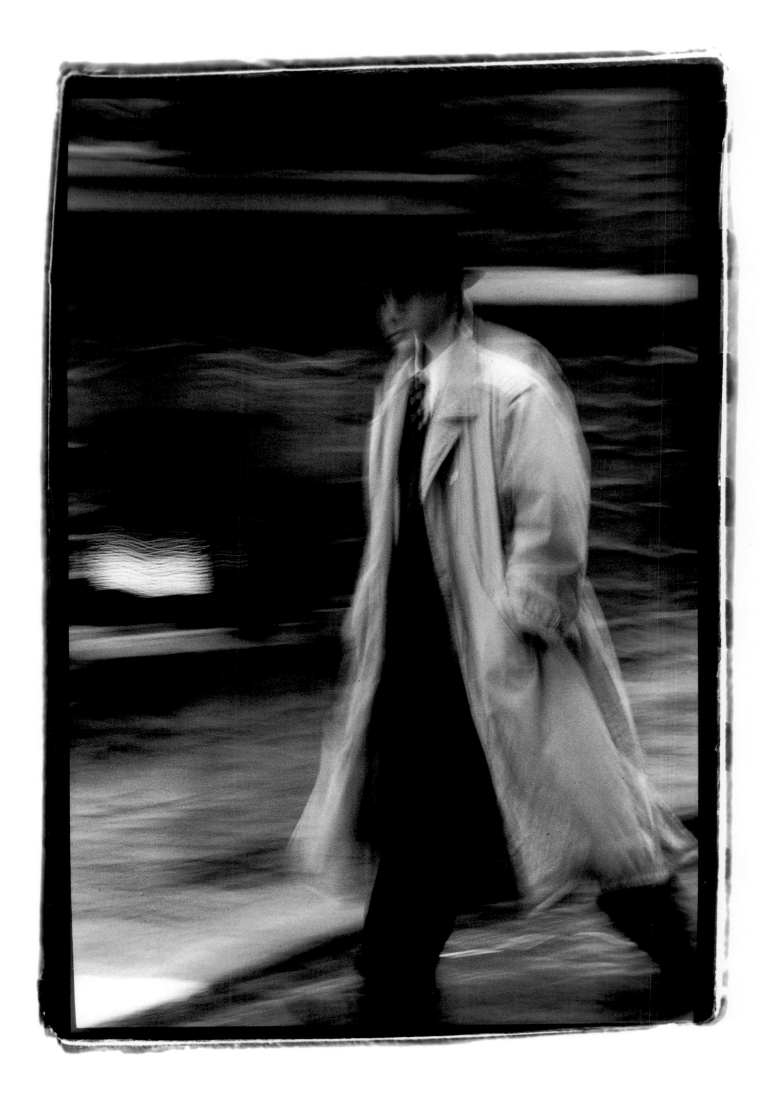

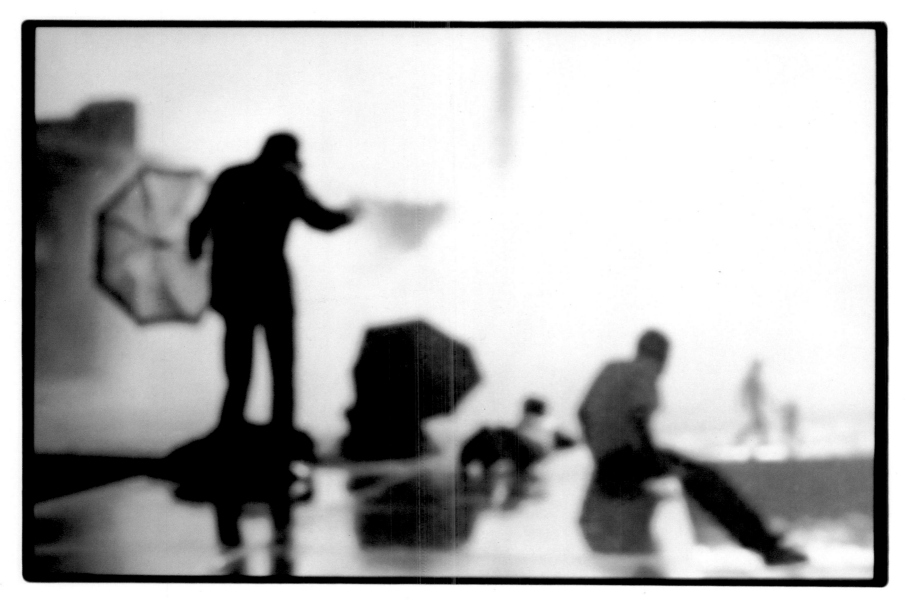

Rieder & Walsh Photography

Brooke Hunyady

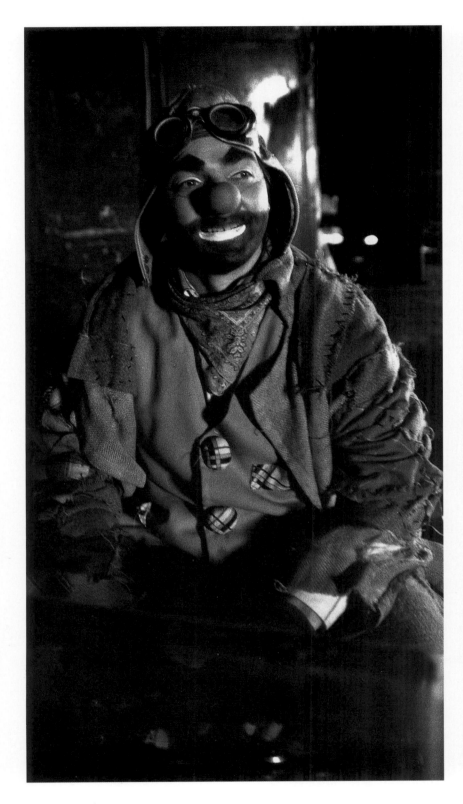

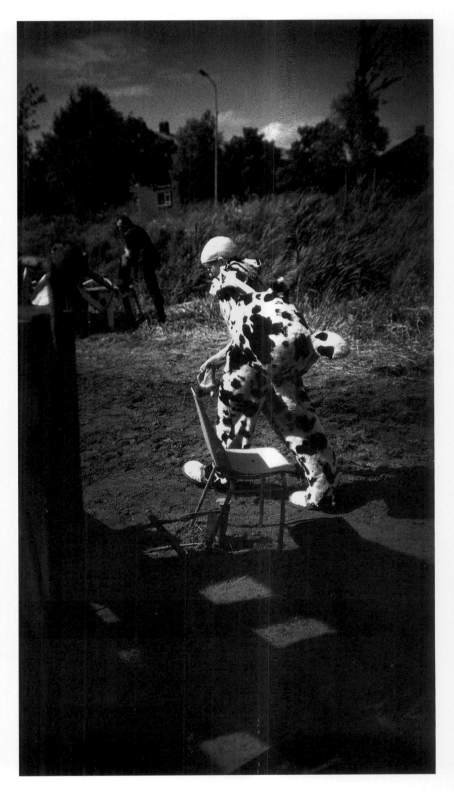

Jocelyn Moreau

Jocelyn Moreau

Karin Kohlberg

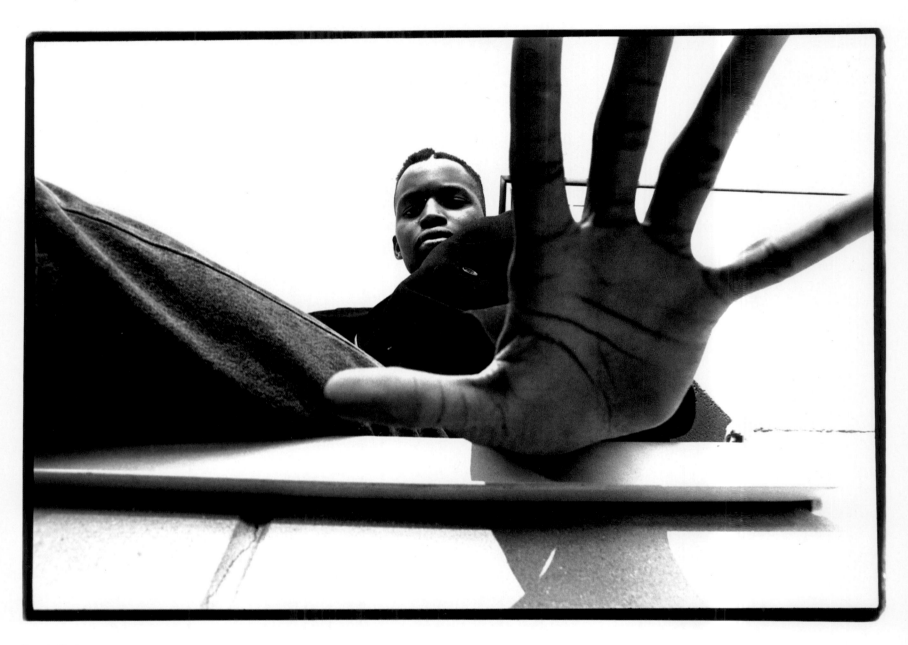

Brenda Peringer

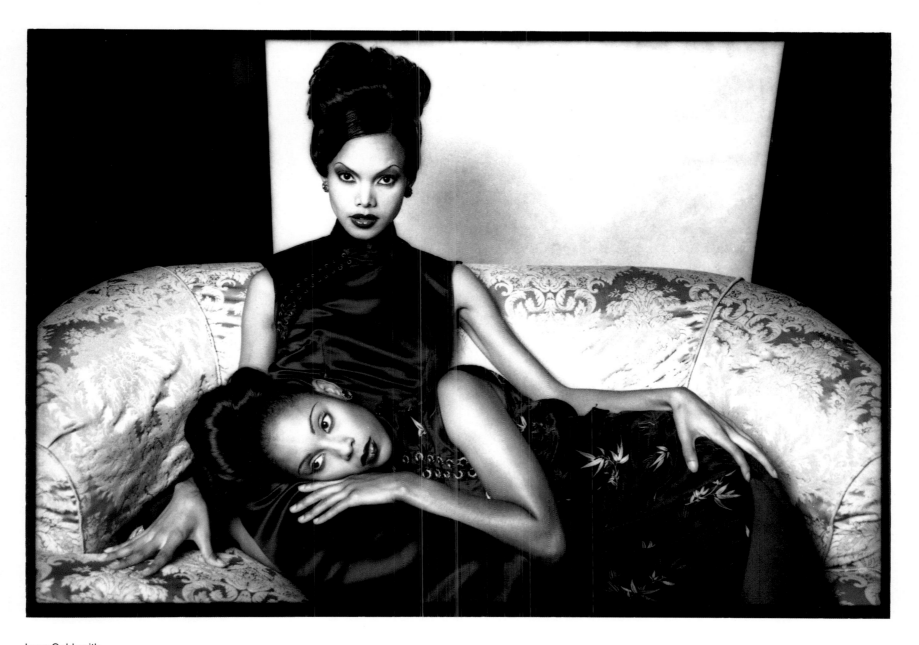

Lynn Goldsmith

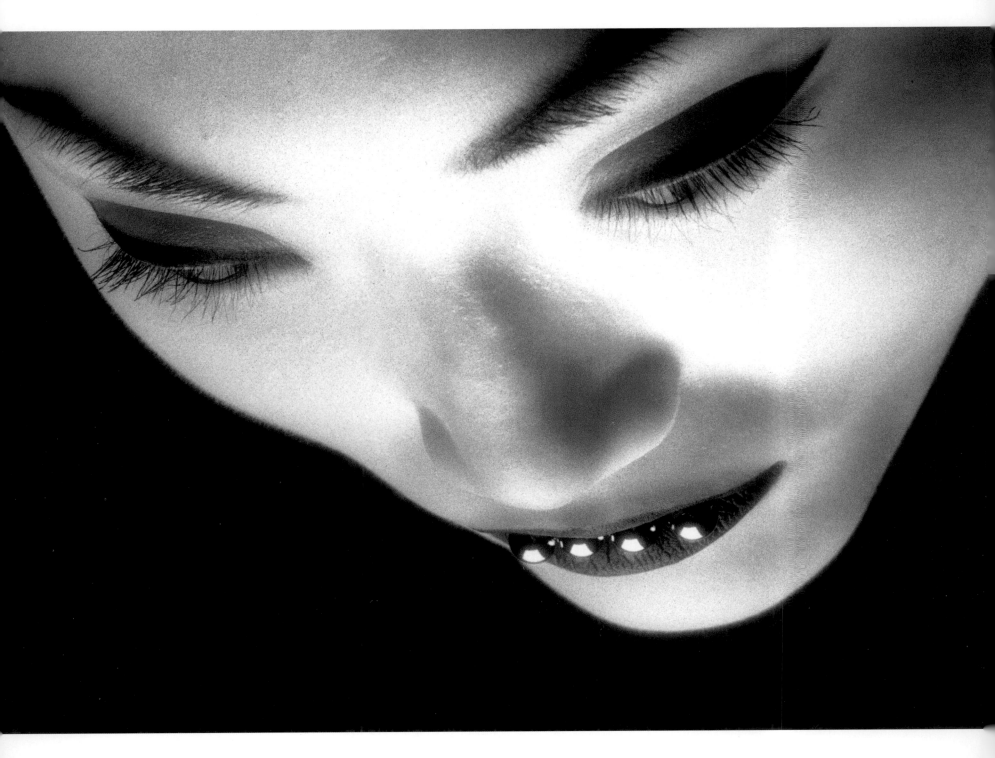

Yuri Dojc

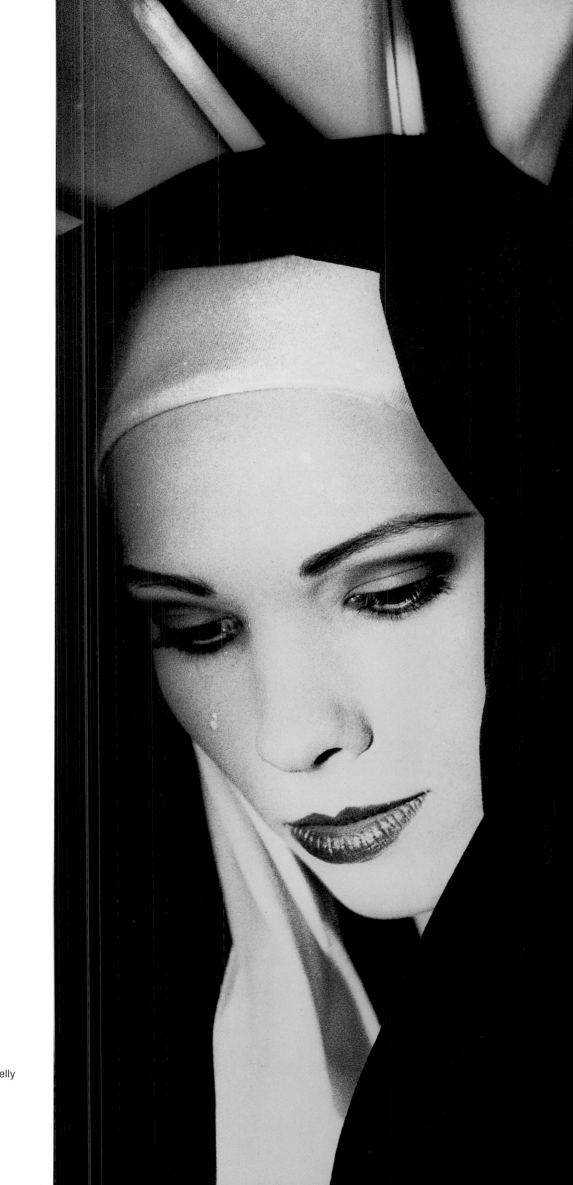

Simon Donnelly

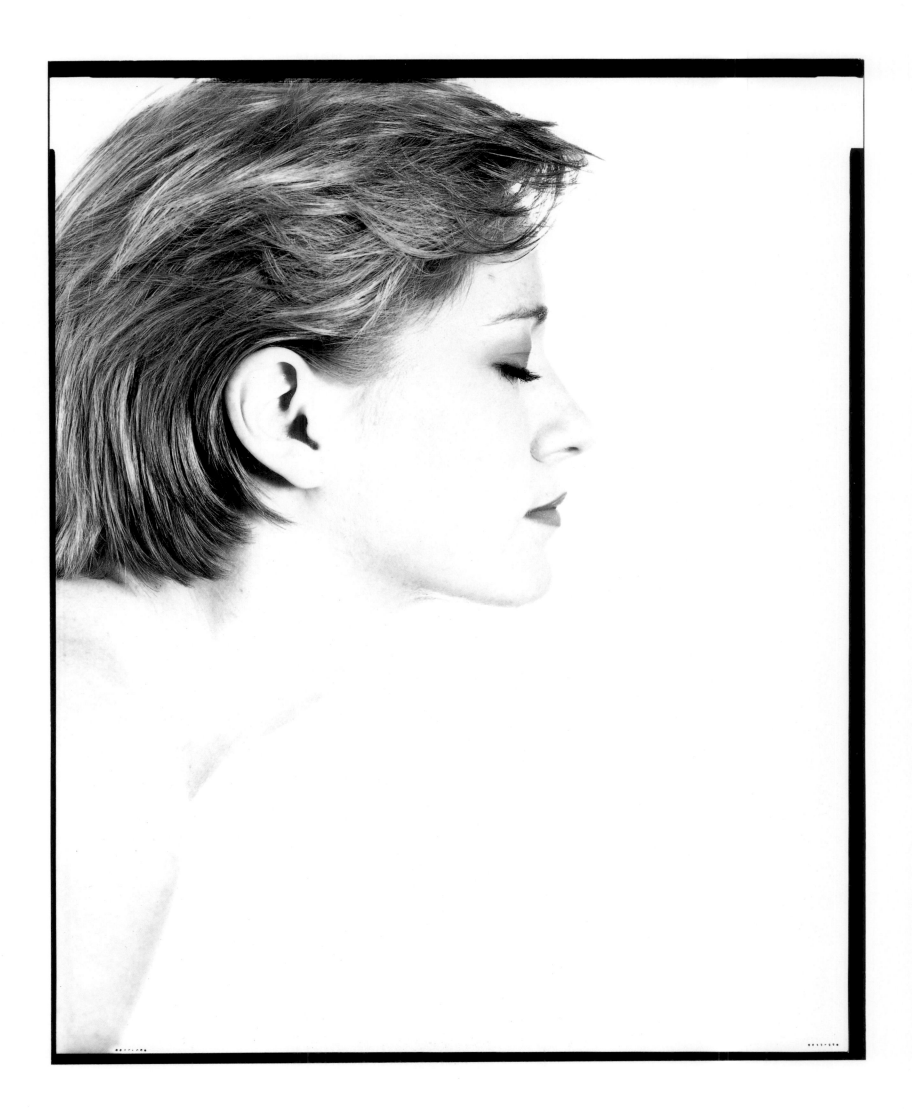

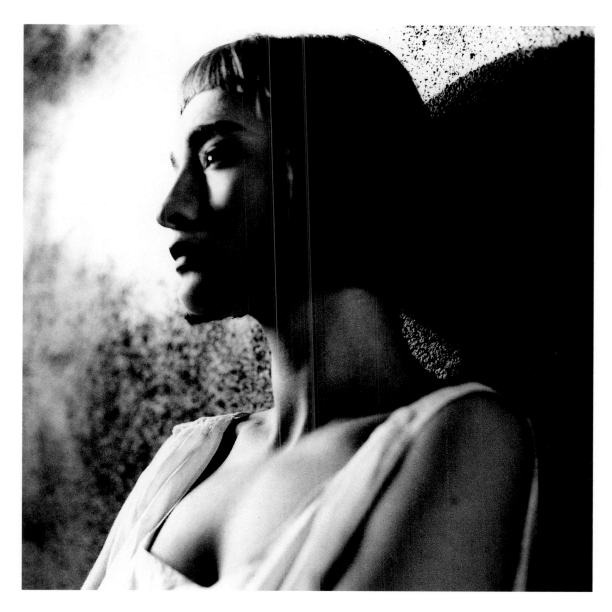

Cat Gwynn

Paul Hampton

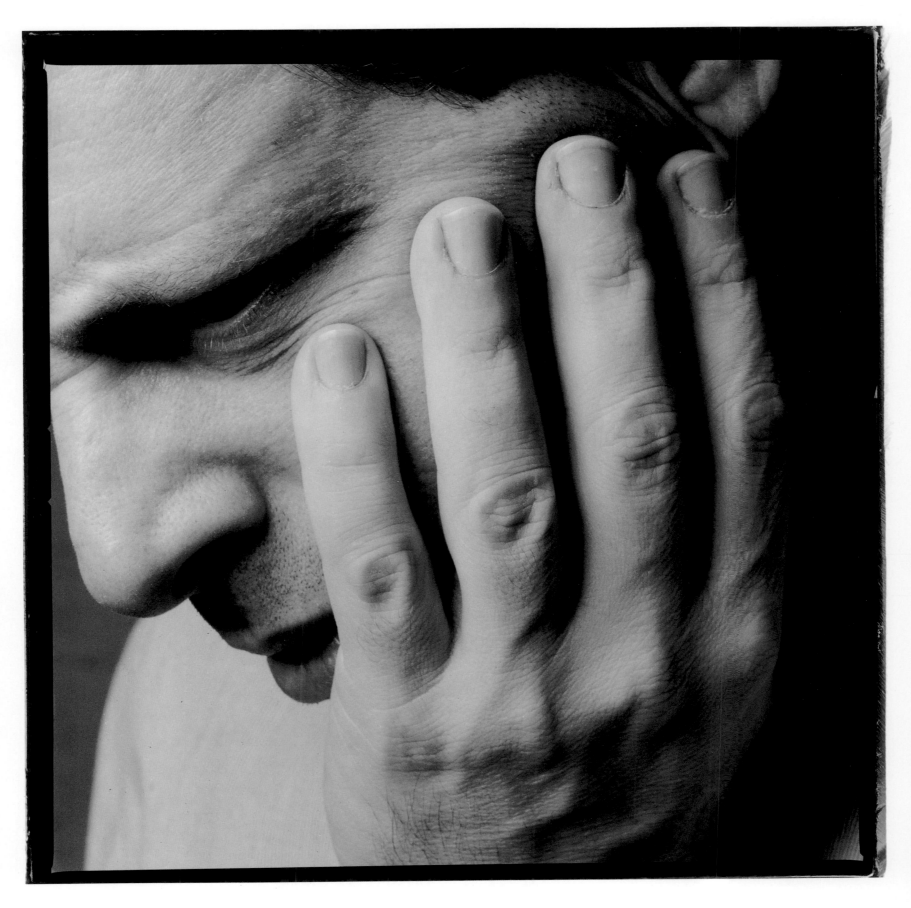

Dan Nelken

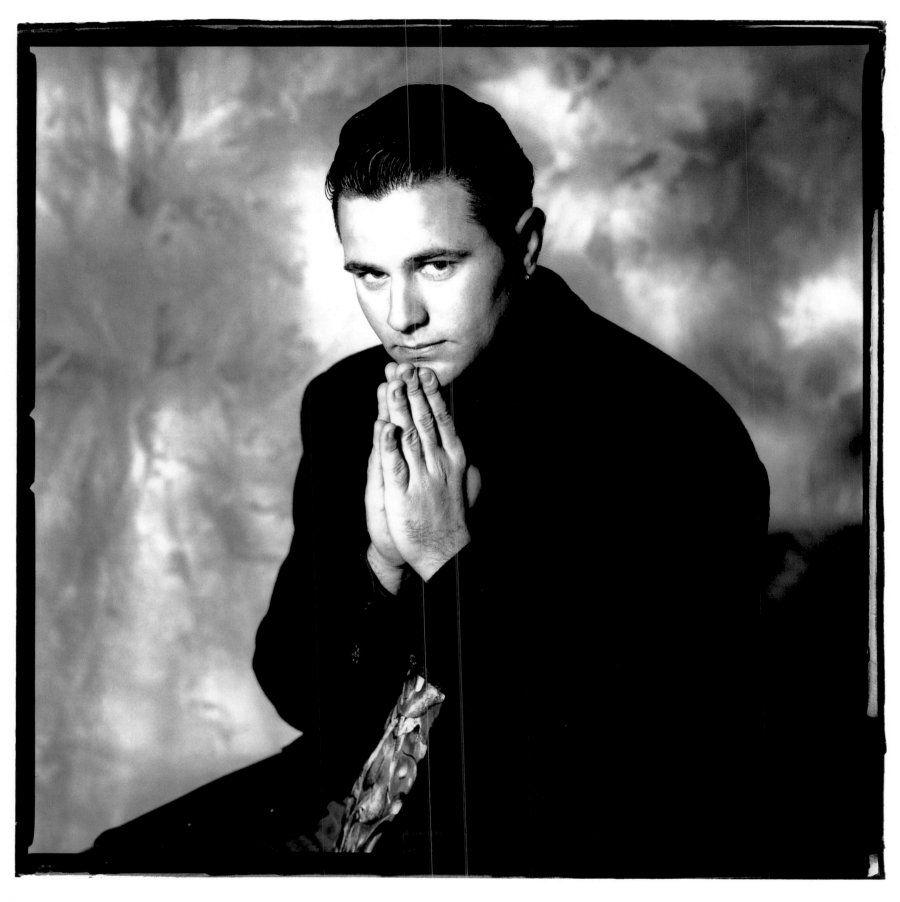

Terence O'Toole

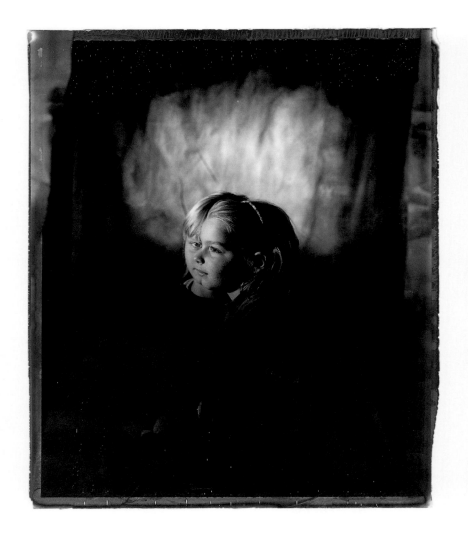

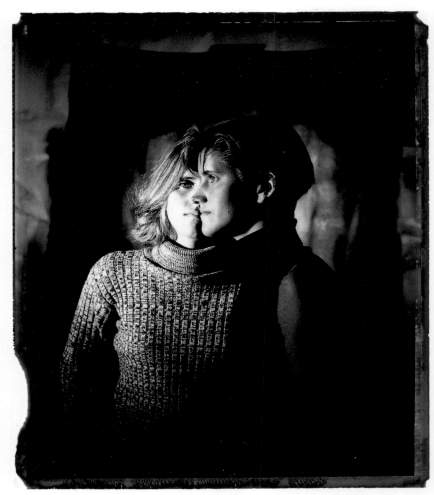

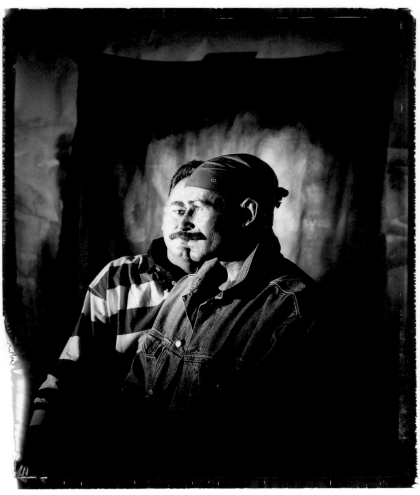

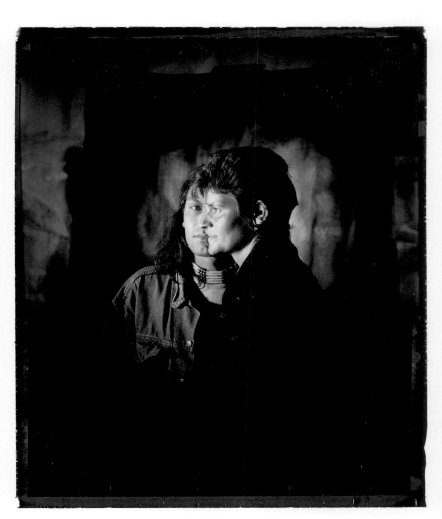

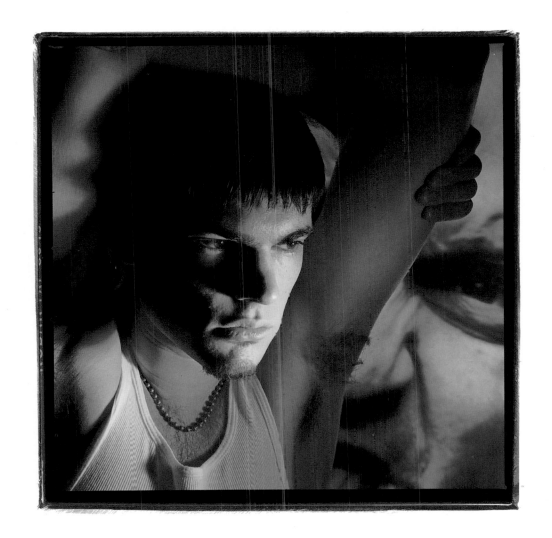

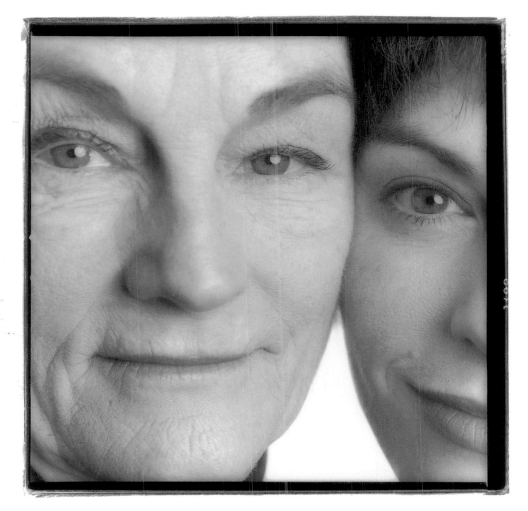

Michael Jaeger

Dan Nelken

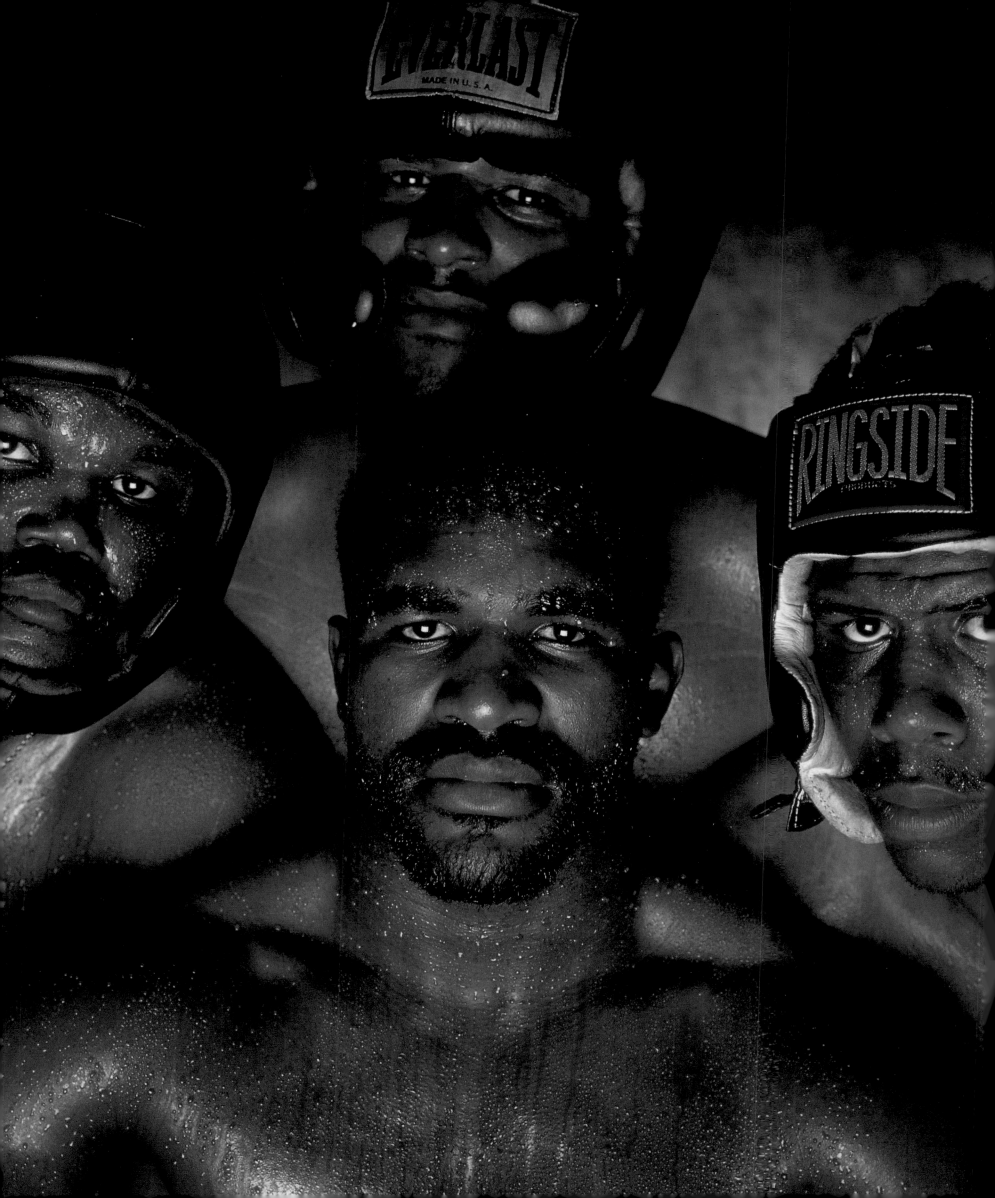

SPORTS

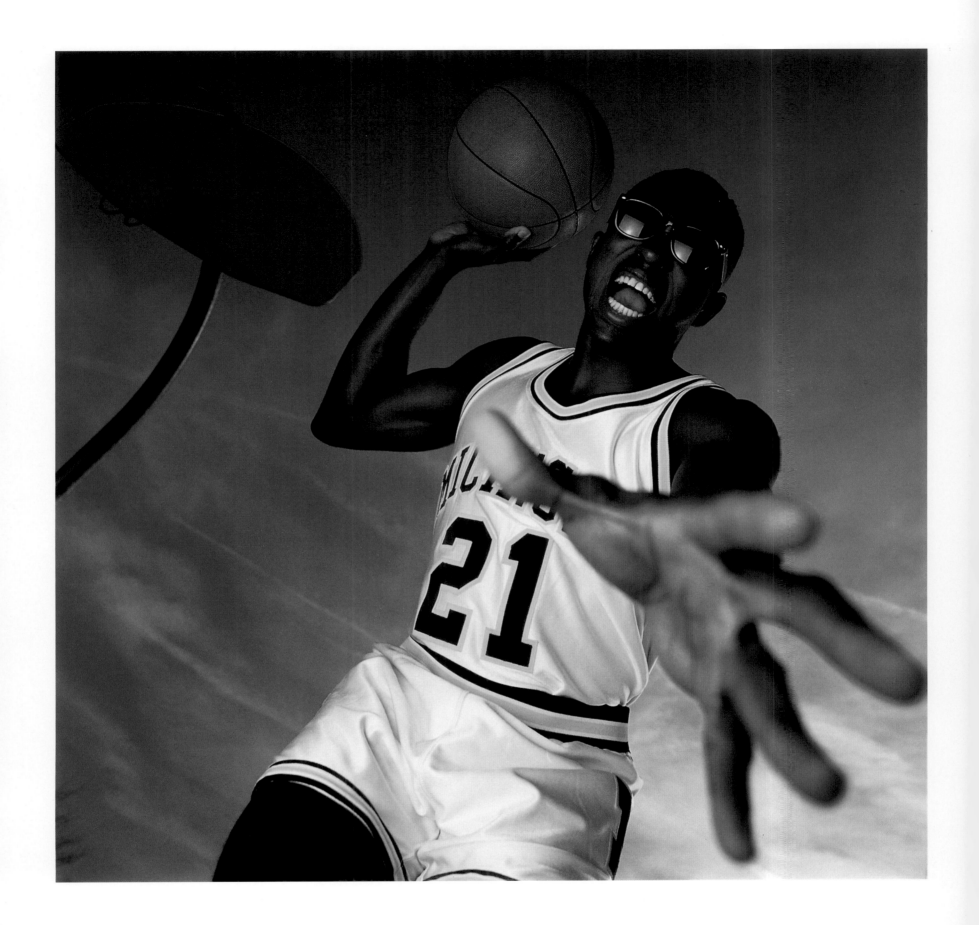

Brad Trent

◁◁ Brad Trent

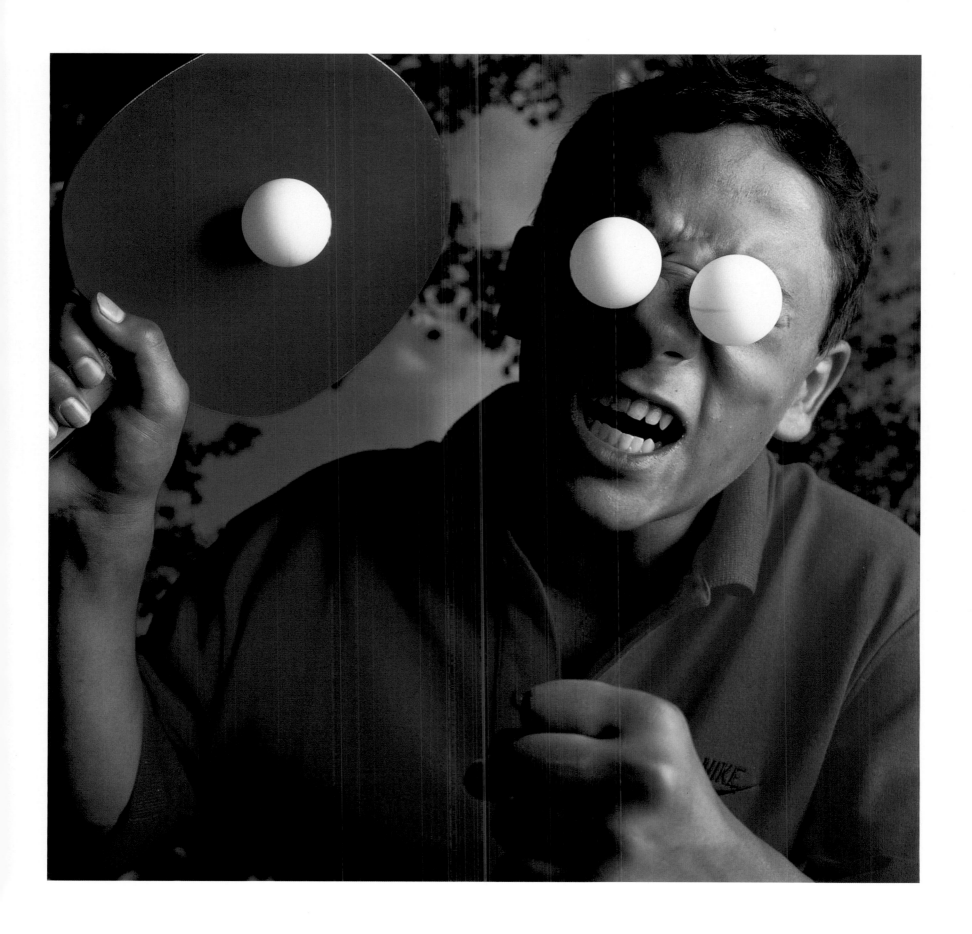

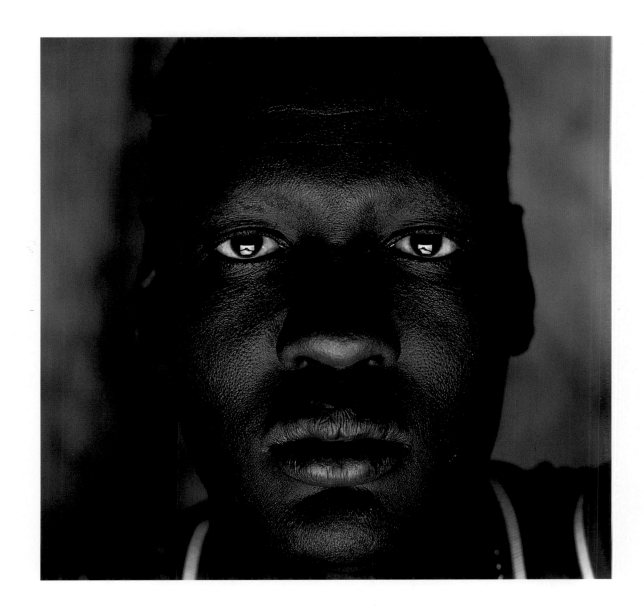

Brad Trent

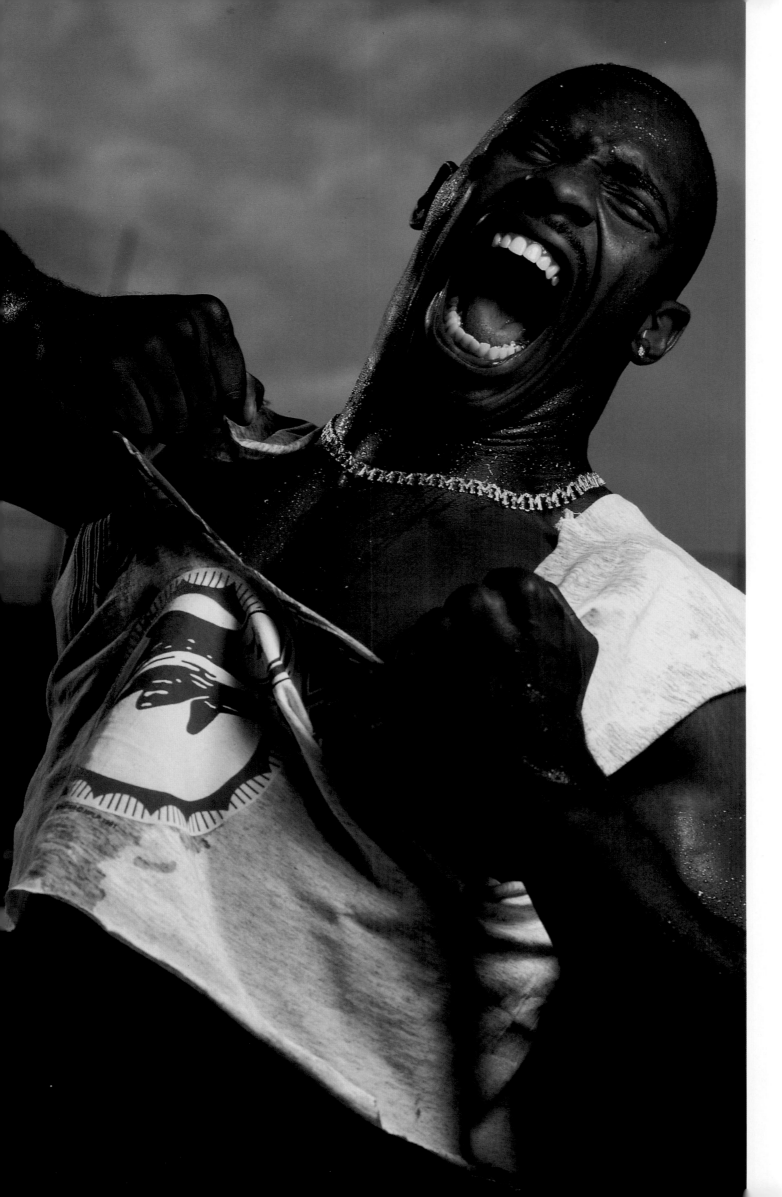

Brad Trent

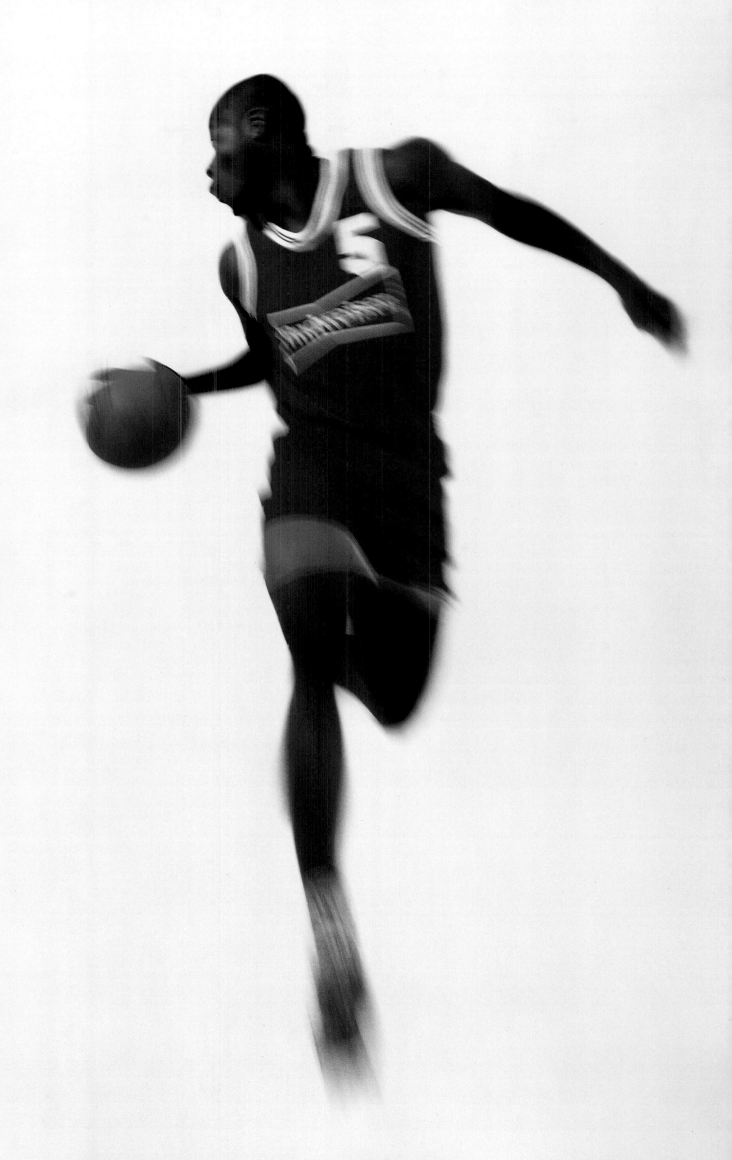

Richard Bradbury

Kai H. Mui

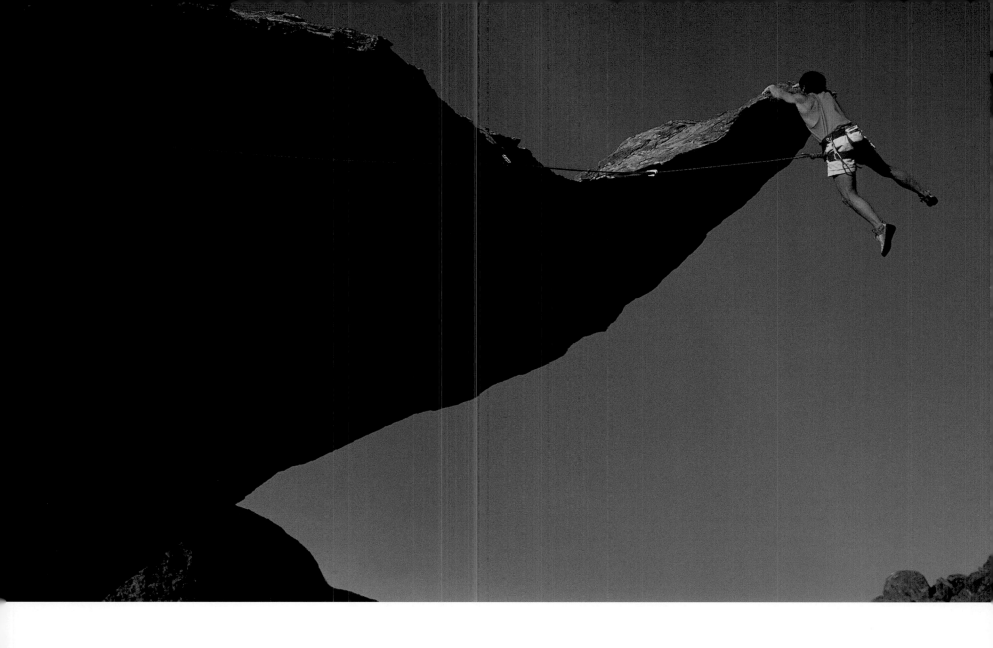

Mark Gamba

Peter Pobyjpicz ▷

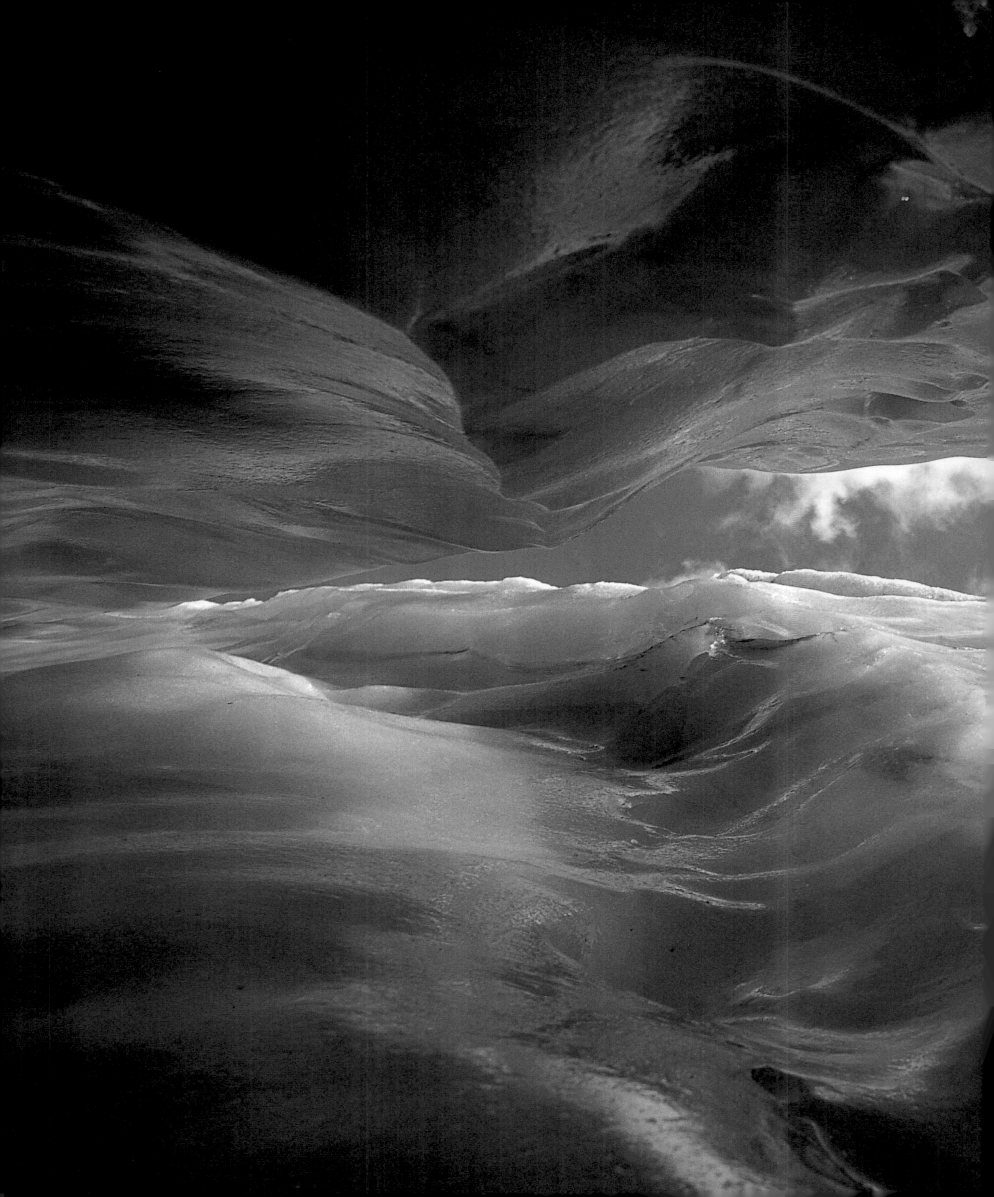

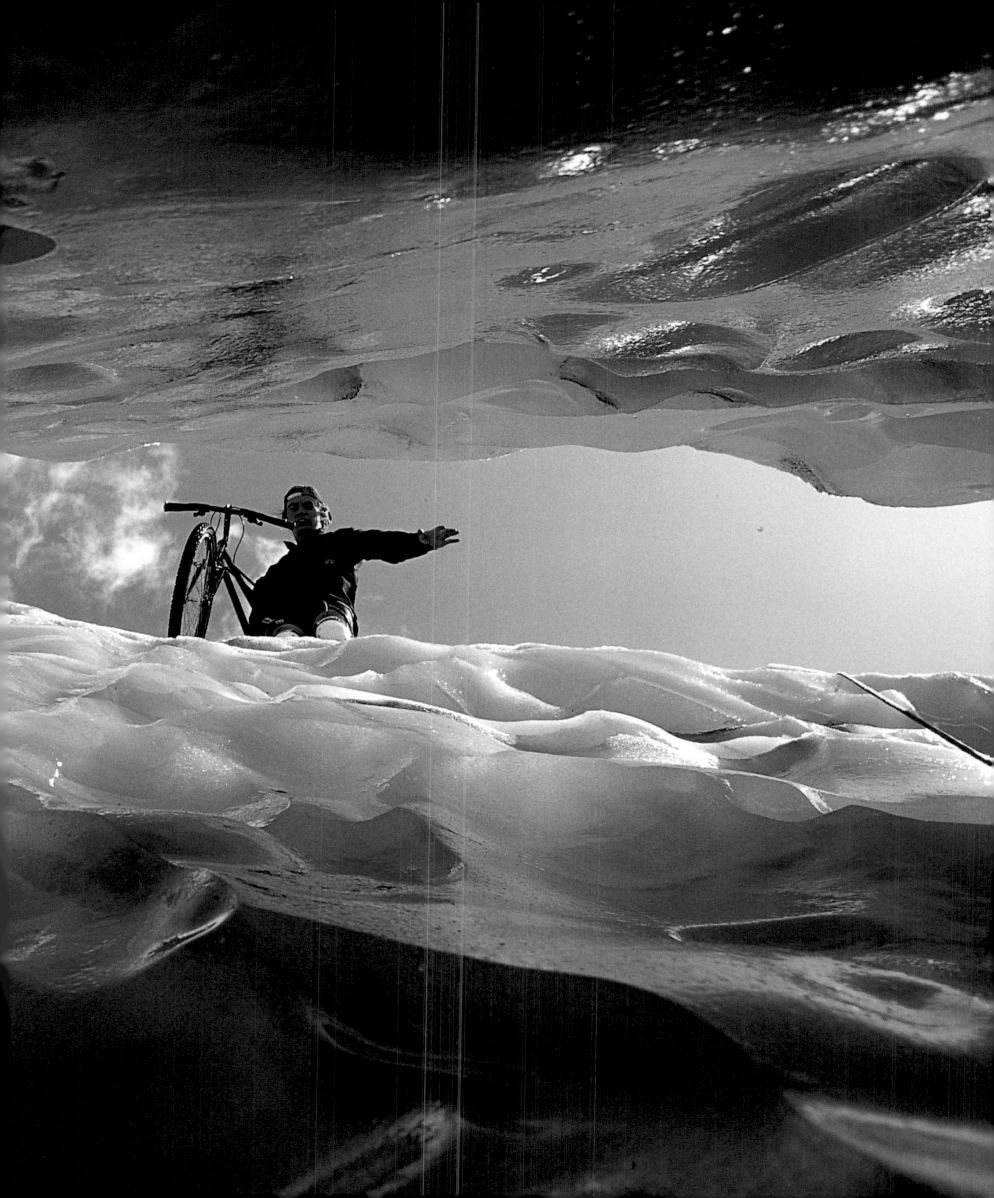

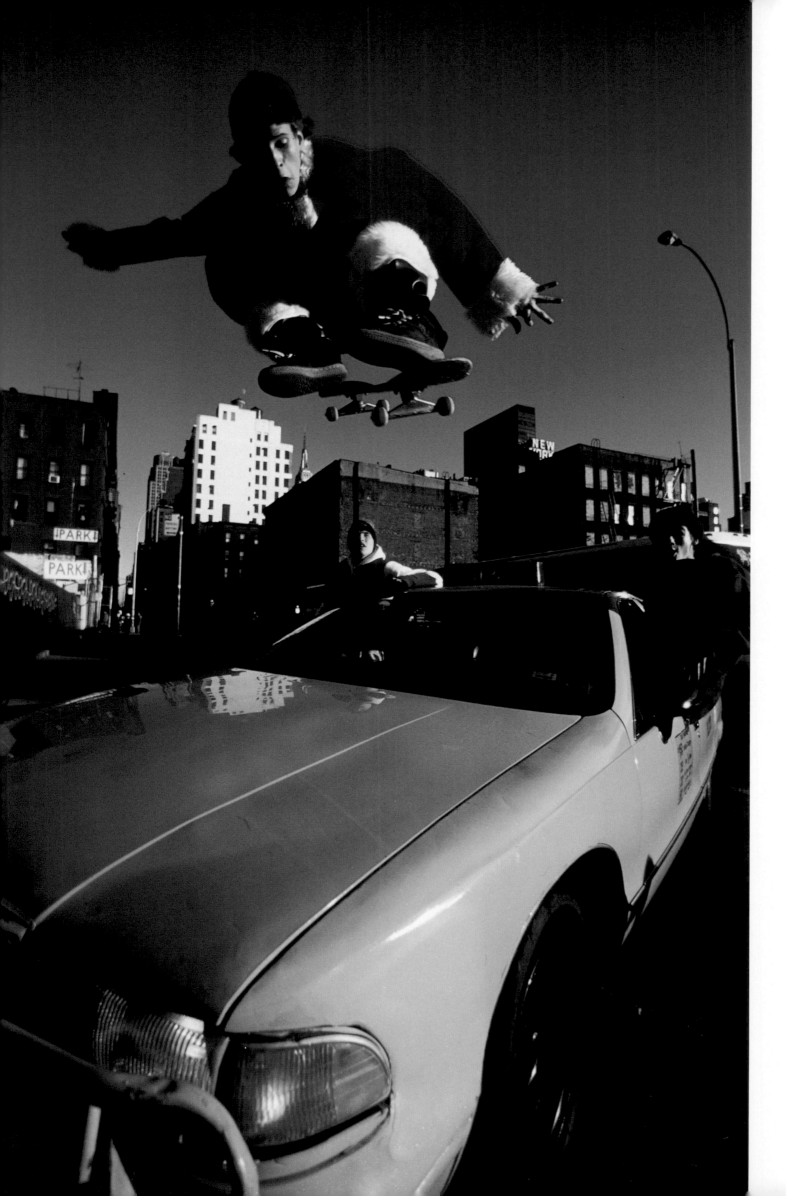

Mark Gamba

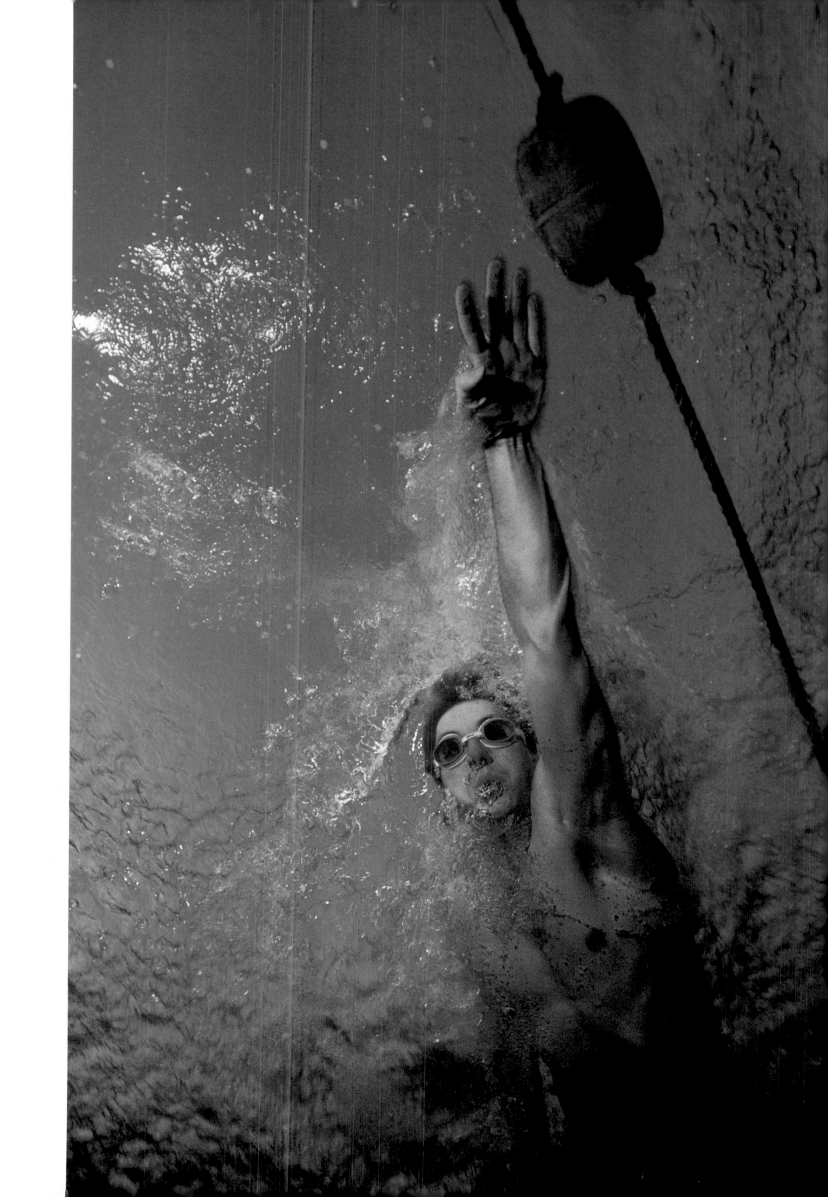

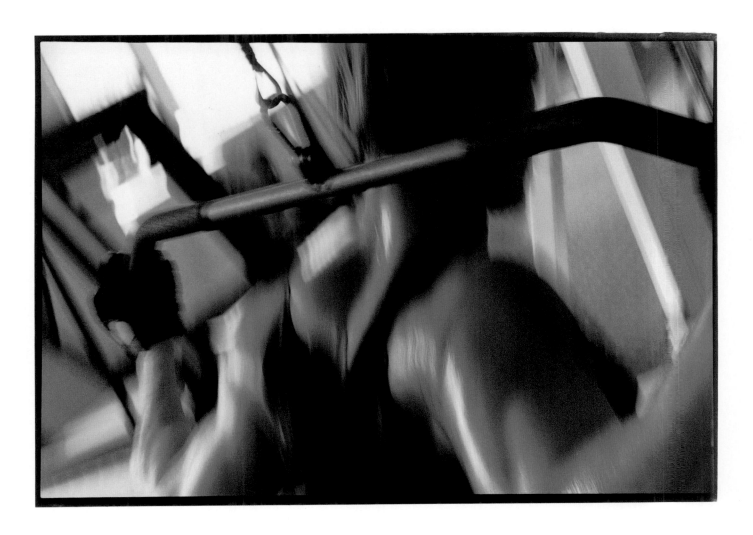

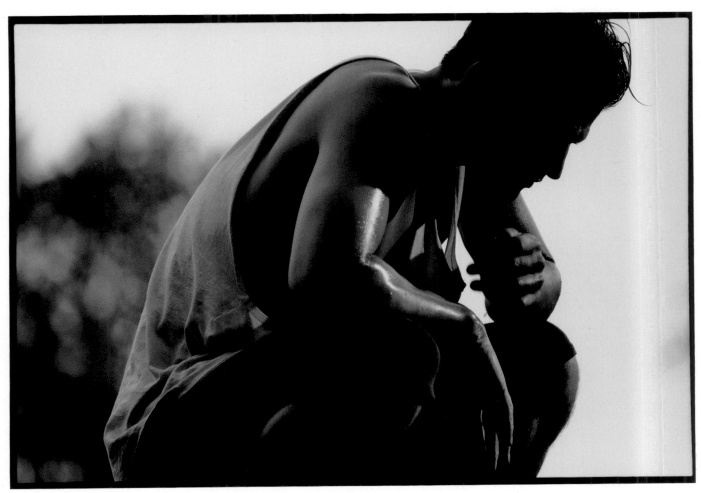

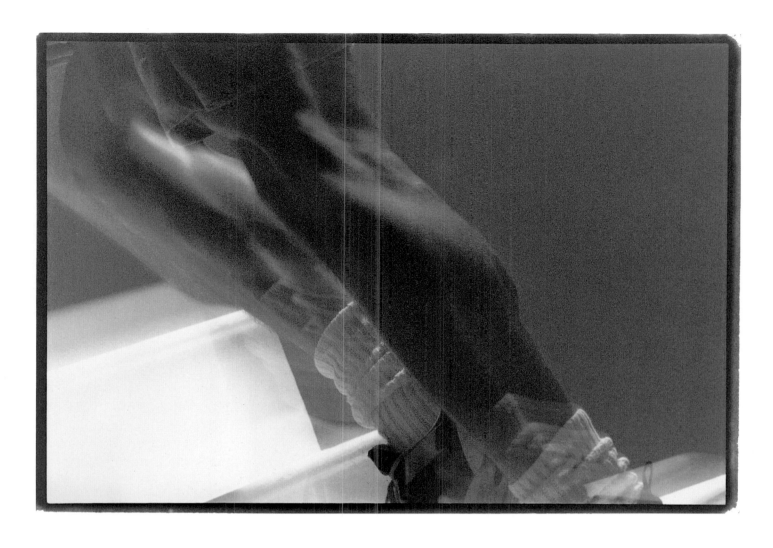

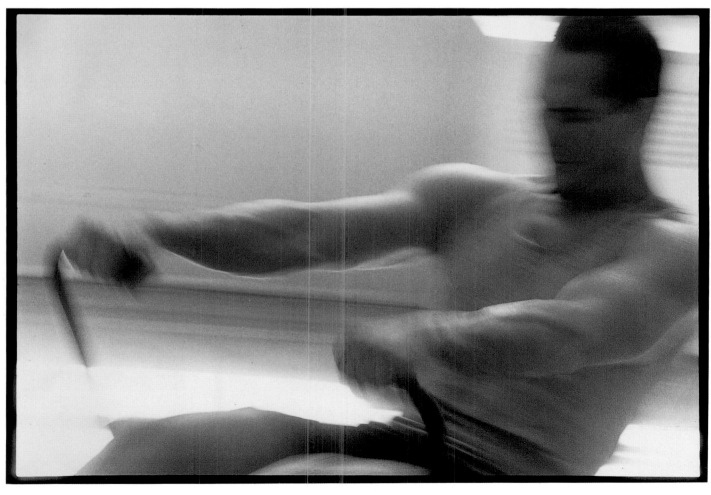

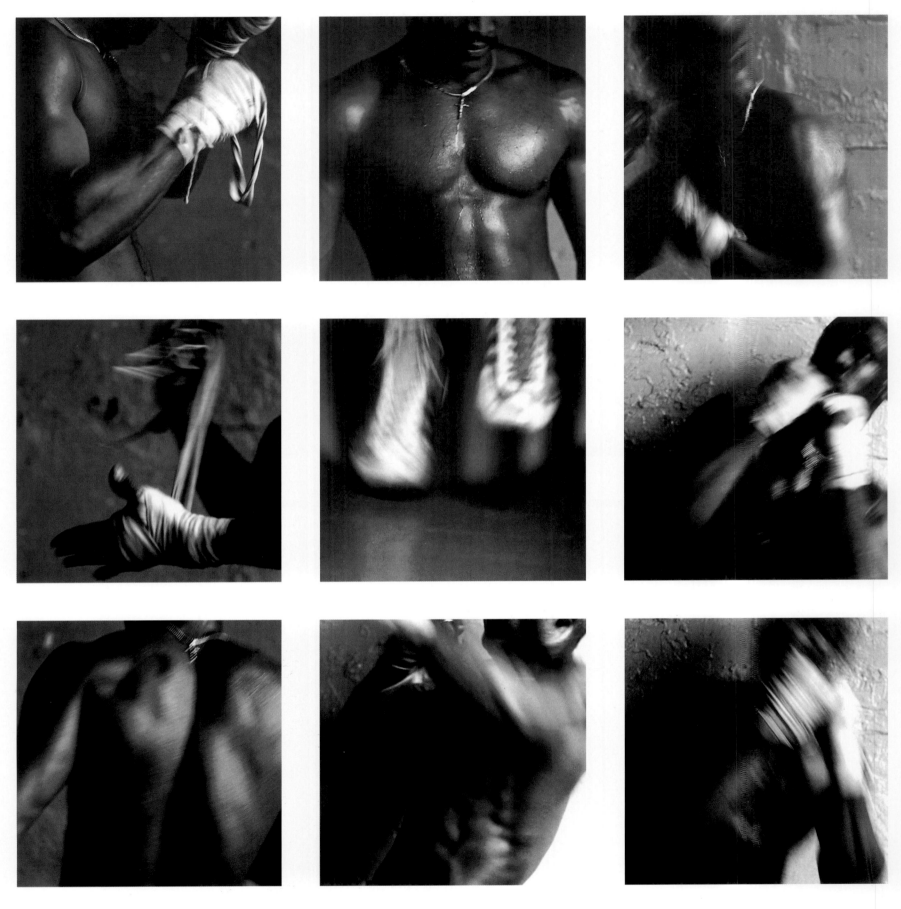

Mark Ferri

◅◅ Mitchel Gray

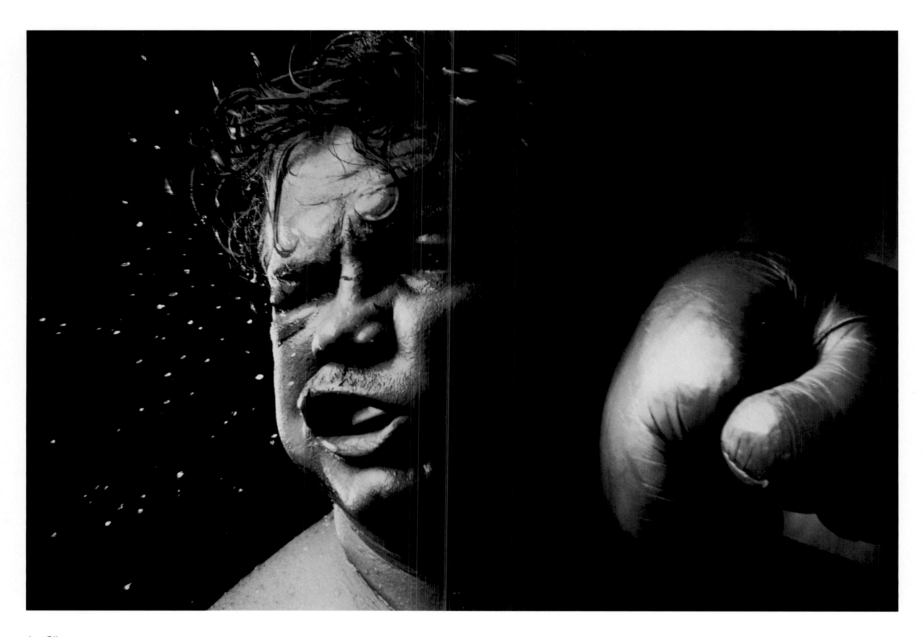

Jay Silverman

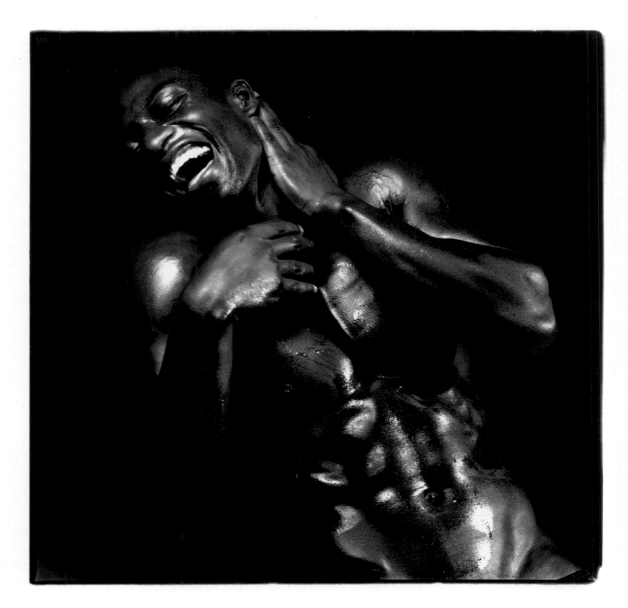

Mitchel Gray

Kai H. Mui

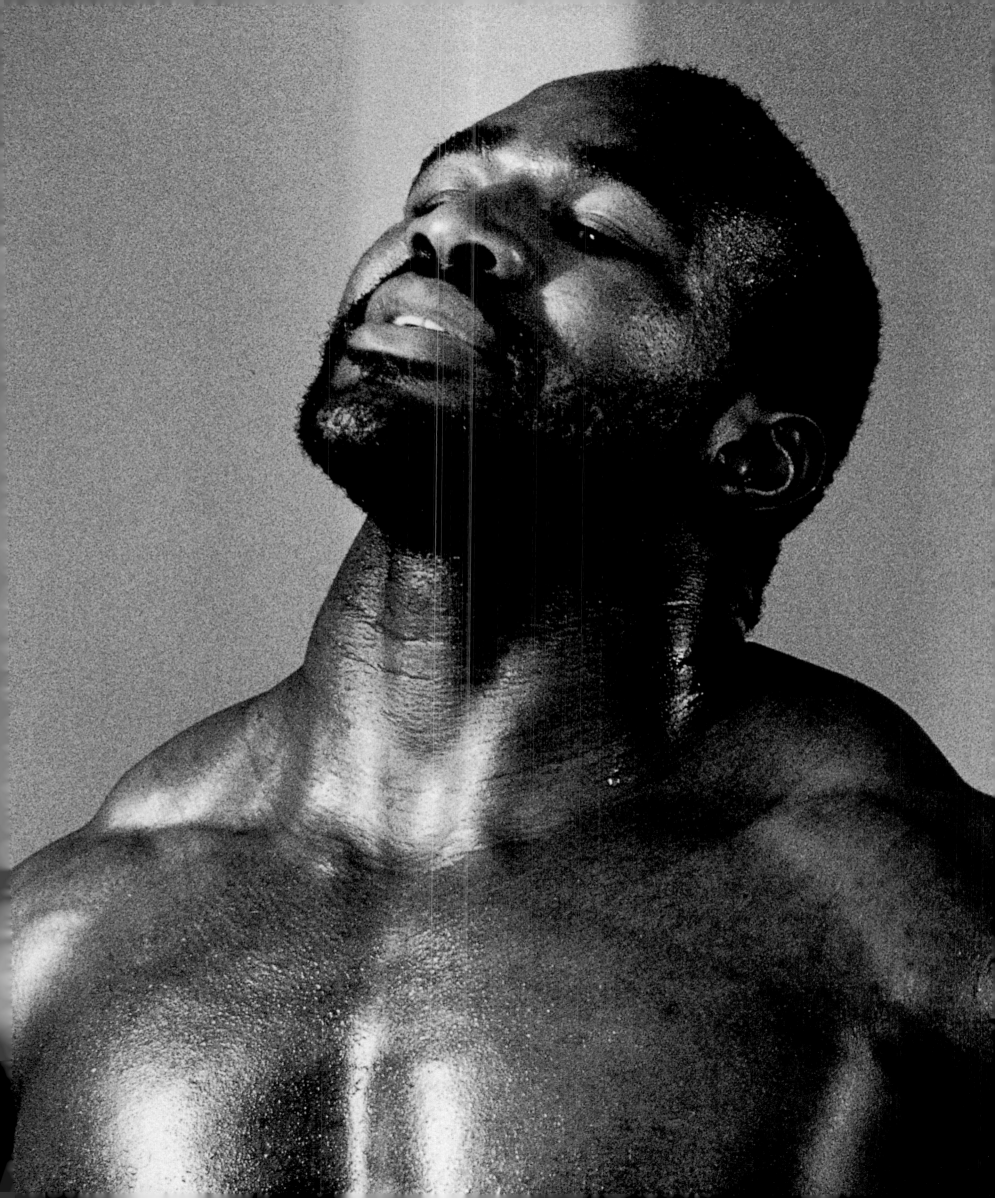

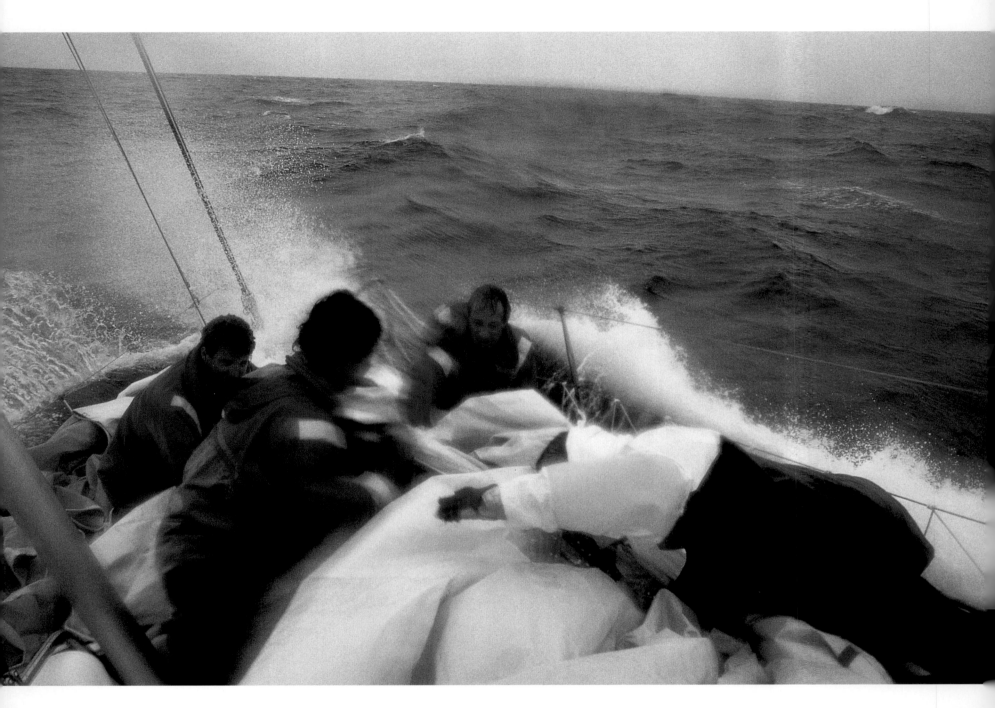

Clint Clemens

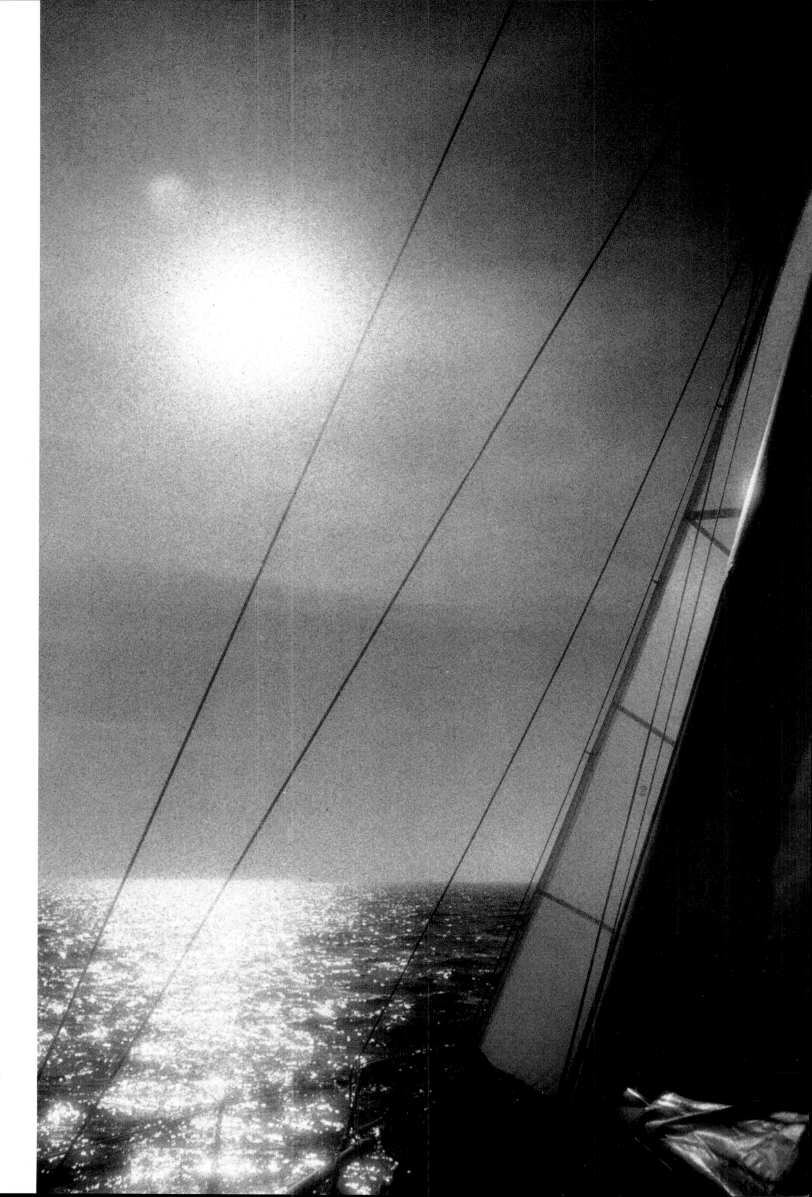

Martin Kurtenbach

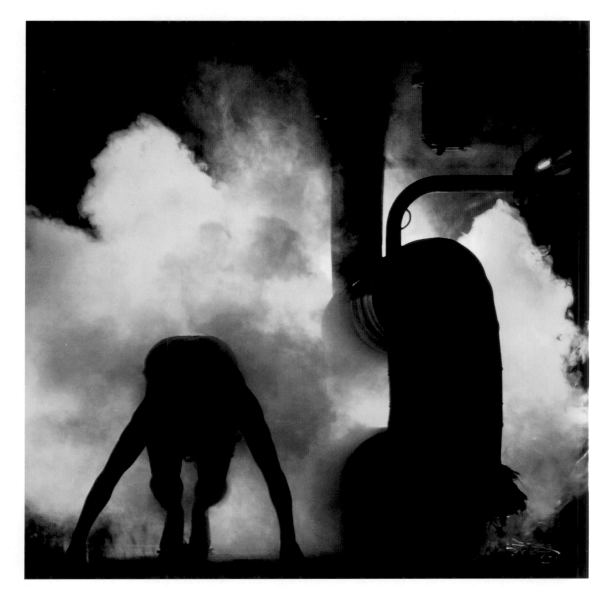

Peter Pobyjpicz

Clint Clemens

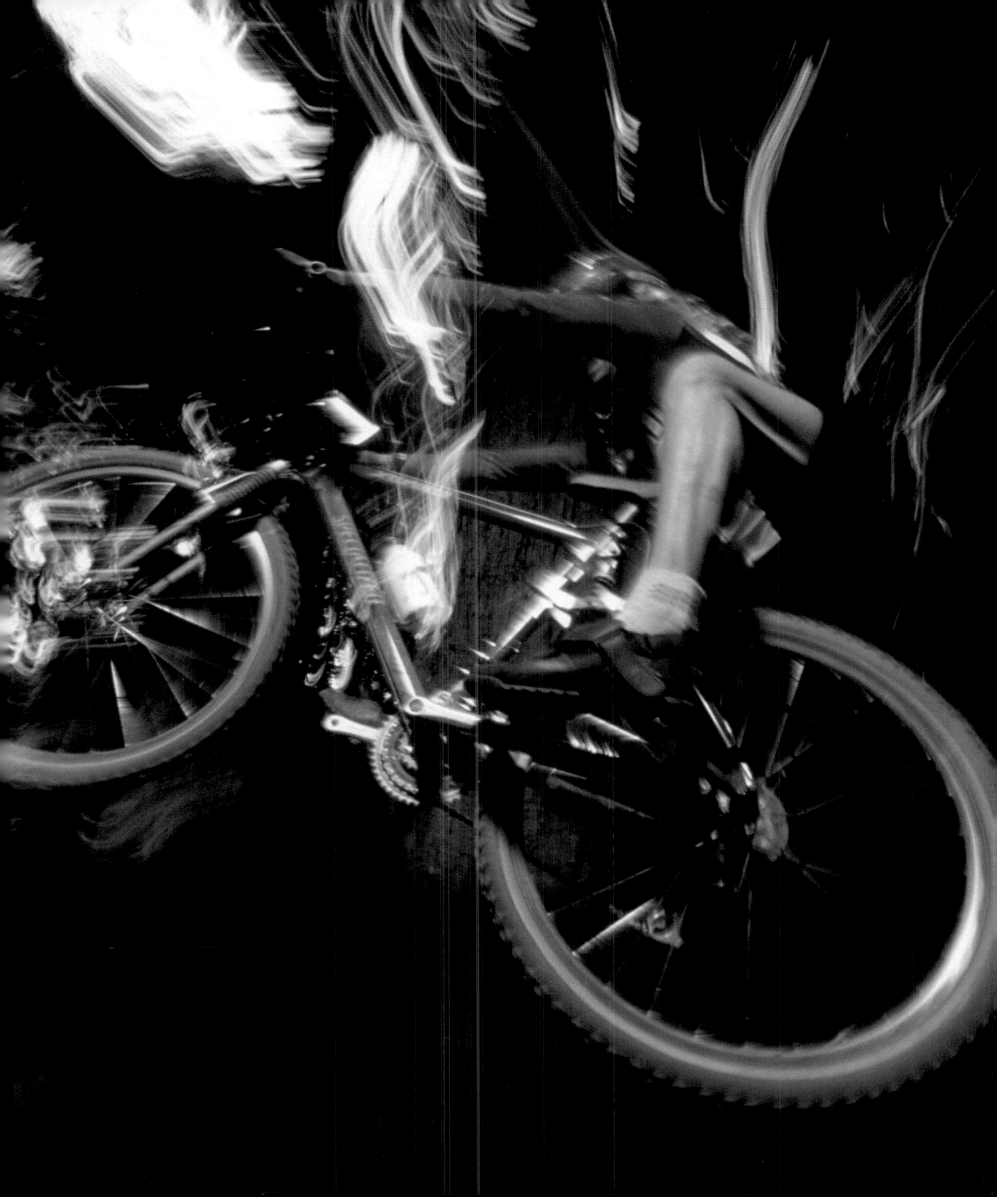

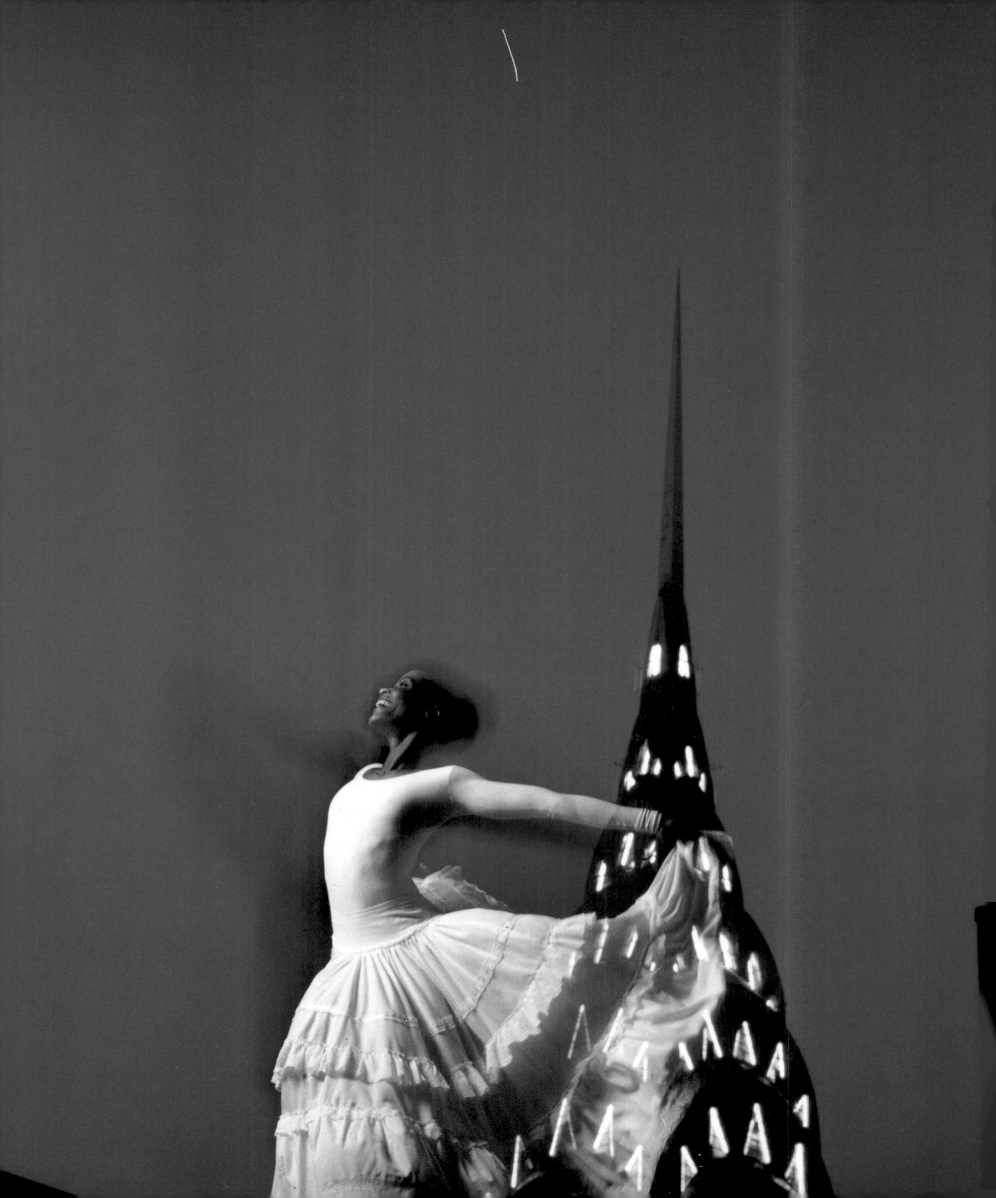

FASHION

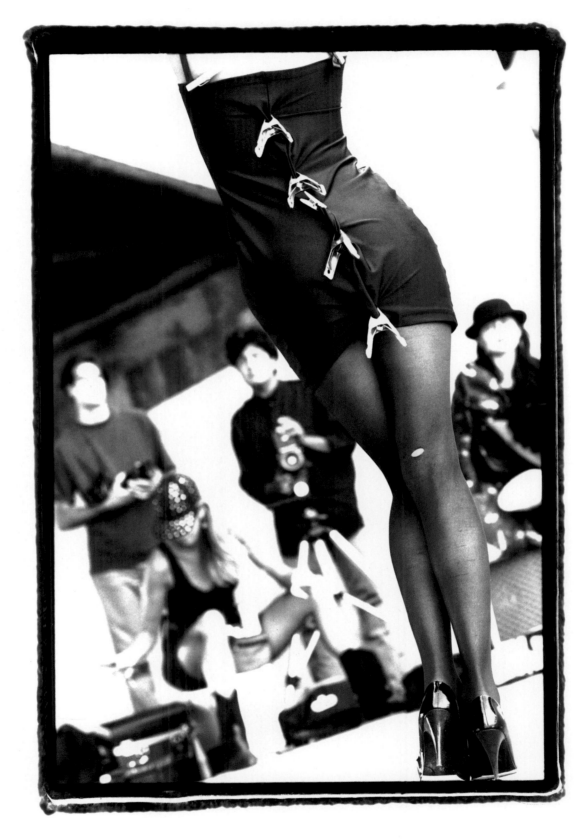

Larry Bartholomew

Craig Cutler

◅◅ Fred George

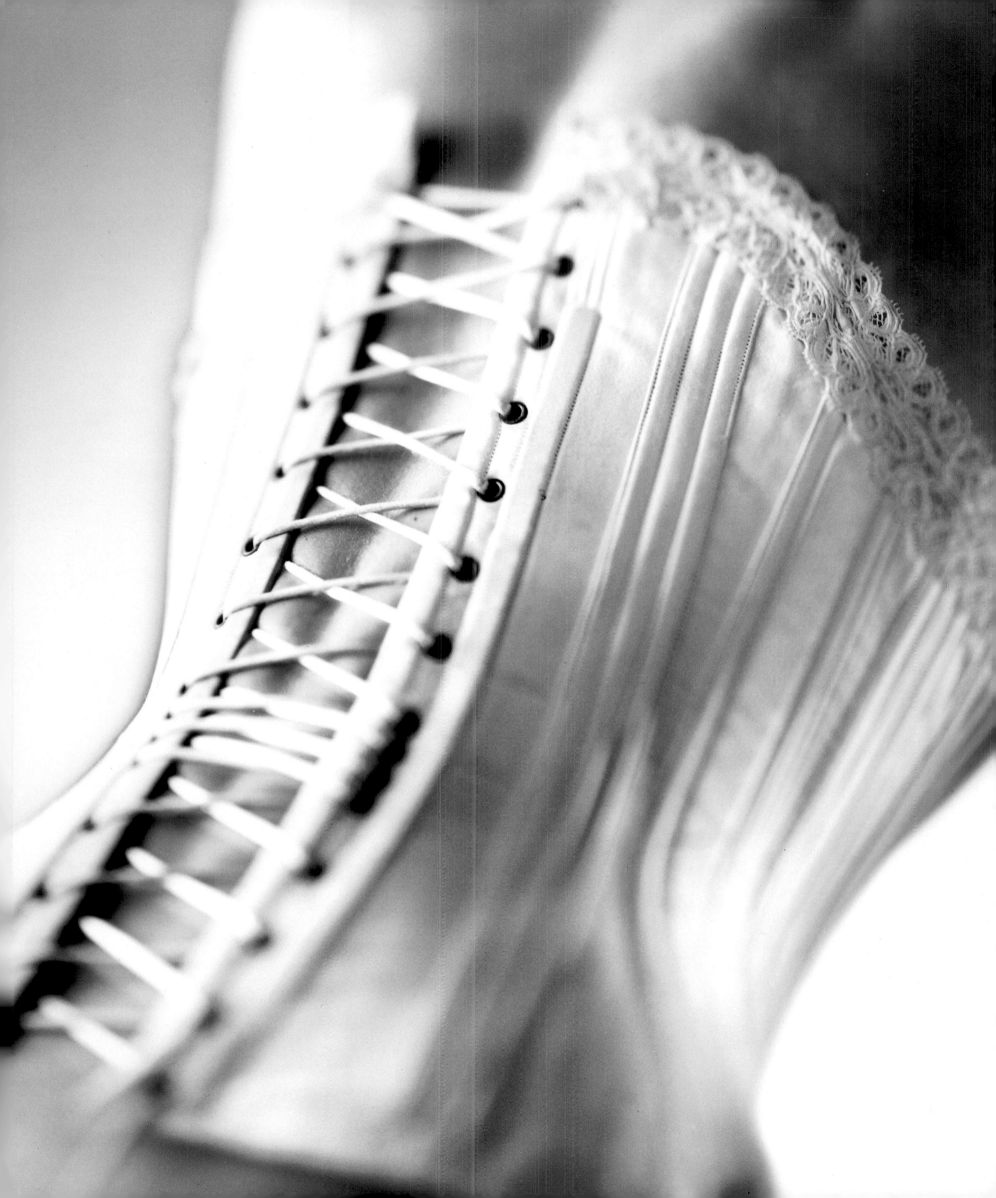

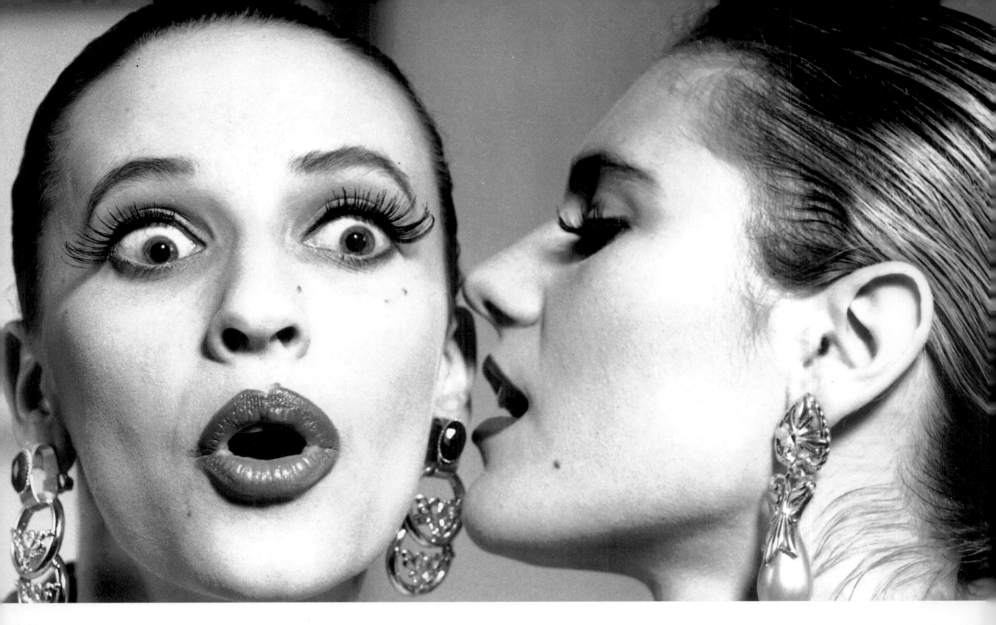

Larry Bartholomew

Yuri Dojc

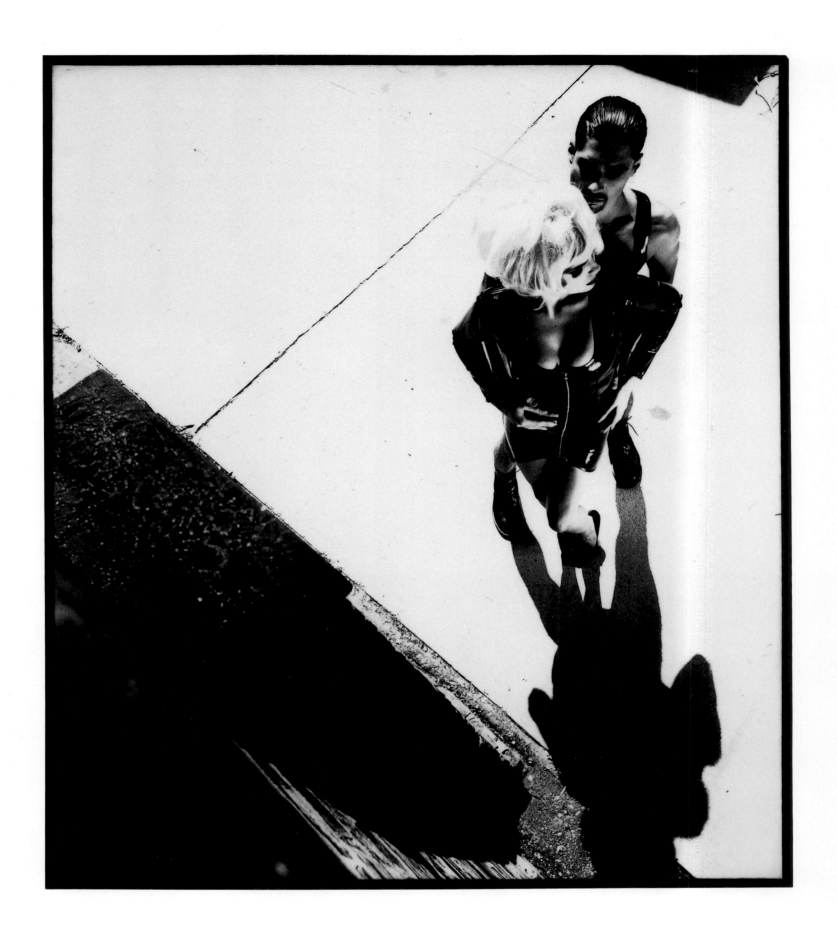

John Morrison

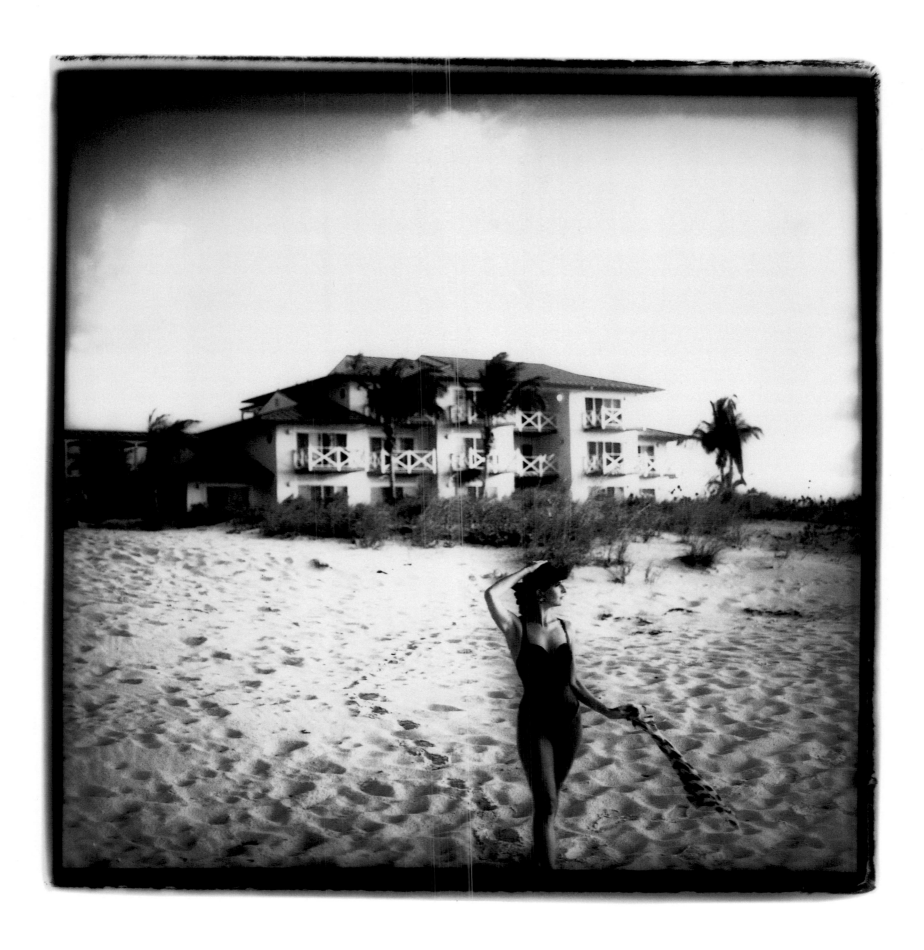

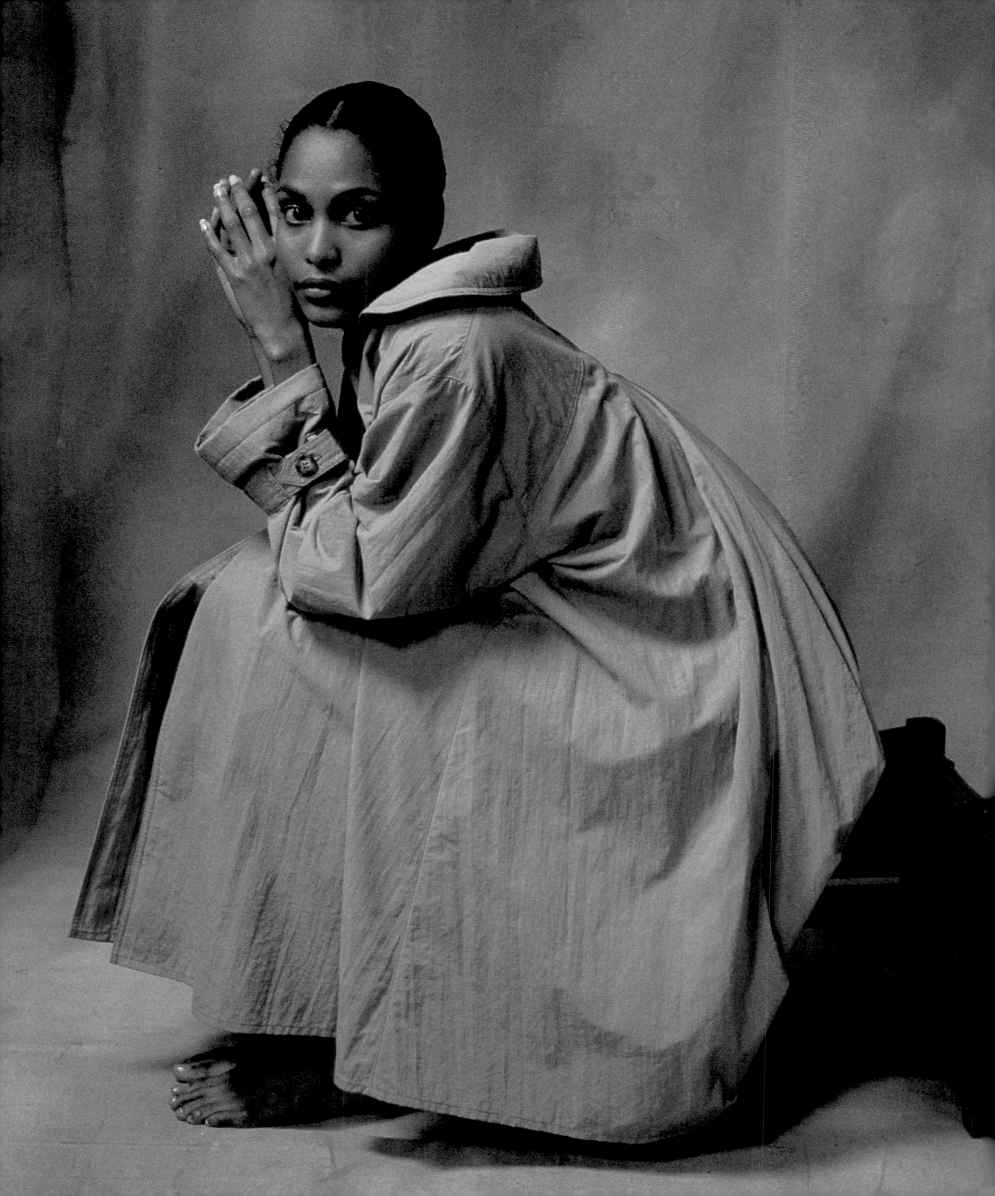

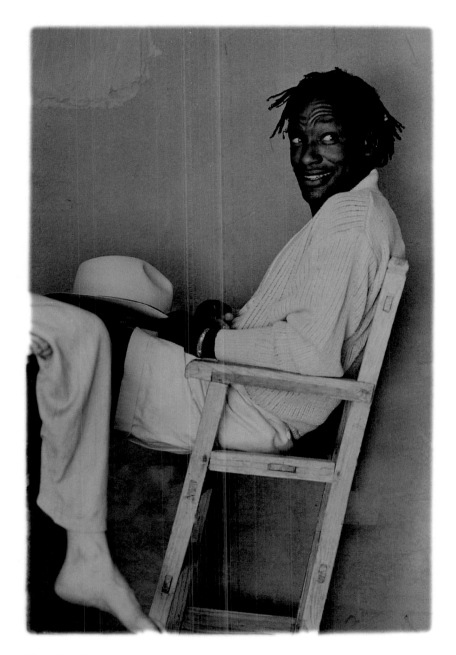

Terry Husebye

Alen MacWeeney

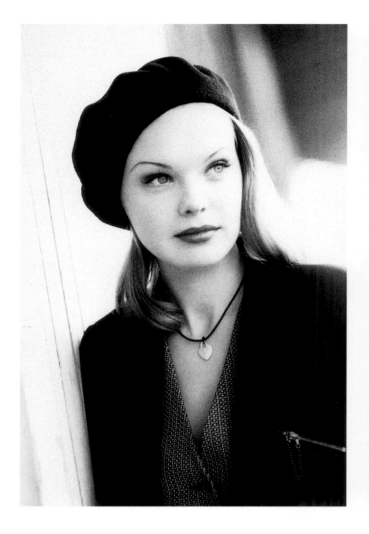

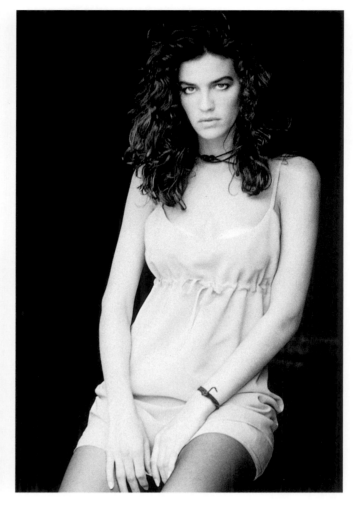

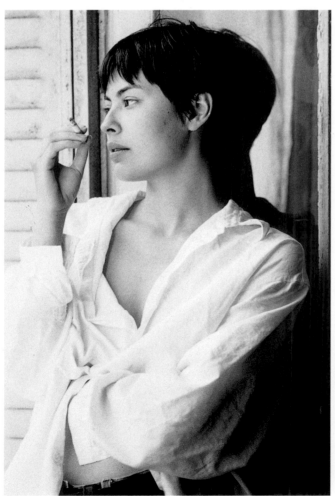

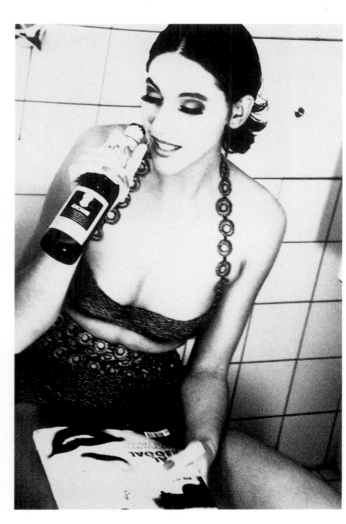

(Top left)
Karin Knoblich

(Bottom left)
Karin Knoblich

(Top right)
Karin Knoblich

(Bottom right)
Esther Haase

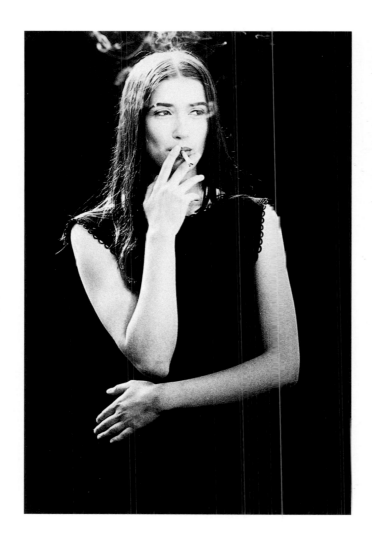

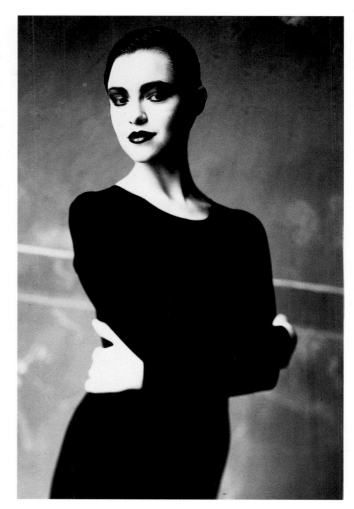

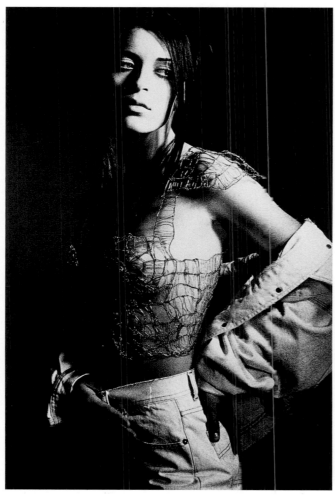

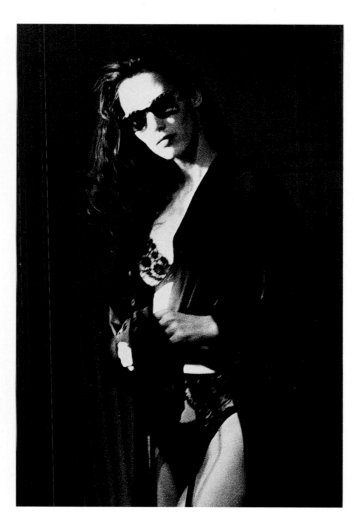

(Top left)
Dirk Fischer

(Bottom left)
Dirk Fischer

(Top right)
Michel Dubois

(Bottom right)
Dirk Fischer

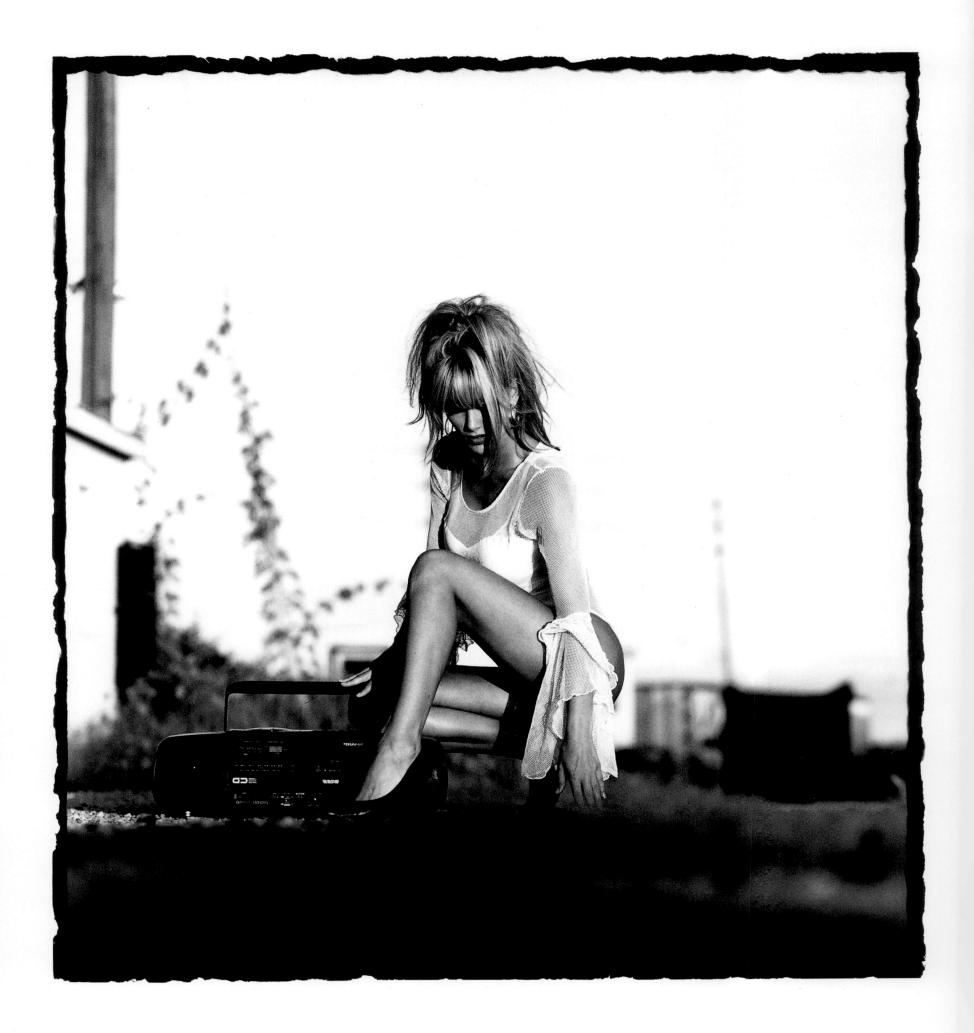

John Morrison

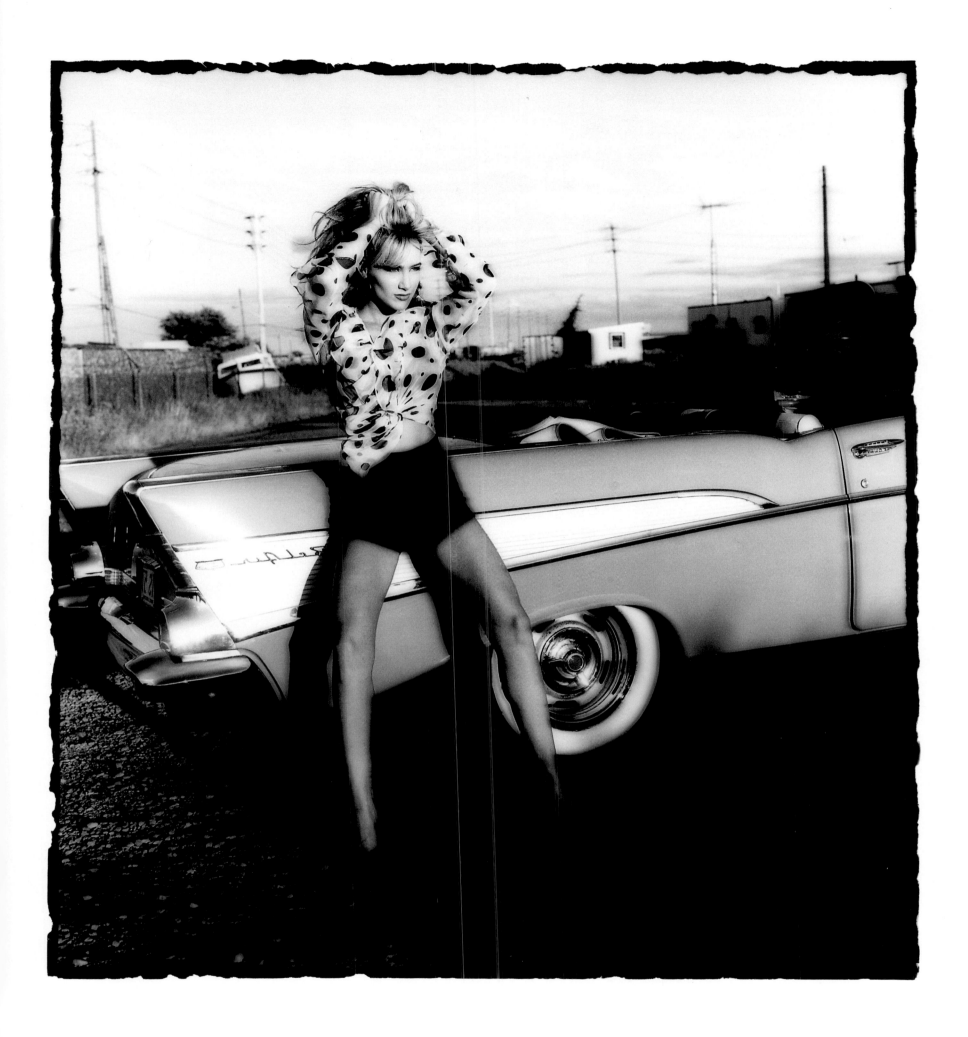

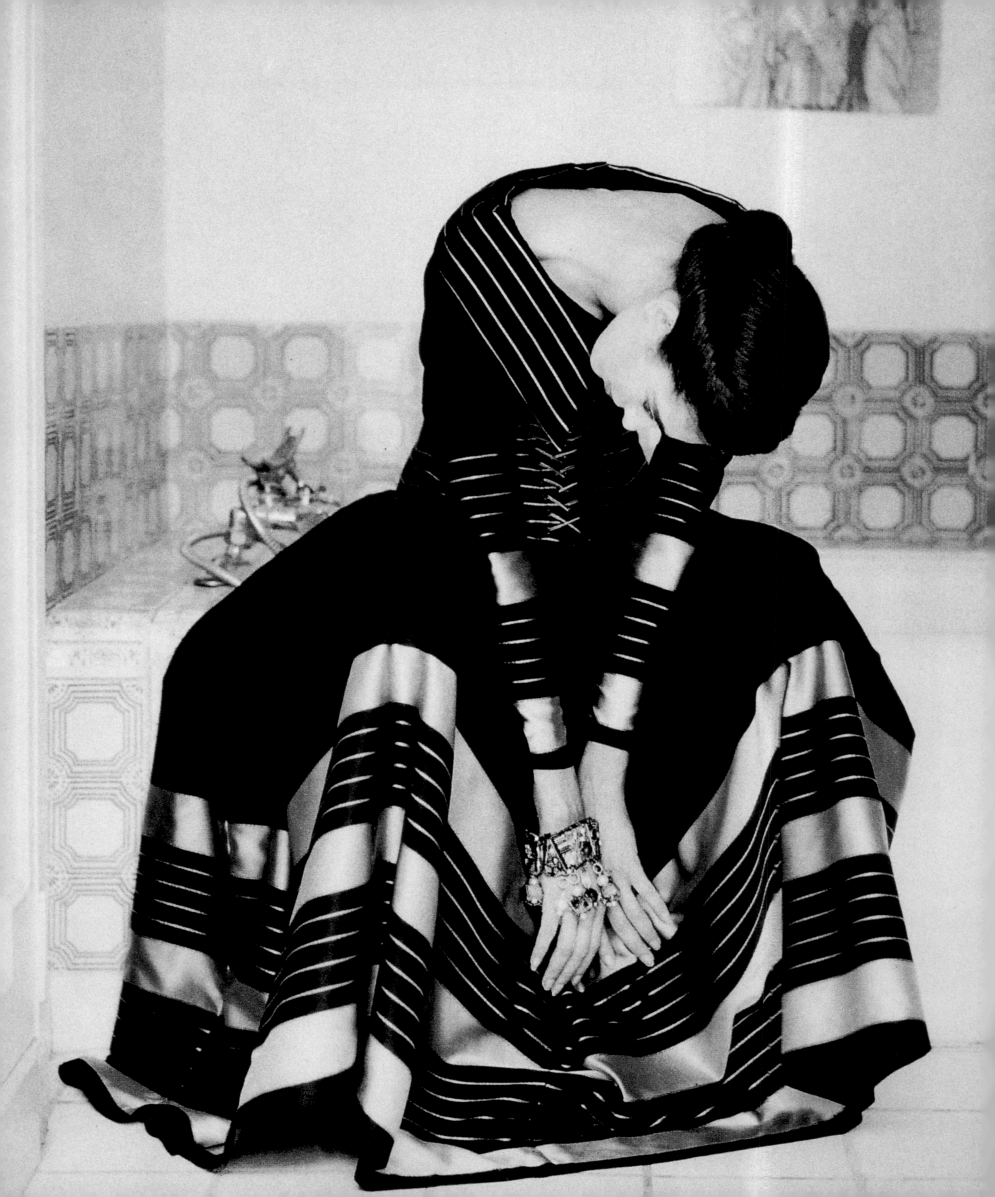

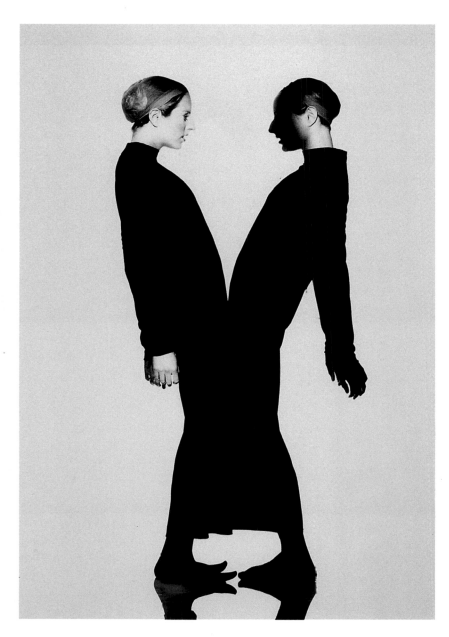

Eva Mueller

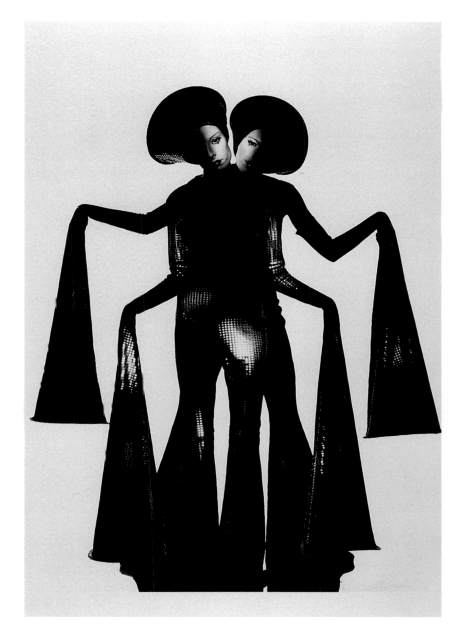

Eva Mueller

Elke Hesser

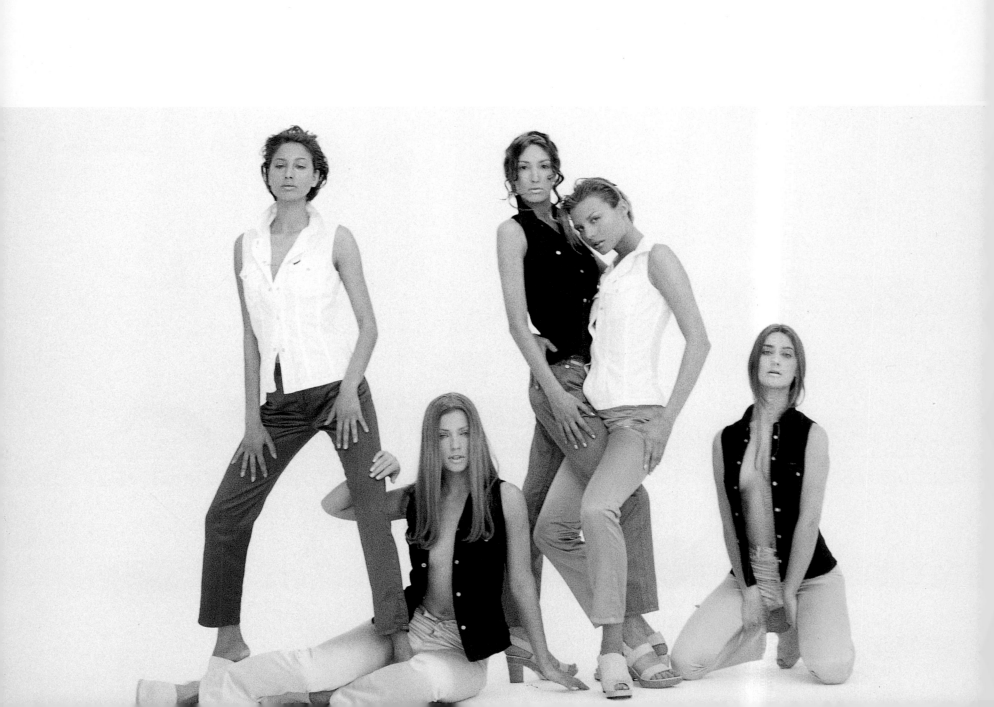

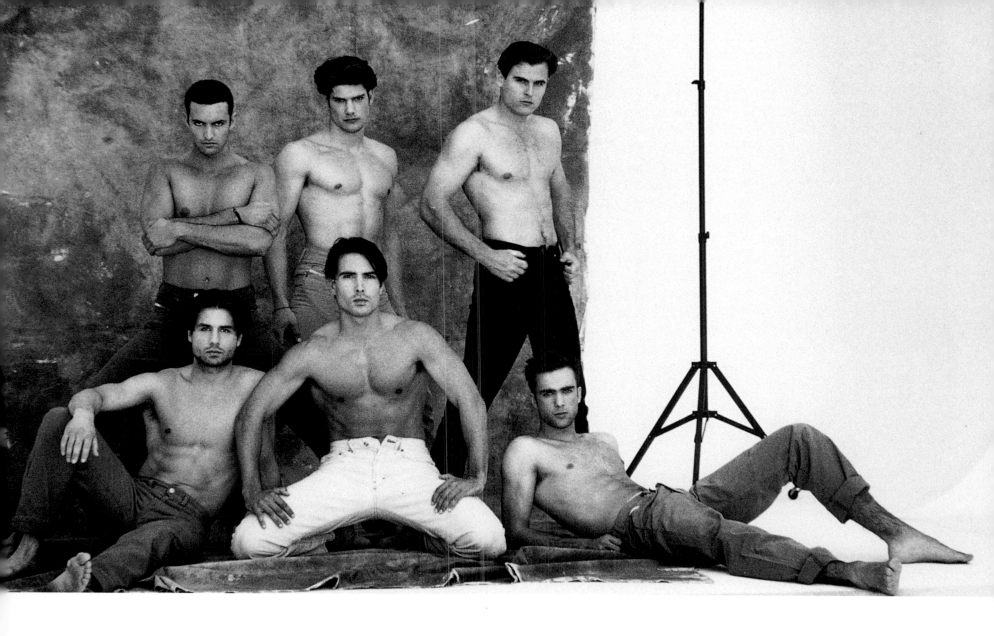

Jordi Cubells I. Biela

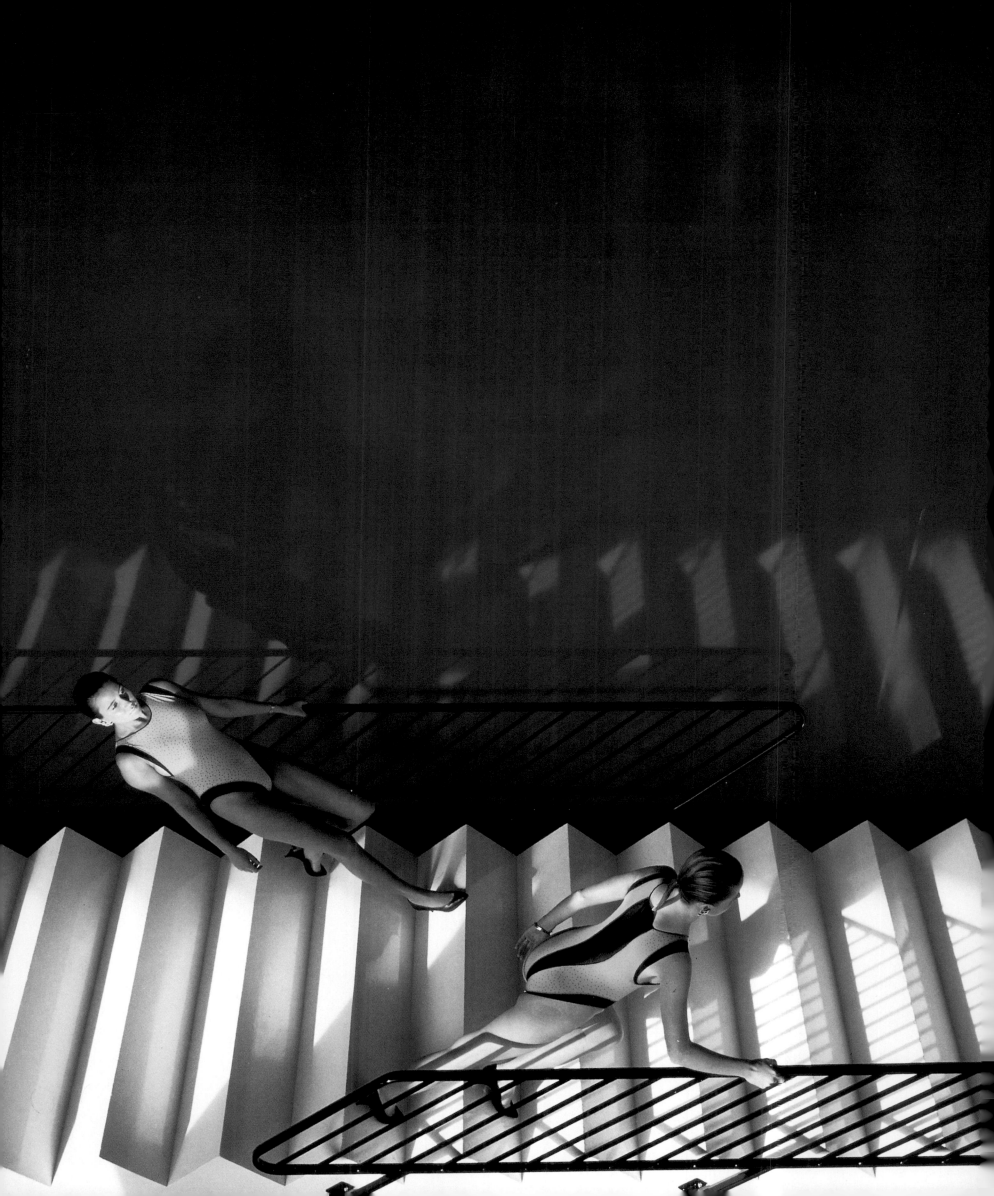

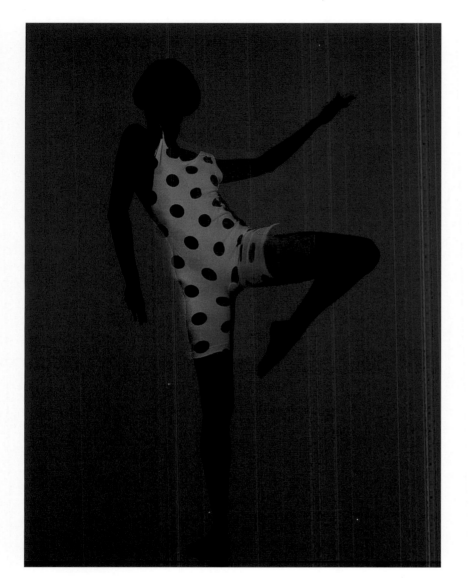

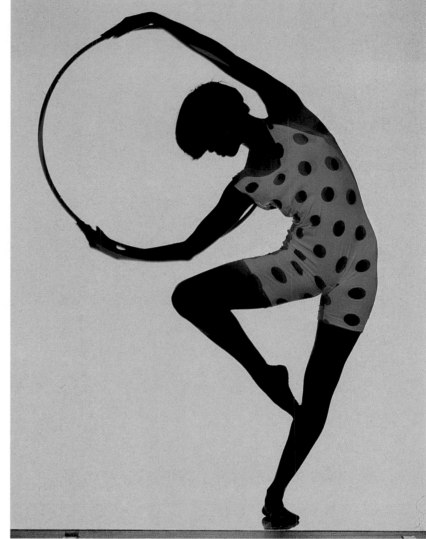

Tak Kojima

Tak Kojima

Conny J. Winter

Tak Kojima ▷▷

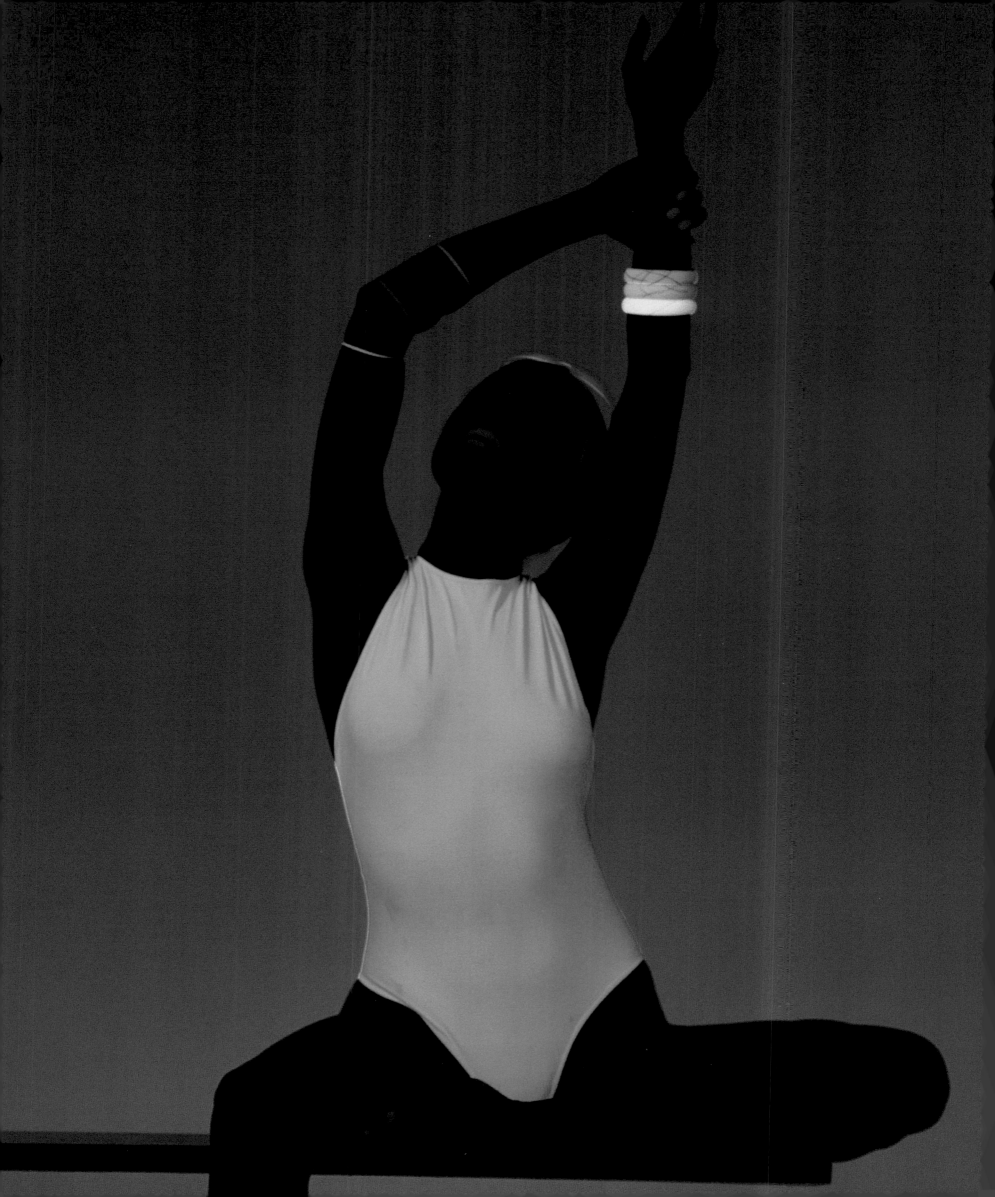

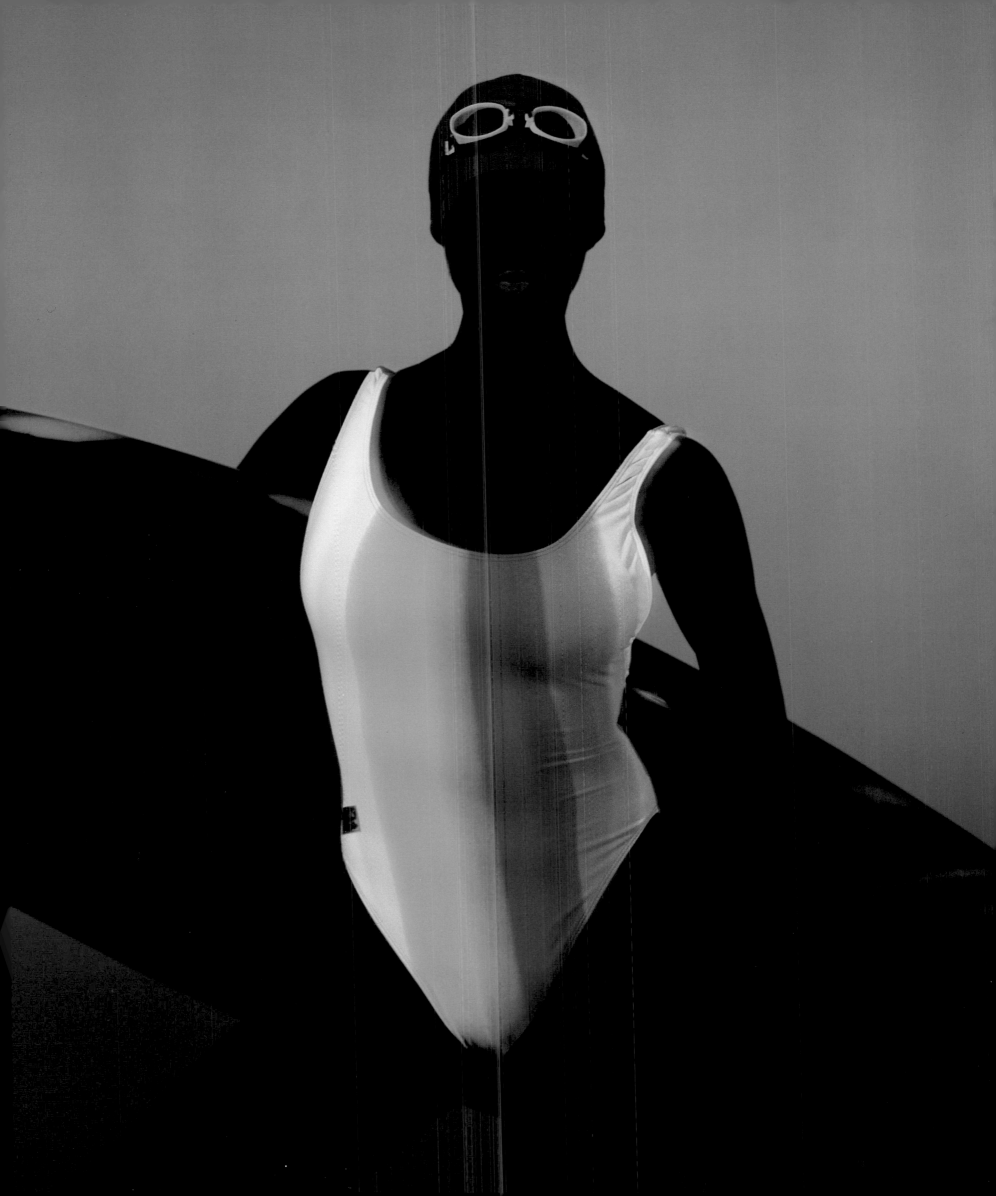

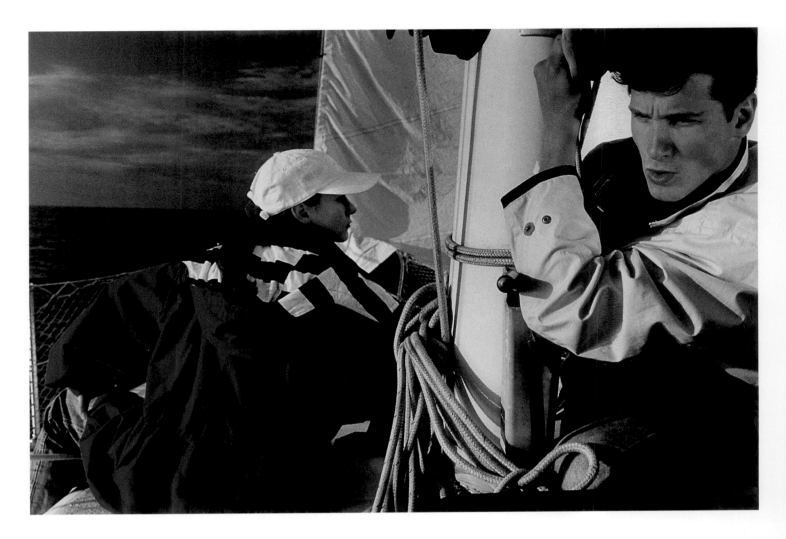

Kai H. Mui

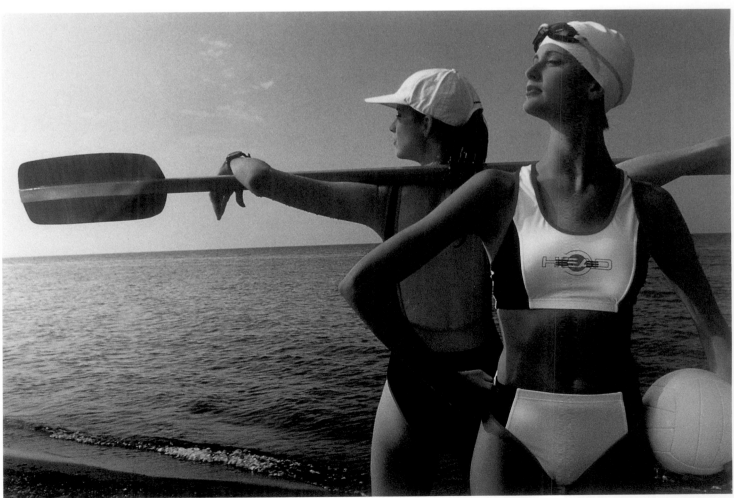

Kai H. Mui

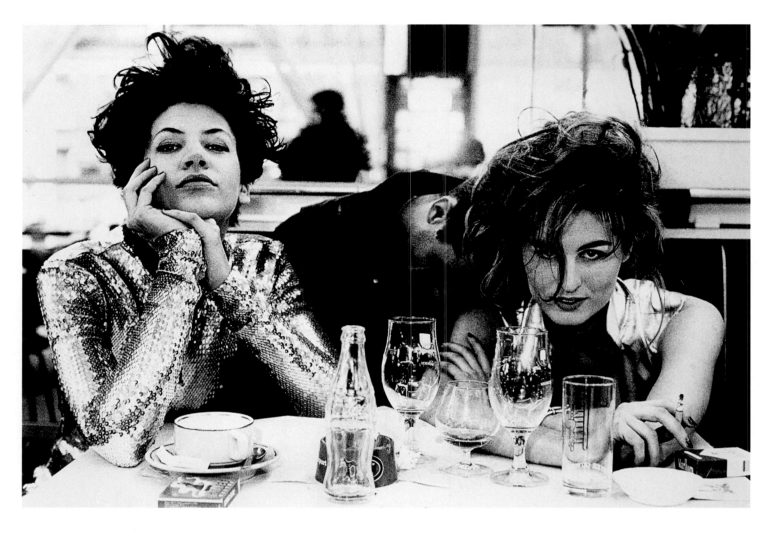

Elke Hesser

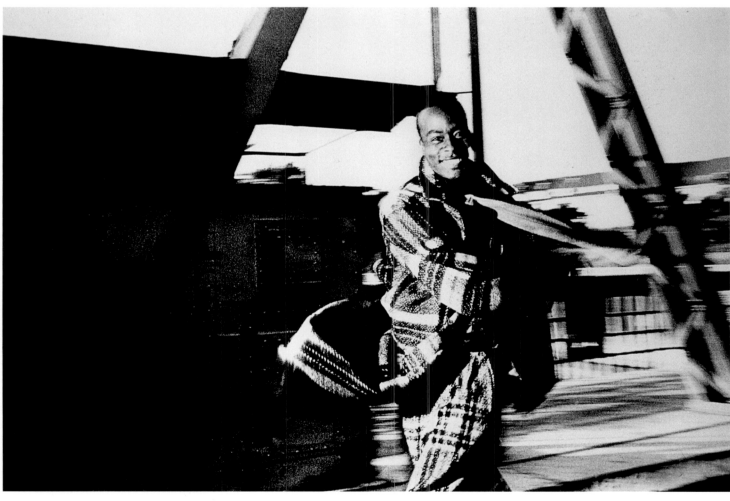

Elke Hesser

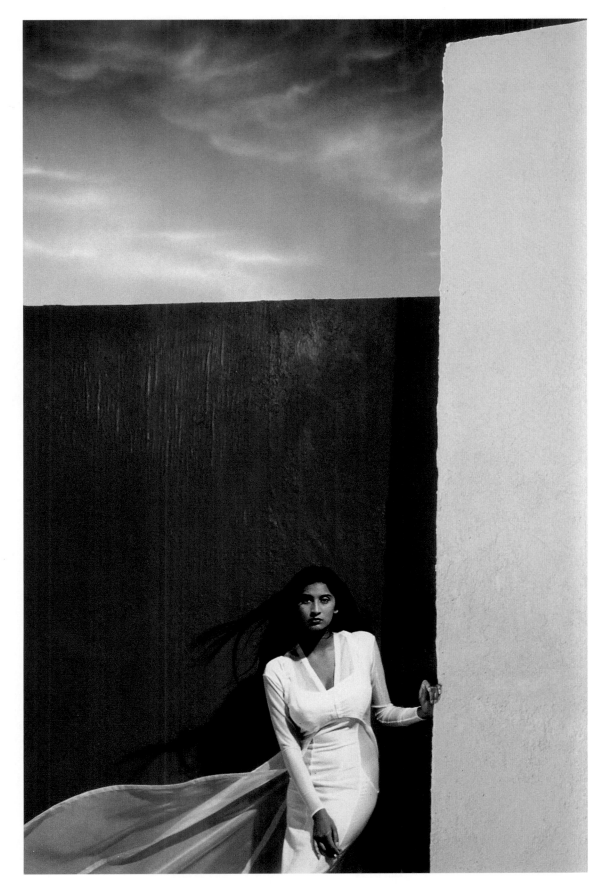

Esther Haase

Larry Bartholomew

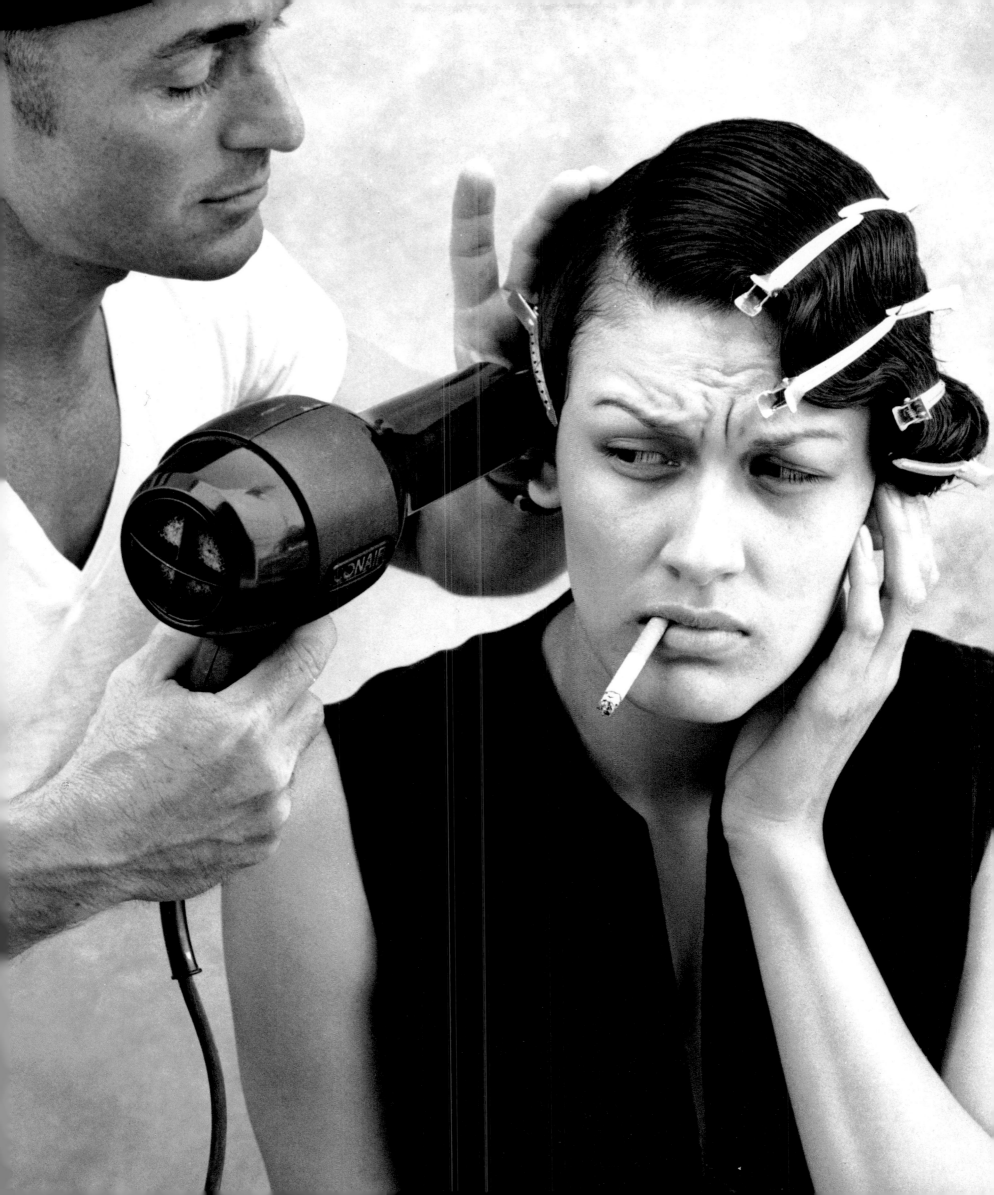

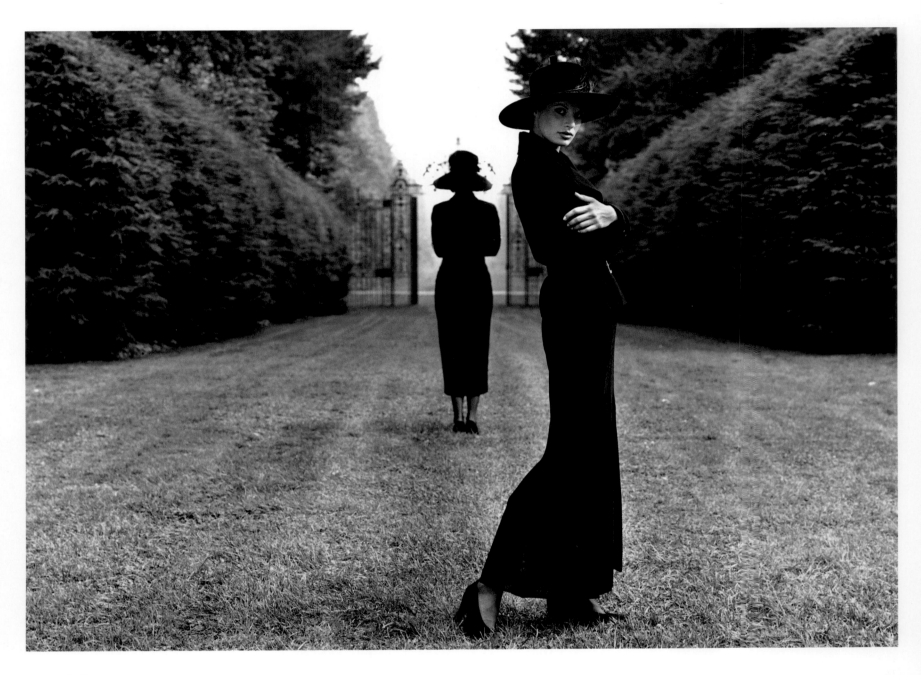

Rodney Smith

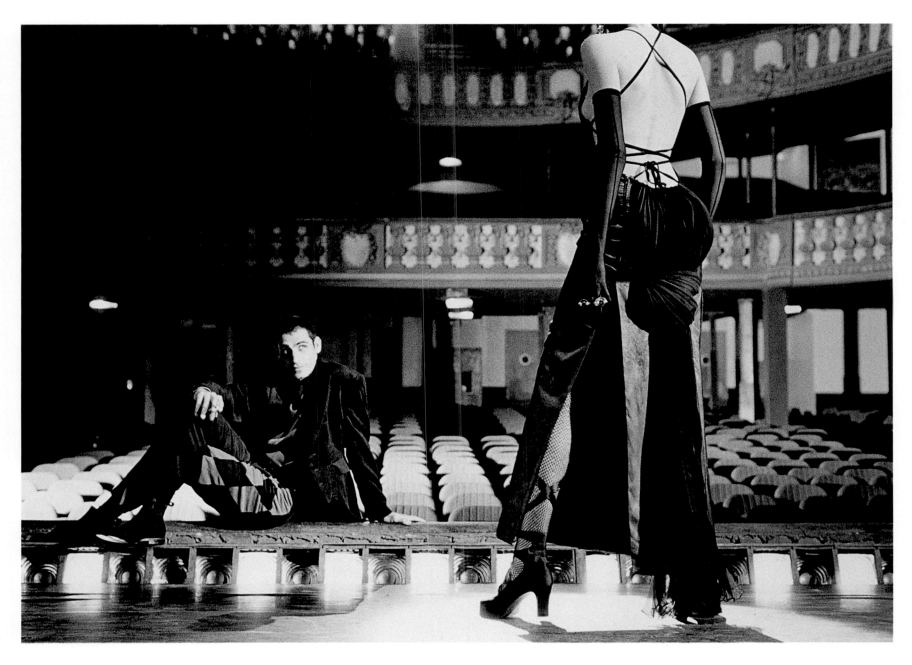

Elke Hesser

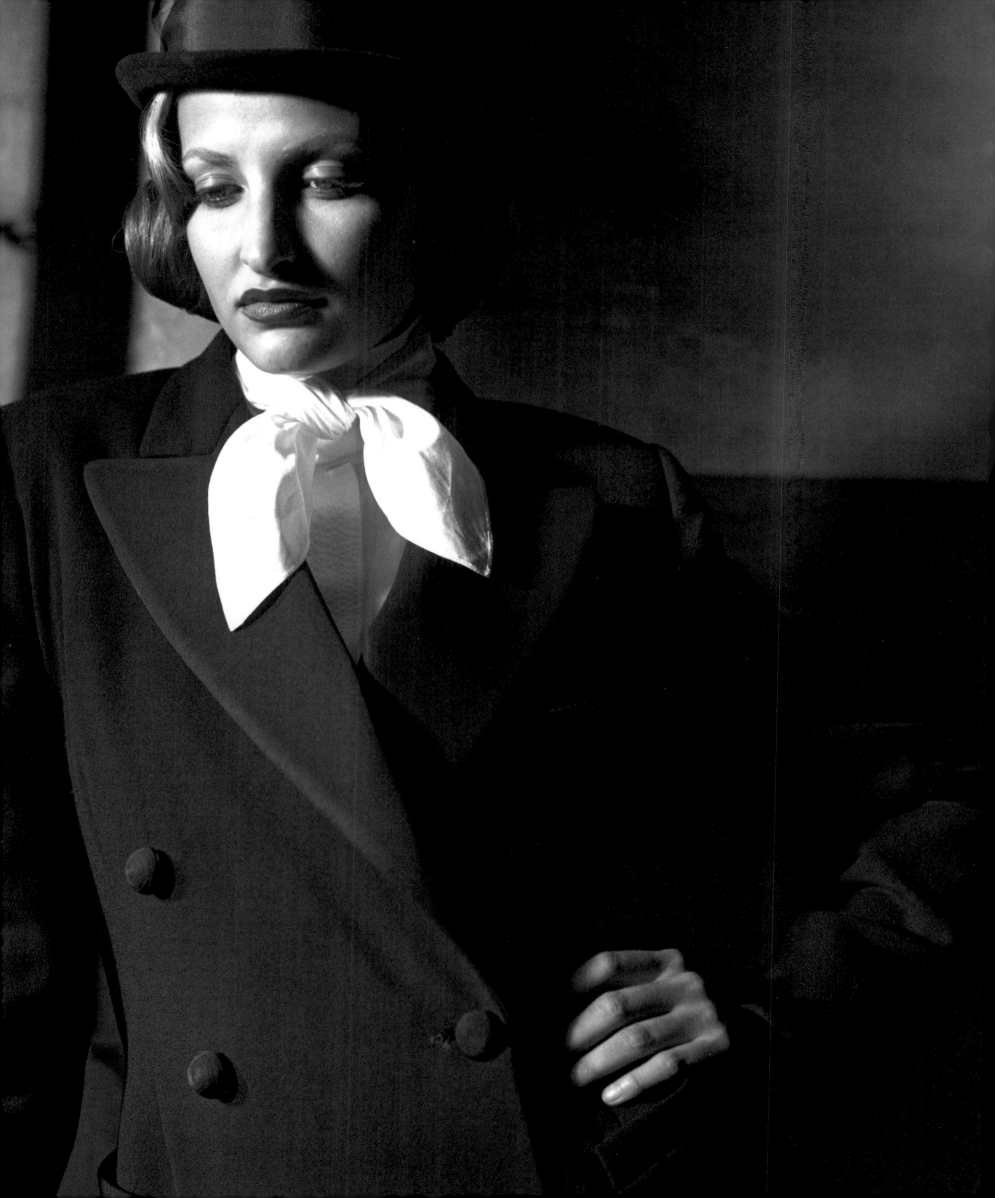

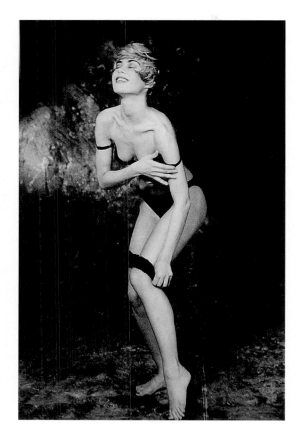

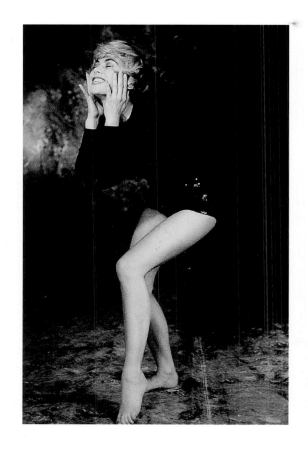

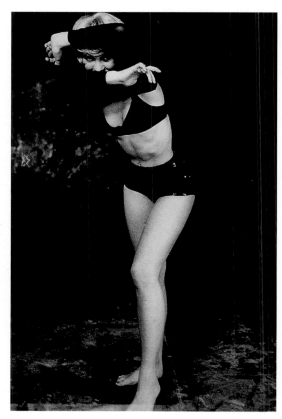

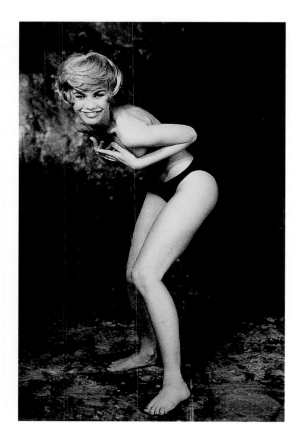

Elke Hesser

Rodney Smith

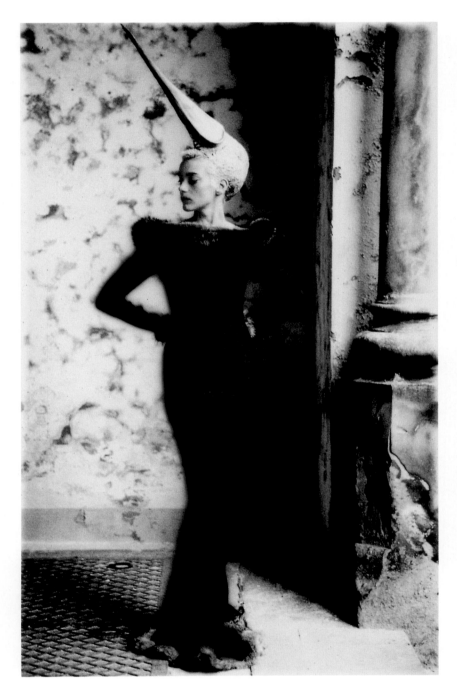

Det Kempke

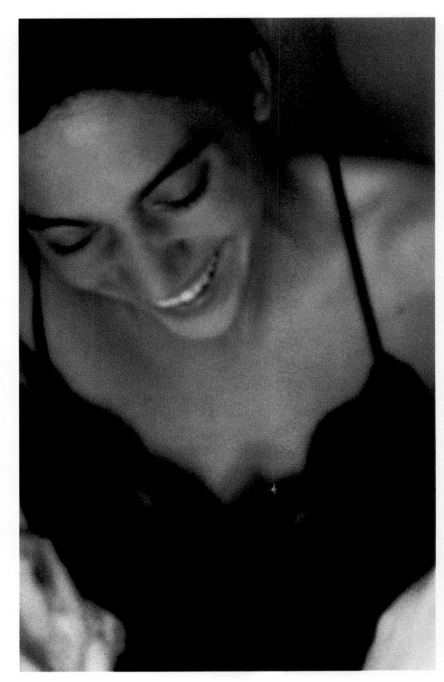

Esther Haase

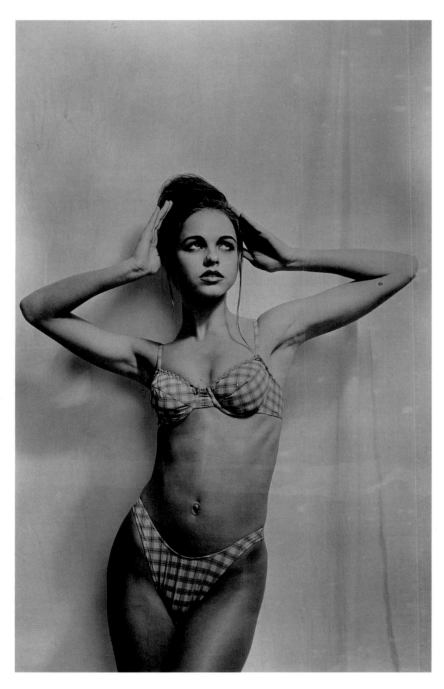

Dr. David Wood

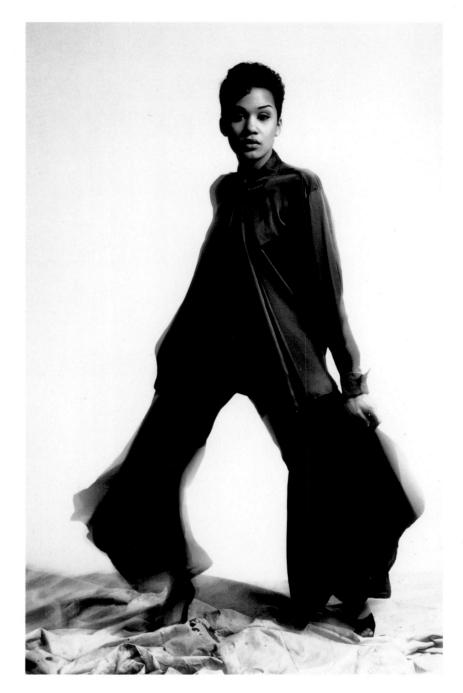

Dr. David Wood

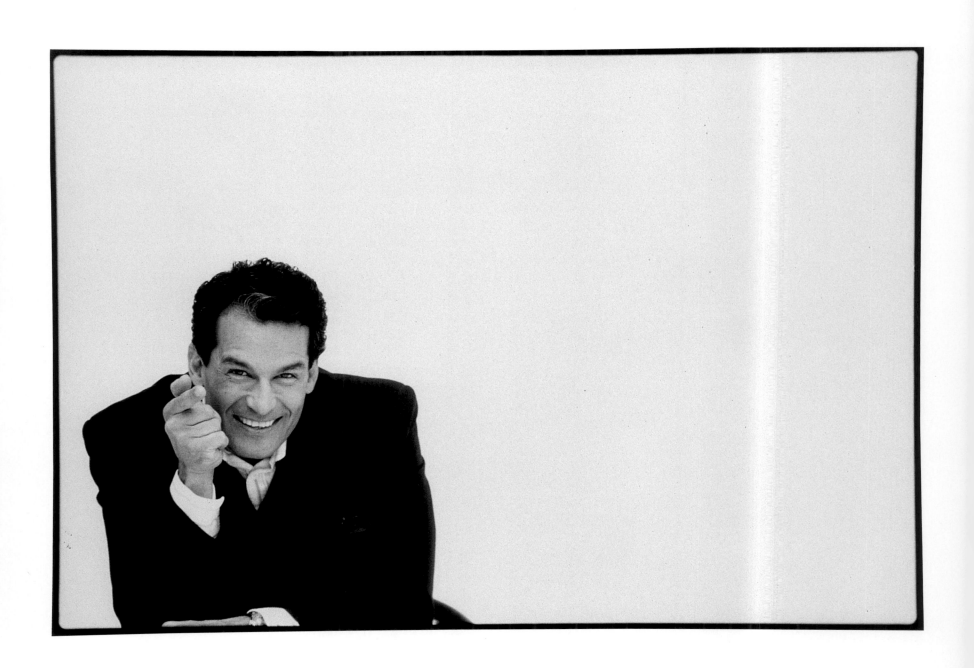

Jordi Cubells I. Biela

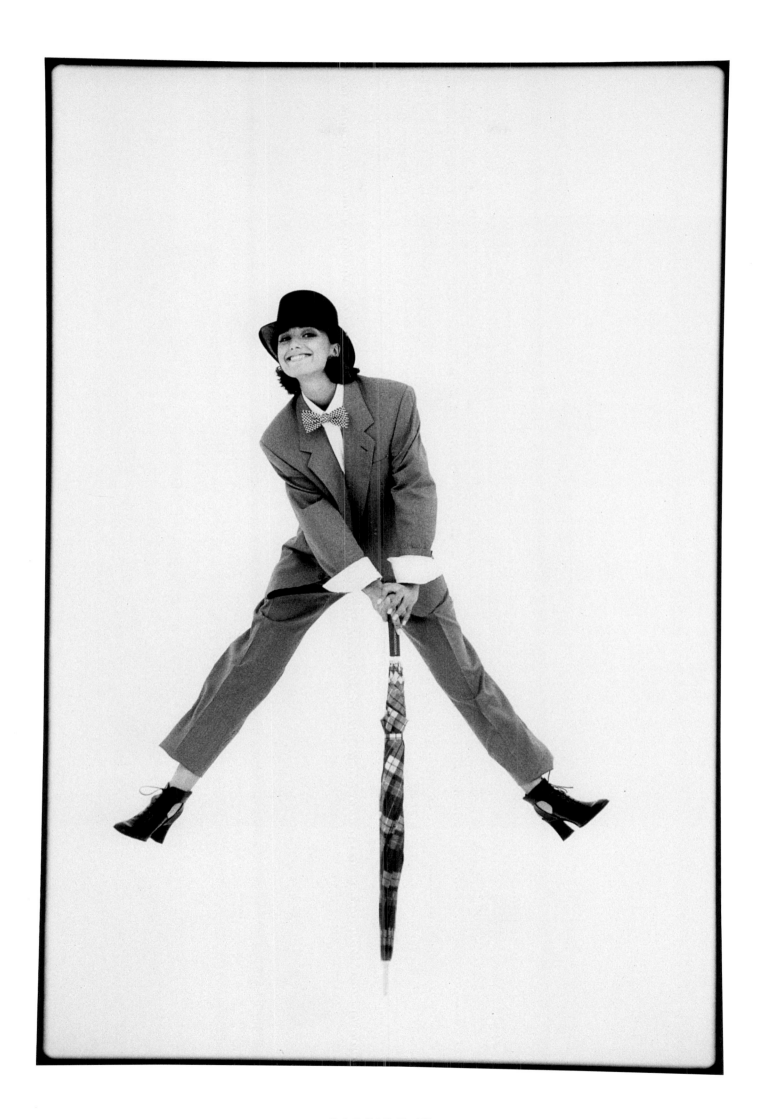

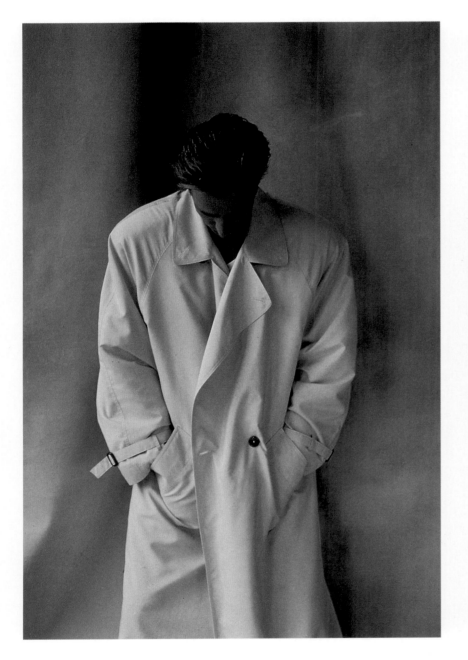

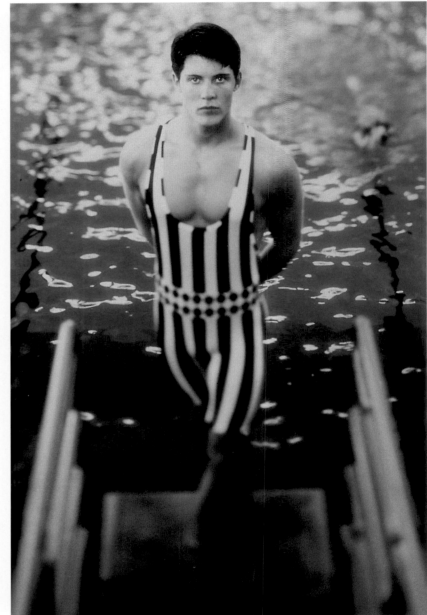

Alen MacWeeney

Det Kempke

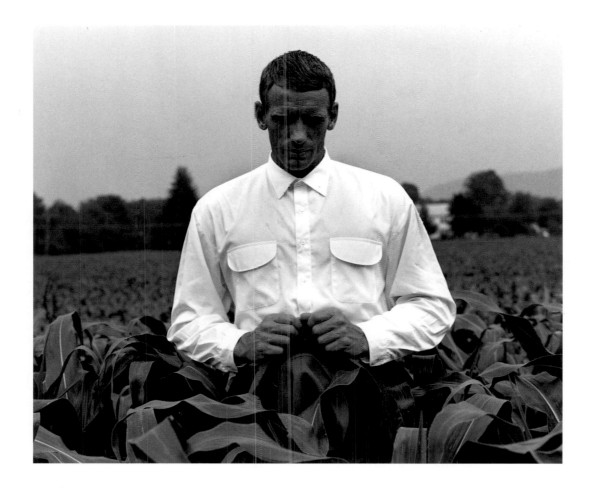

Rodney Smith

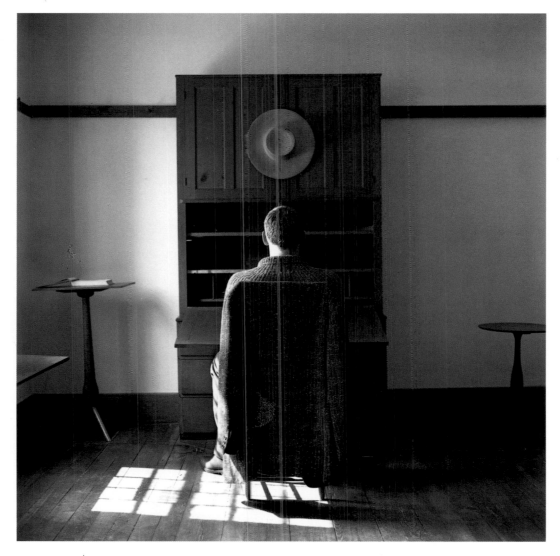

Rodney Smith

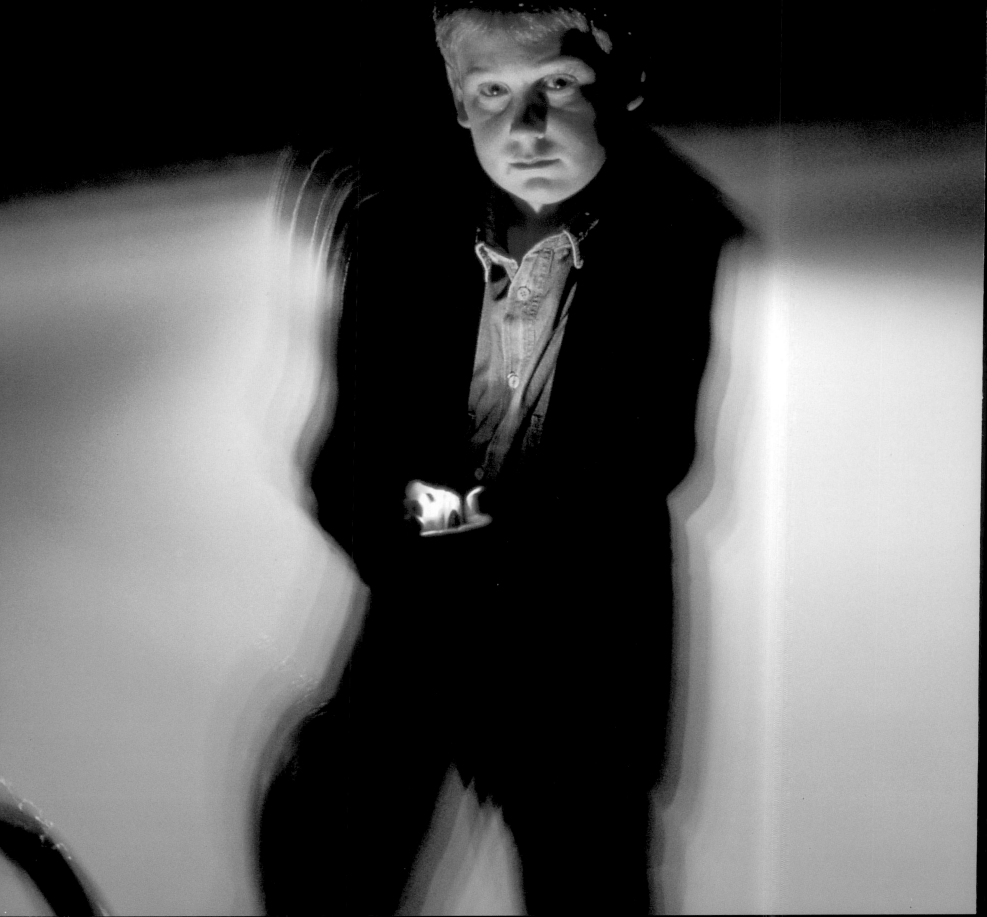

CHILDREN

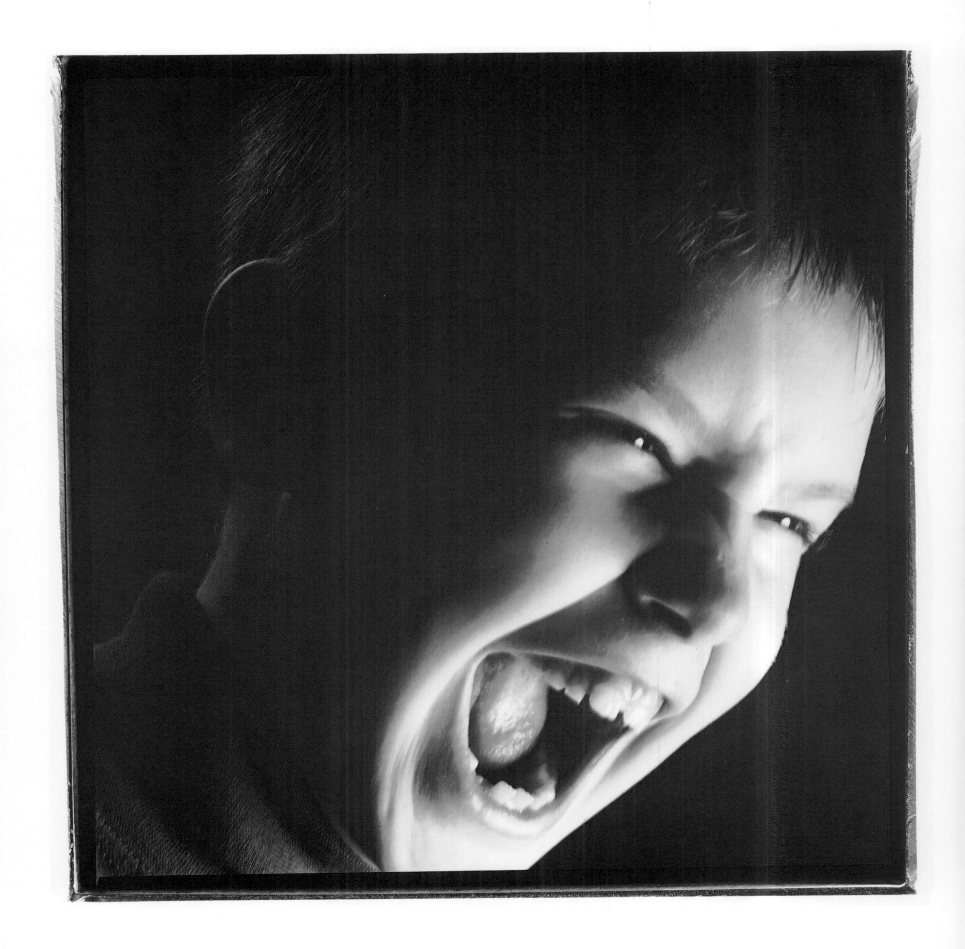

Dan Nelken

◁◁ Lonnie Duka

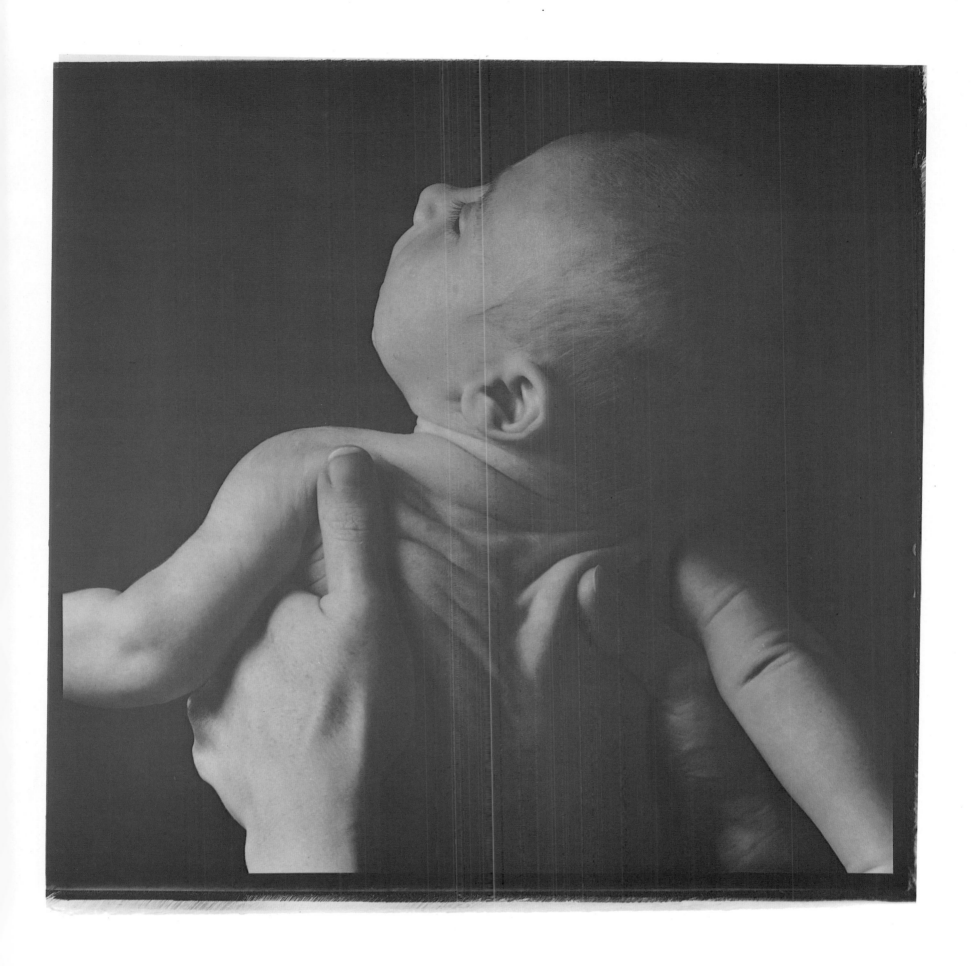

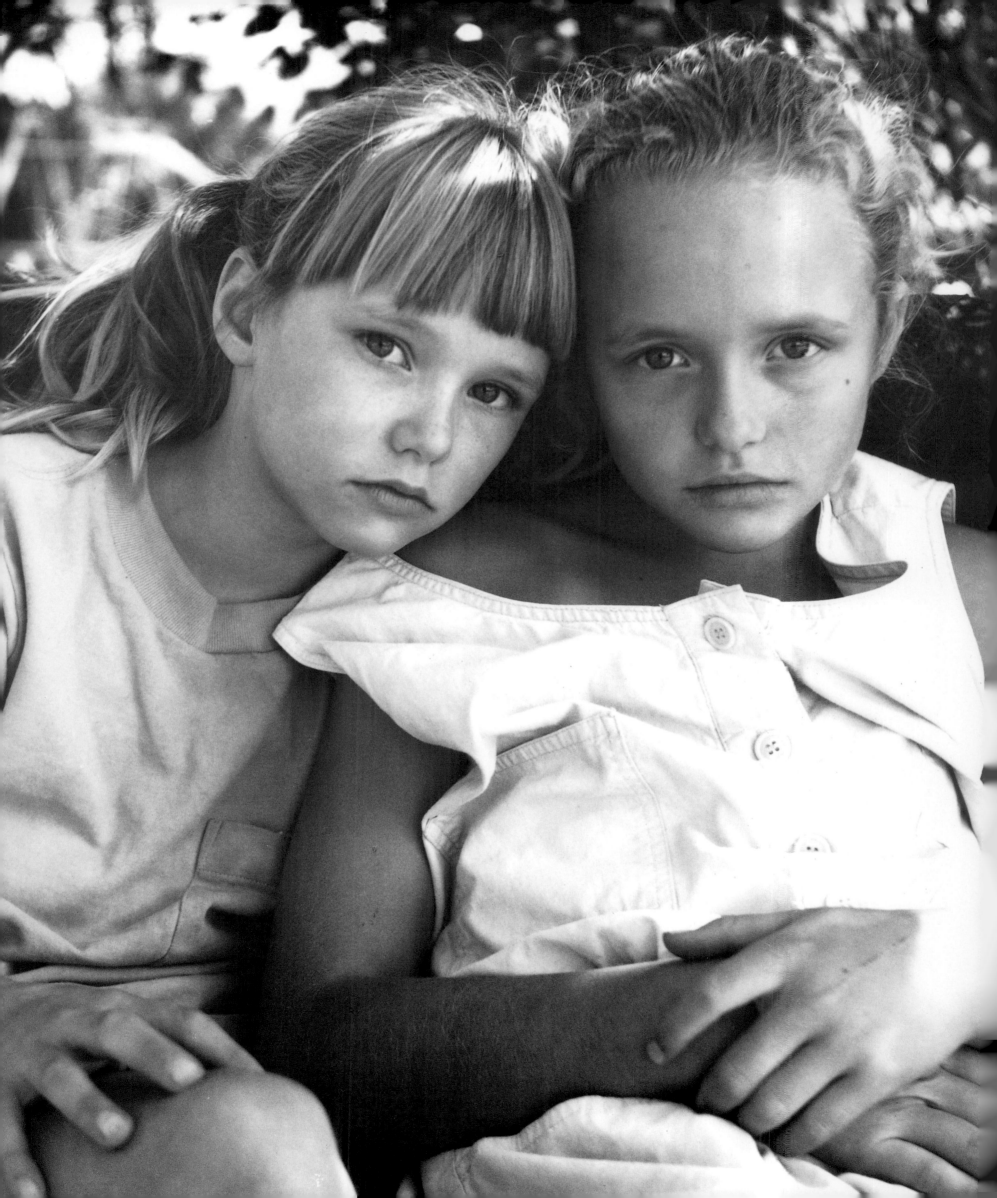

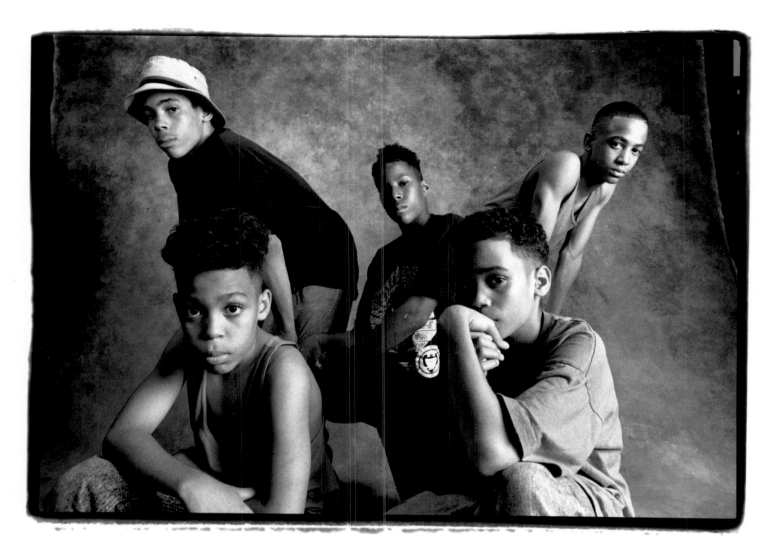

Fred George

Cat Gwynn

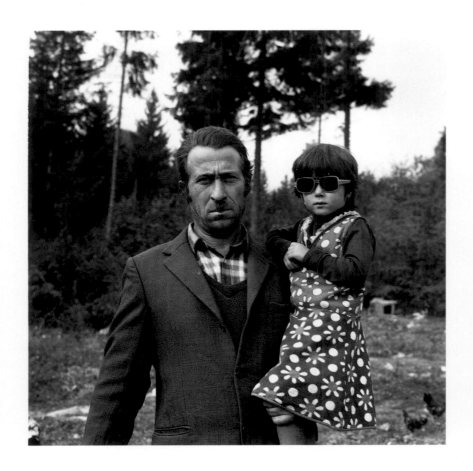
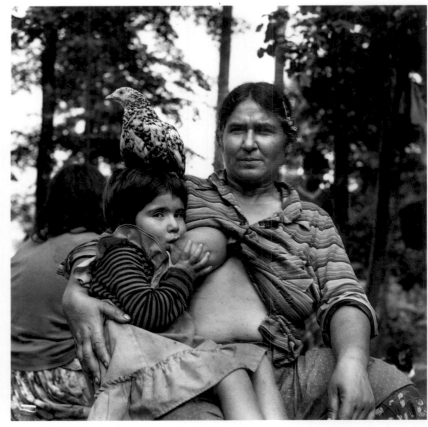
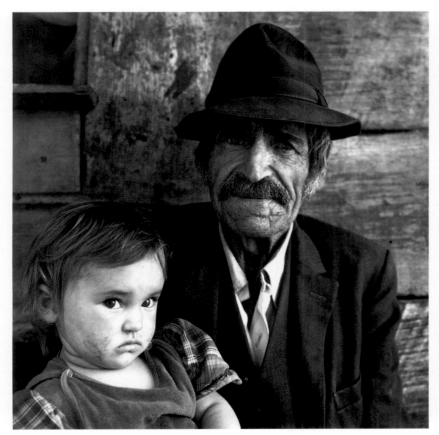
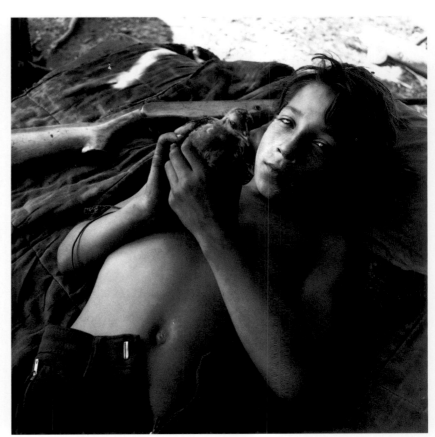

Saša Fuis

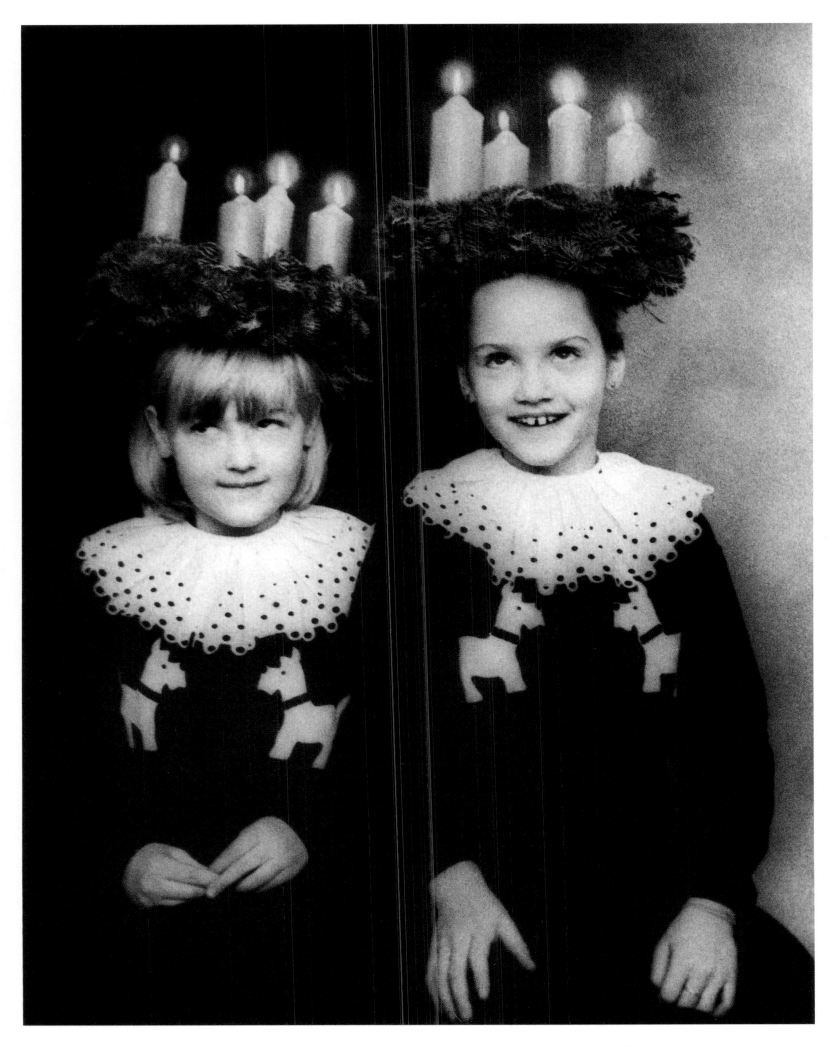

Helmut Claus

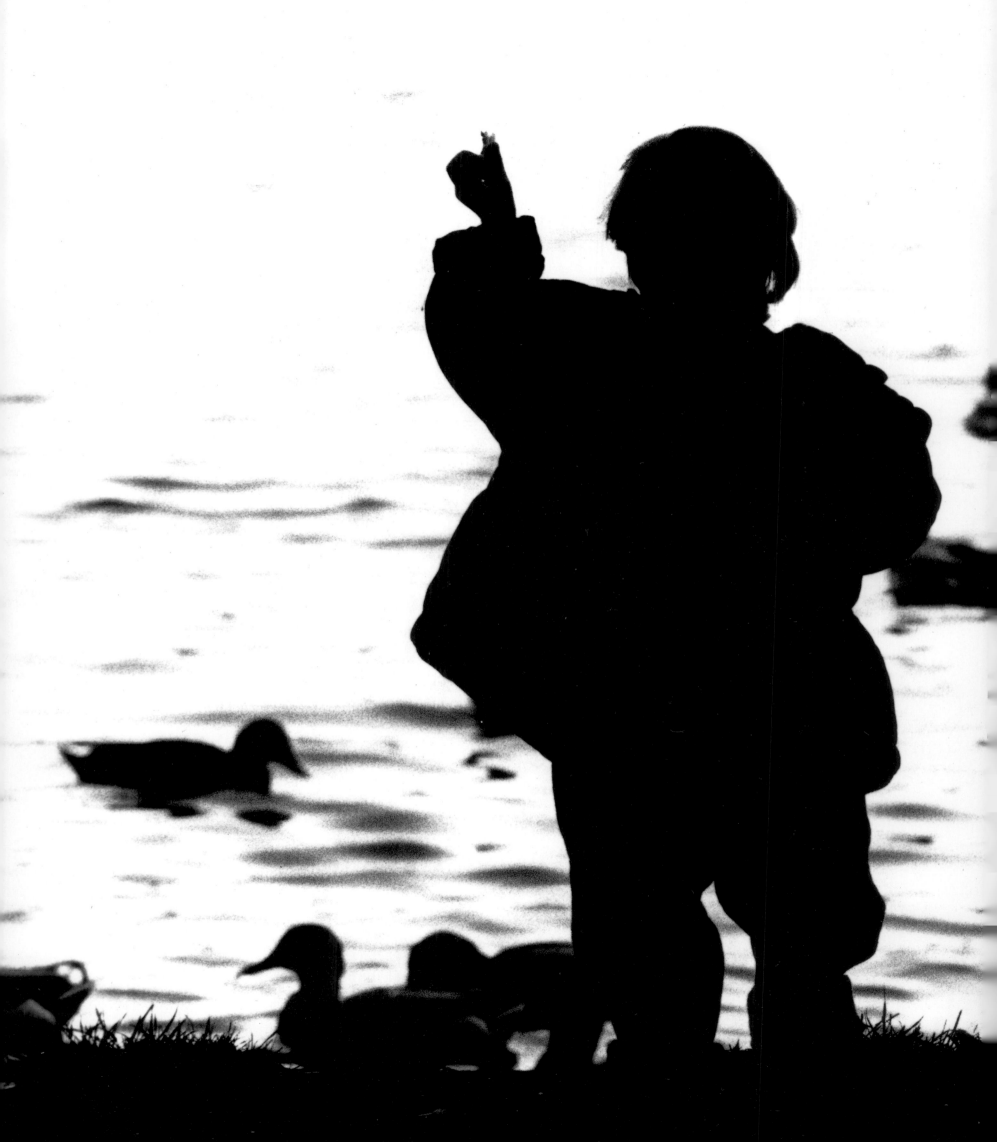

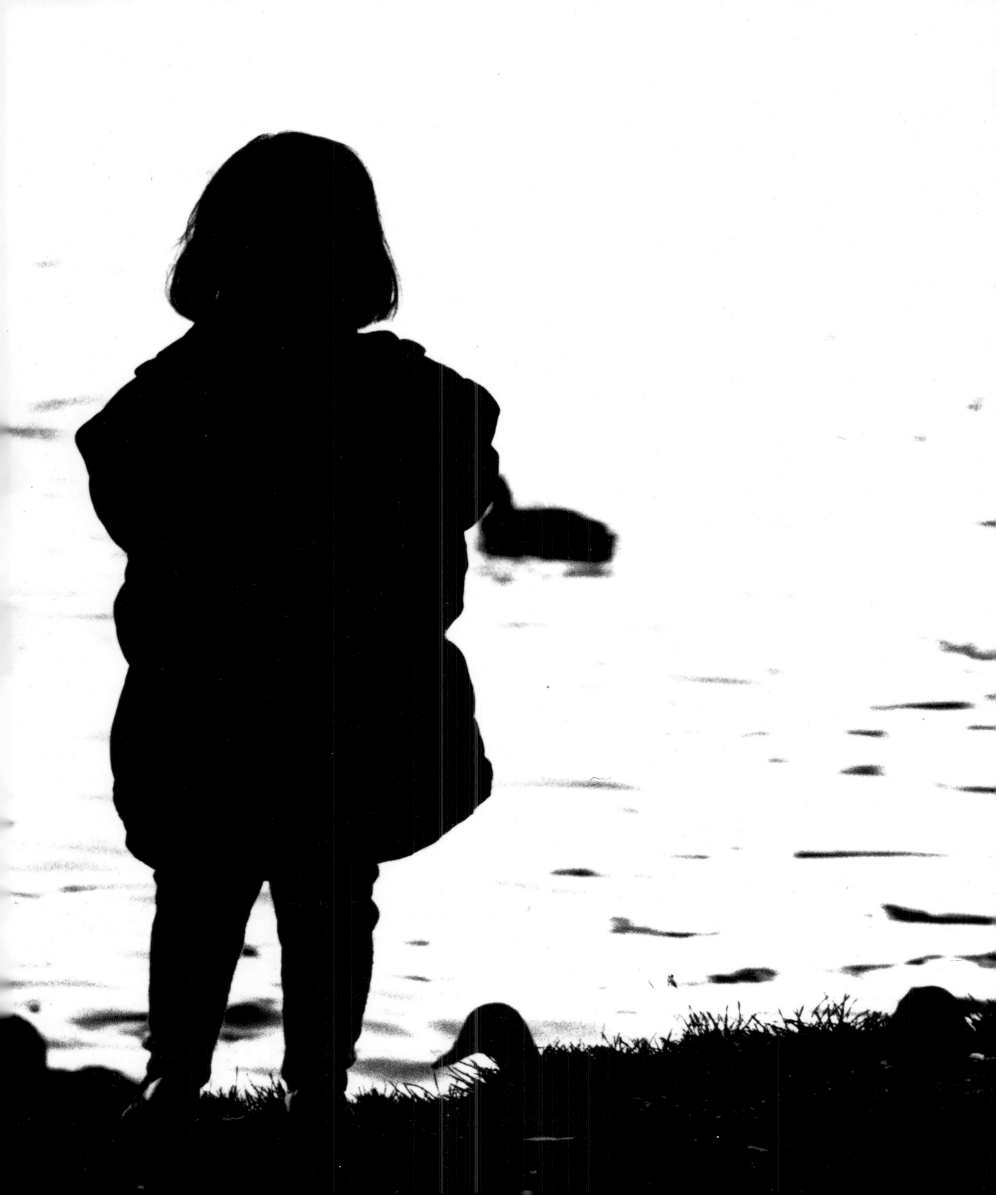

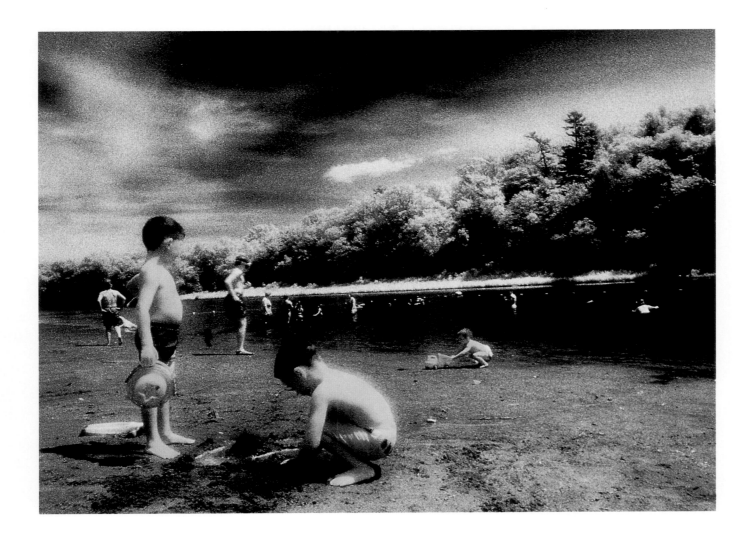

Sancra Eisner

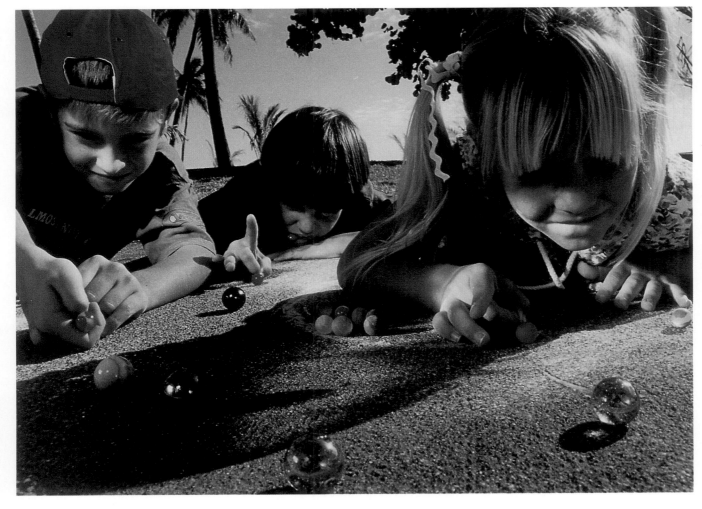

Kai H. Mui

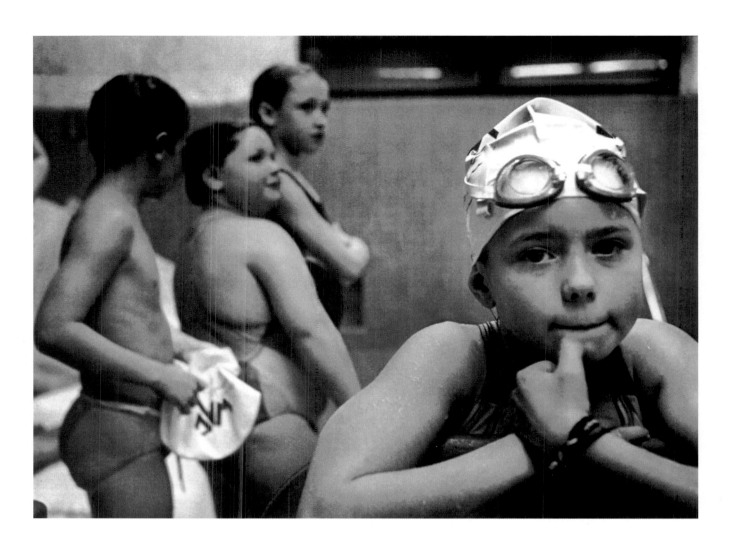

Anne Nielsen

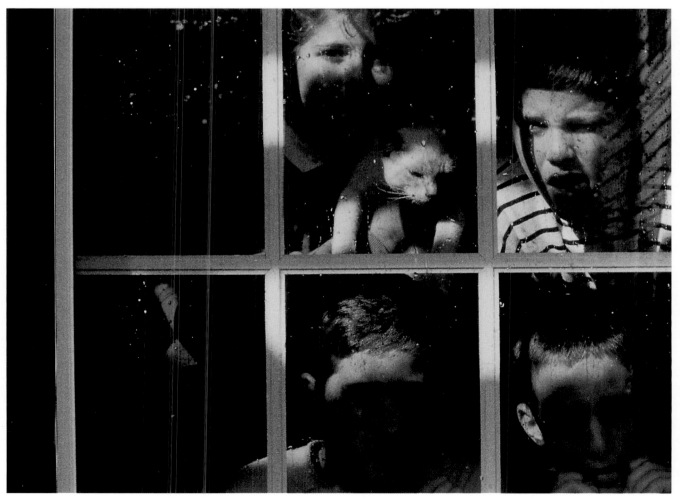

Kai H. Mui

Lonnie Duka

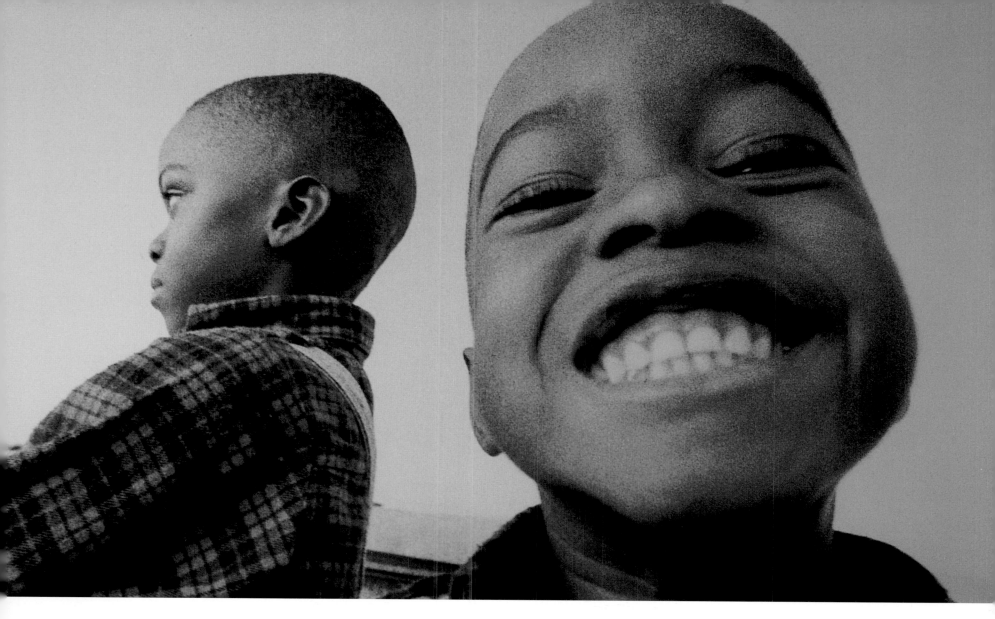

Stephanie Rausser

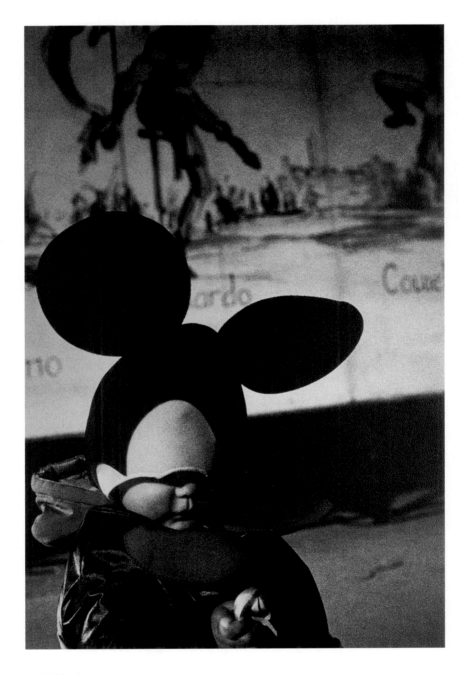

David Hughes

Howard Berman

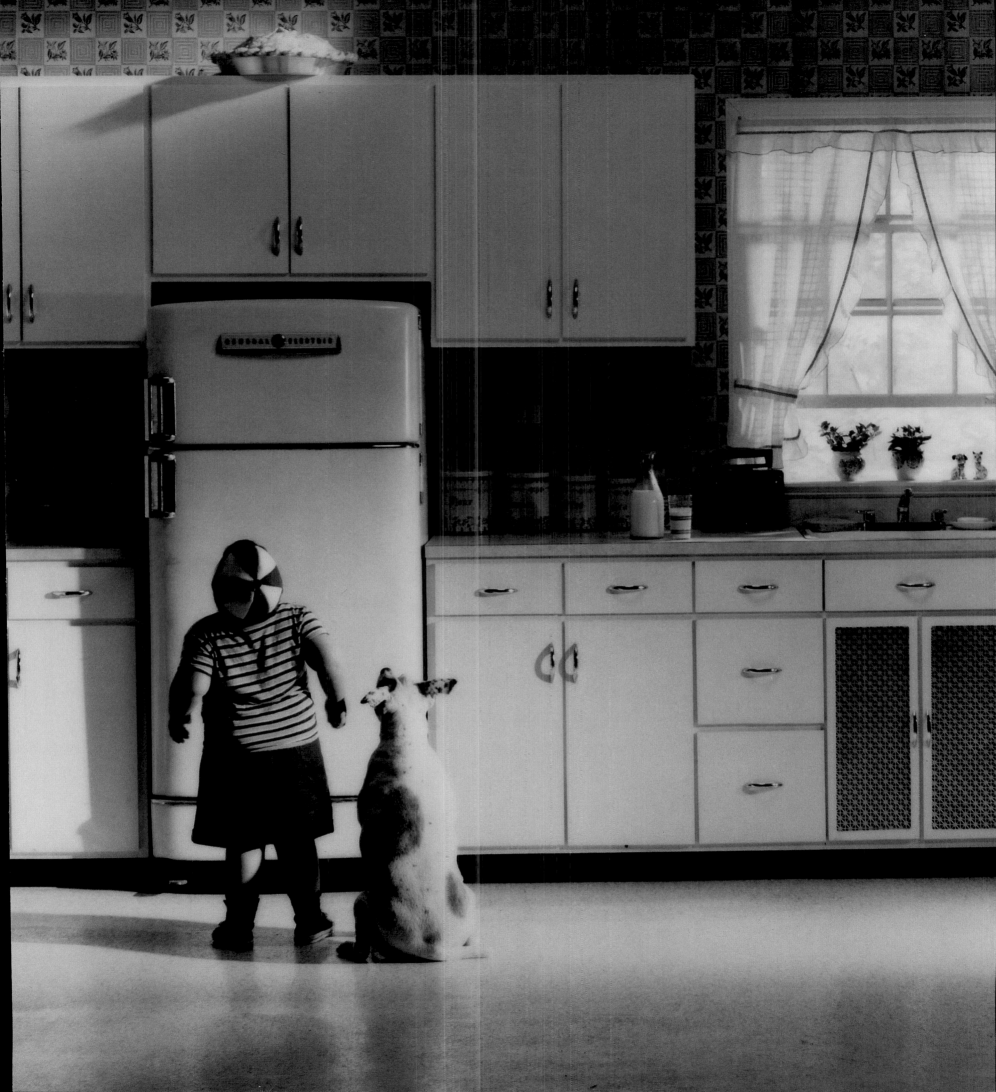

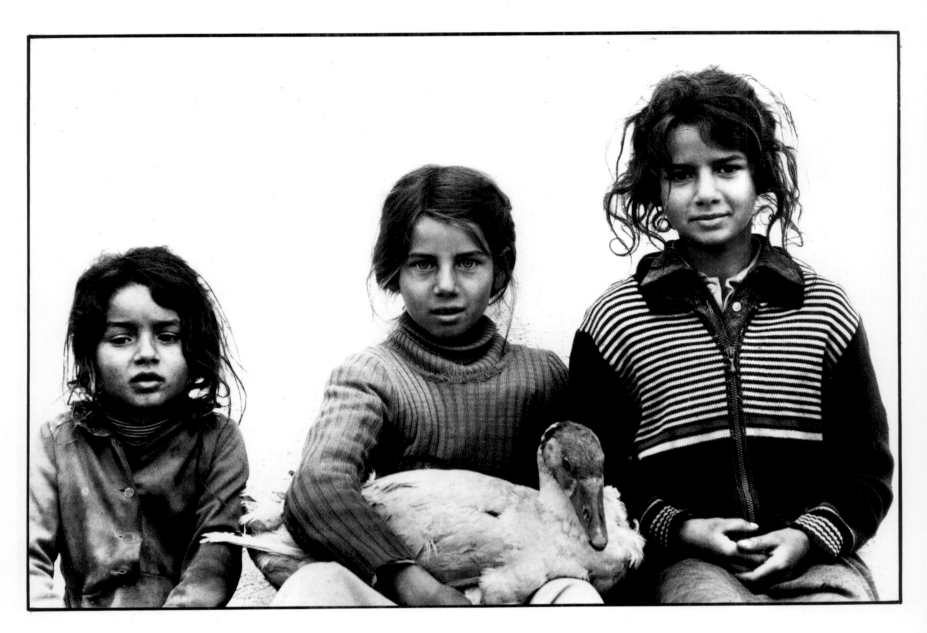

Jacko Vasilev

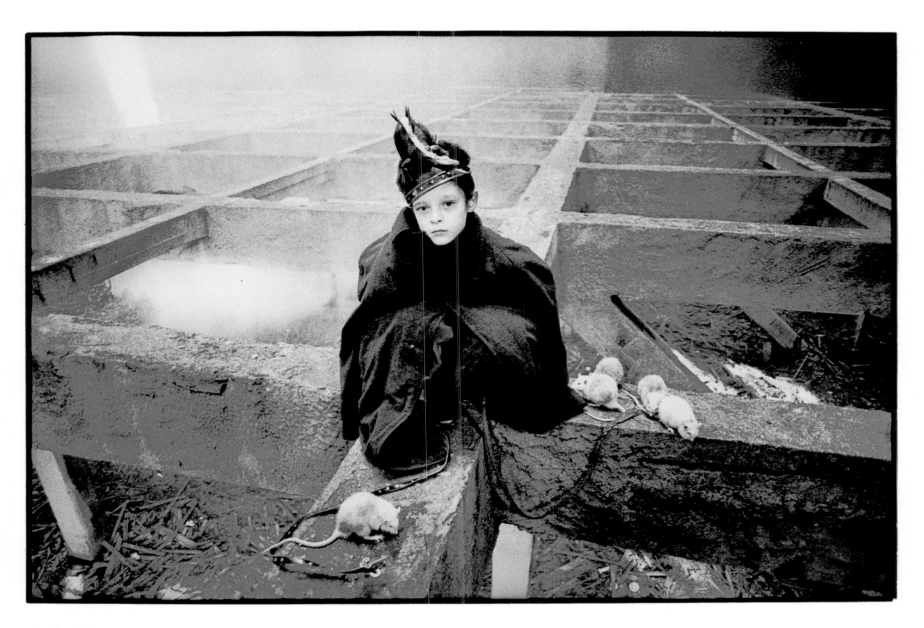

Kuno Rudolph & Thomas Starck

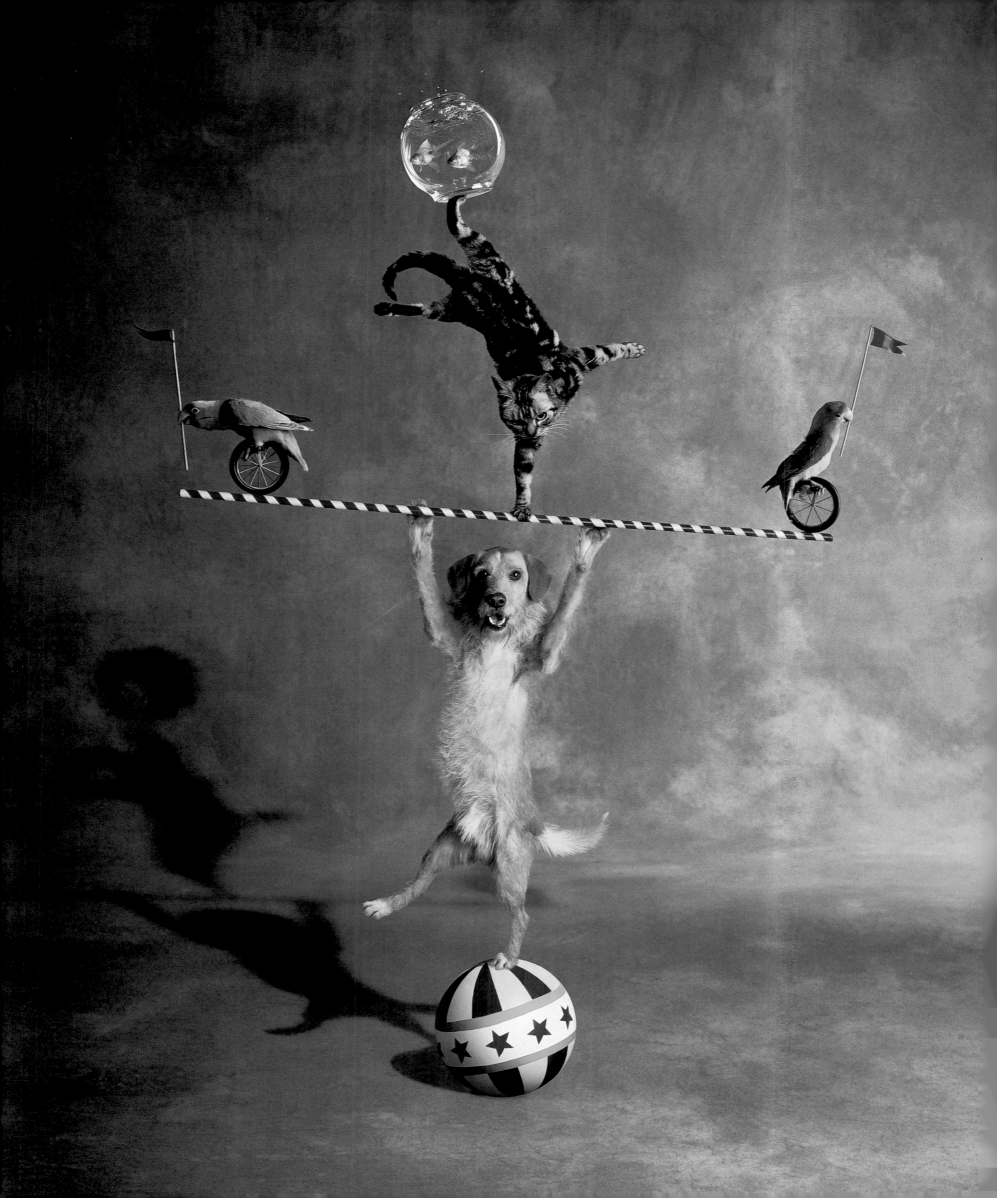

A N I M A L S

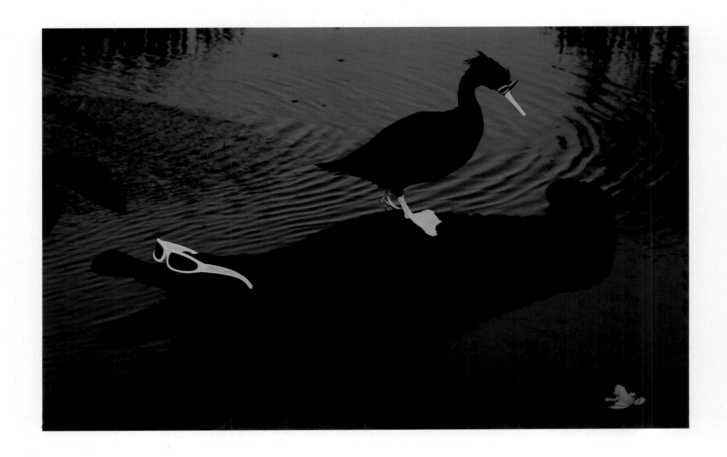

Tak Kojima

◁ Howard Berman

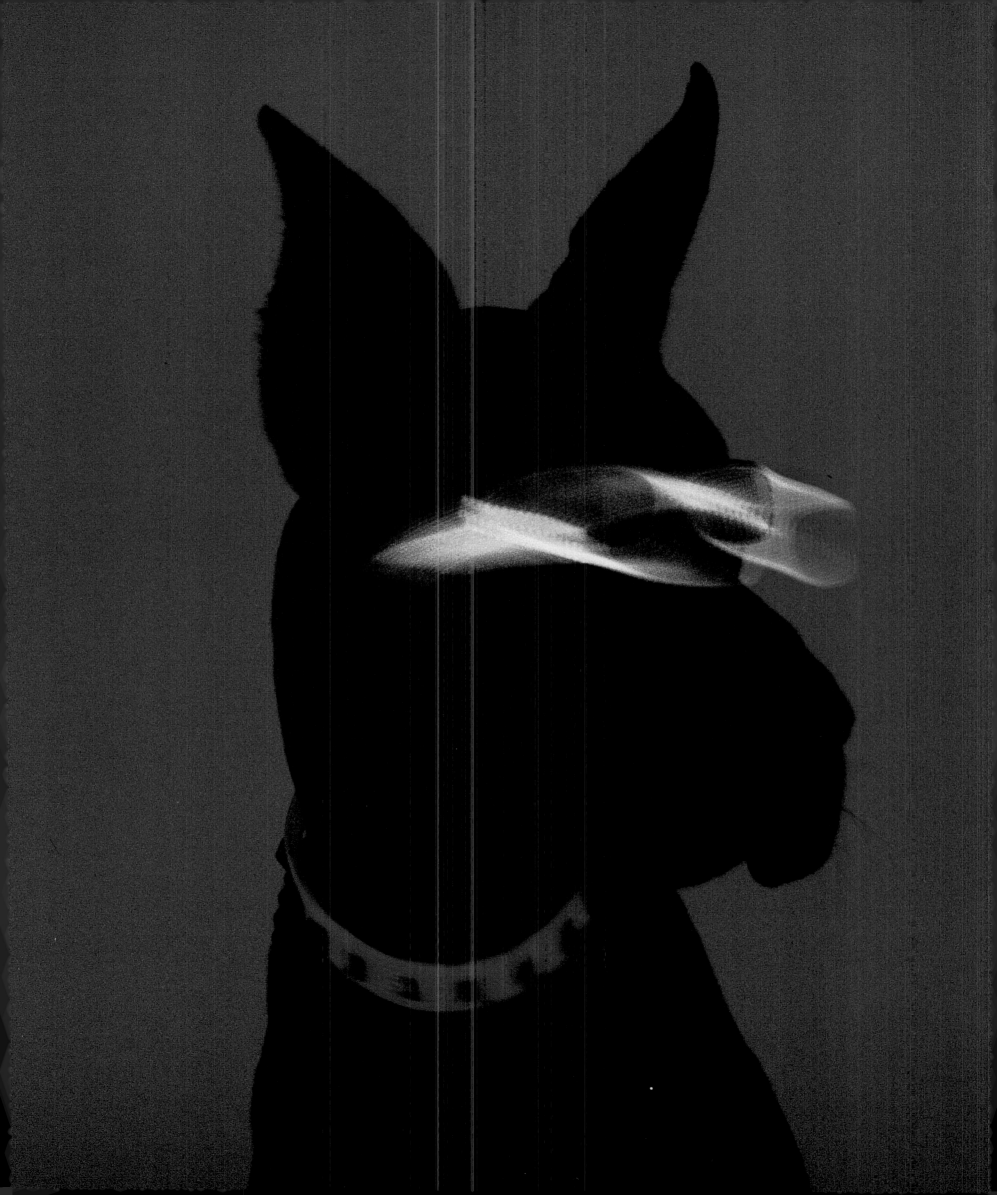

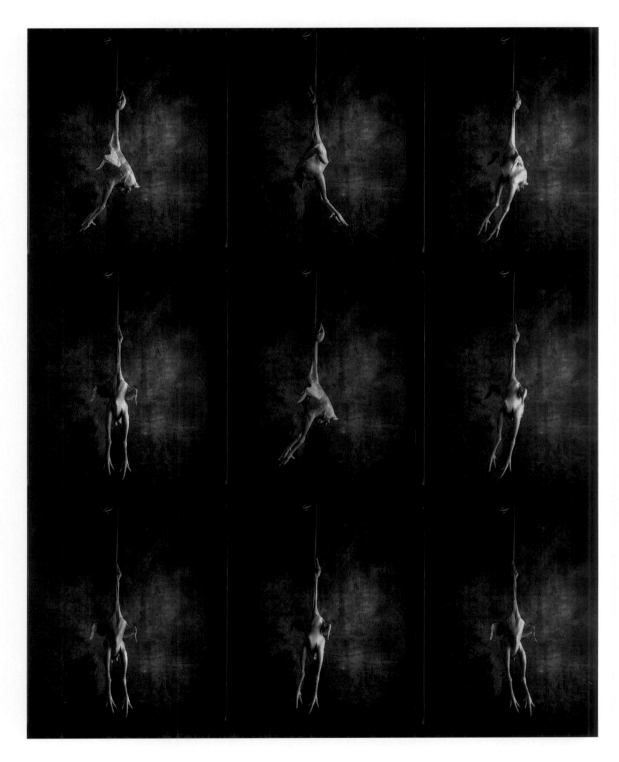

Ringo Tang

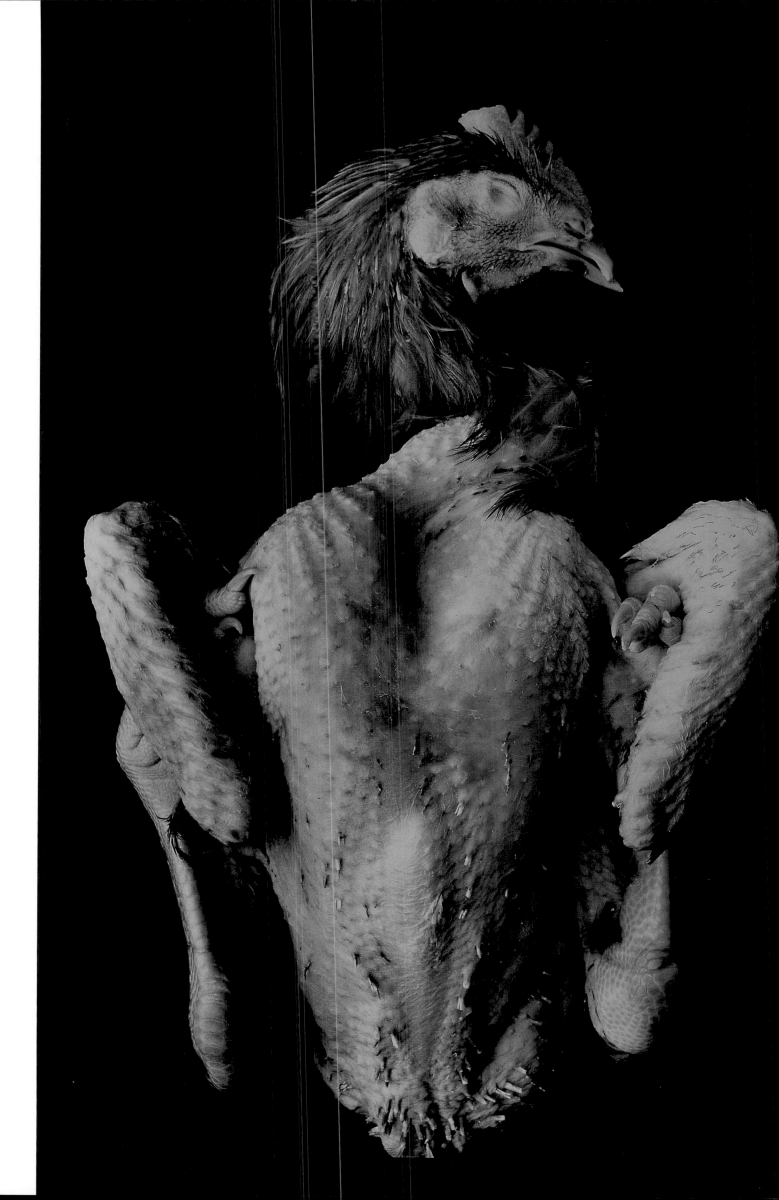

Lorenzo Elbaz

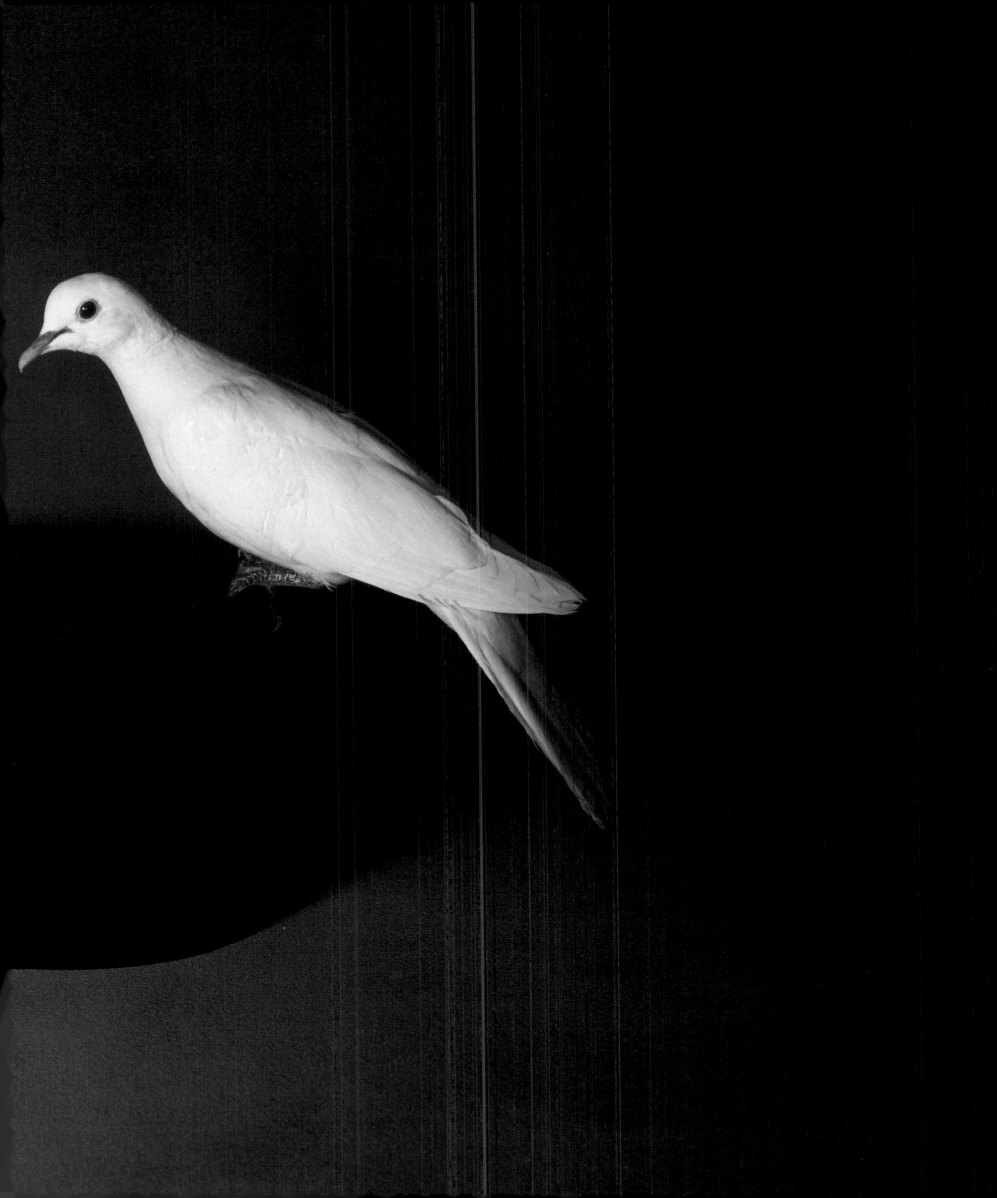

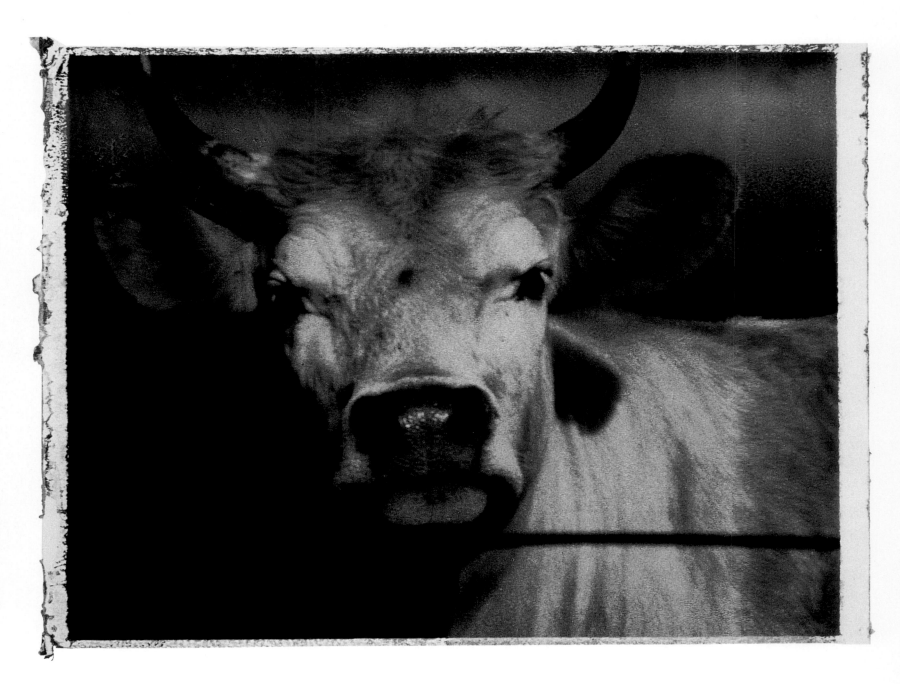

Janis Tracy

◁ Adrian Burke

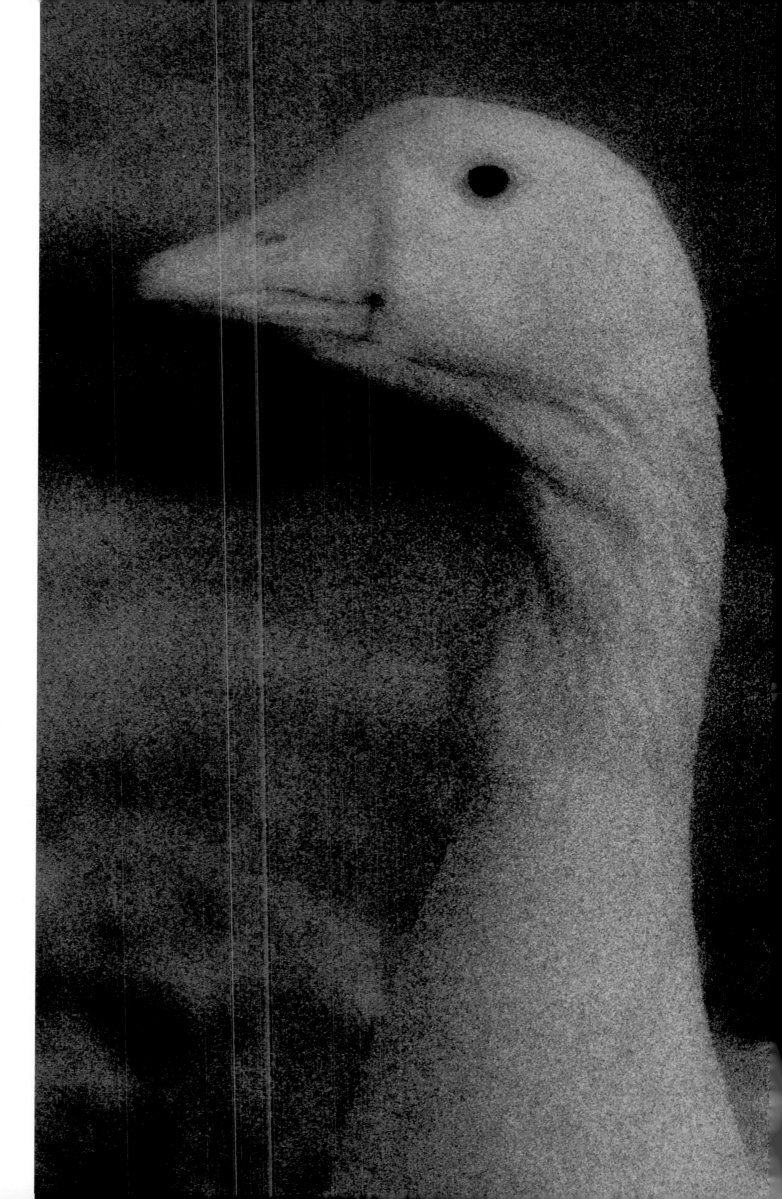

Jill Enfield

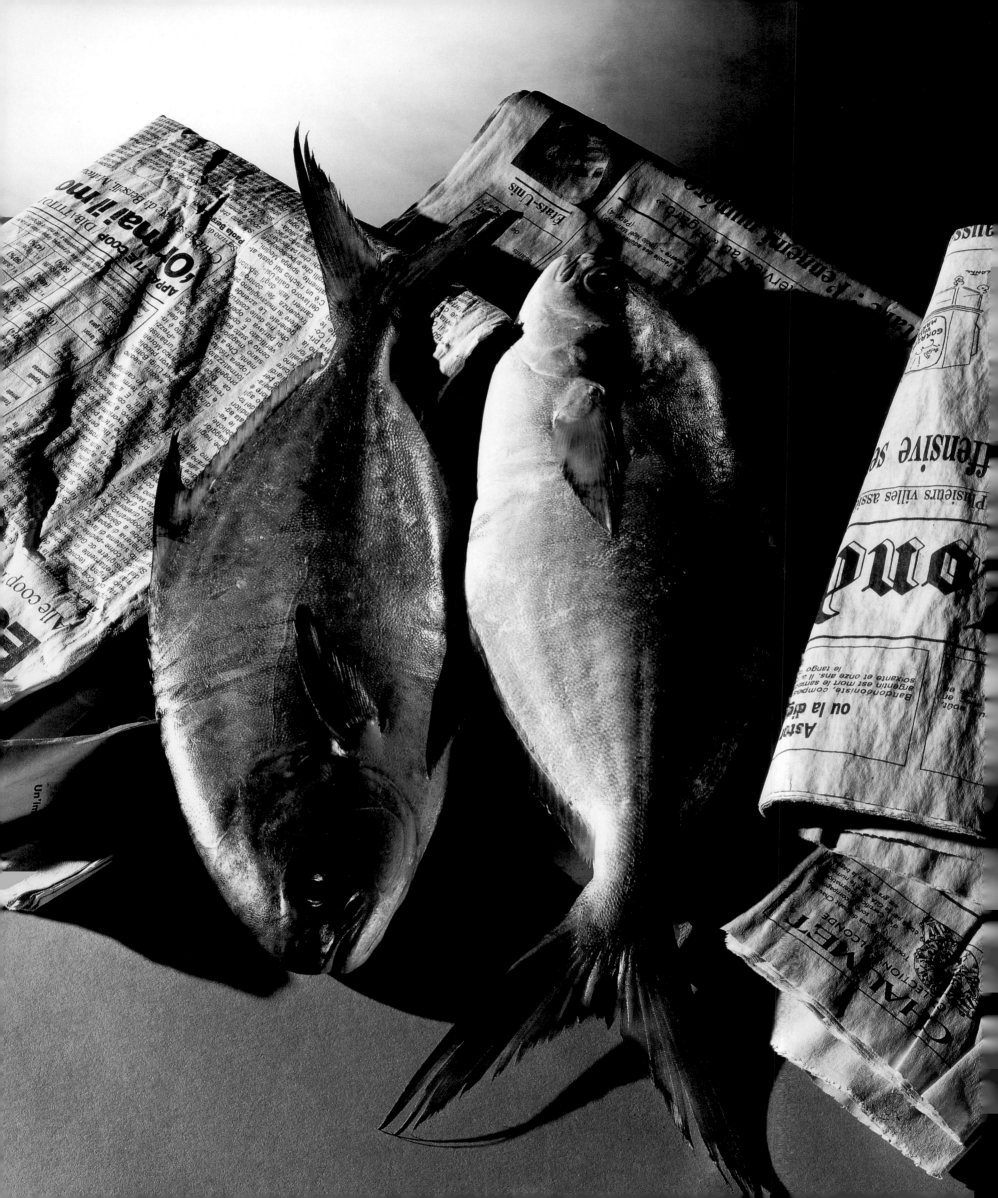

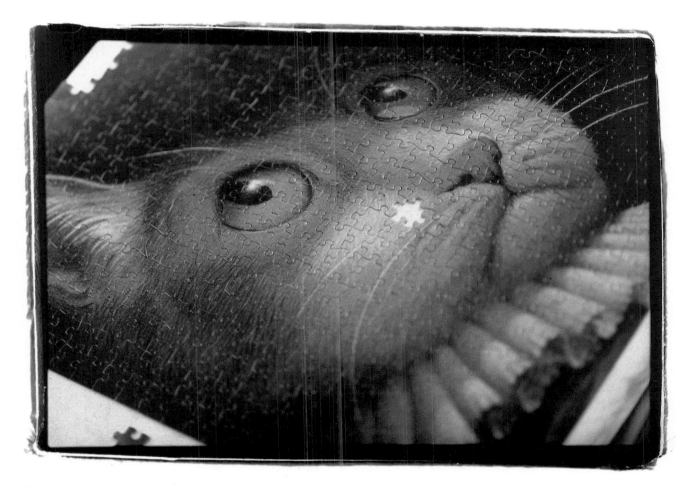

Brooke Hunyady

Craig Cutler

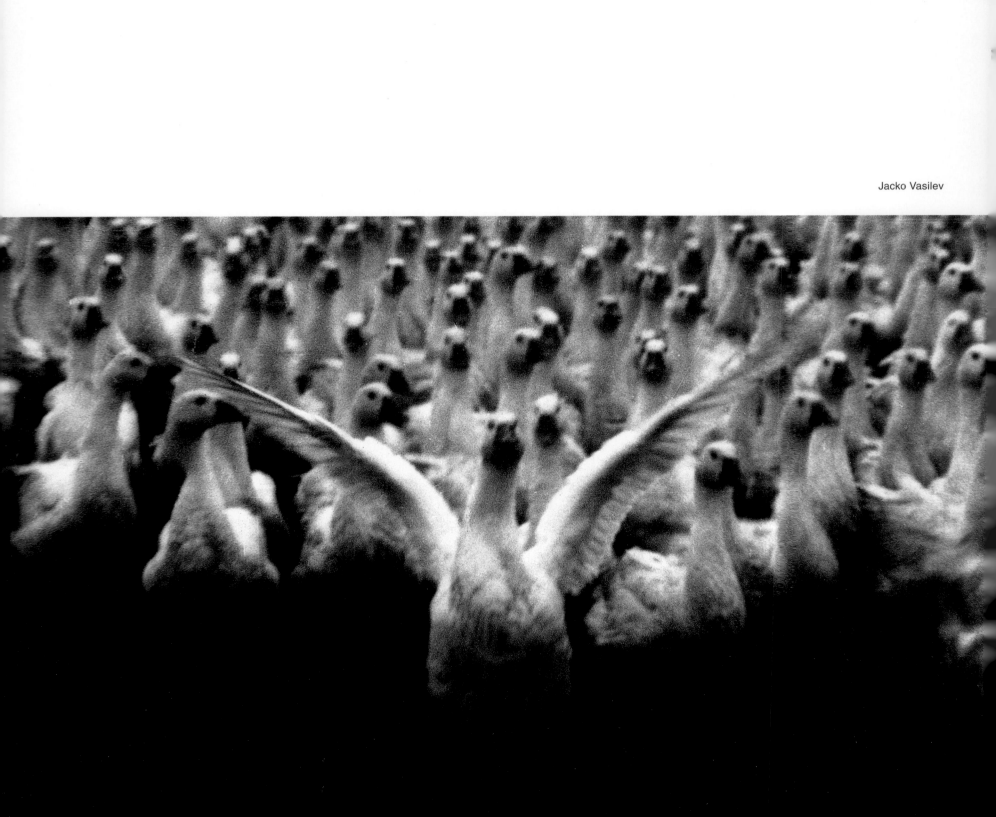

Jacko Vasilev

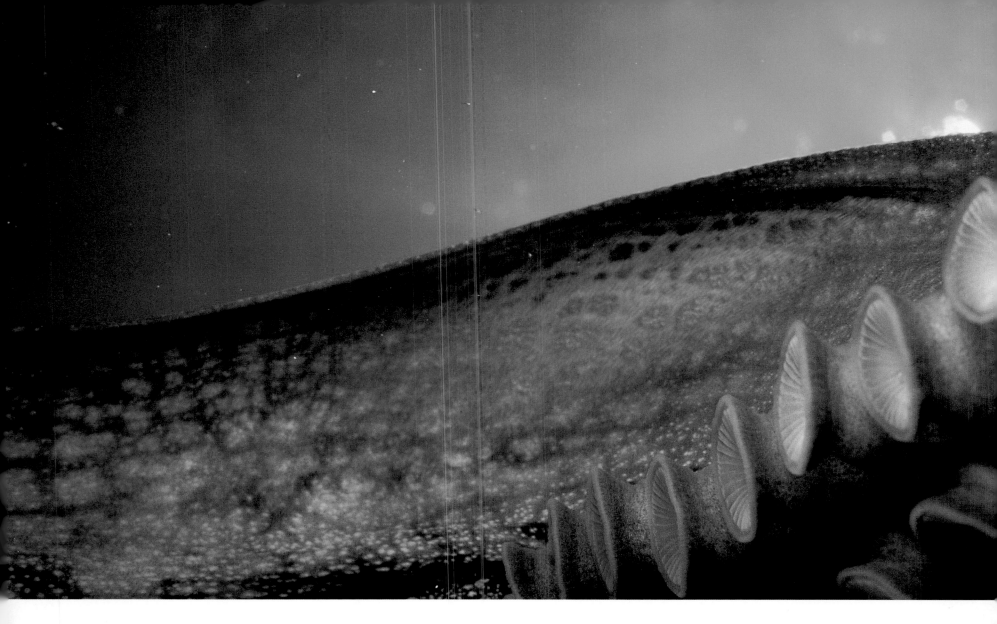

Art Brewer Photography

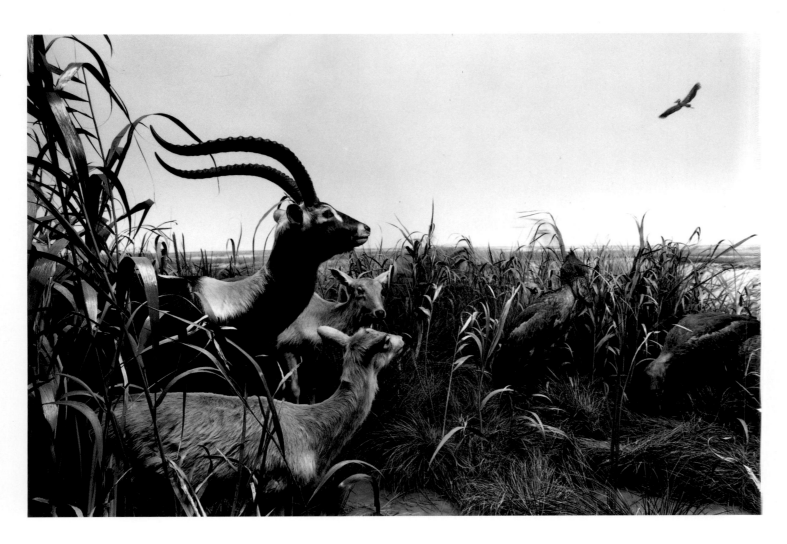

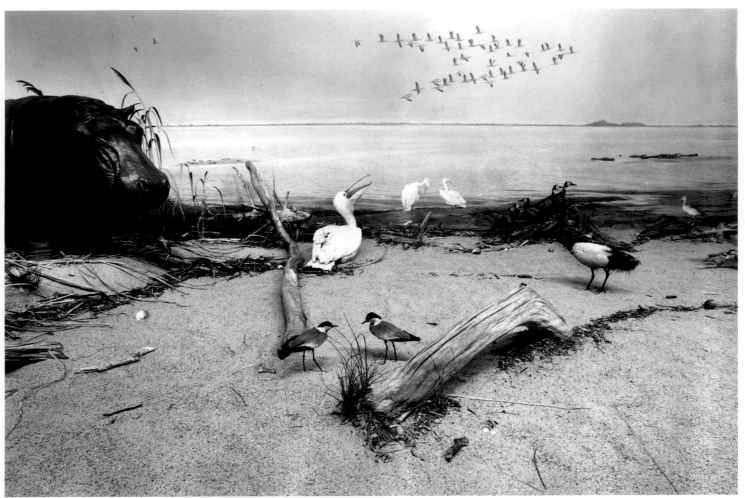

Friedrich K. Rumpf

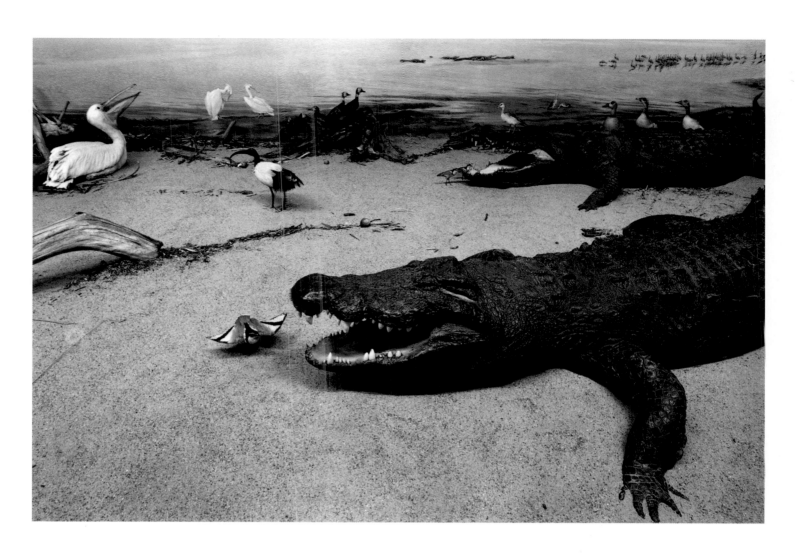

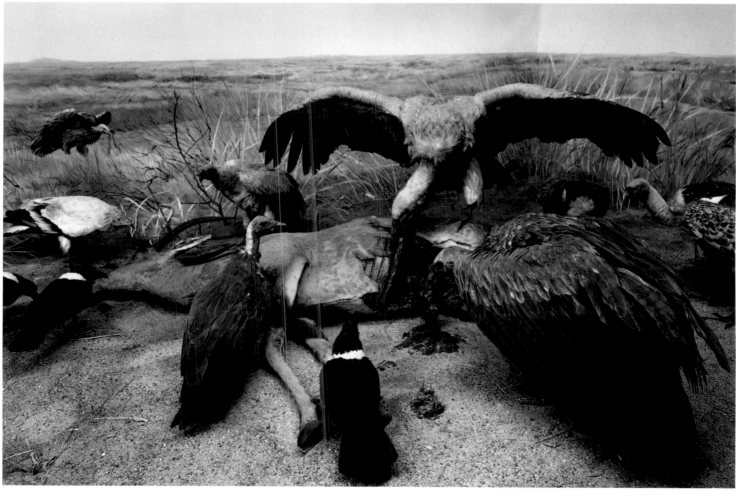

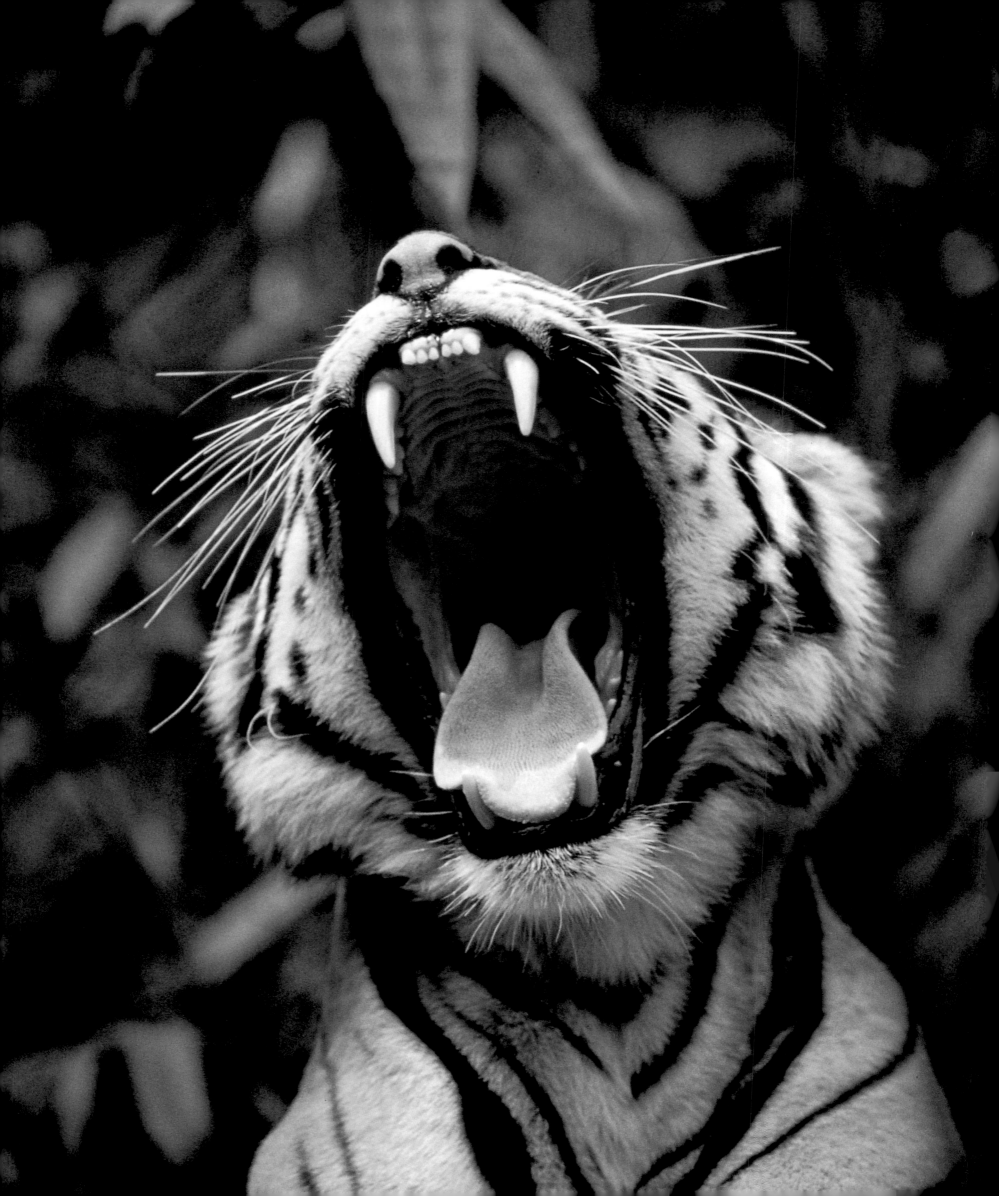

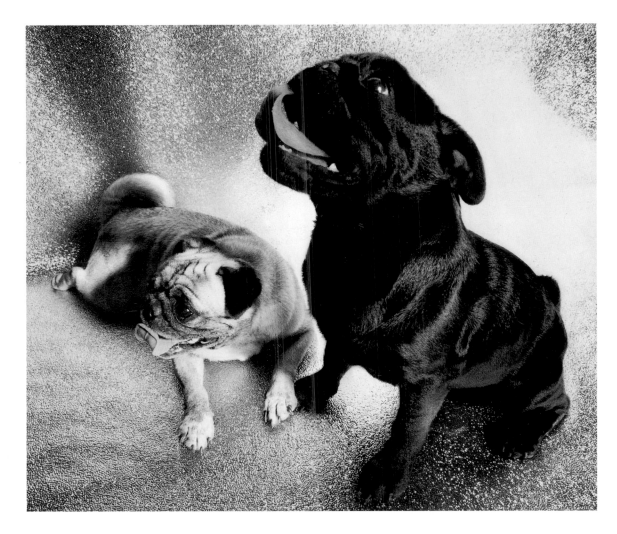

Ed Freeman

Guido Alberto Rossi

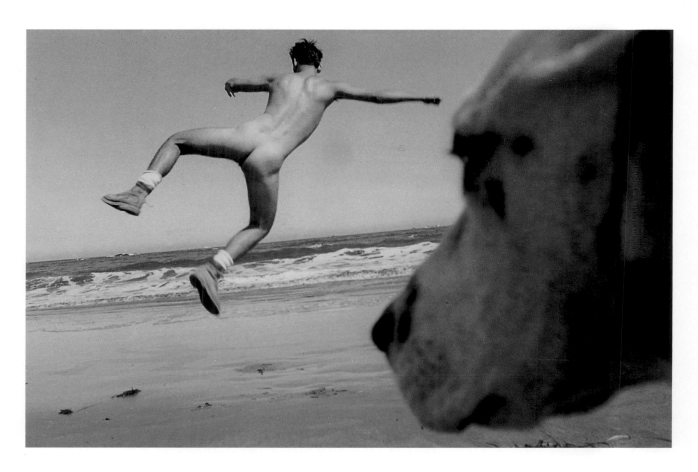

Stephanie Rausser

Jon Fisher

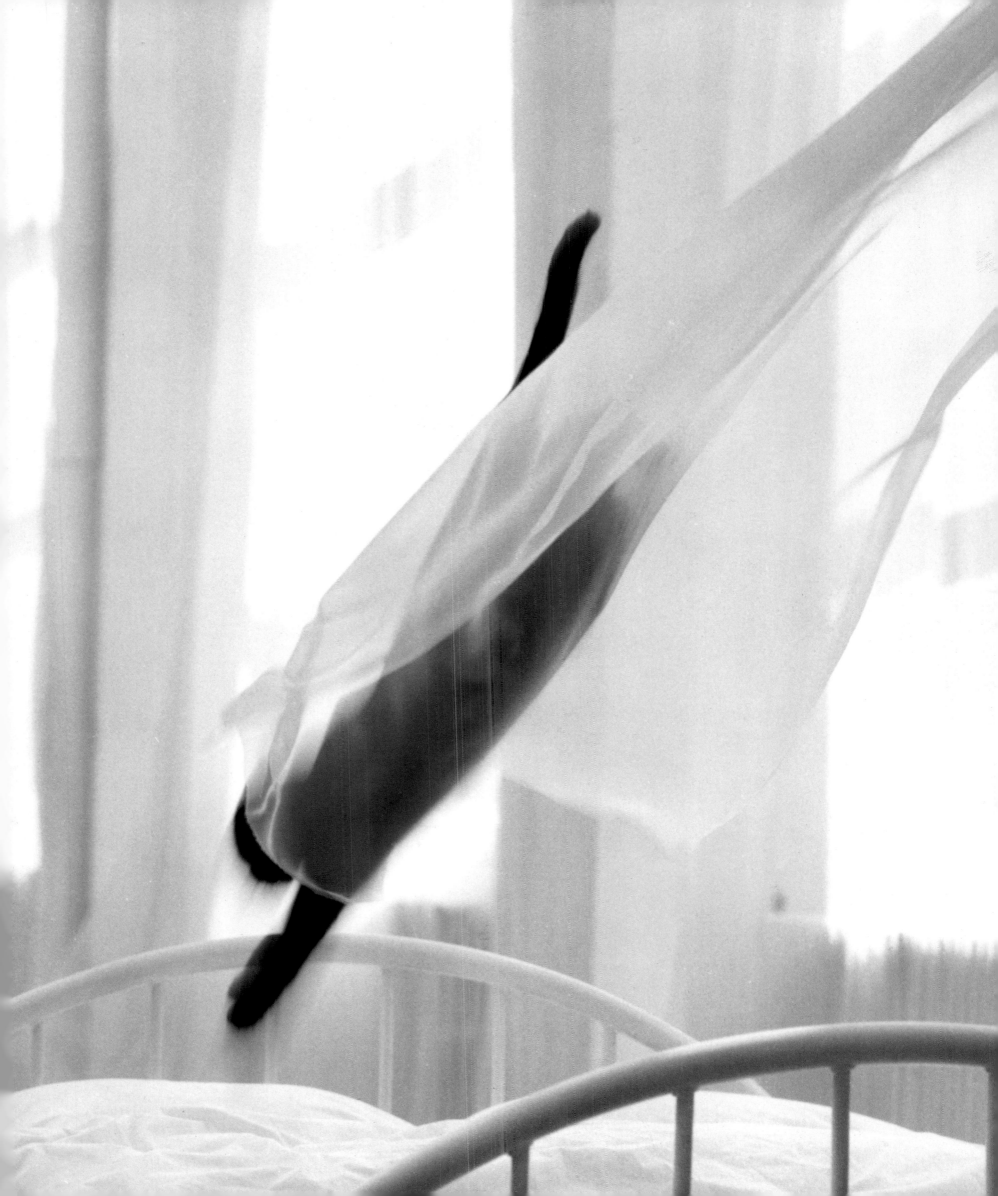

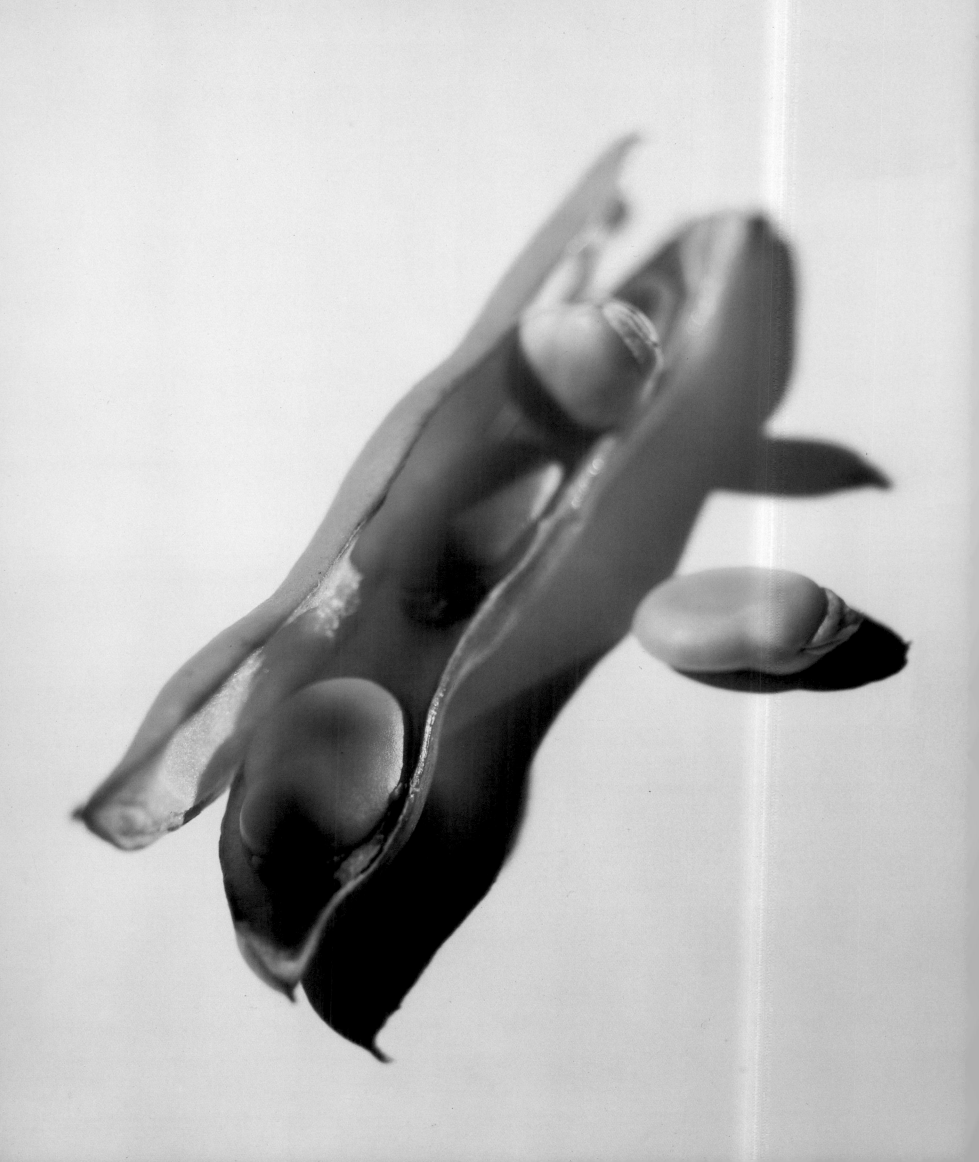

F O O D

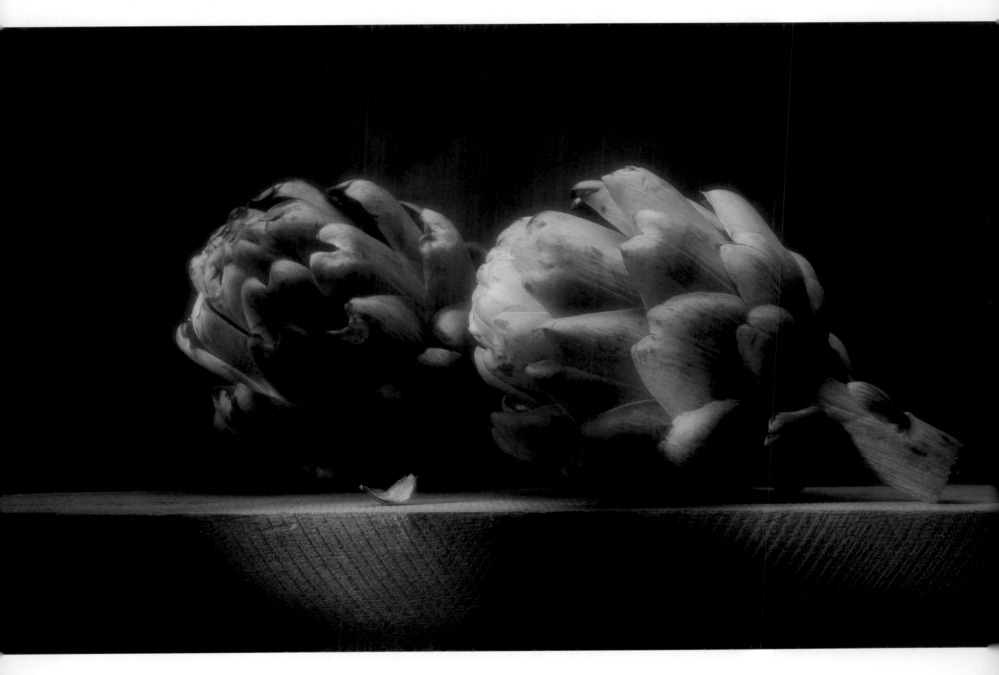

Klaus Arras

◁◁ Yutaka Kawachi

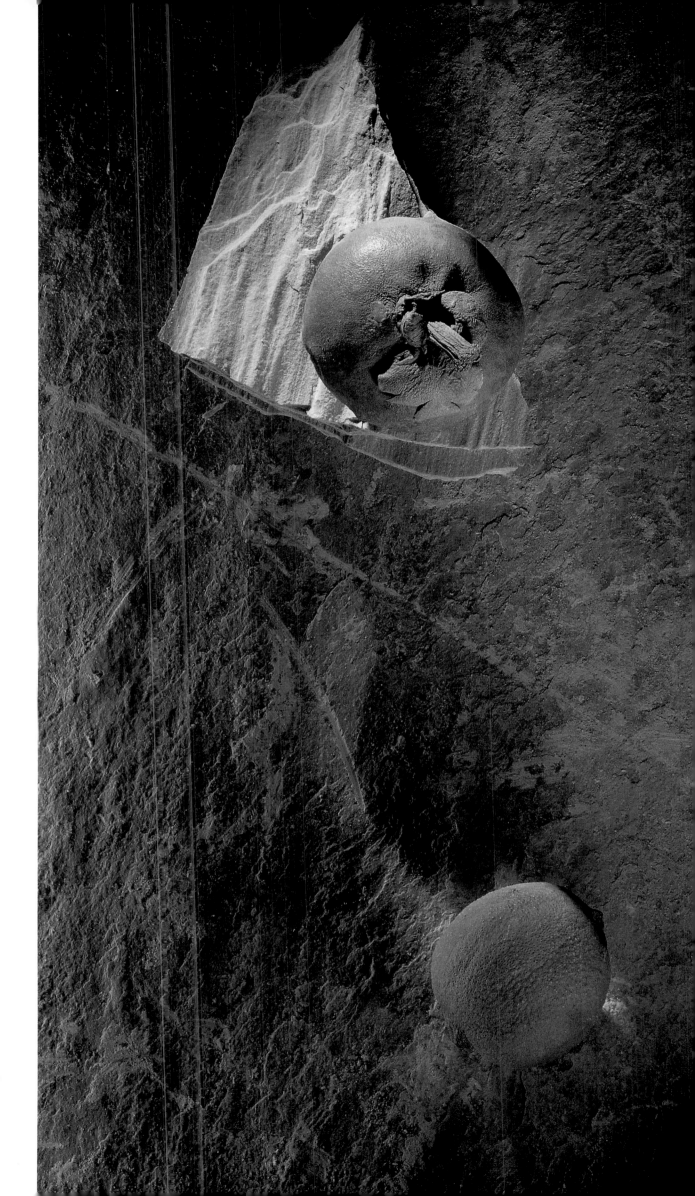

Johan Vanbecelaere

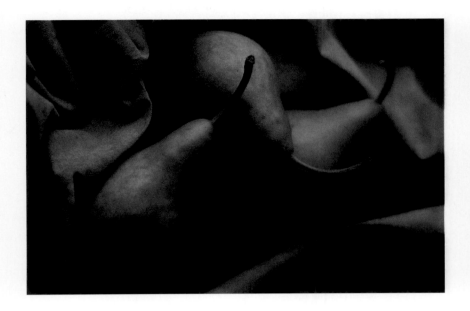

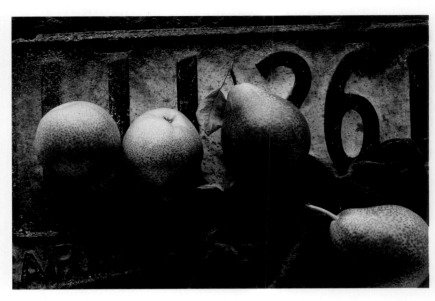

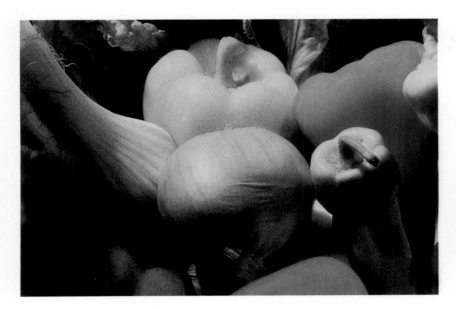

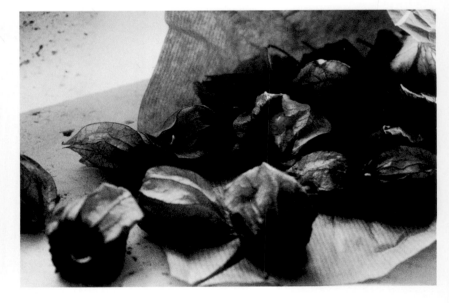

Holly Stewart

Jill Enfield

Ian Campbell

Dirk Olaf Wexel

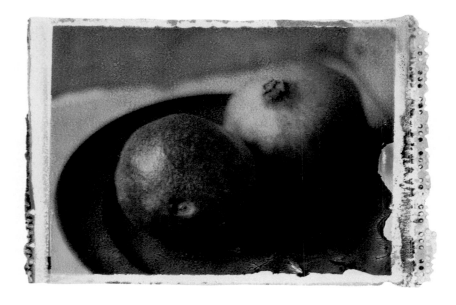

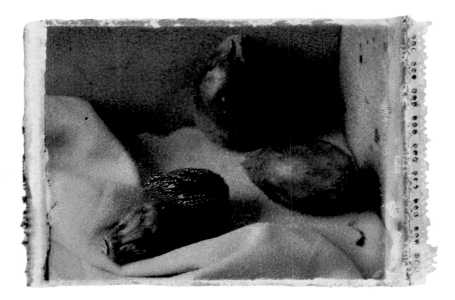

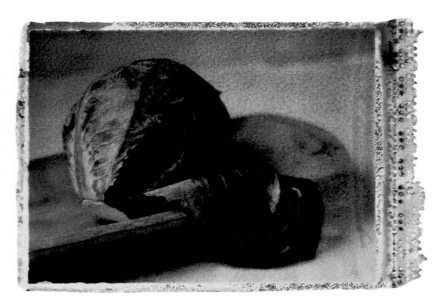

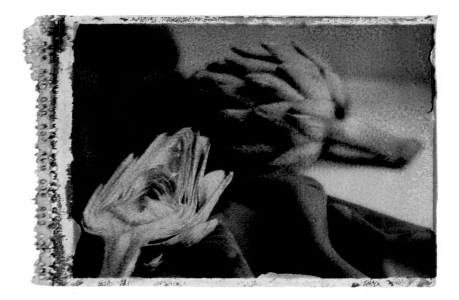

Janis Tracy

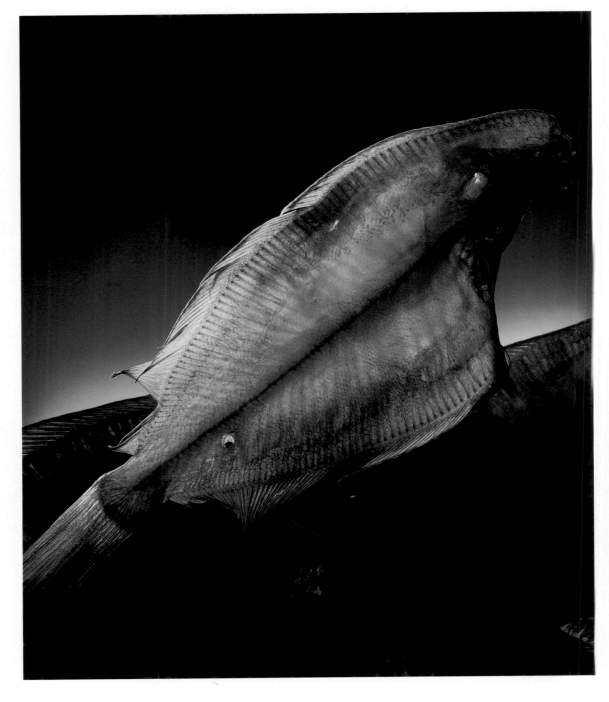

Johan Vanbecelaere

Peter Strobel

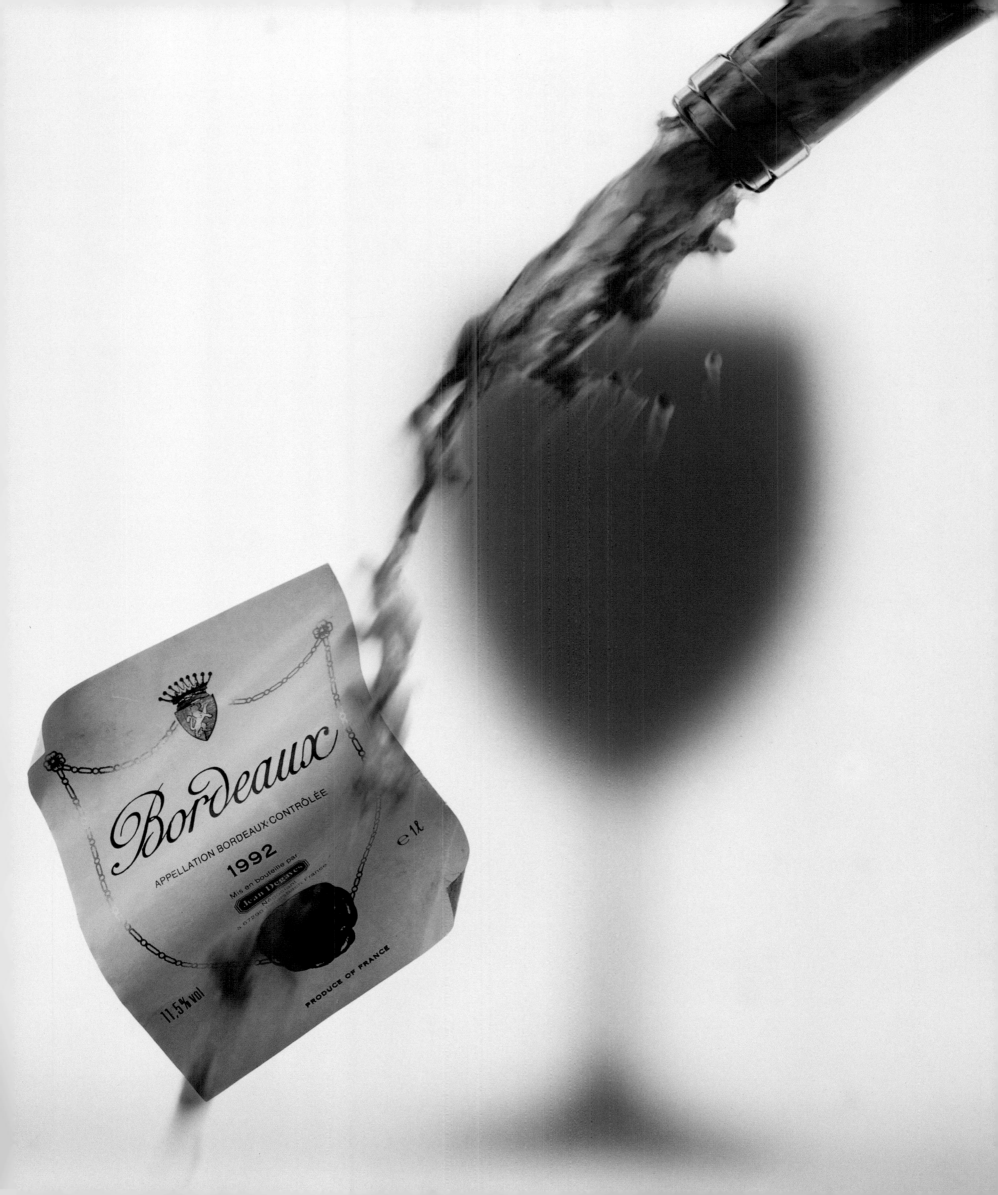

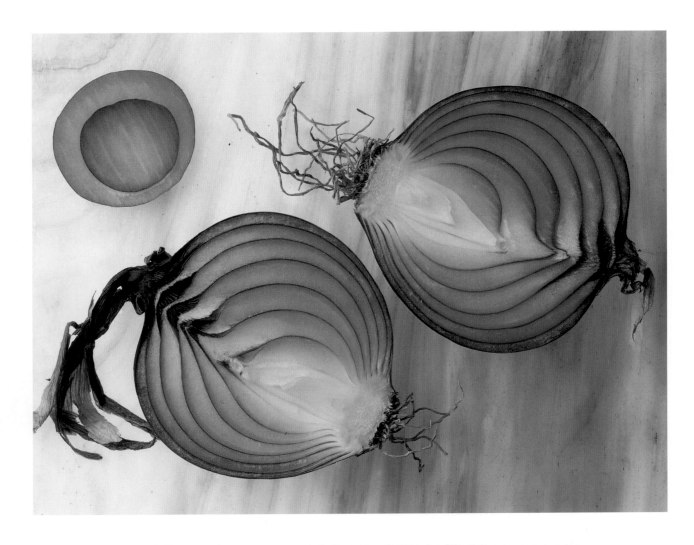

Christoph Heidelauf

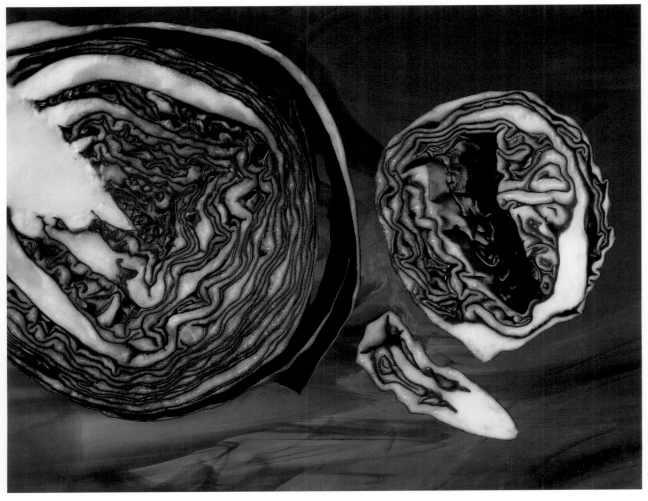

Christoph Heidelauf

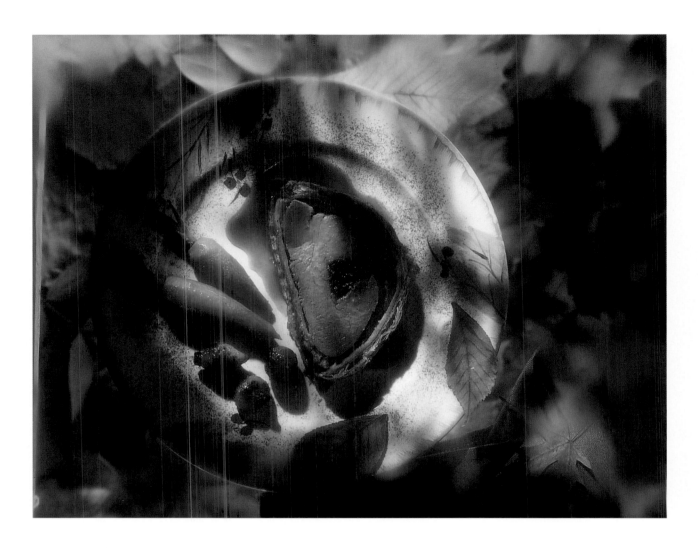

Food Foto

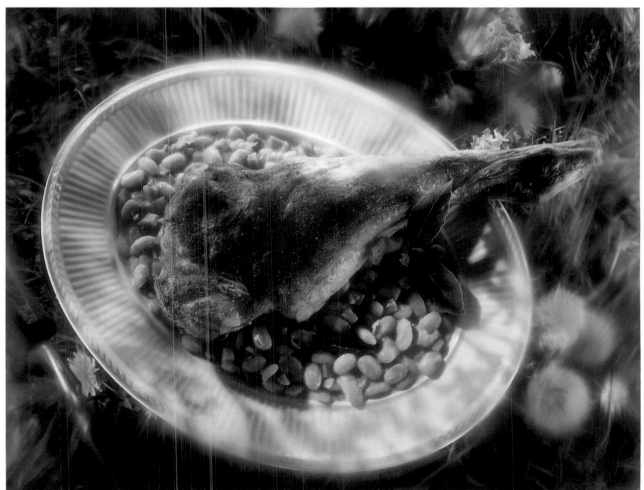

Food Foto

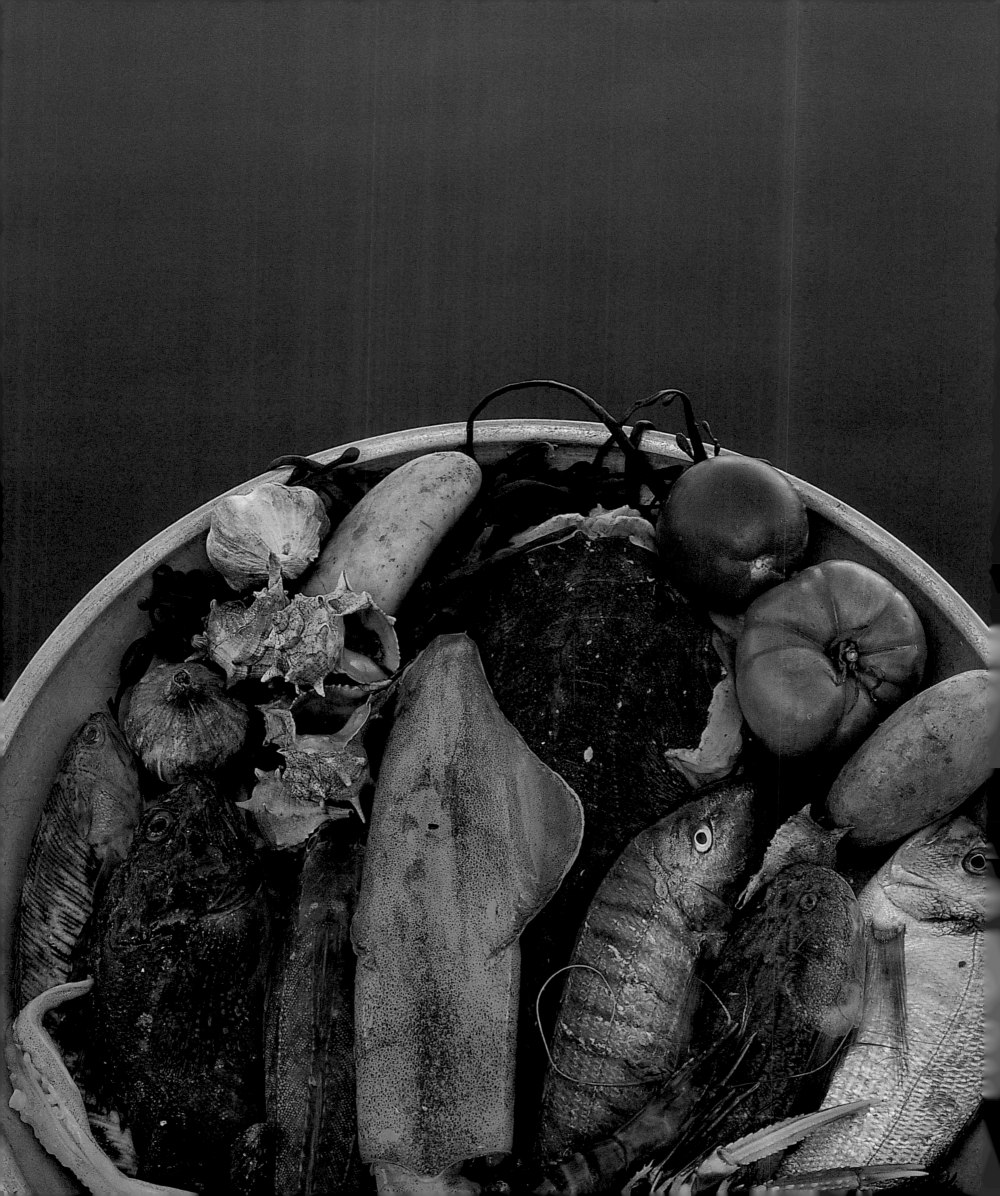

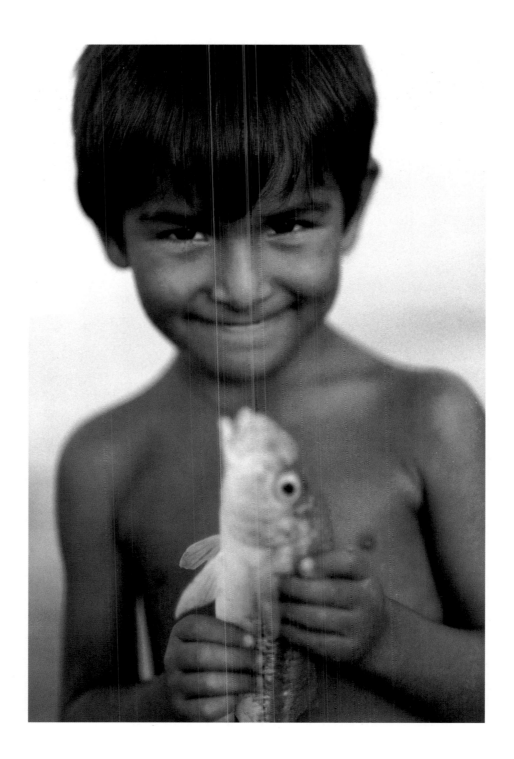

Guenter Beer

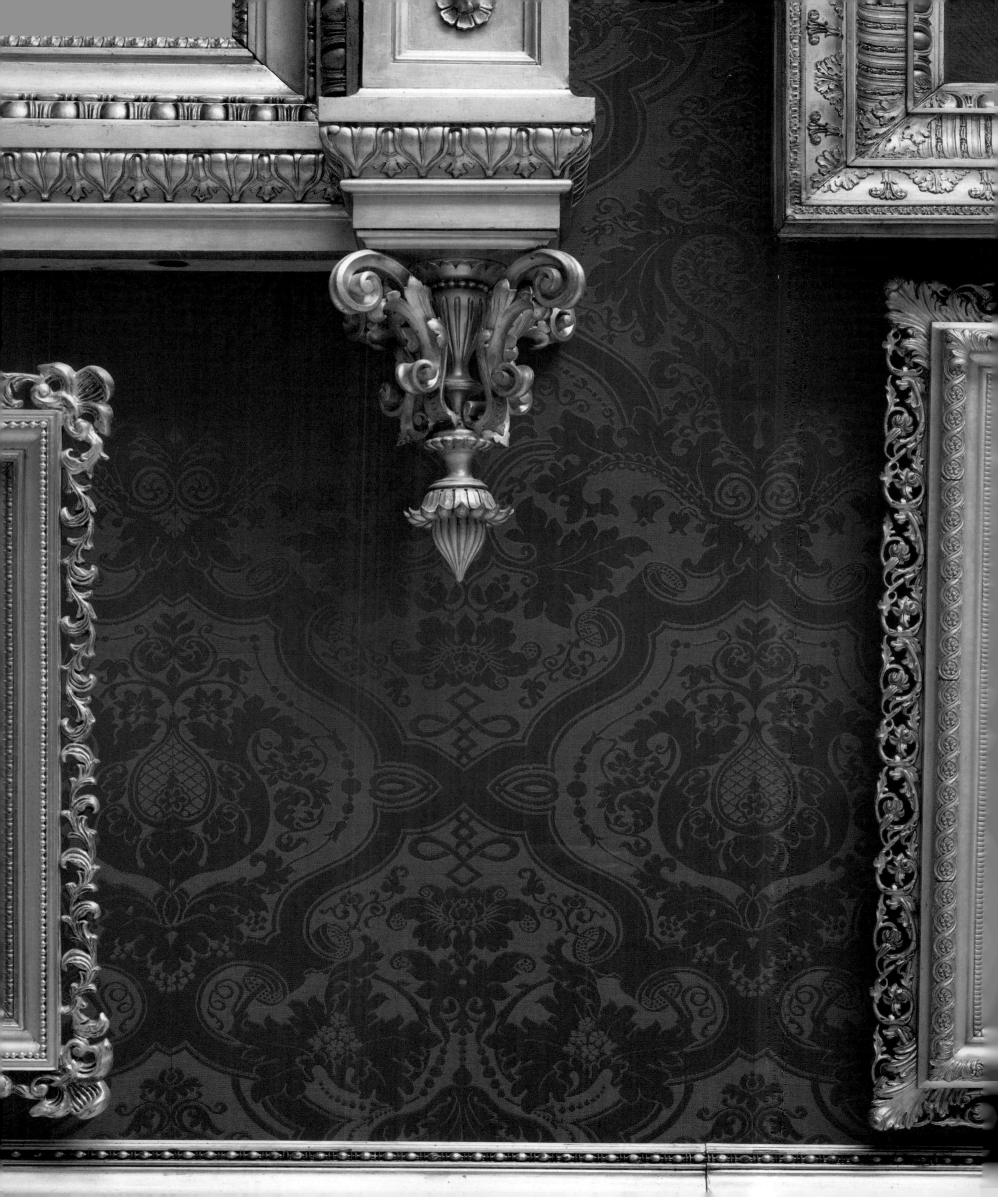

L A N D S C A P E S

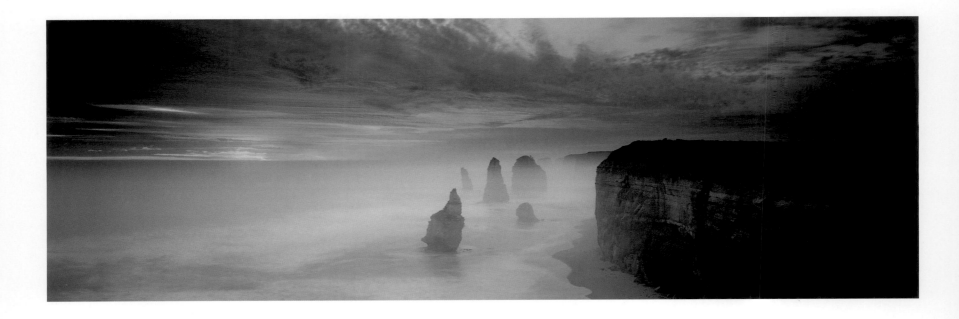

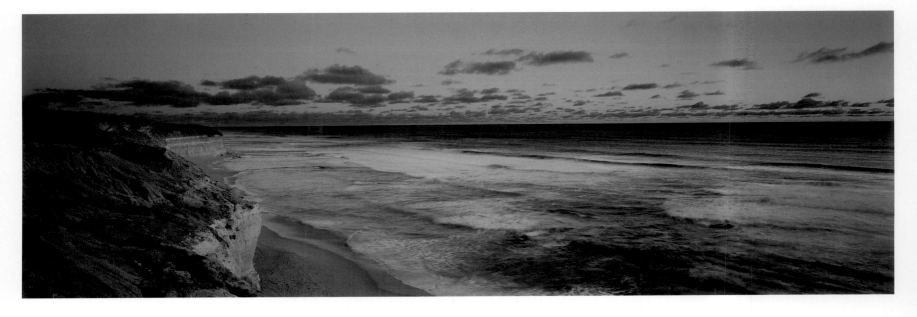

Aernout Overbeeke

◁ Klaus Frahm

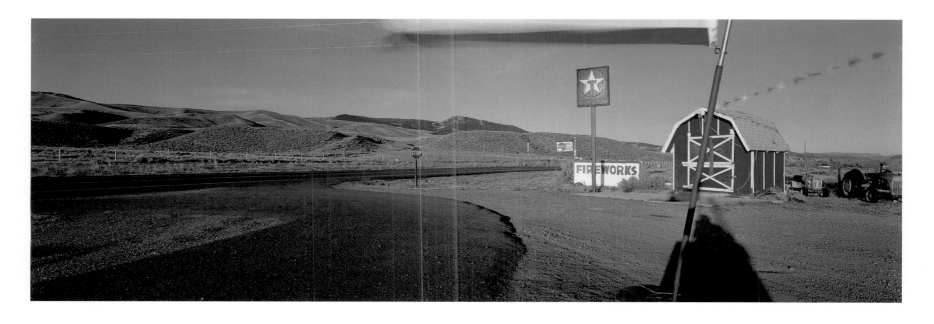

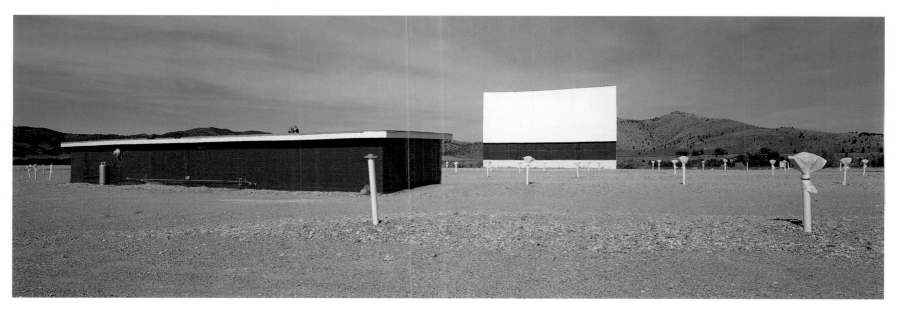

Philip Bekker

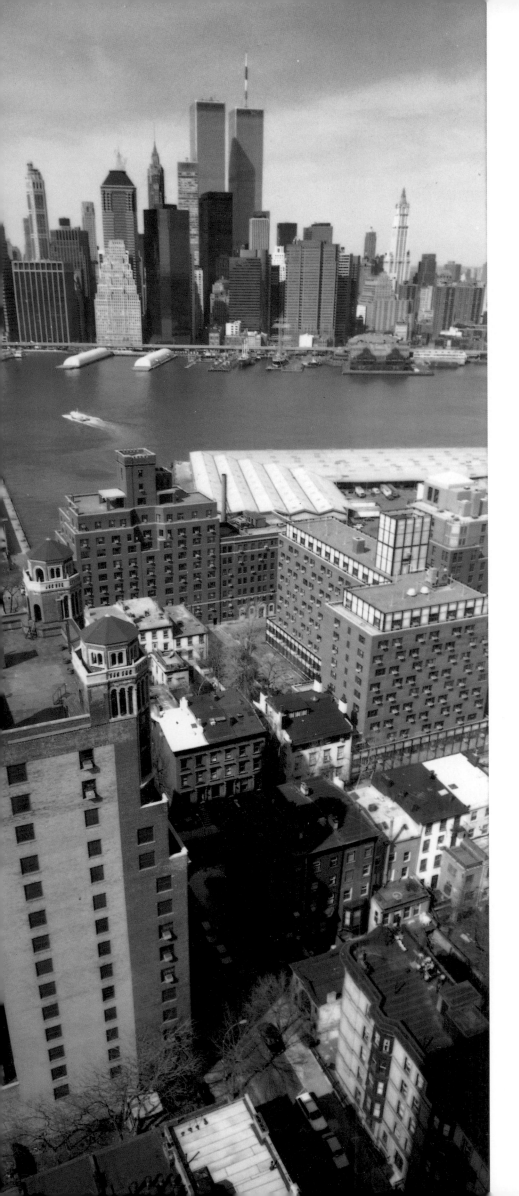

Horst Hamann

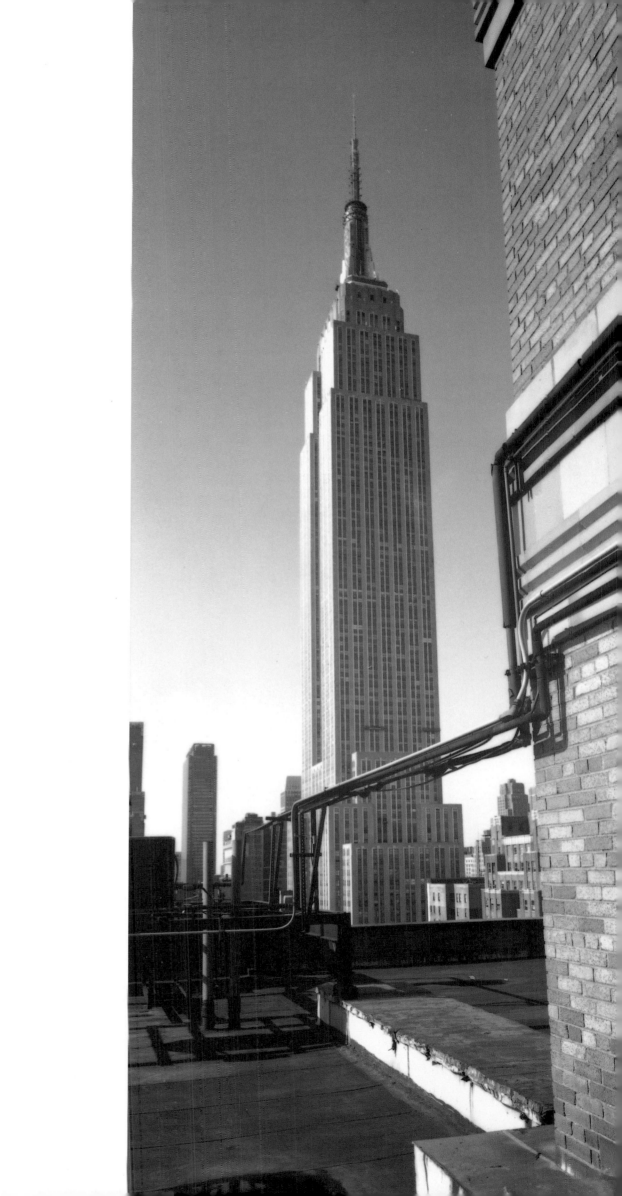

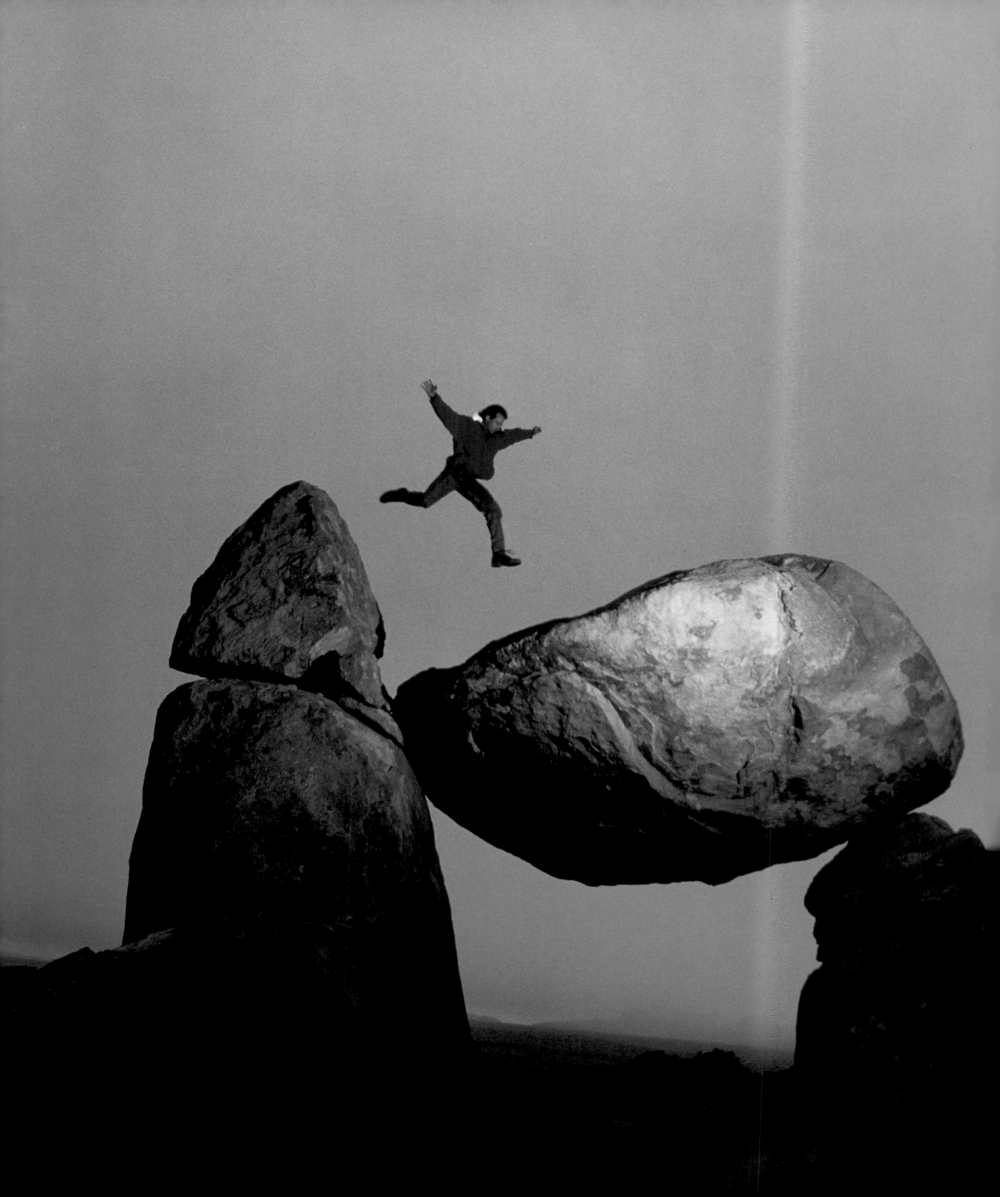

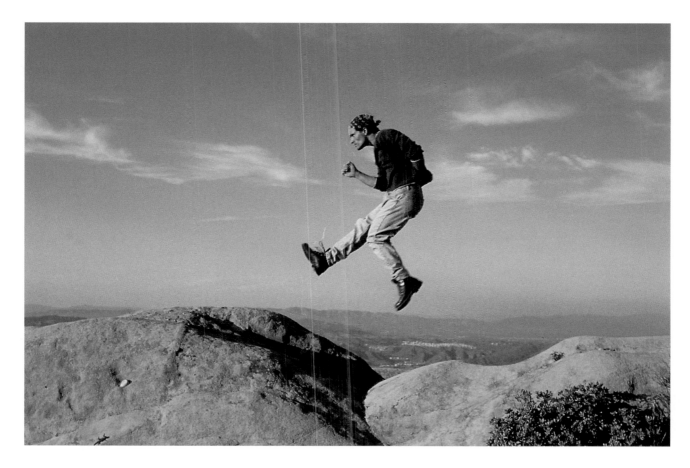

Rob Lang

Mark Gamba

Dominique Davoust

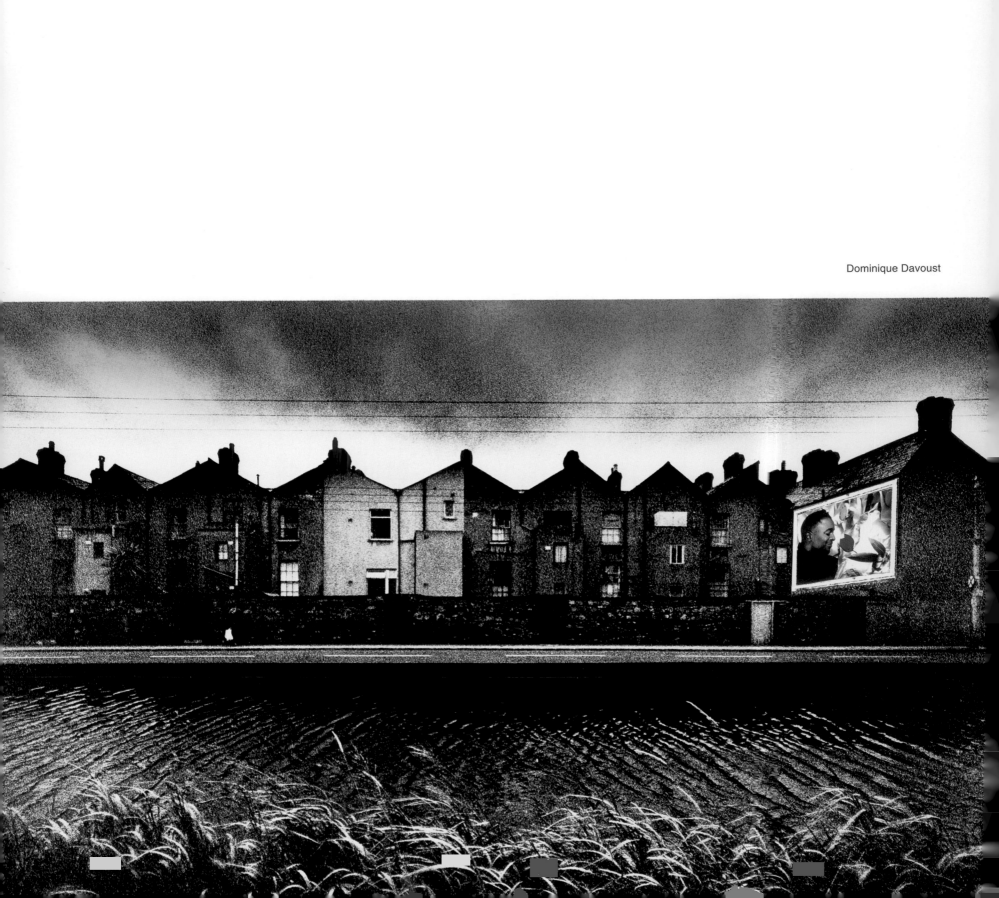

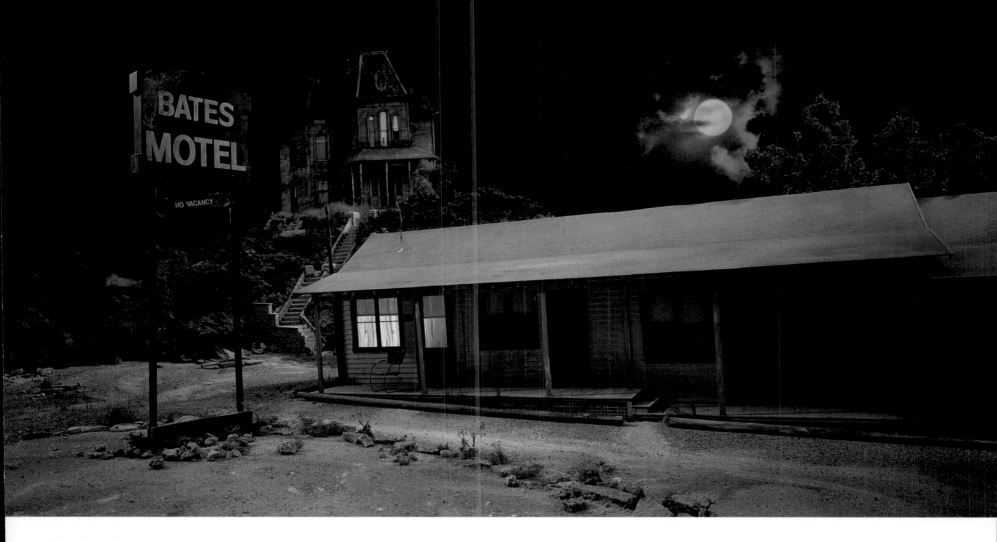

Steve Bronstein

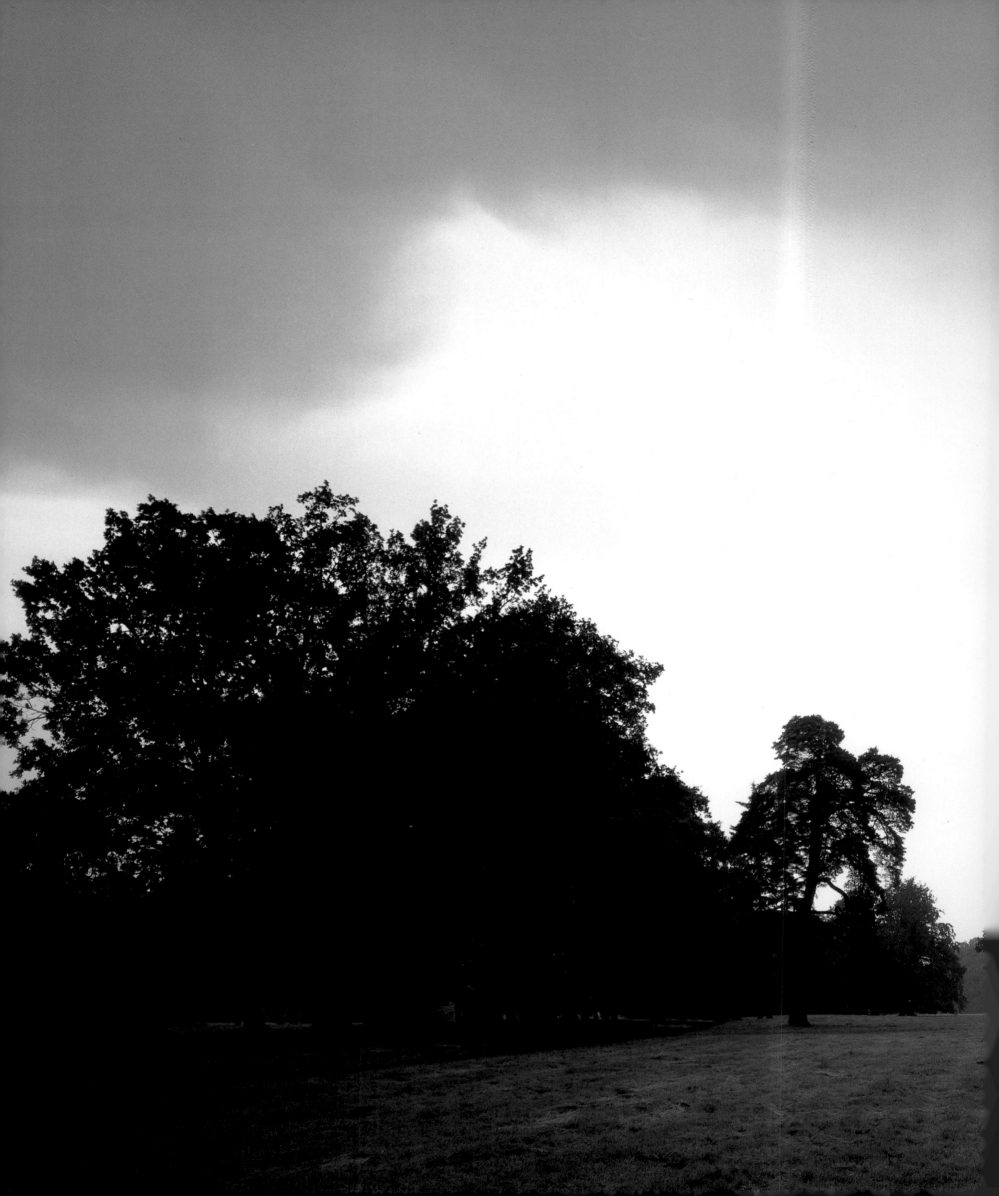

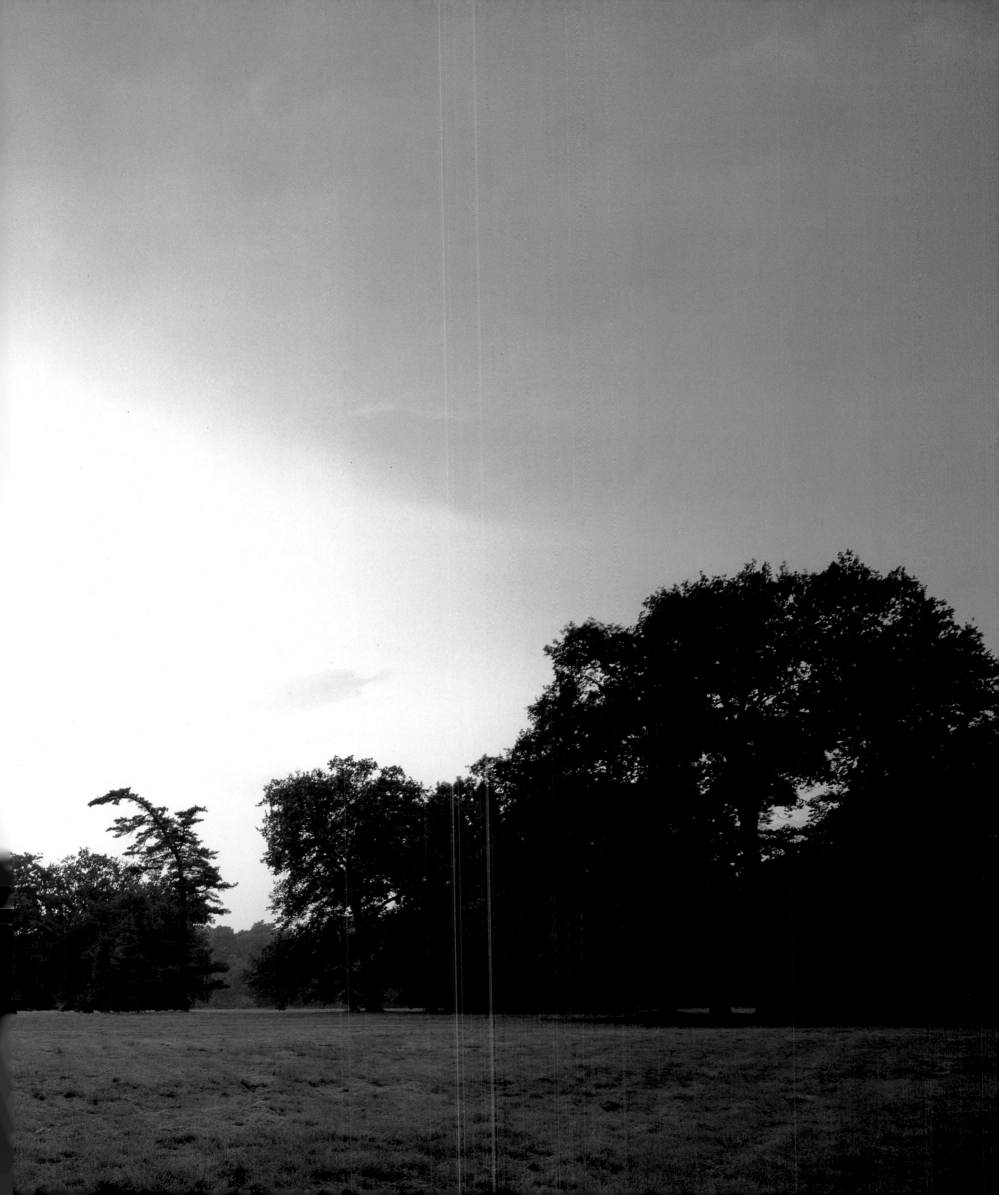

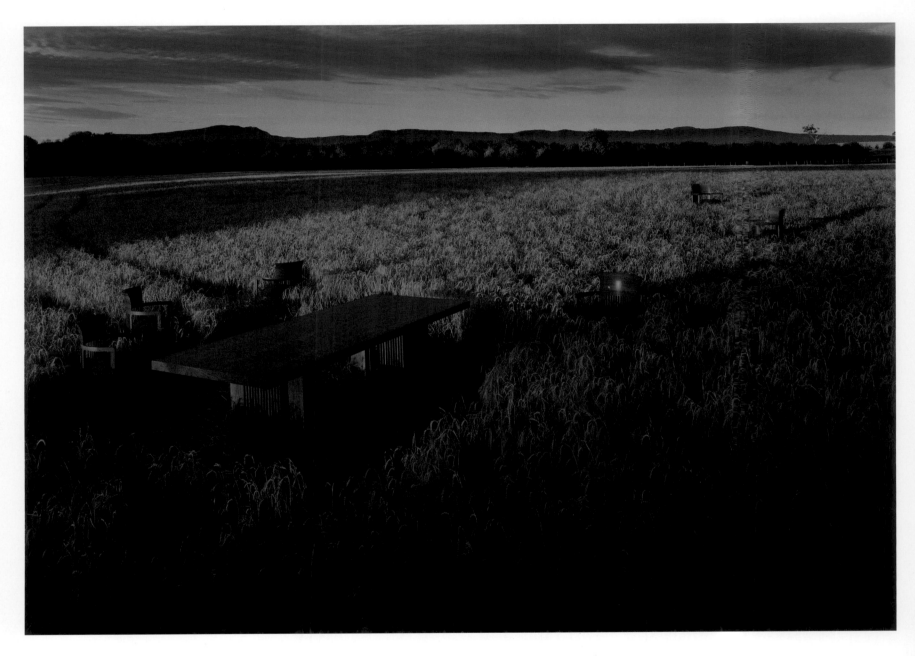

Aernout Overbeeke

◁ Klaus Frahm

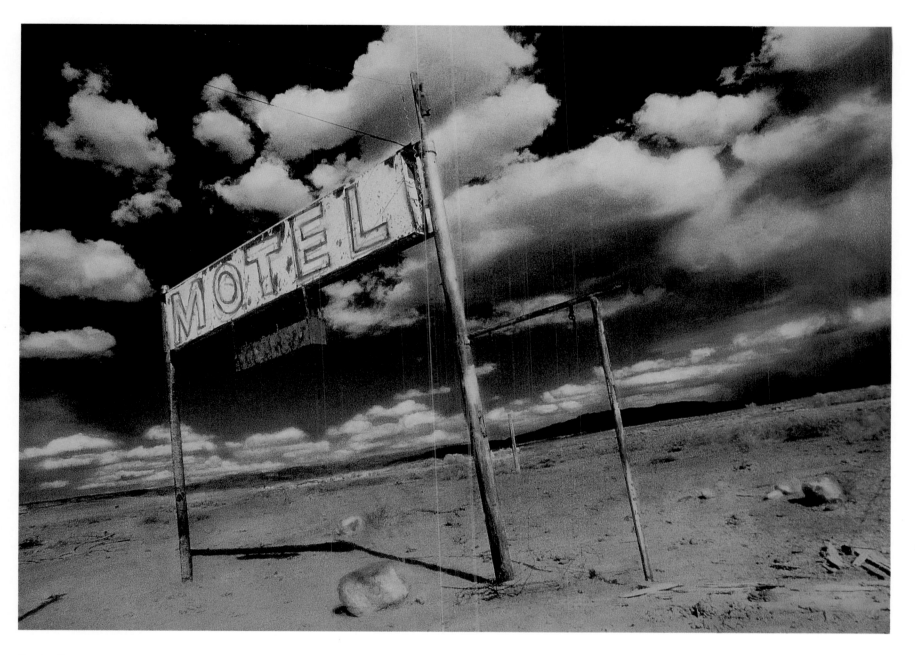

Sandra Eisner

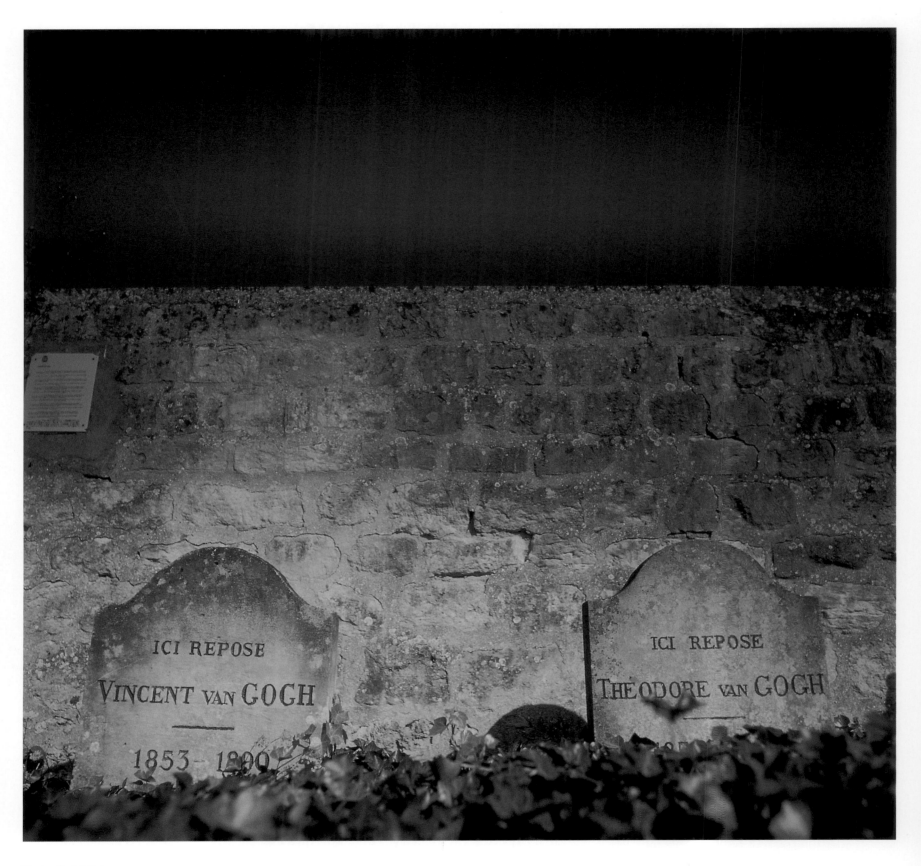

Fjodor Cyriel Buis

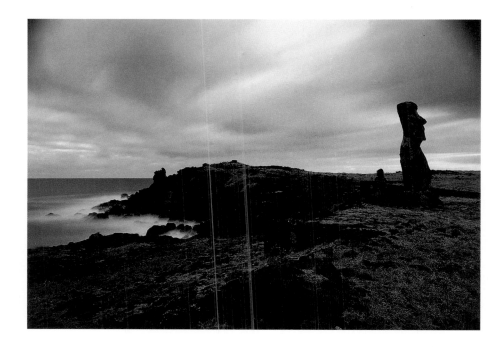

Kenro Izu

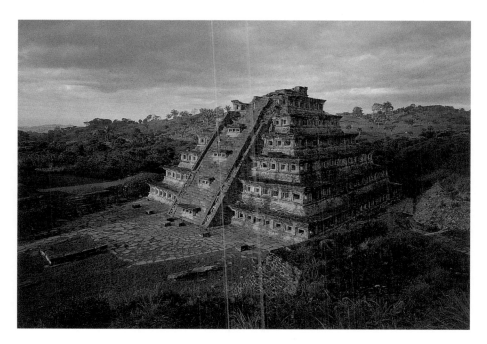

Kenro Izu

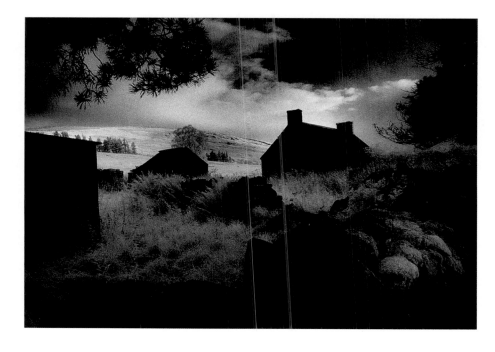

Ian Fraser

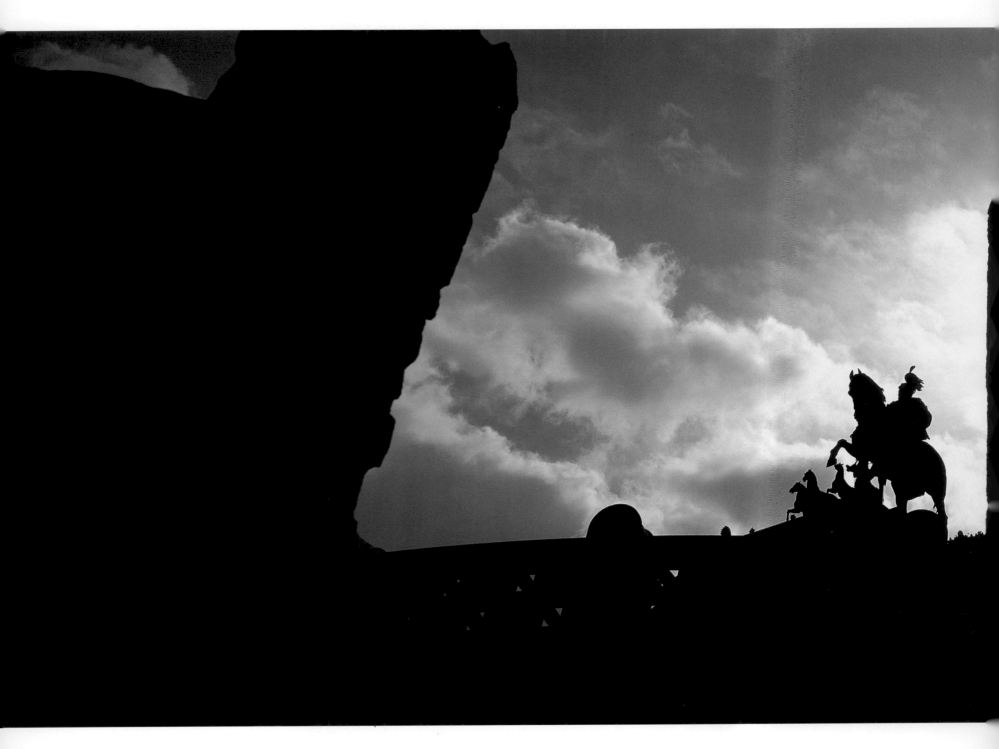

Barry Jell

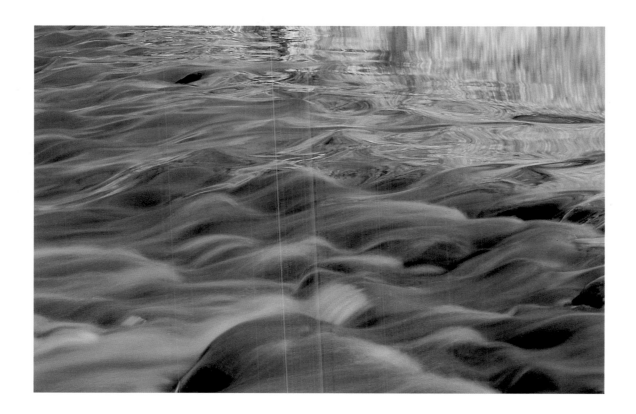

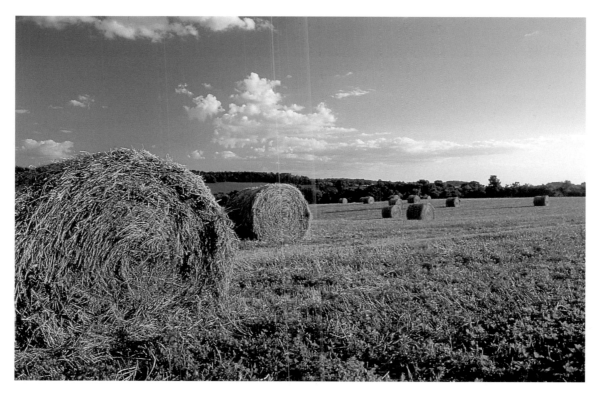

Philip Michael

Jim Wark

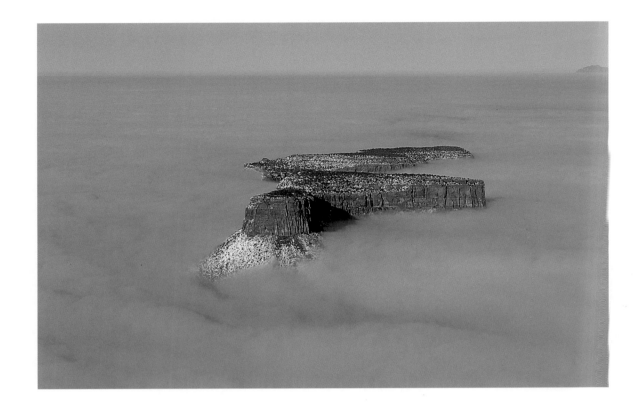

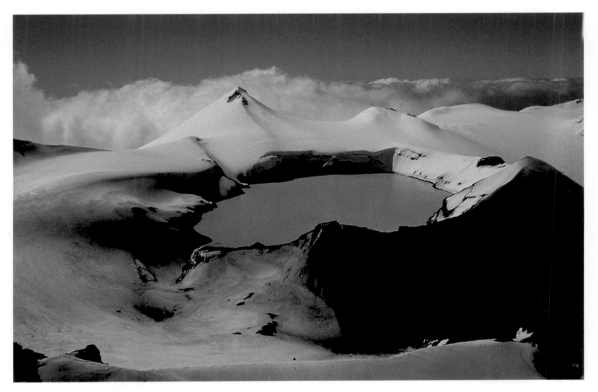

Jim Wark

Dottsie Dorothy Nat

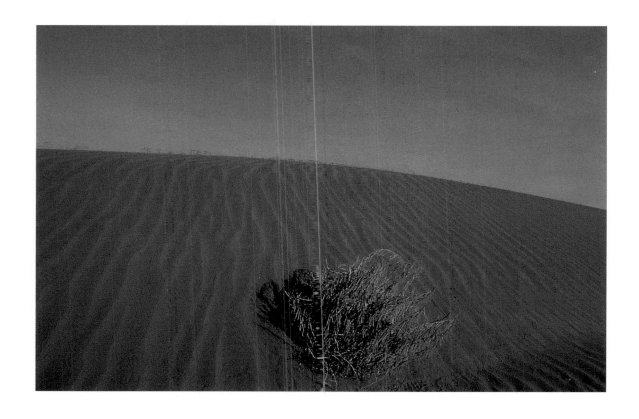

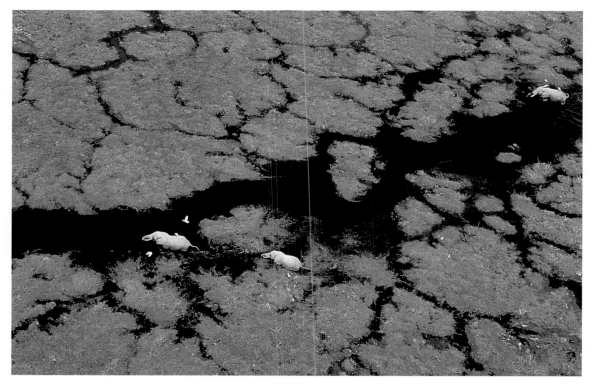

Philip Michael

Guido Alberto Rossi

John Pearson

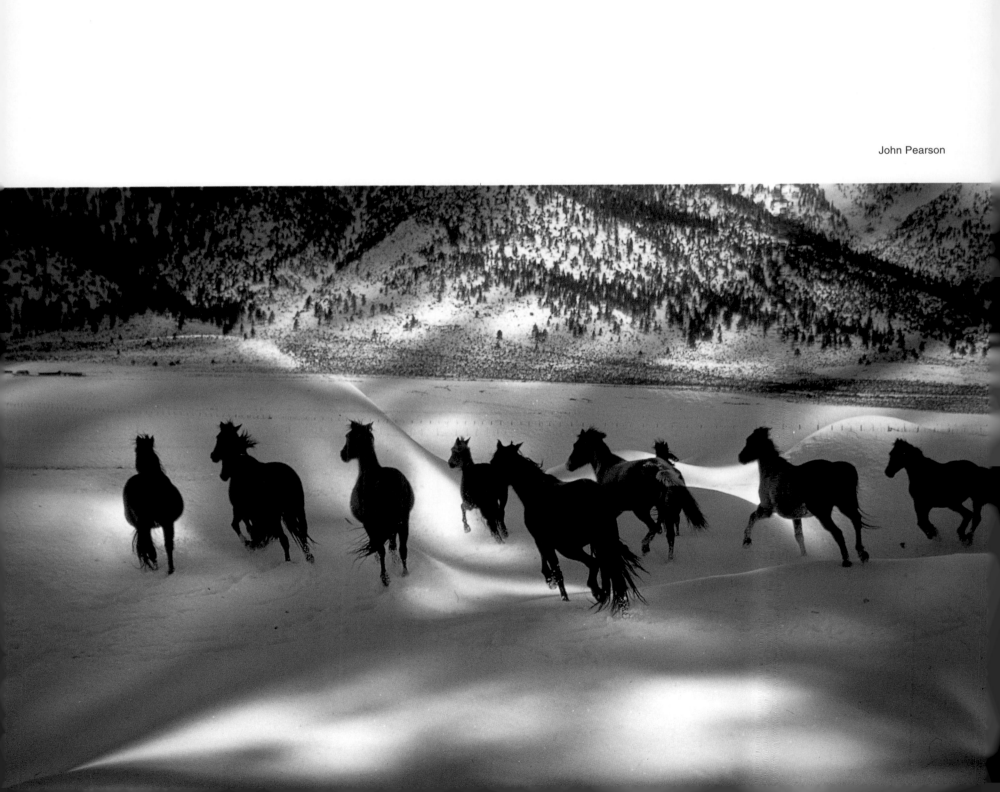

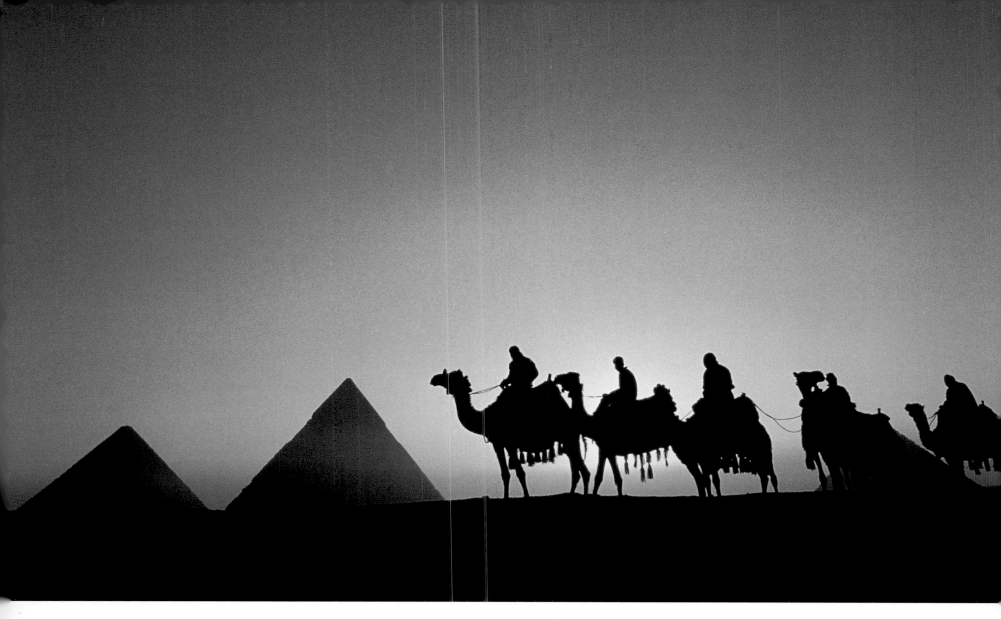

Guido Alberto Rossi

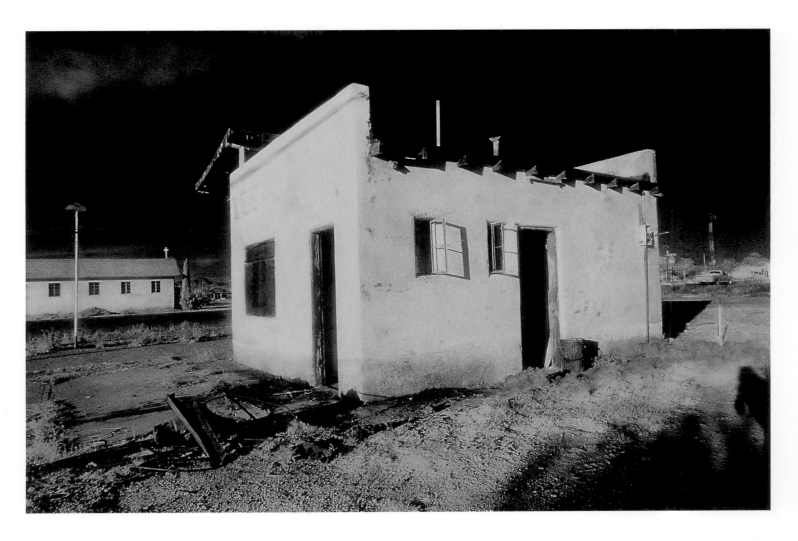

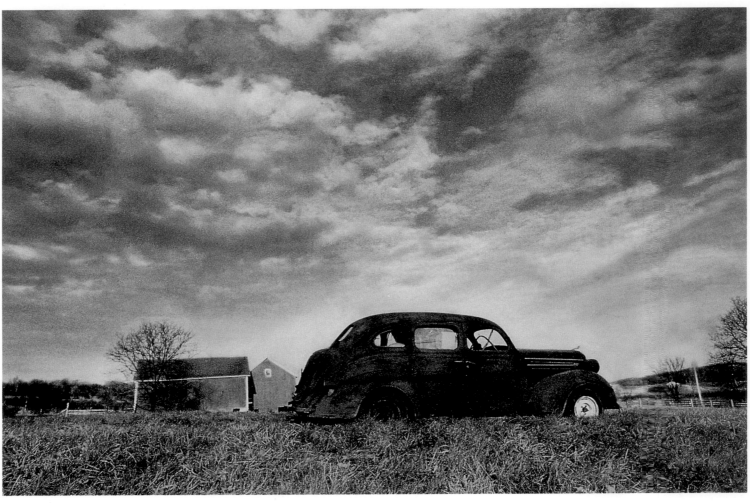

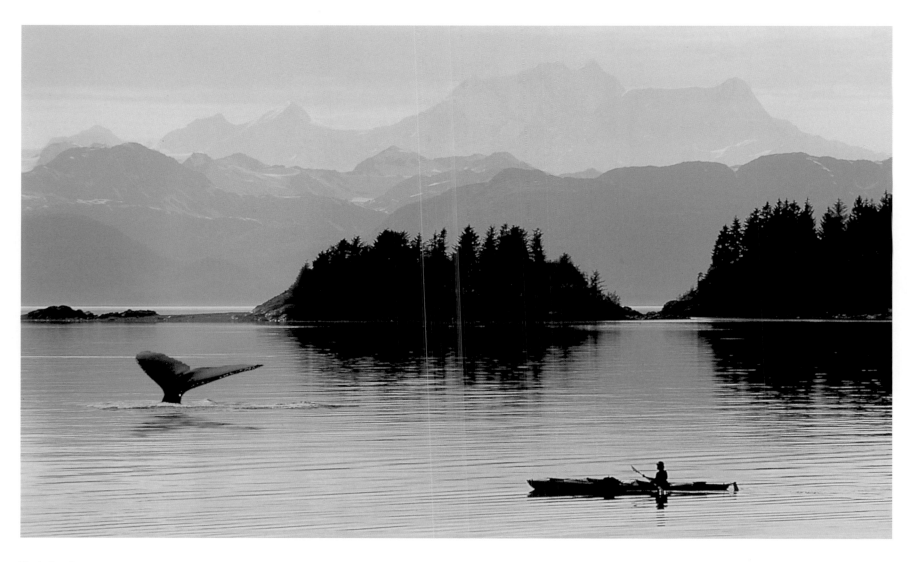

Mark Gamba

Sandra Eisner

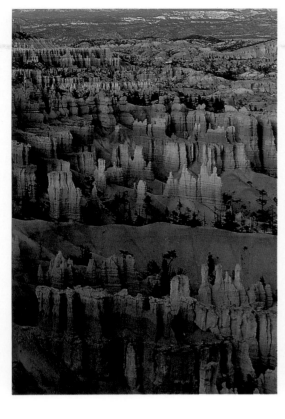
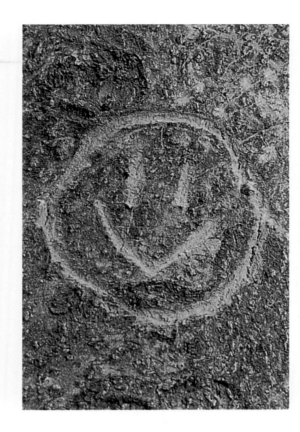
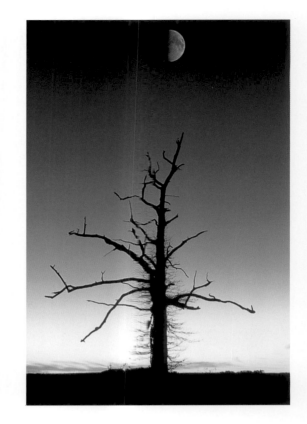
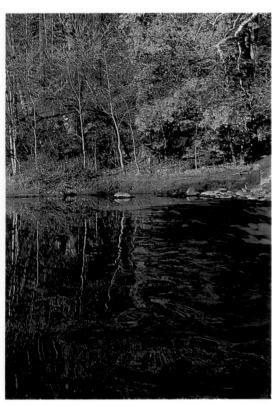
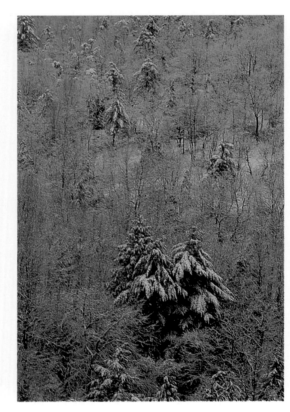
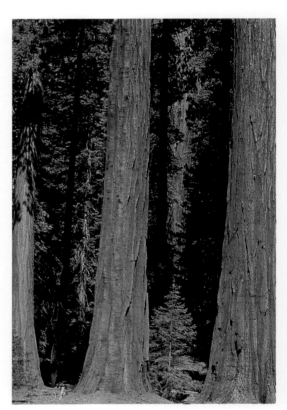

Philip Michael

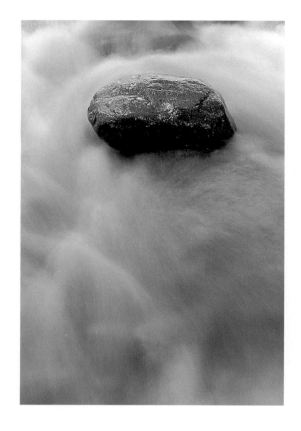

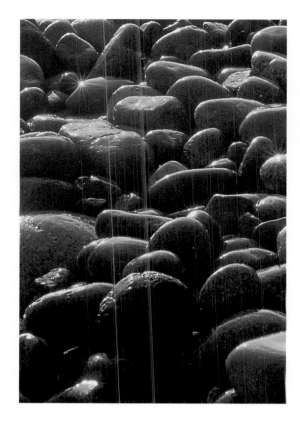

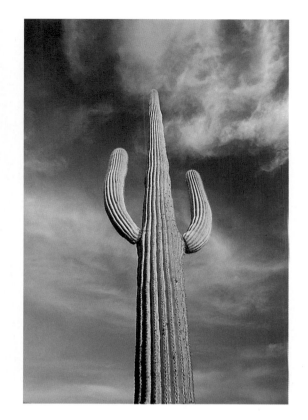

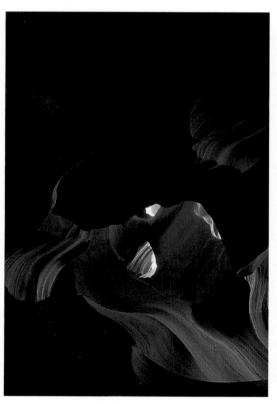

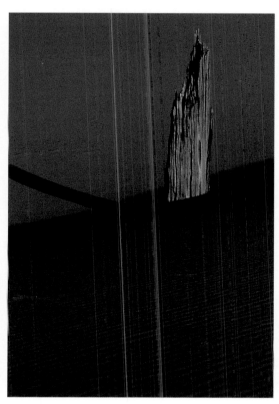

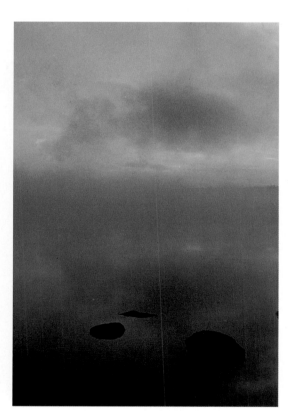

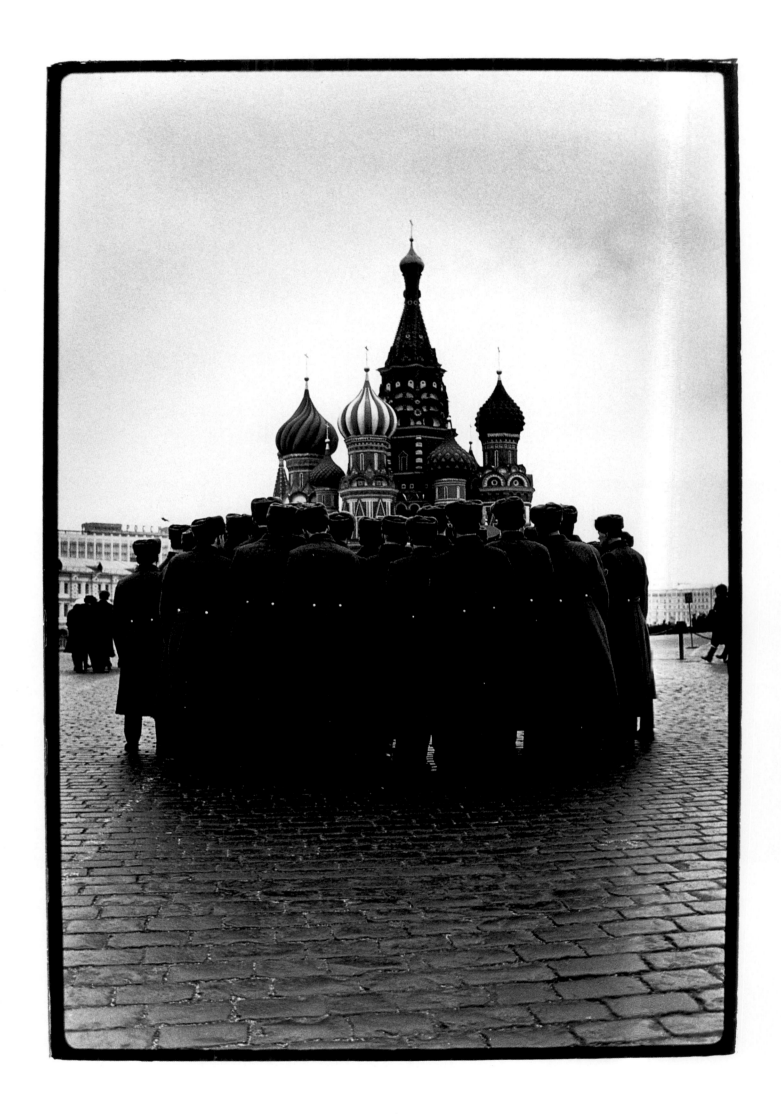

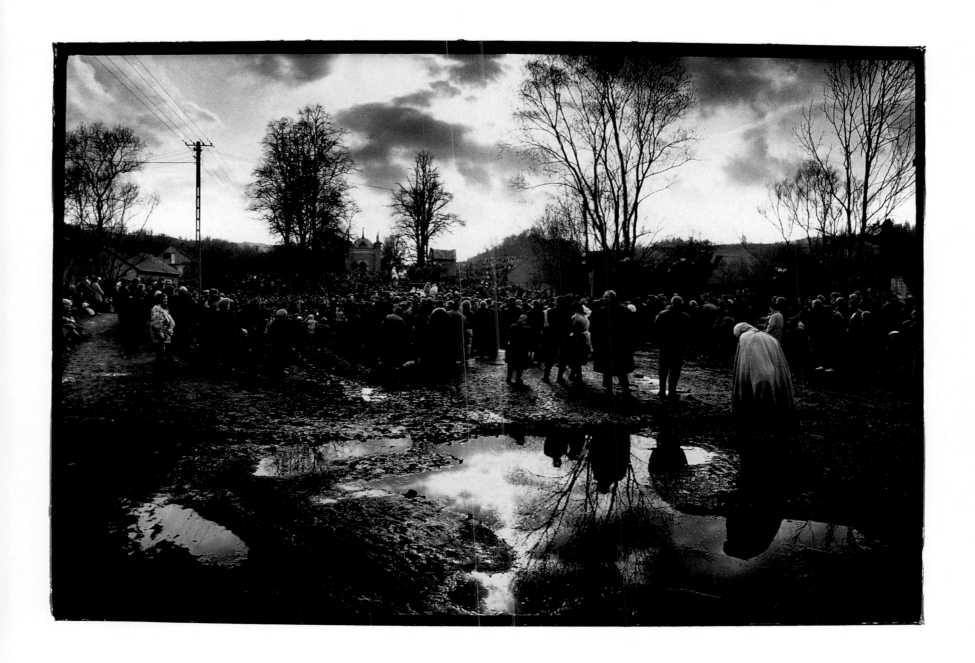

Manfred Wirtz

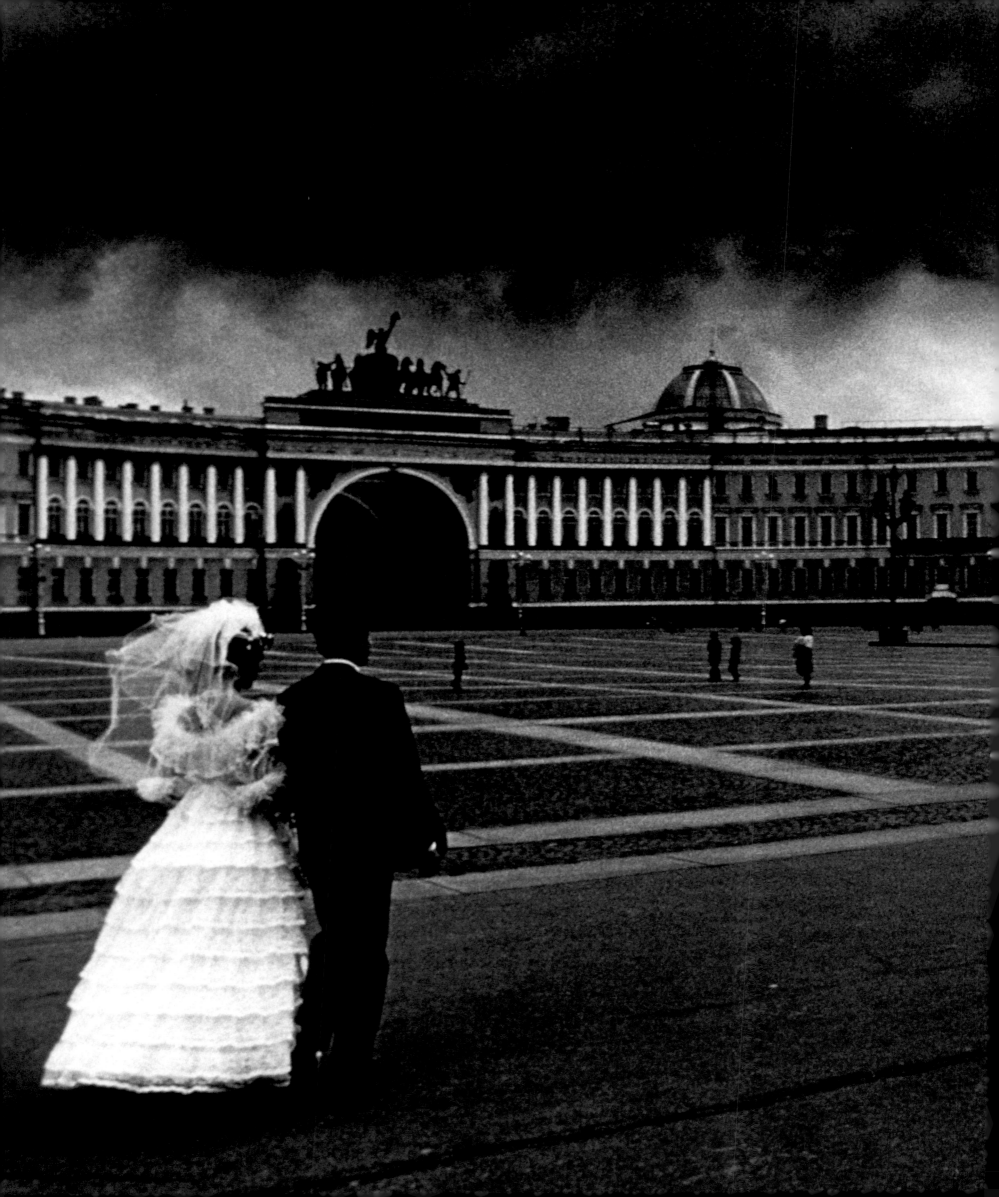

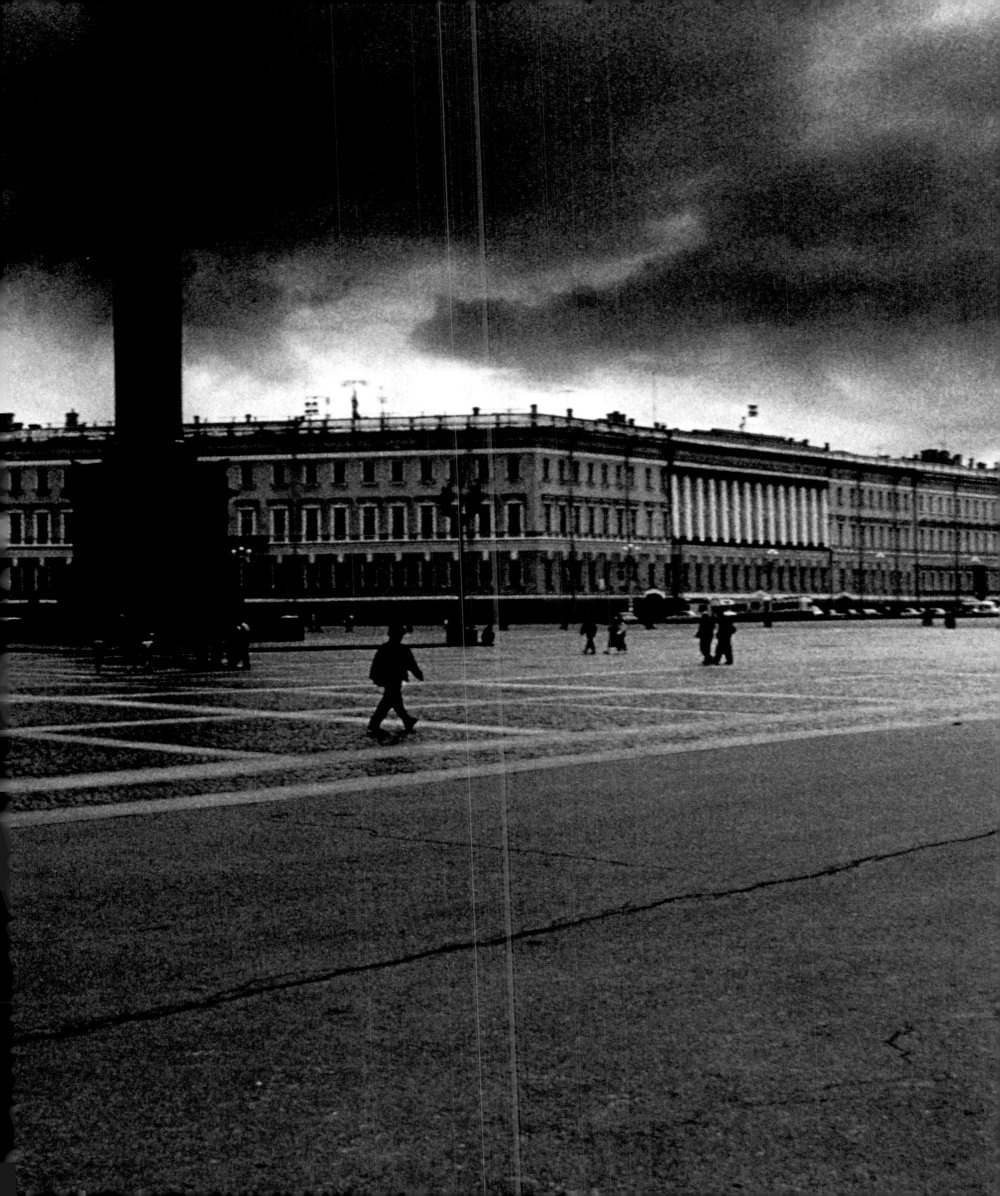

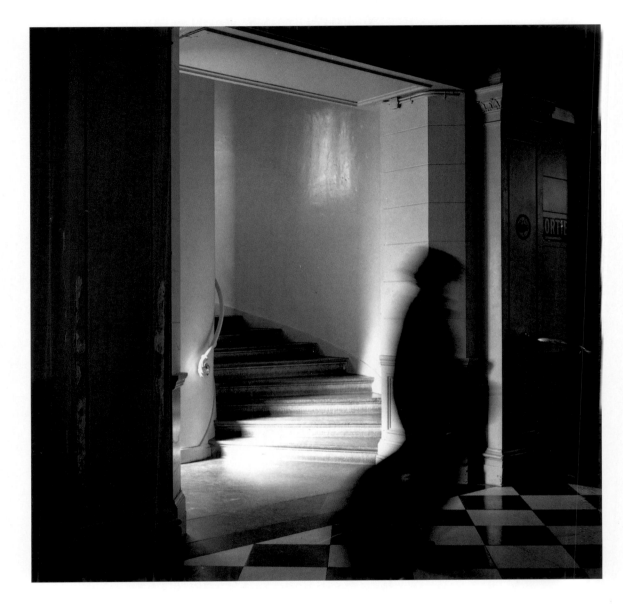

Alain Janssens

Keith Lanpher

◁ Manfred Wirtz

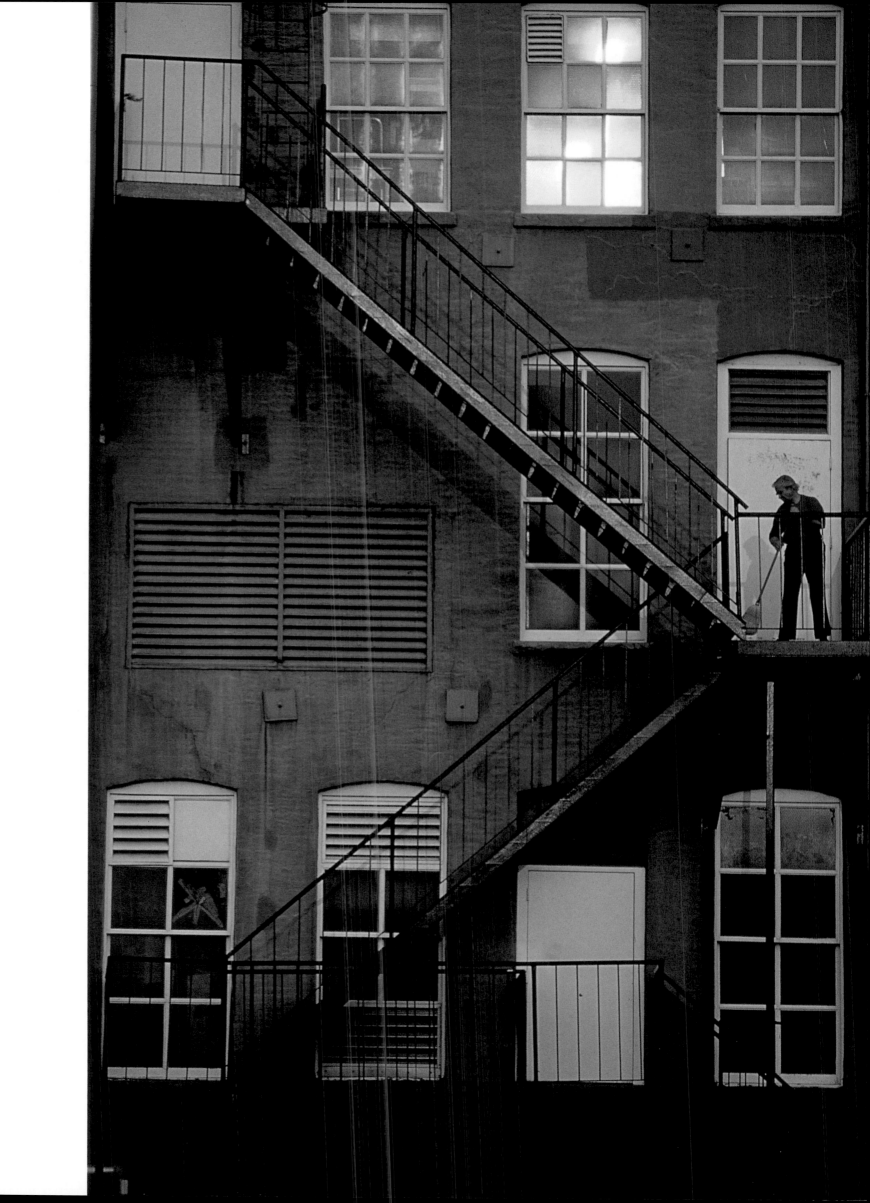

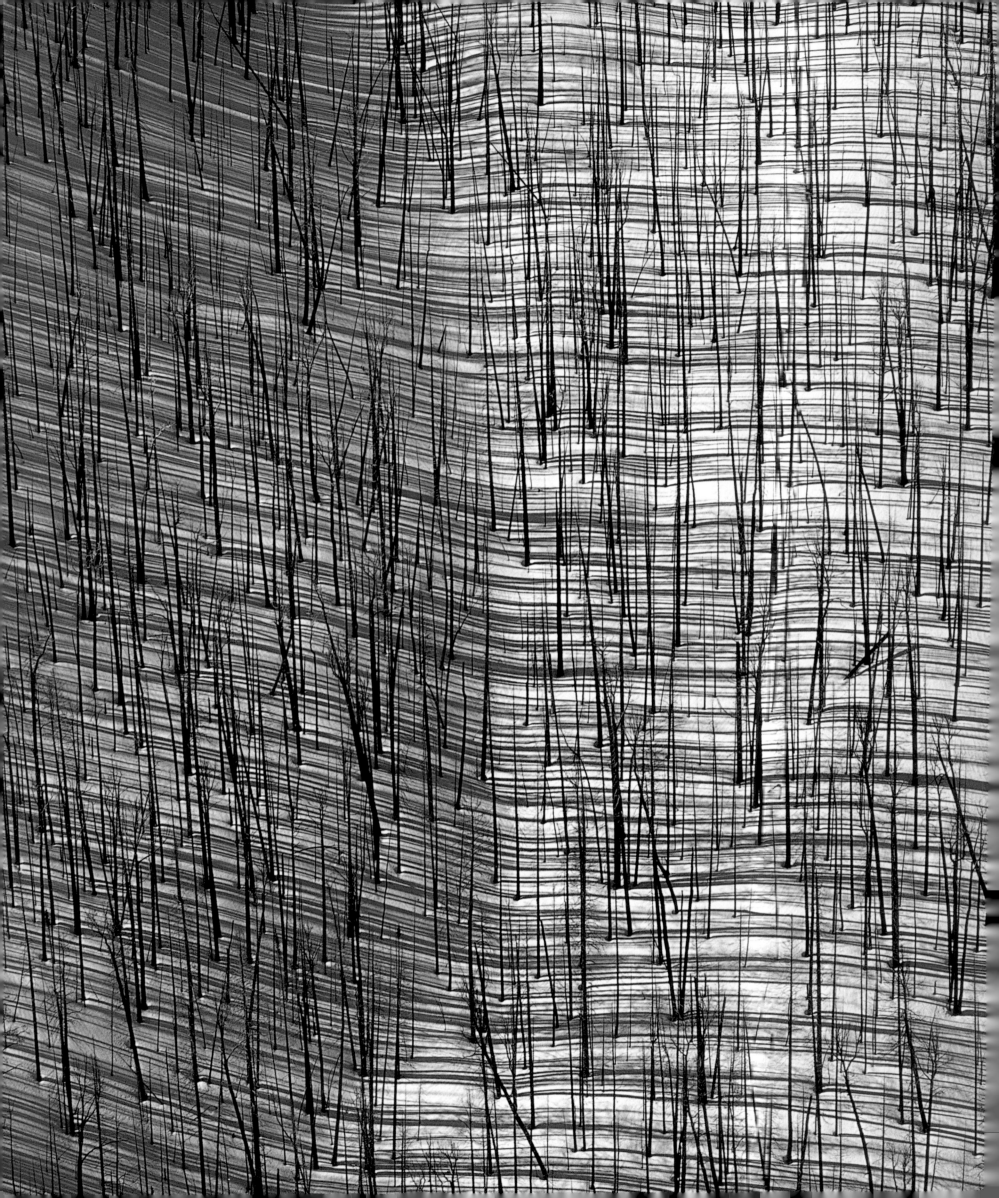

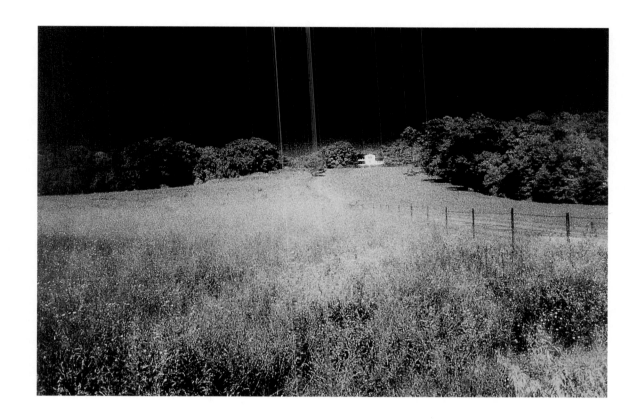

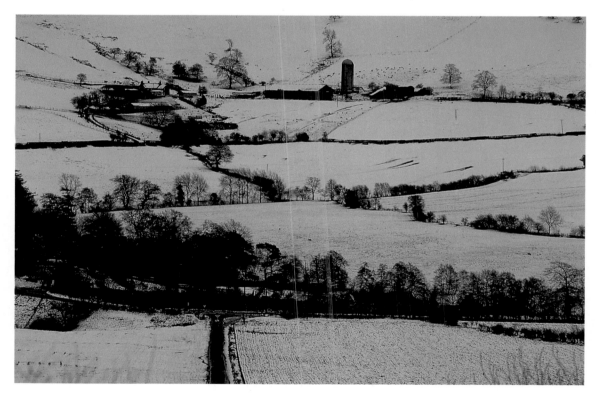

Jill Enfield

David Paterson

Jim Wark

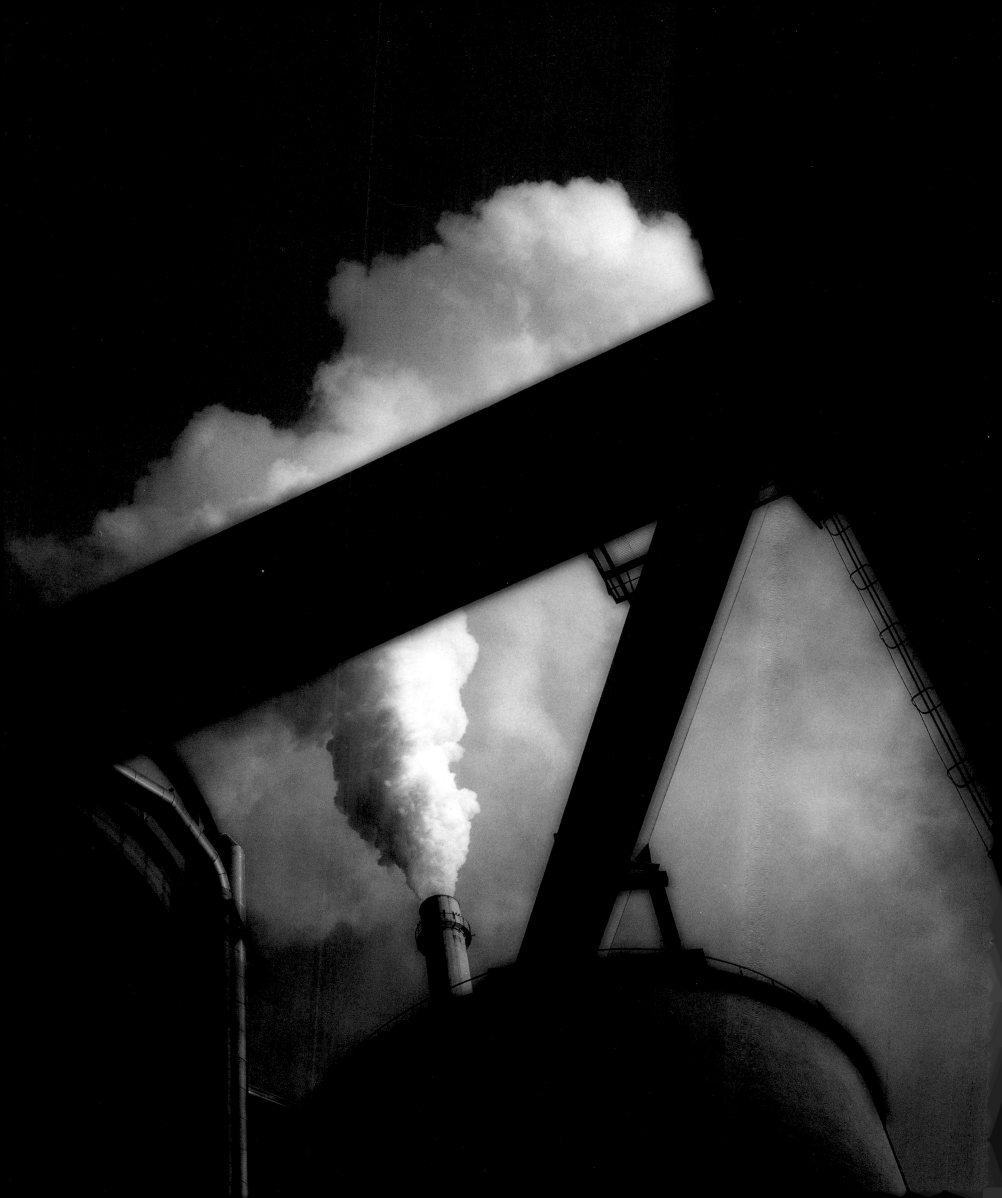

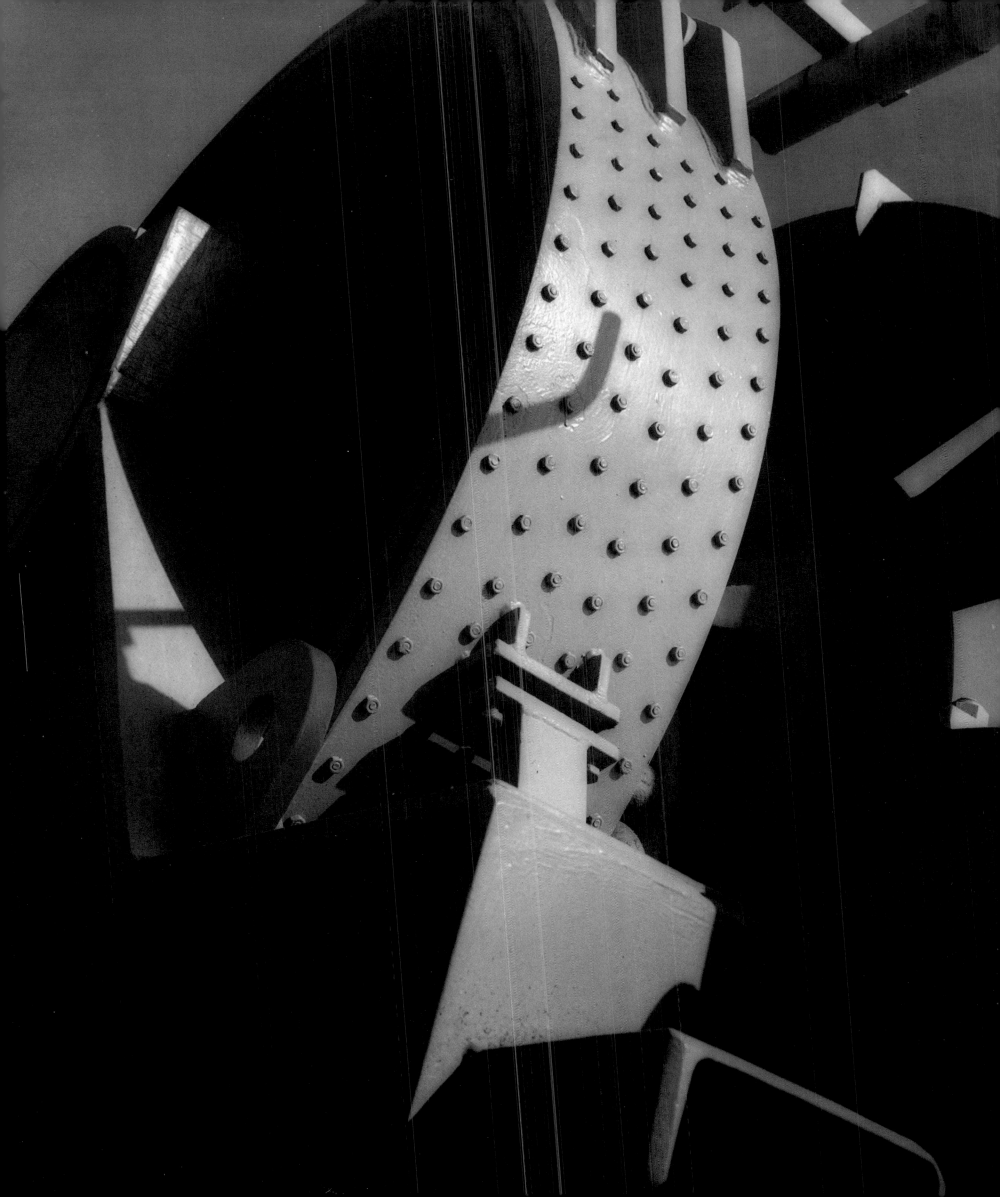

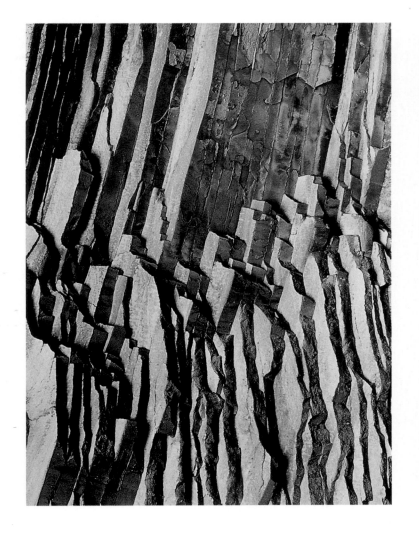
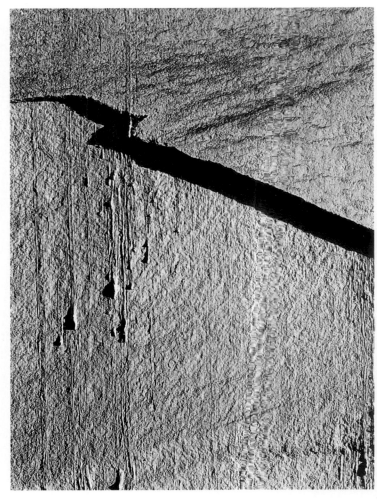
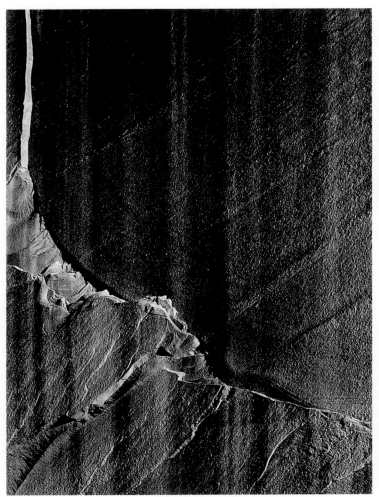
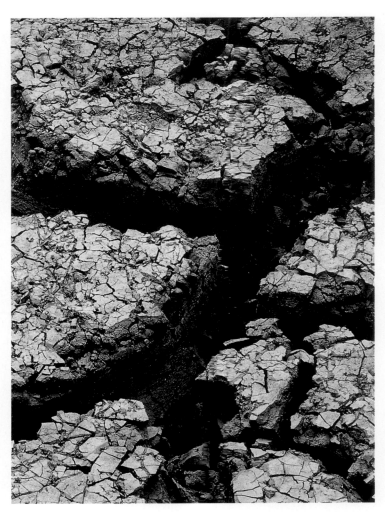

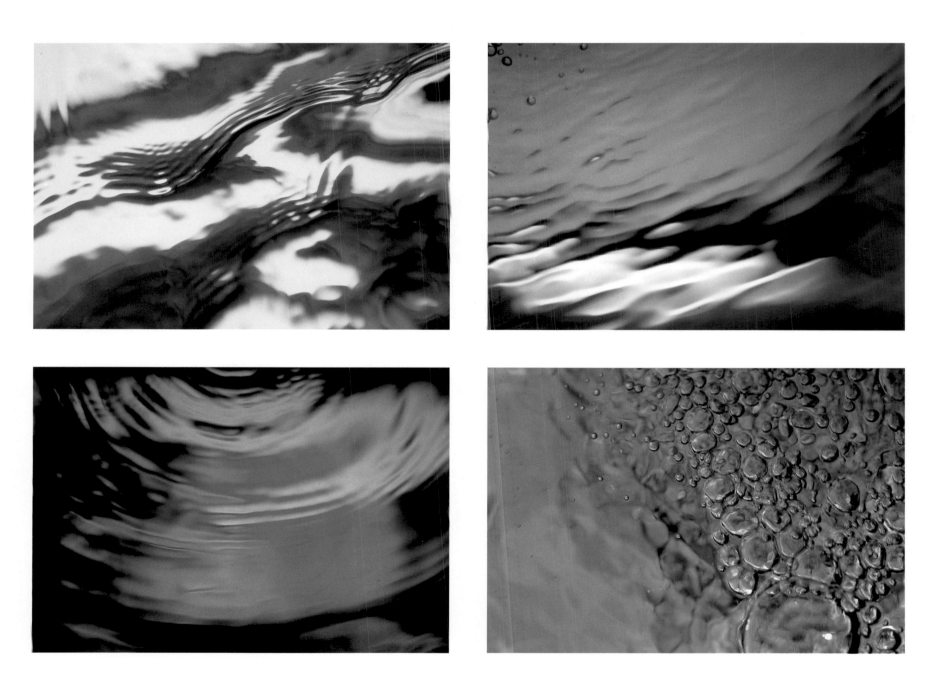

Stefano Morini

Peter Neumann

◁ Aernout Overbeeke

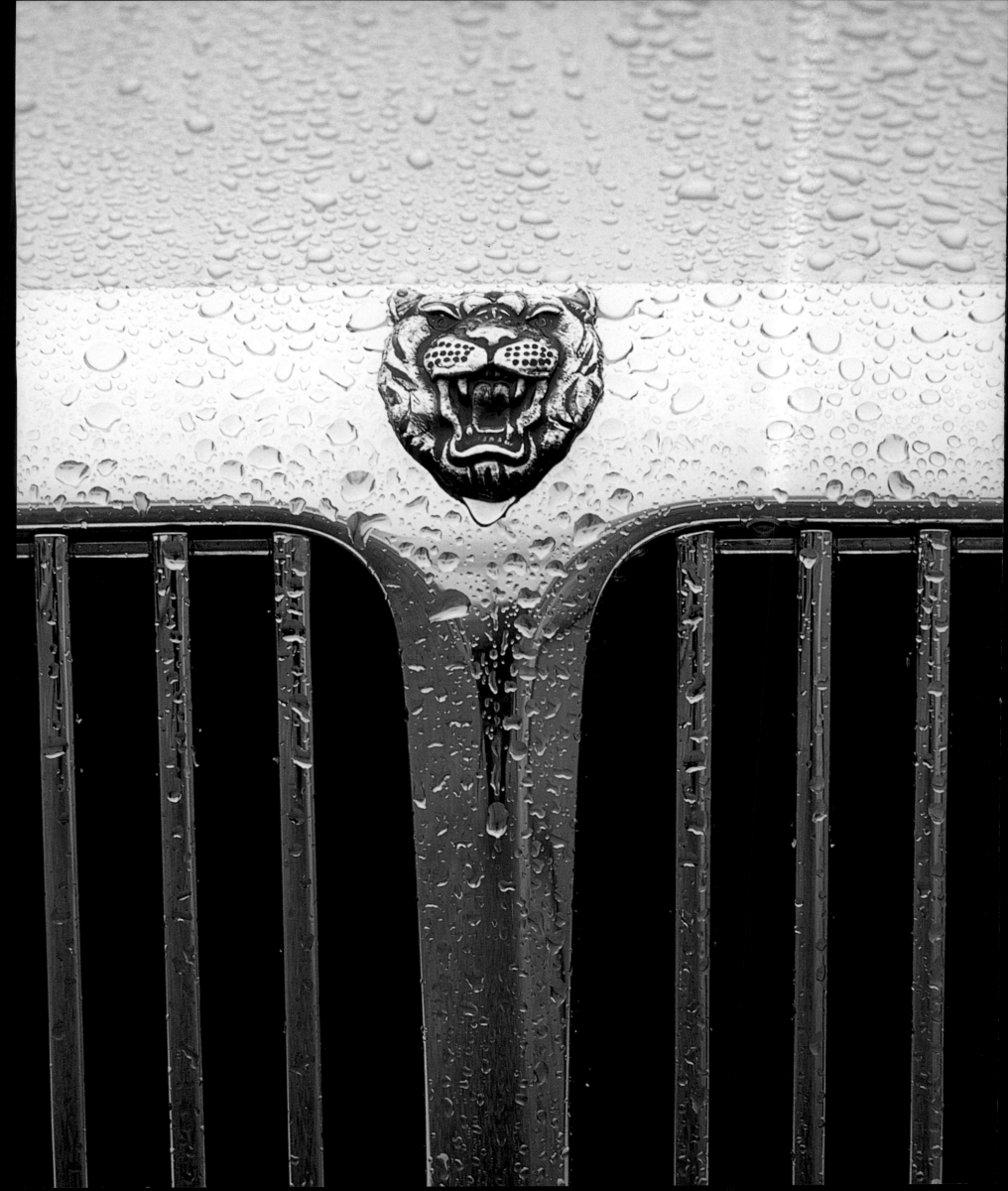

T R A N S P O R T

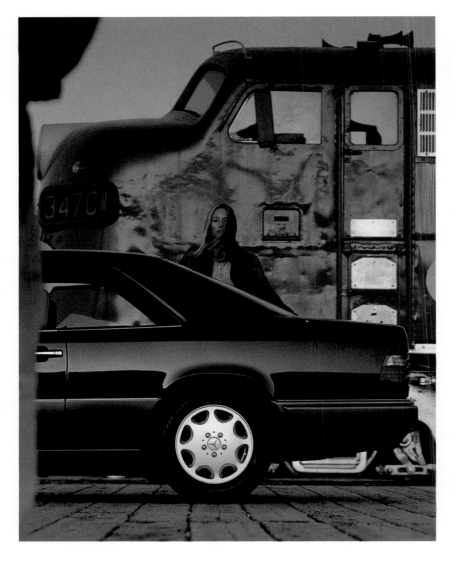

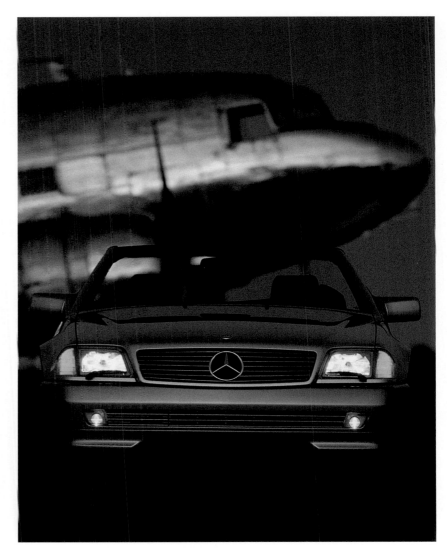

Clint Clemens

Clint Clemens

Craig Cutler

◁ Thomas Starck

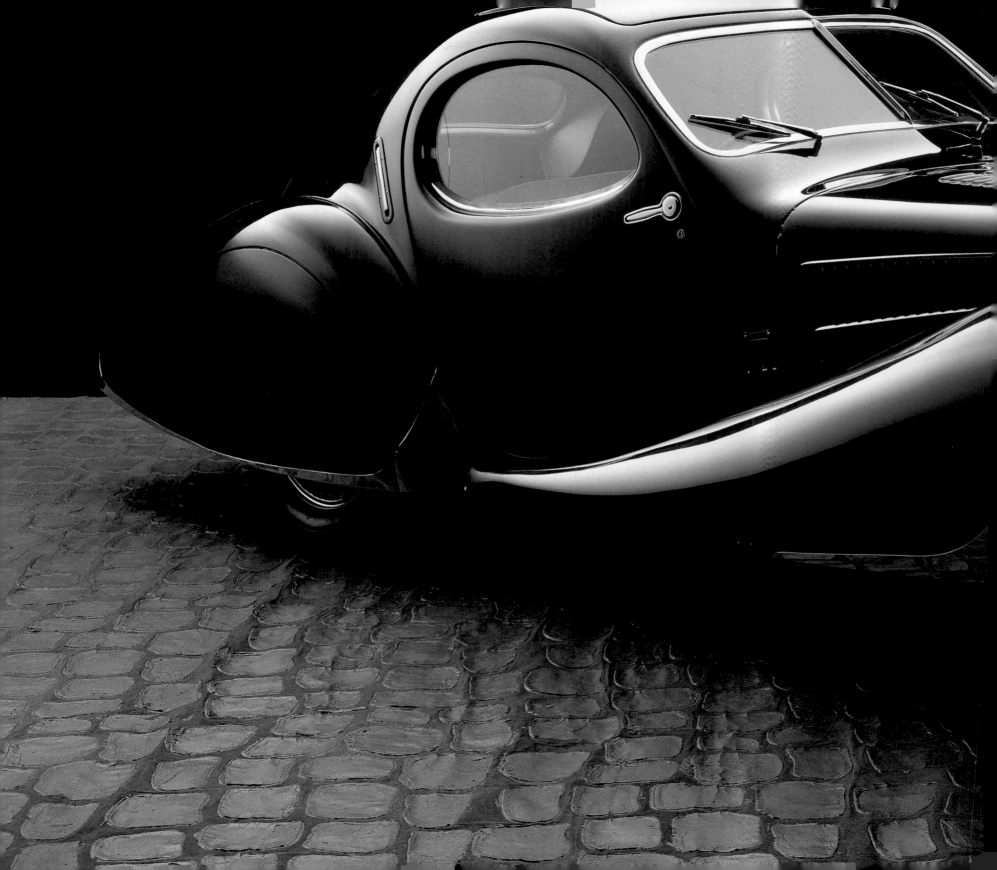

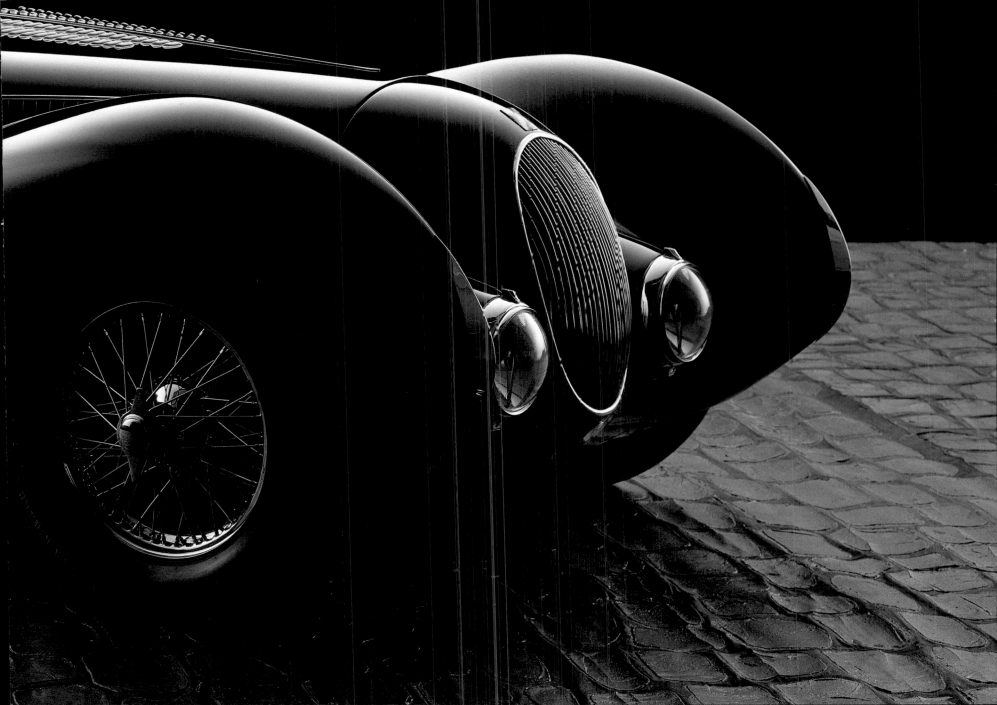

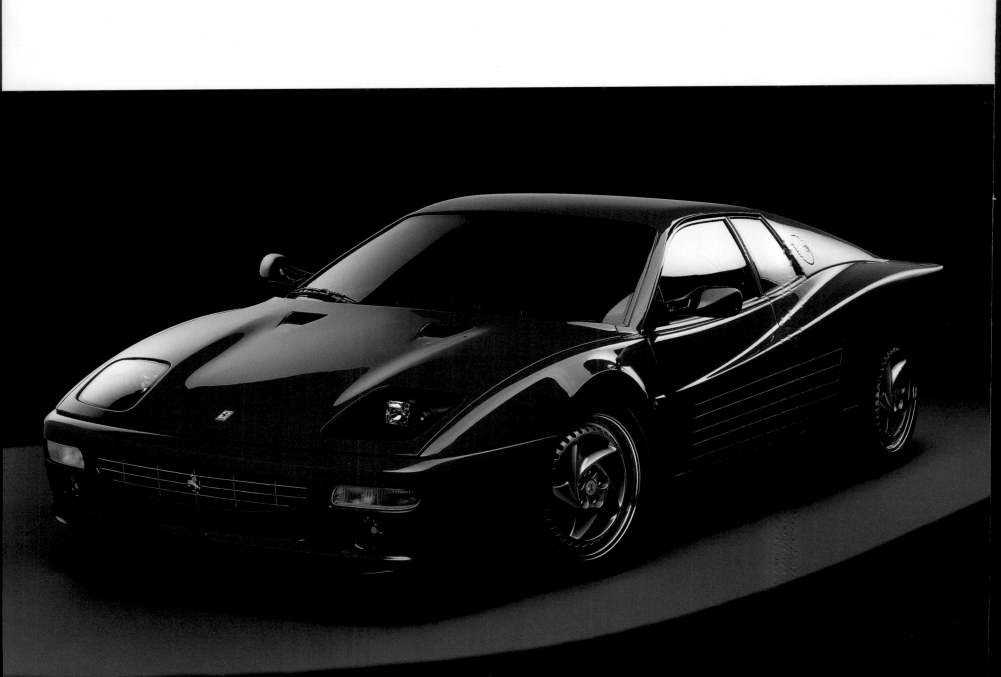

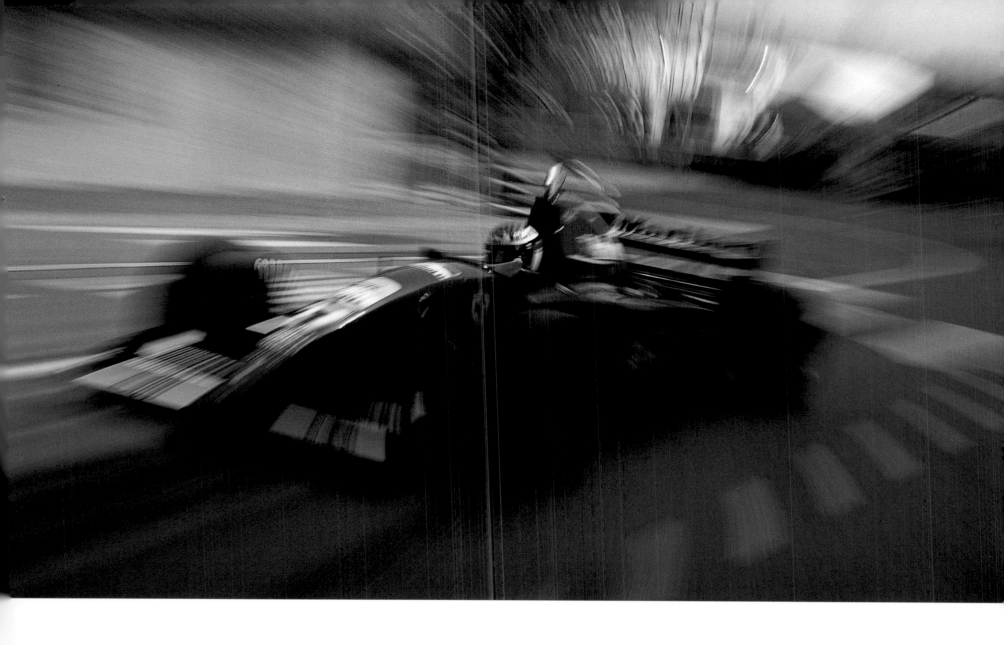

Rainer Schlegelmilch

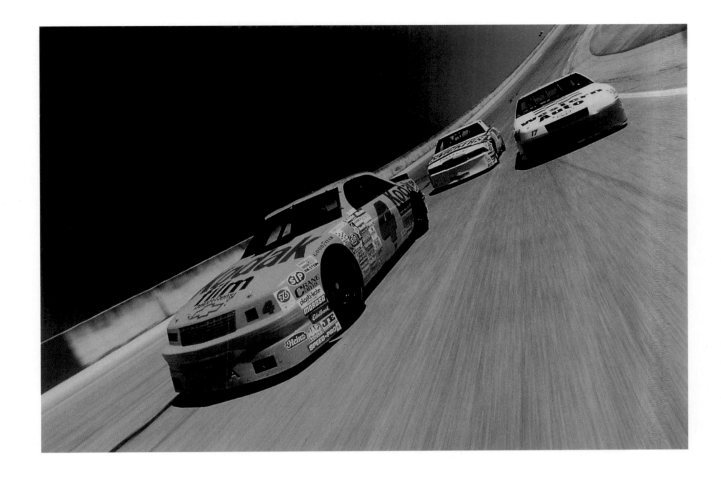

Kai H. Mui

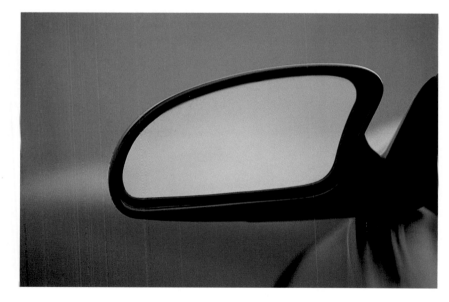

Thomas Starck

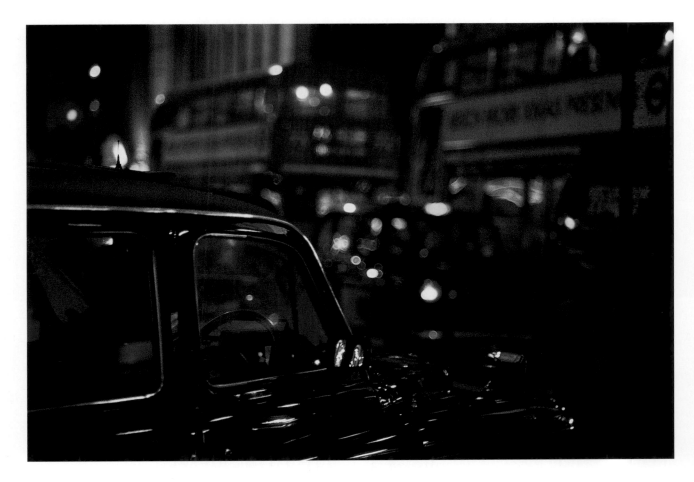

Stewart Charles Cohen

Conny J. Winter

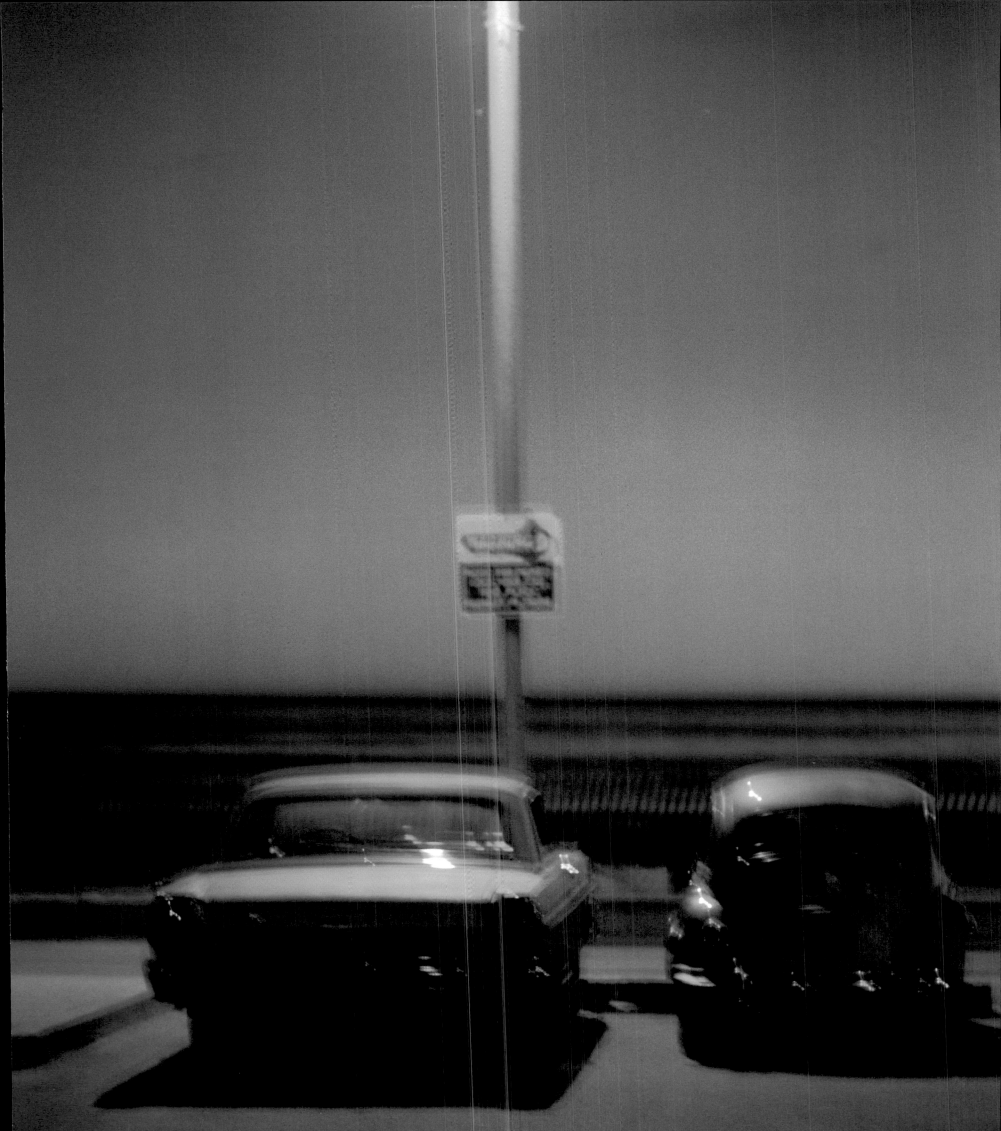

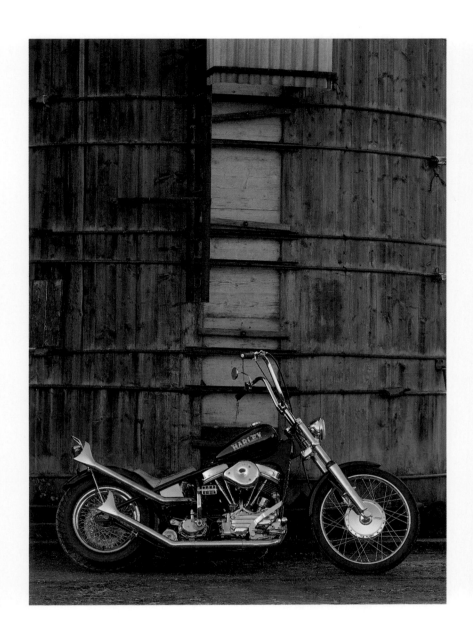
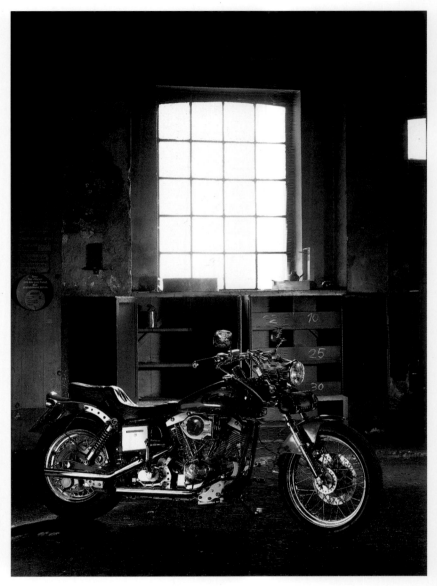

Klaus-Dieter Rebmann

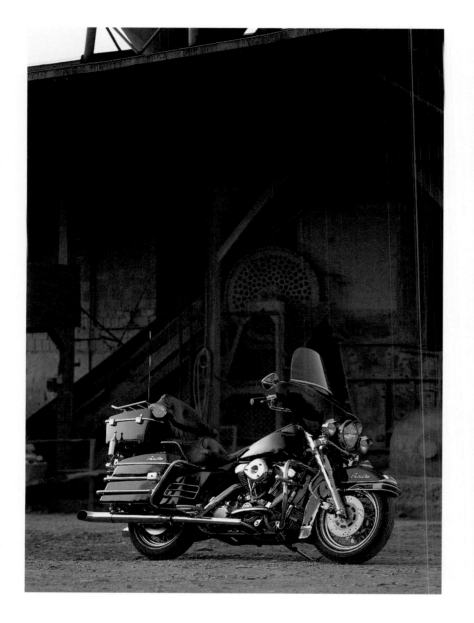

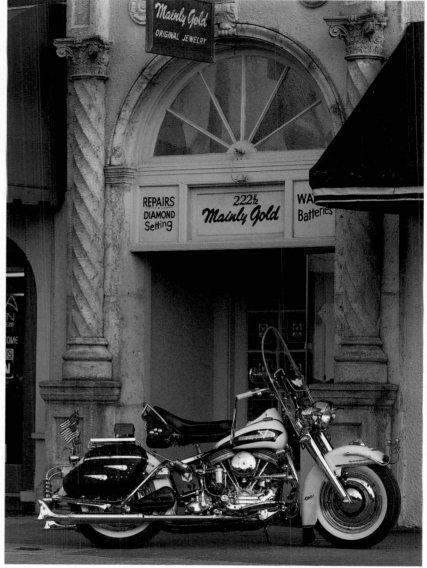

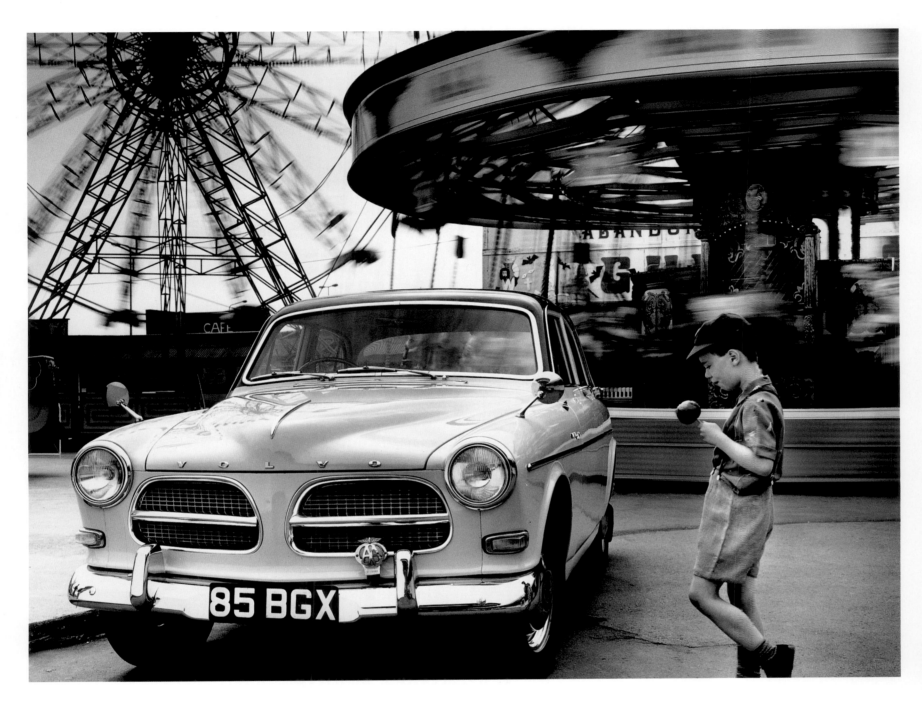

Ian Fraser

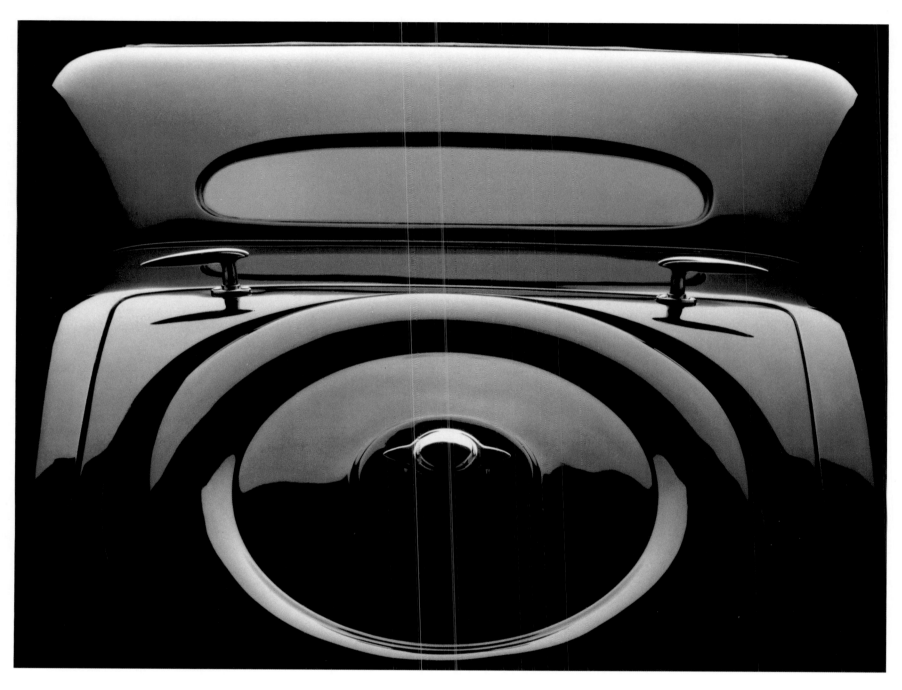

Steve Marsel

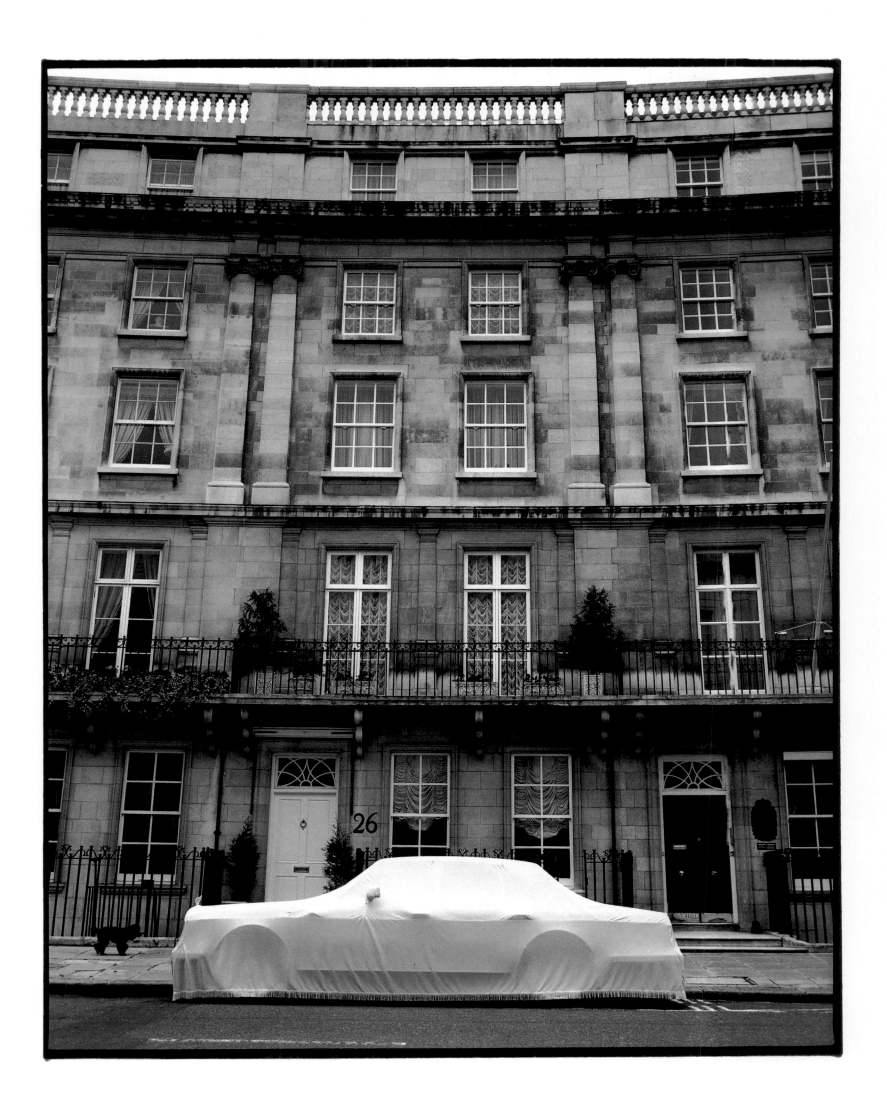

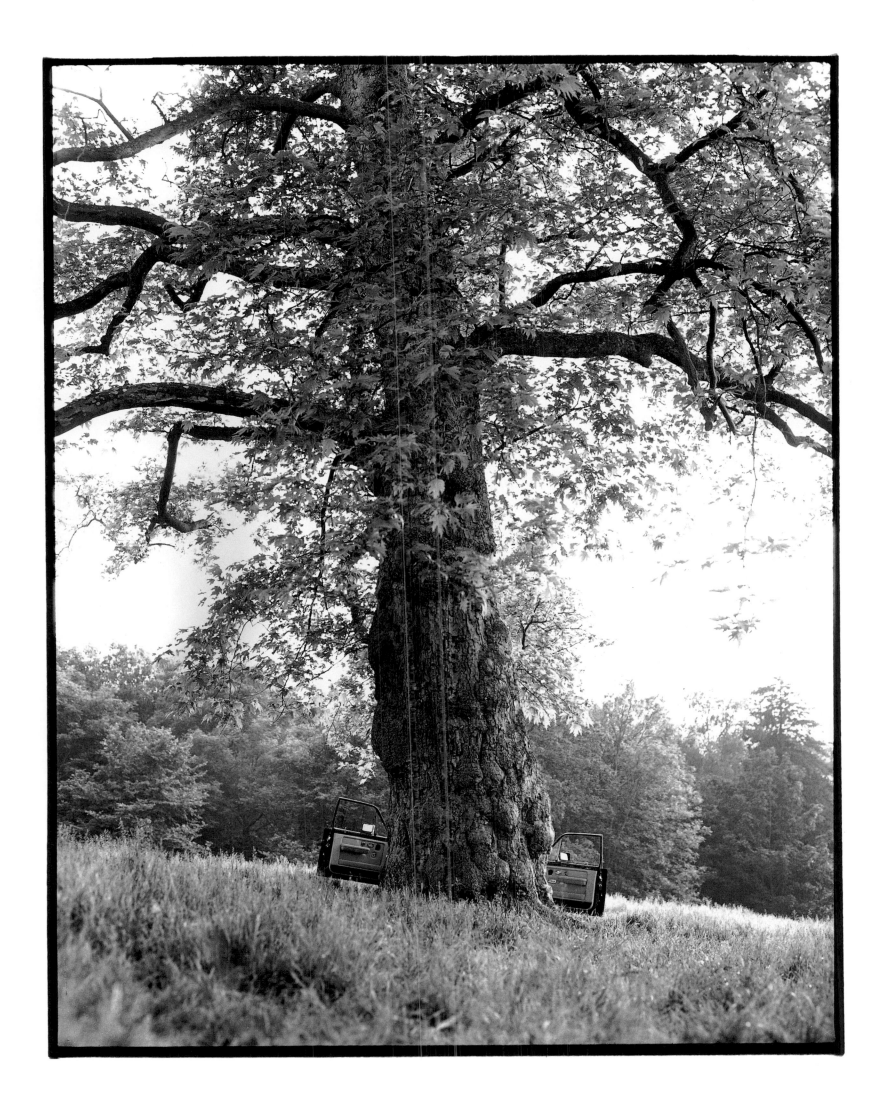

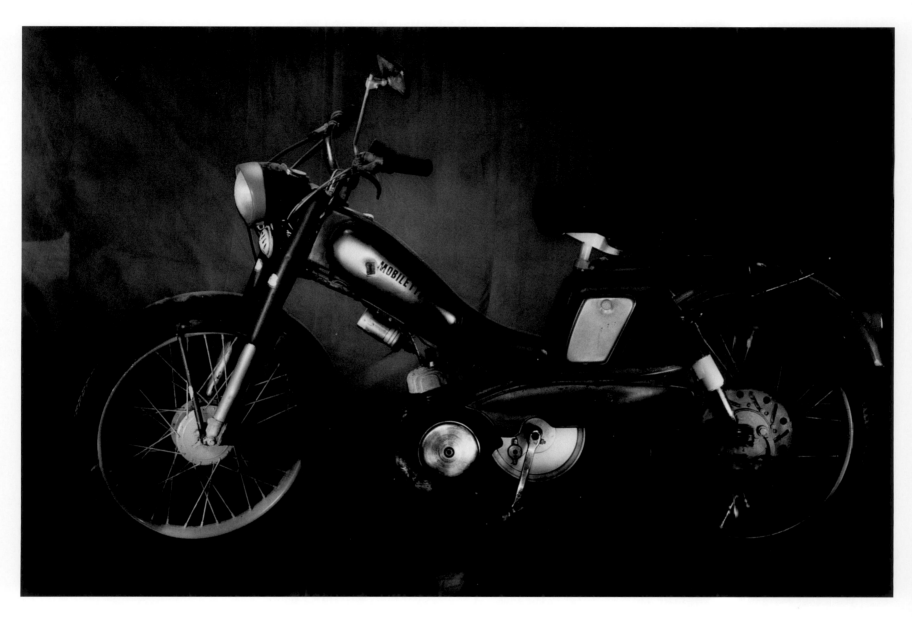

David Pau Antich

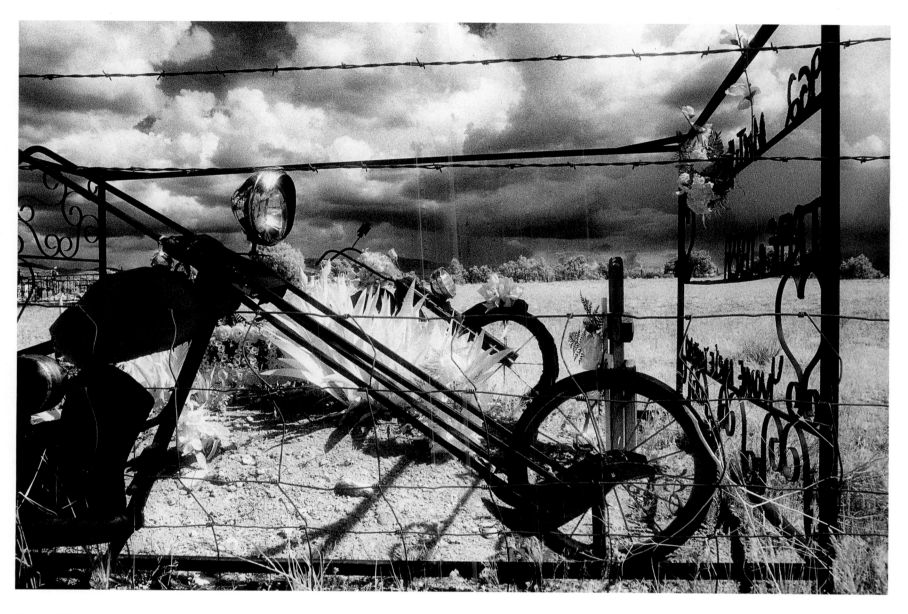

Terence O'Toole

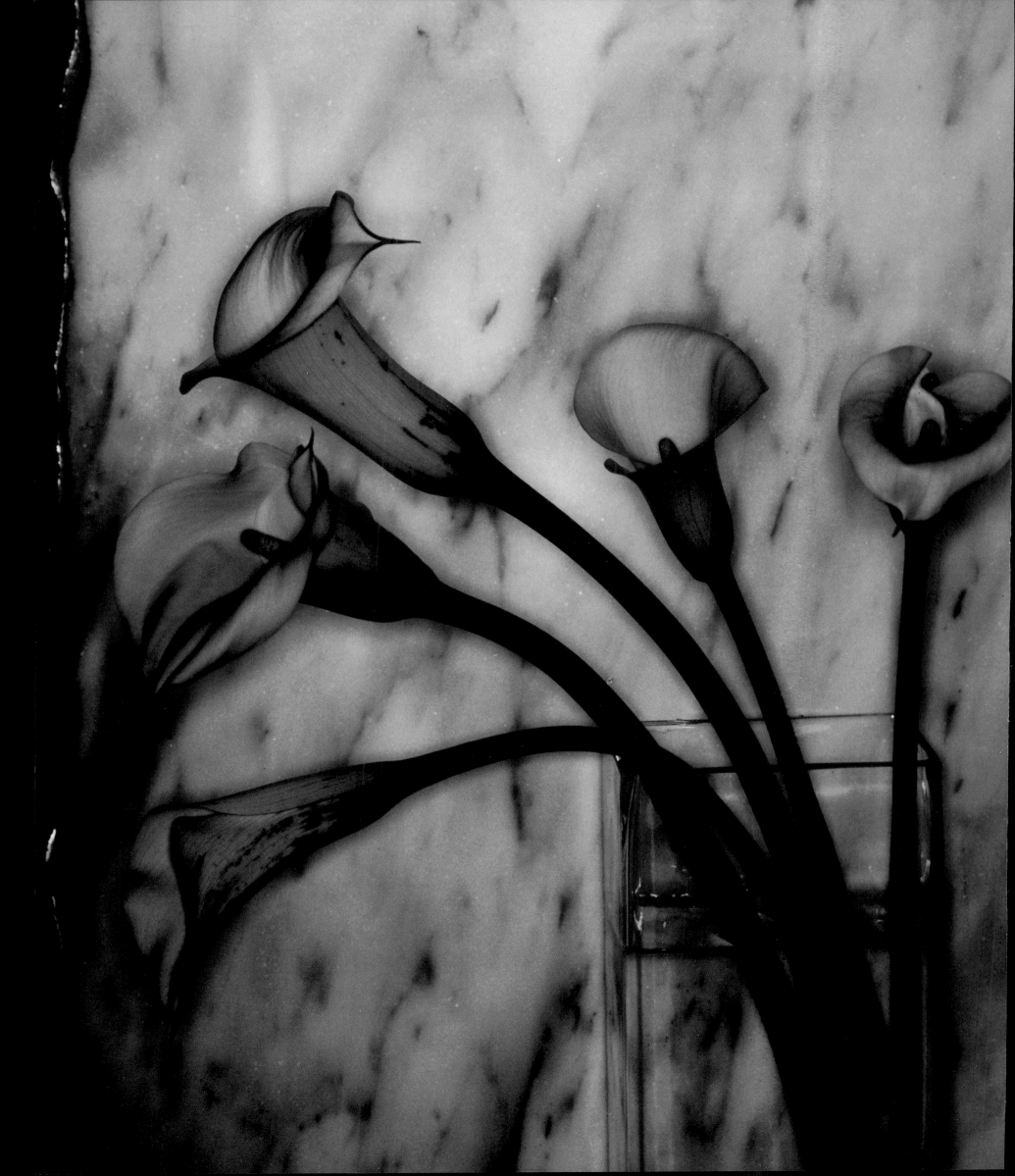

S T I L L

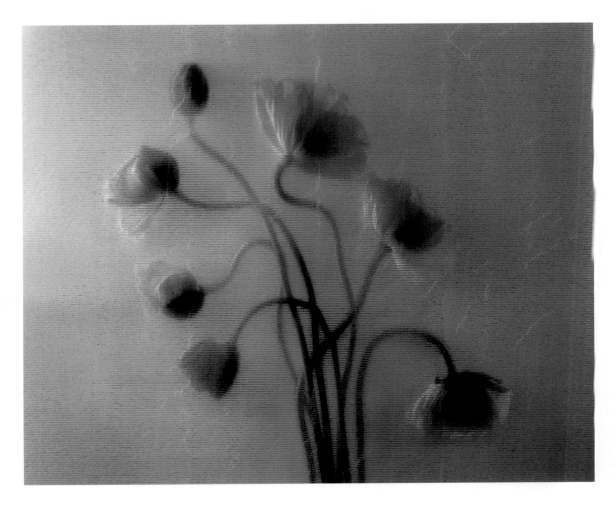

Parish Kohanim

Ian Campbell

◁◁ Anno Pieterse

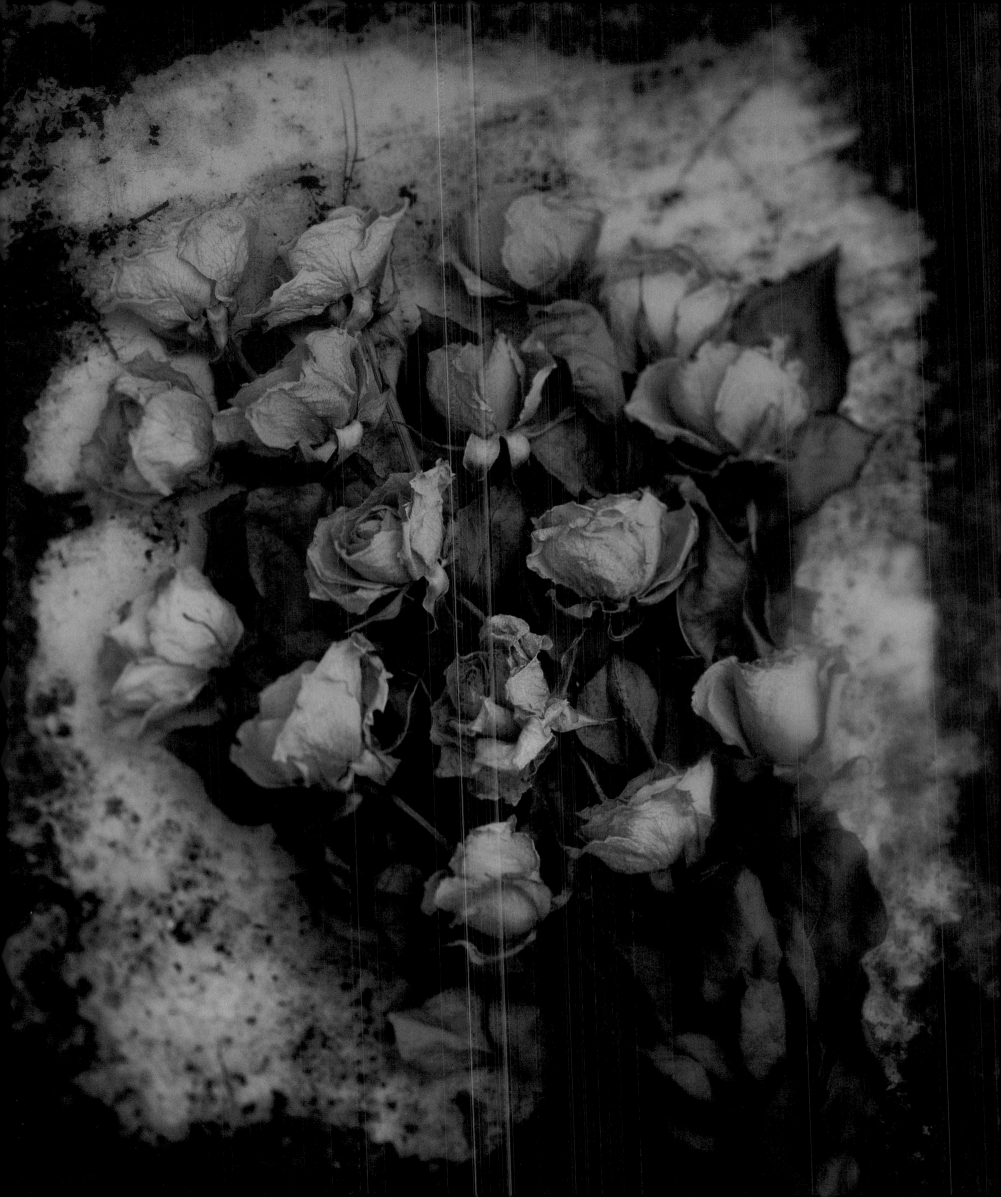

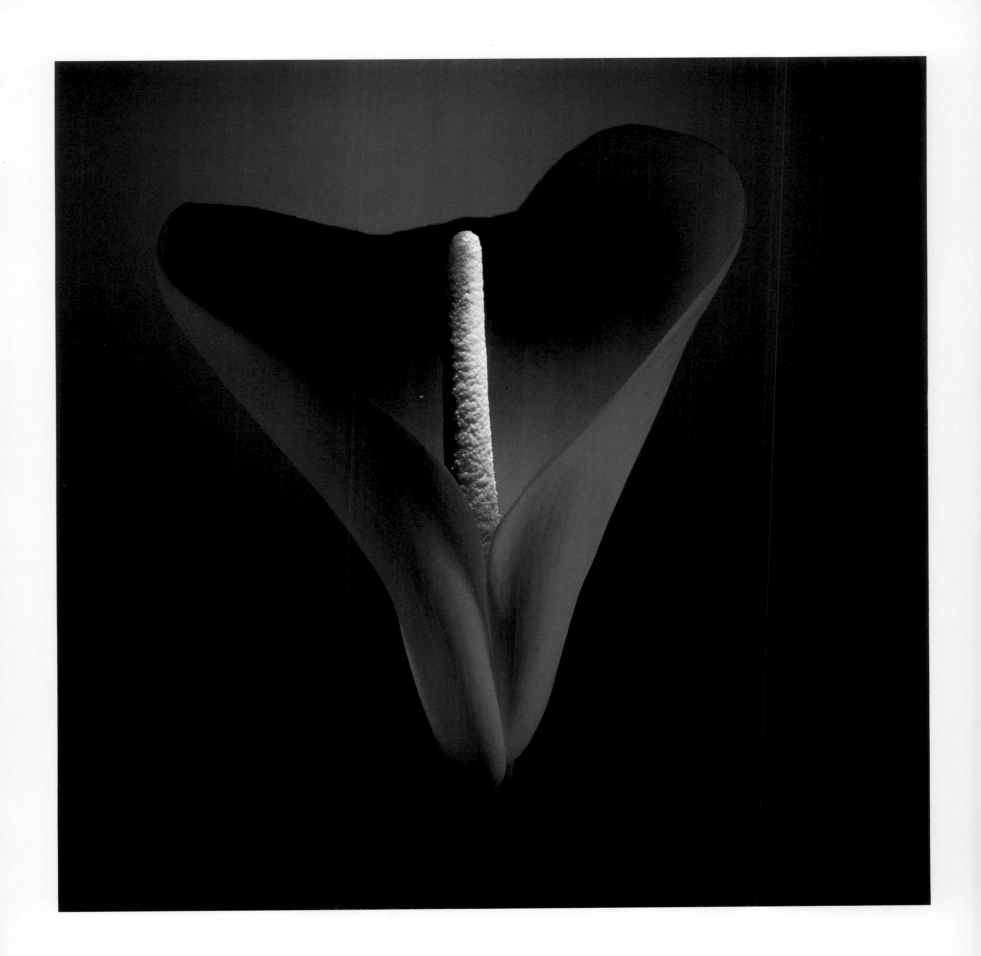

Alfons Iseli

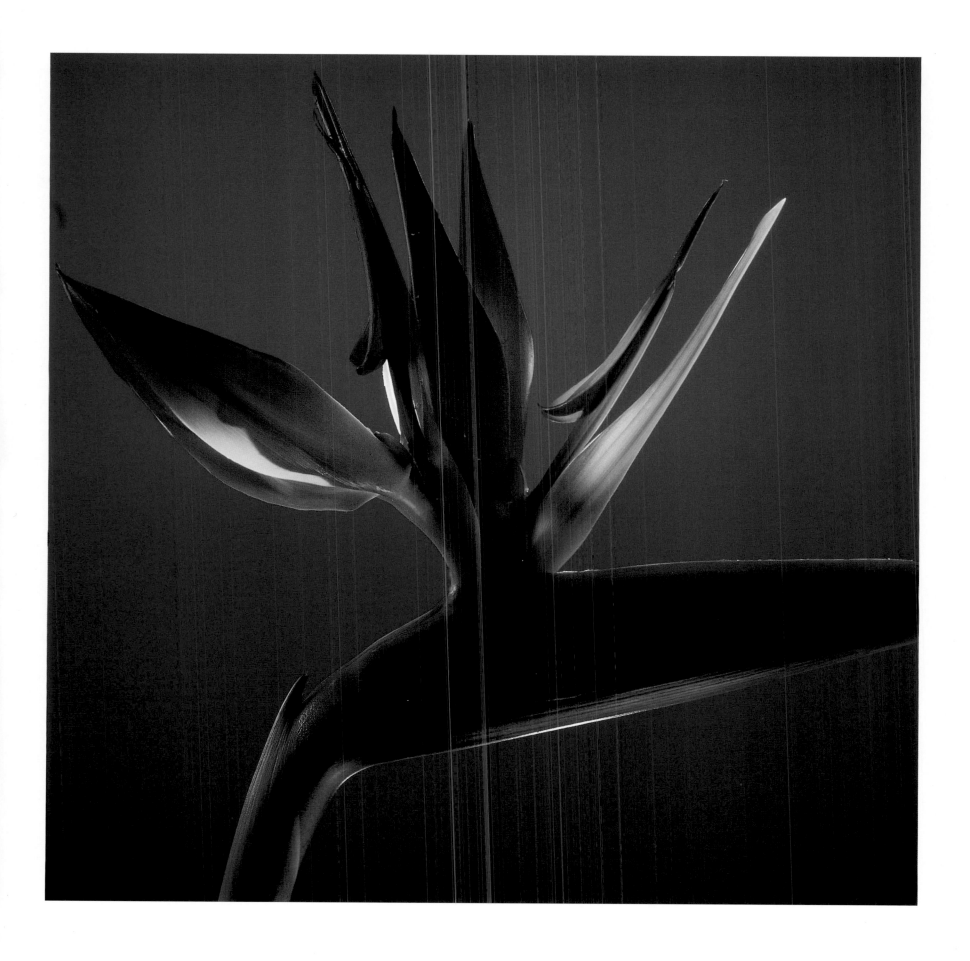

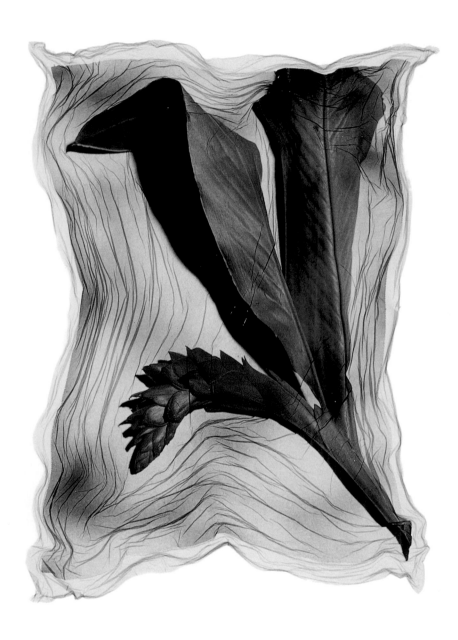

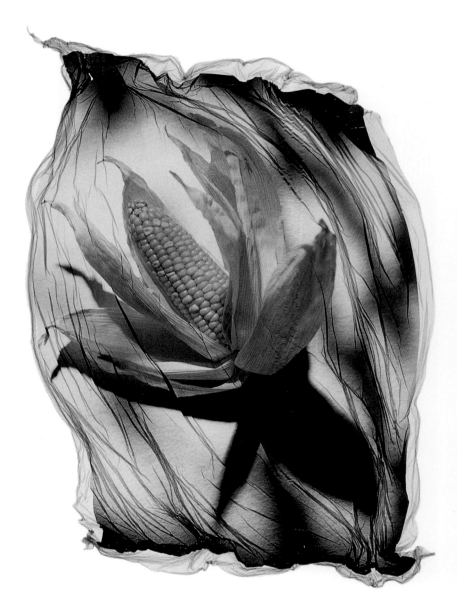

Peter Dazeley

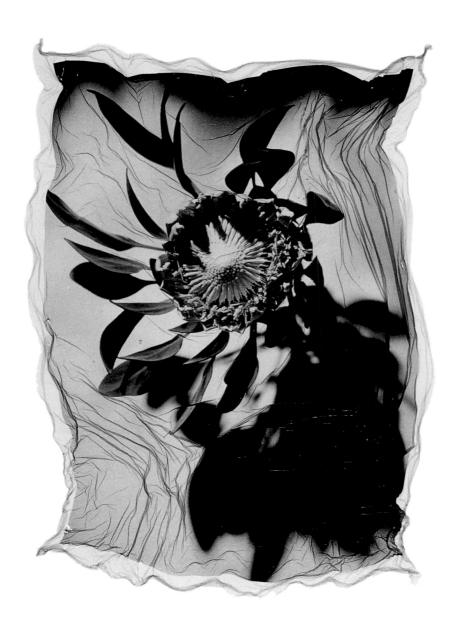
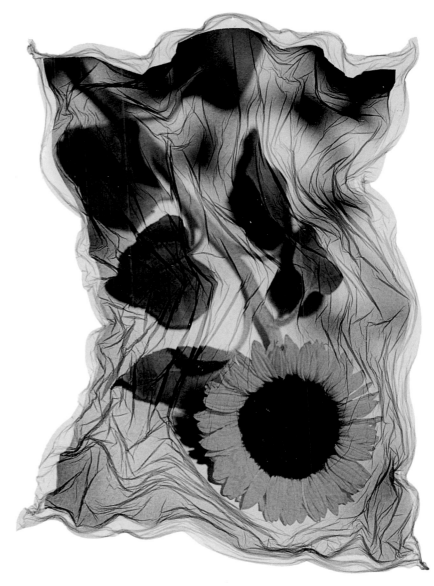

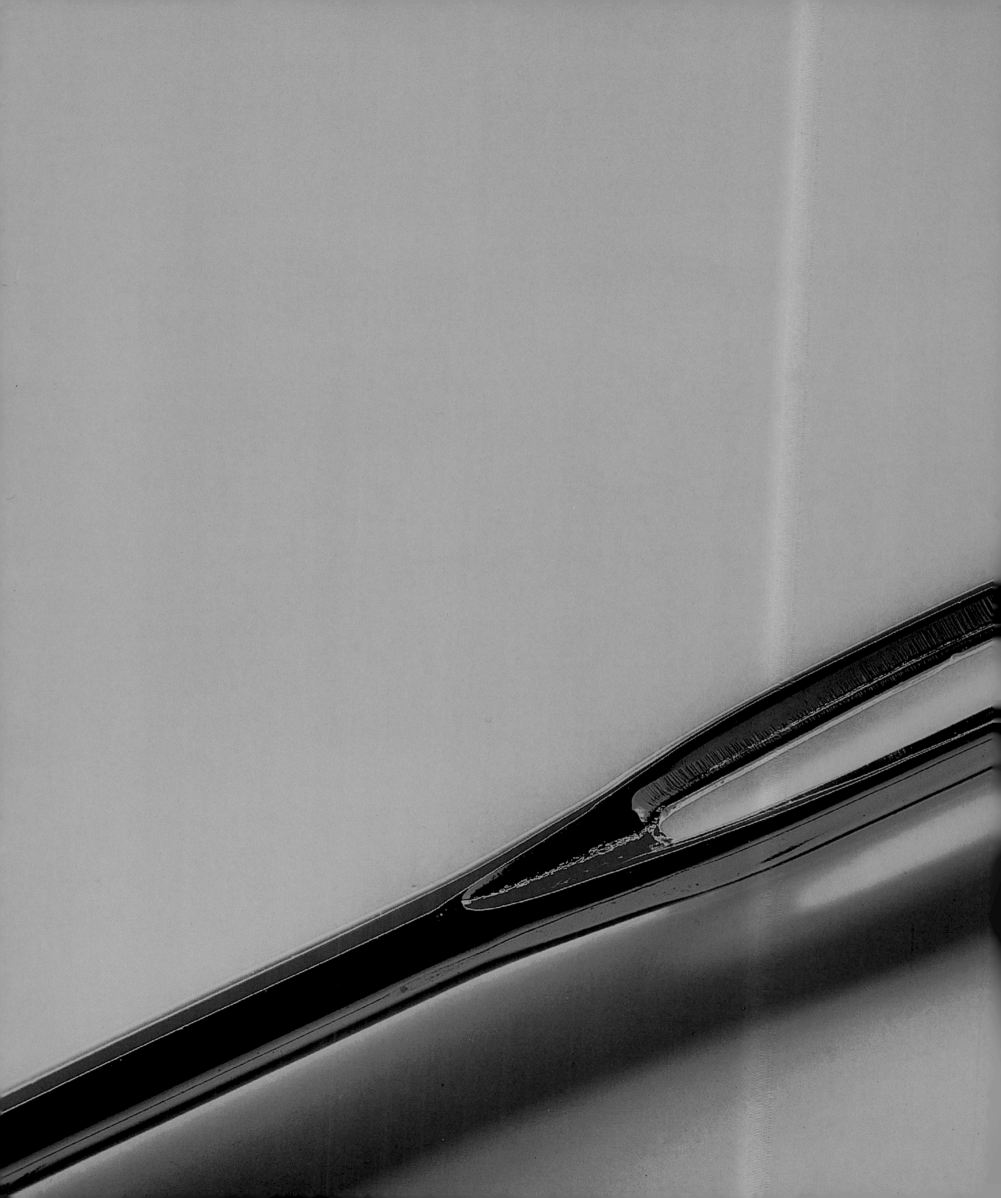

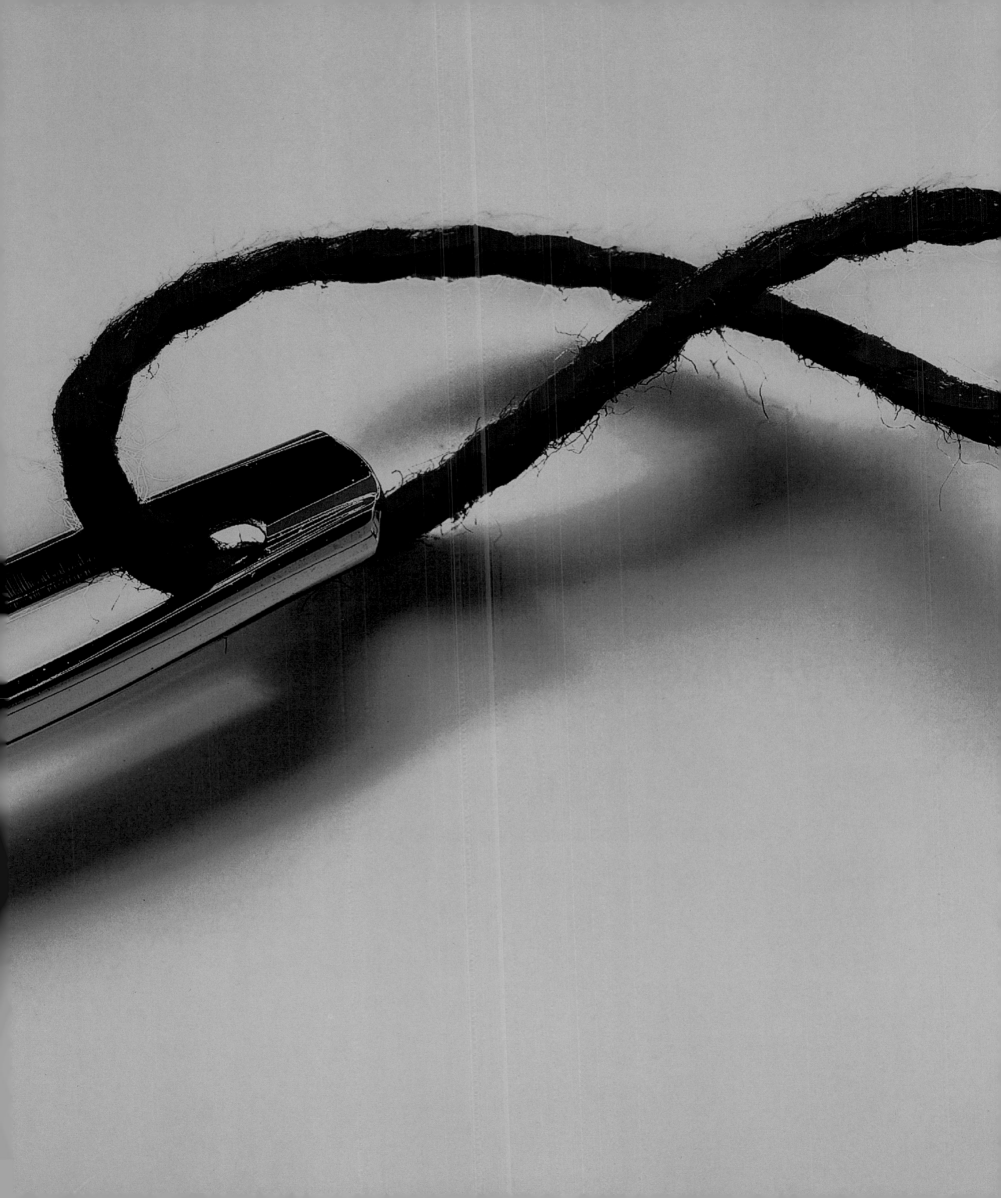

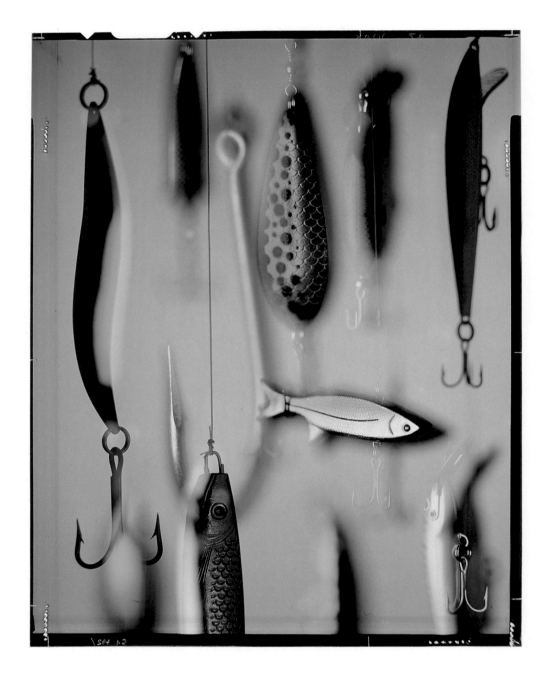

Frank Aschermann

Michael Northrup

◁ Peter Weber

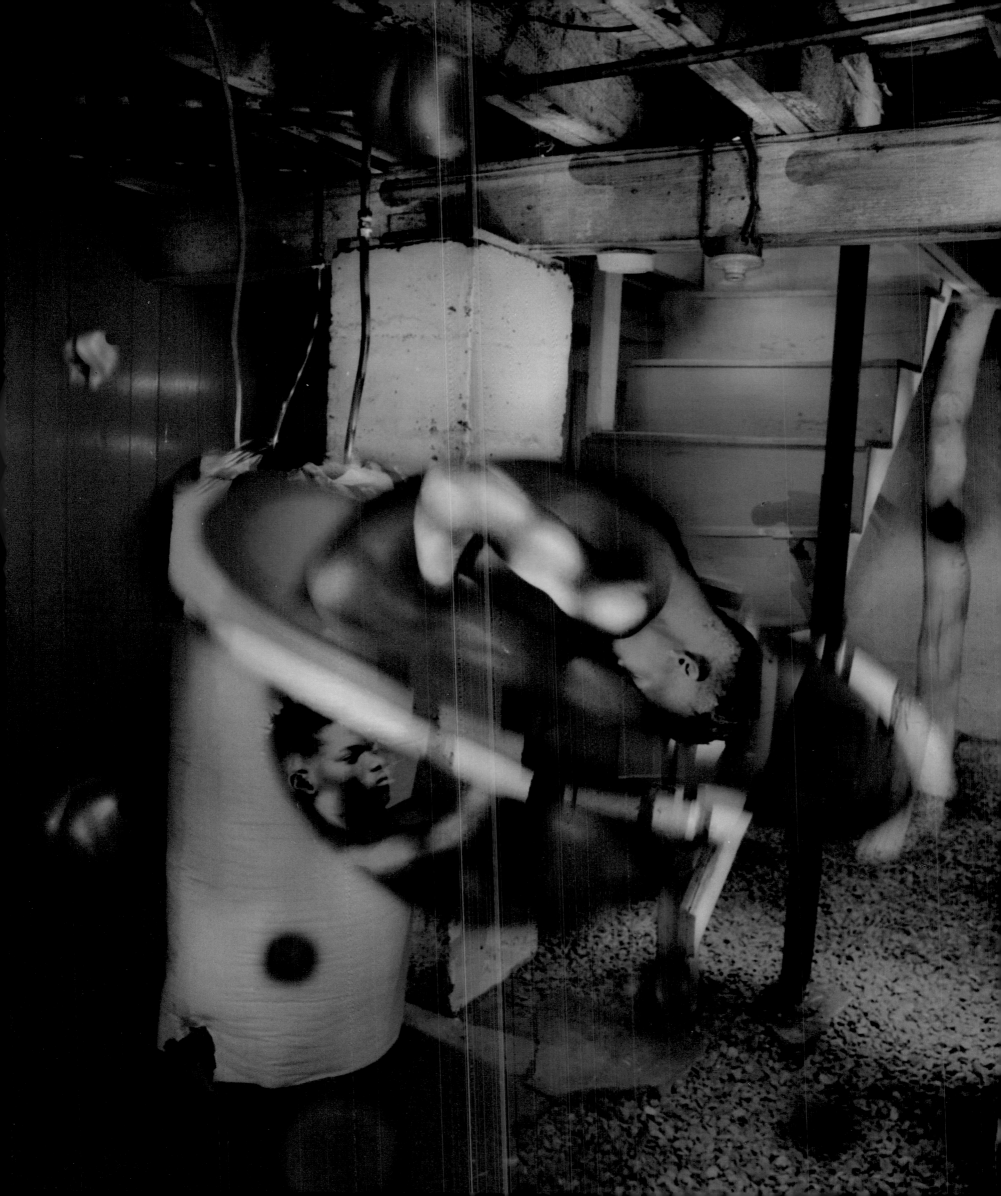

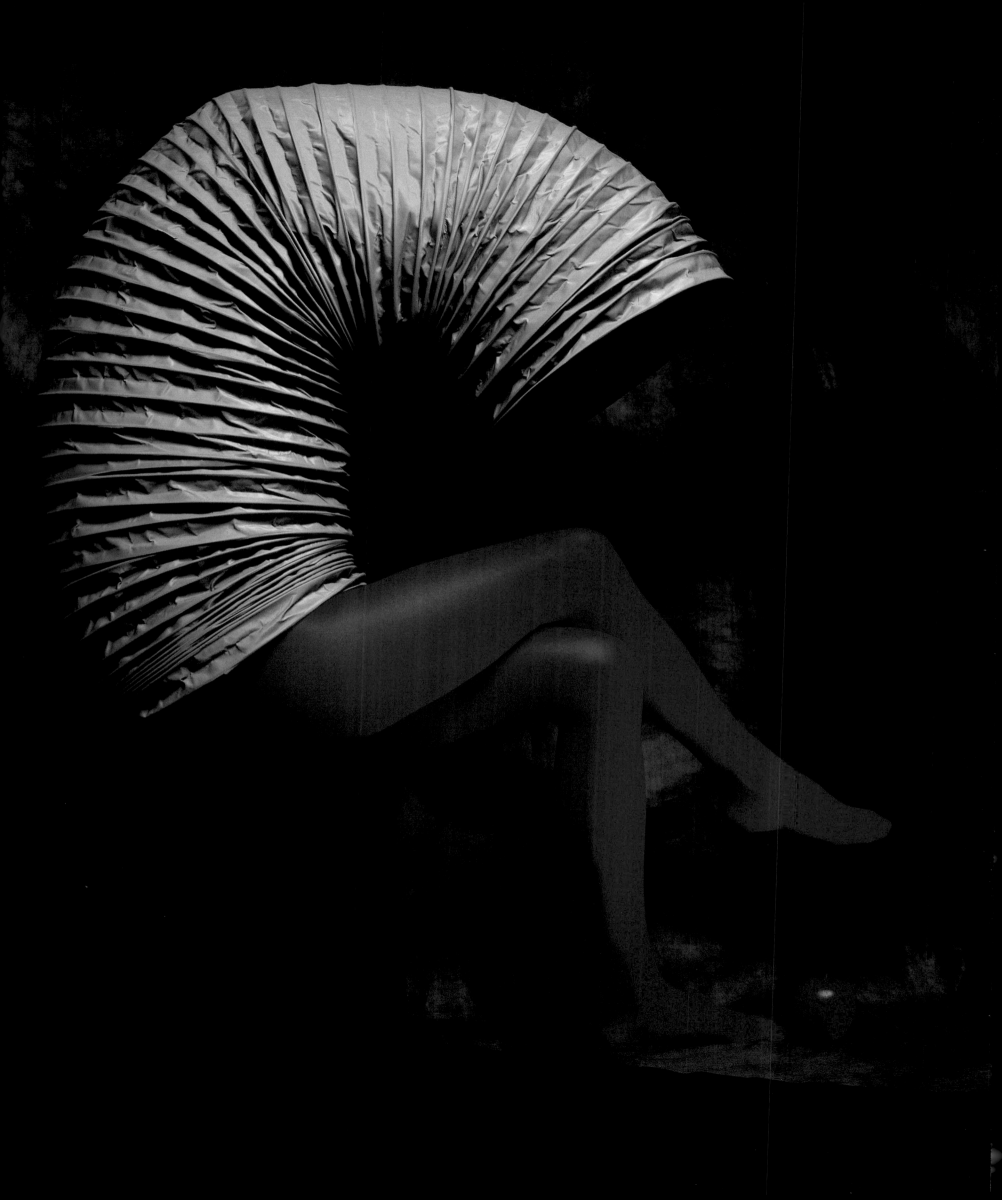

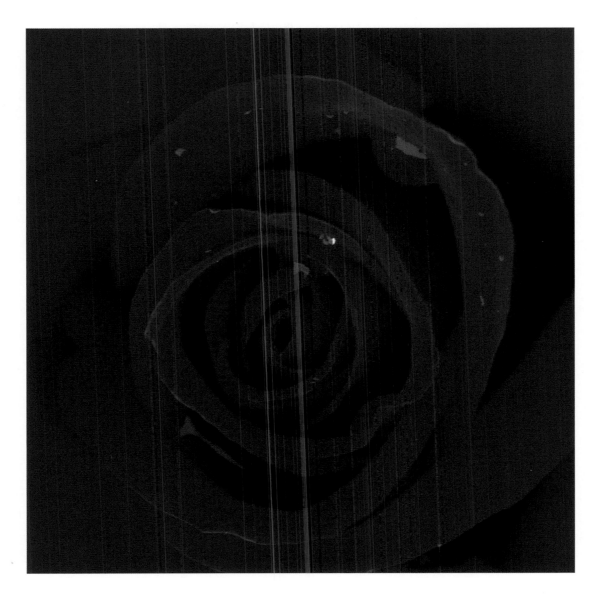

Philip Michael

Guido Cataldo

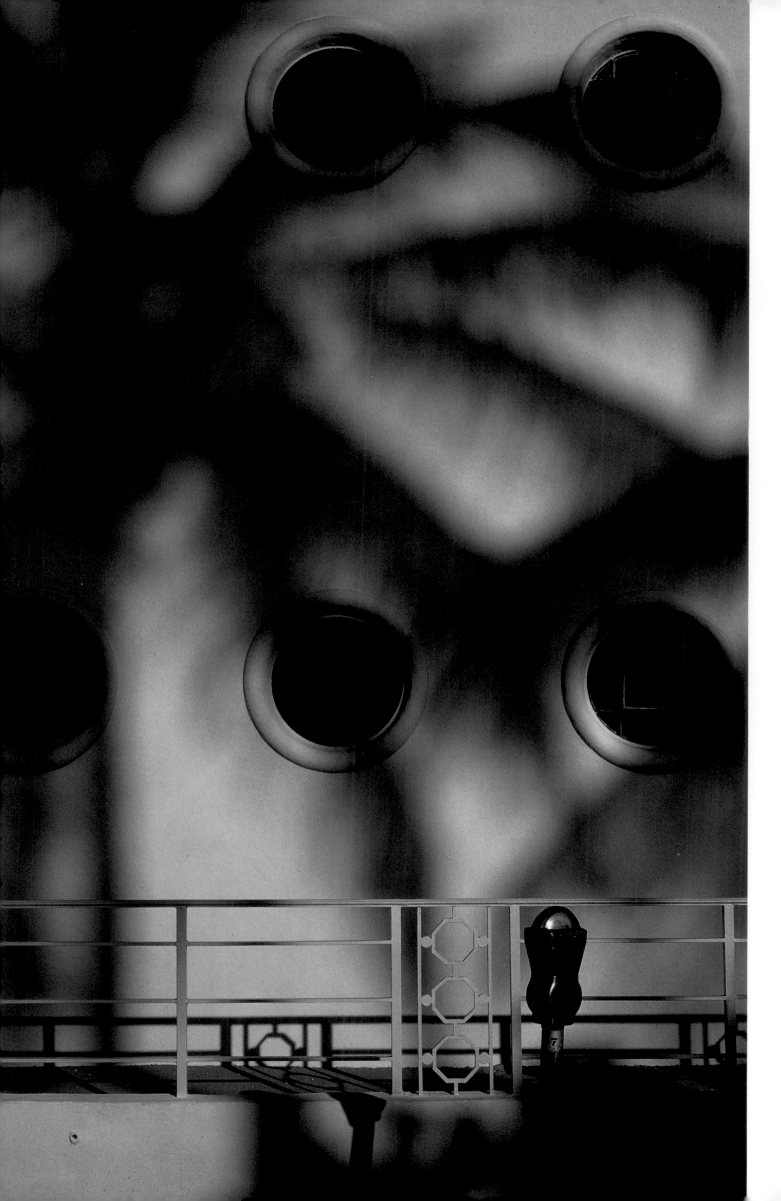

Stewart Charles Cohen

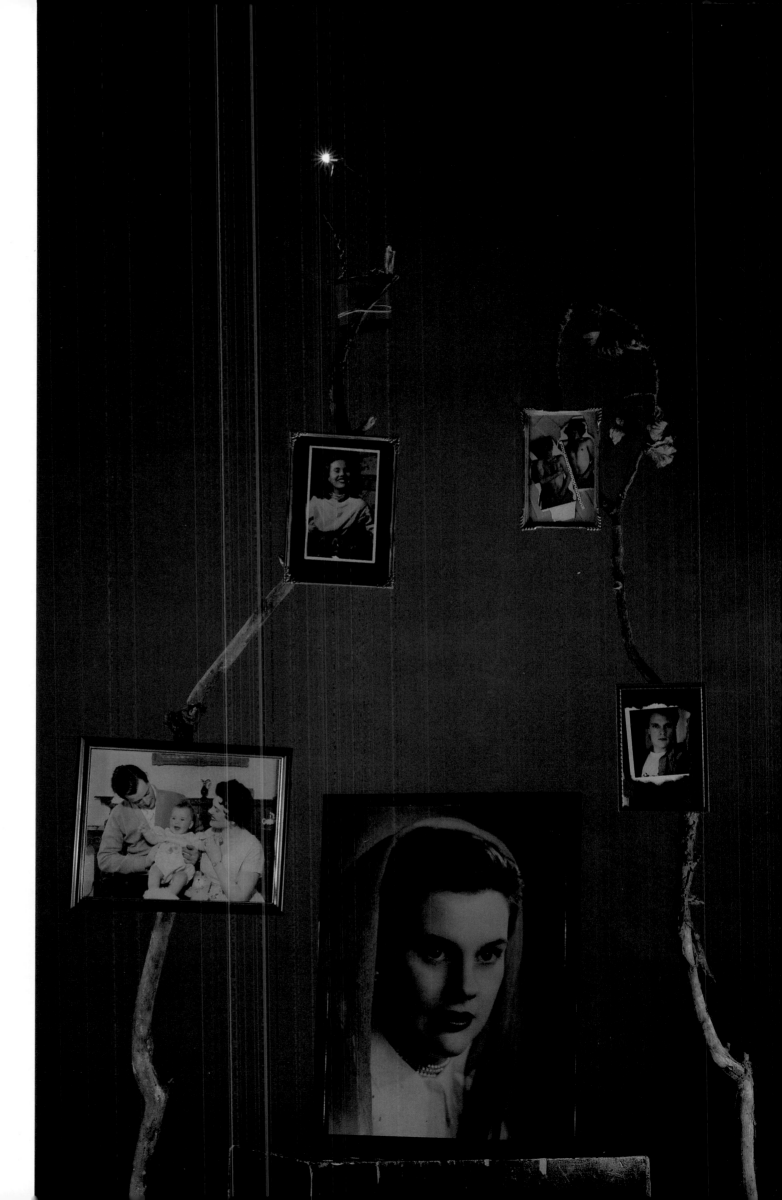

Aatjan Renders

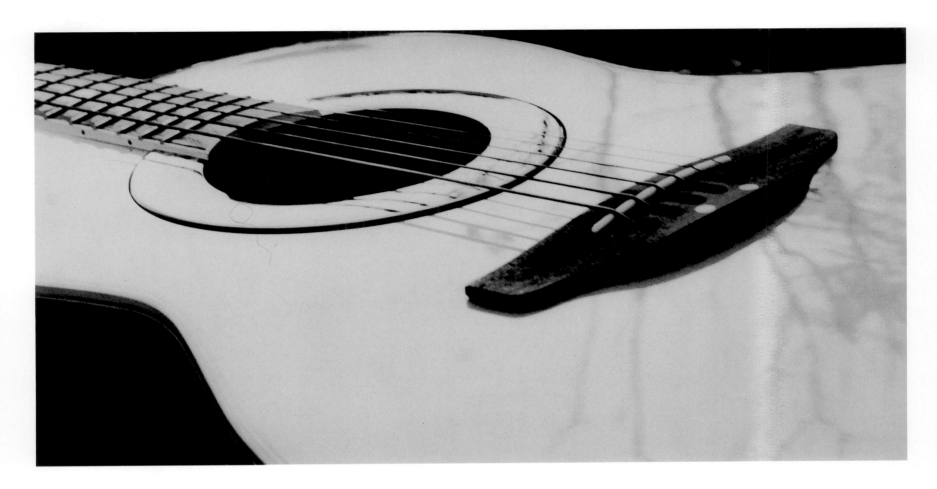

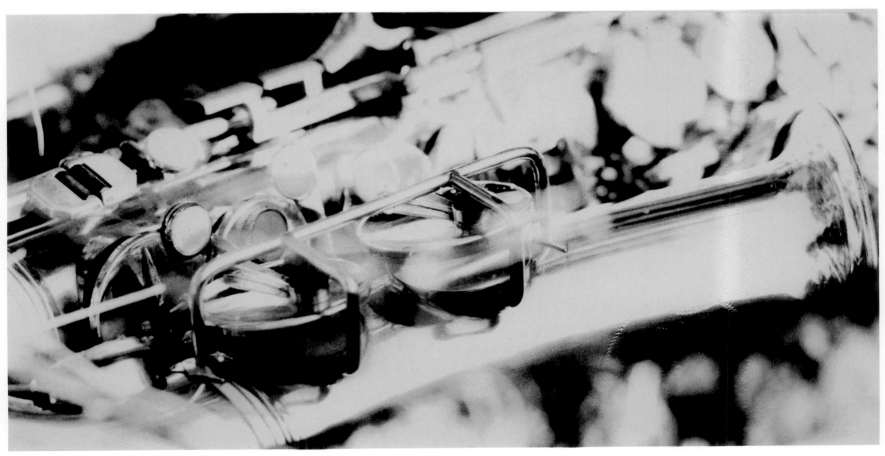

Jesus Martin Chamizo

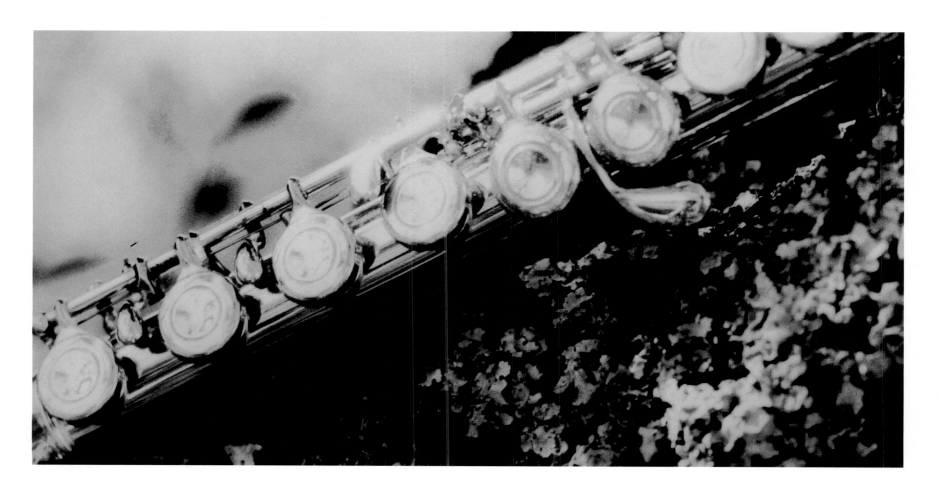

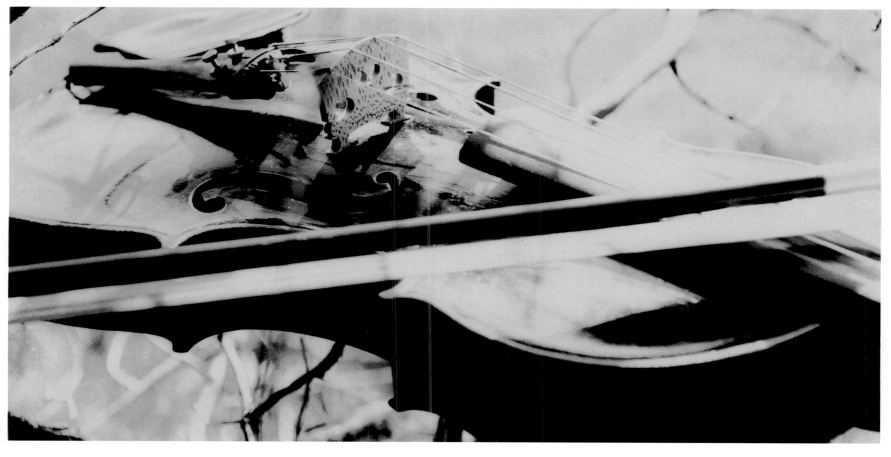

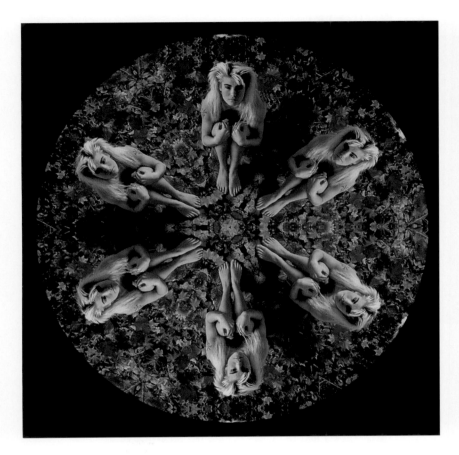

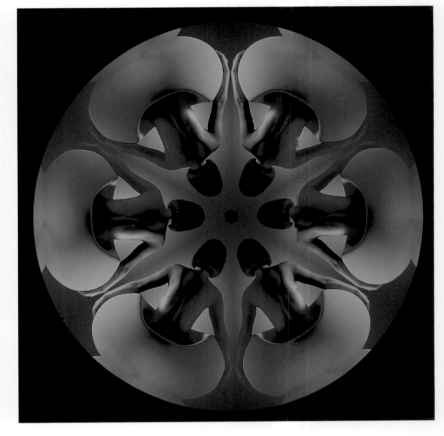

Alfons Iseli

Alfons Iseli

Kuno Rudolph & Thomas Starck ▷▷

Serge Cohen

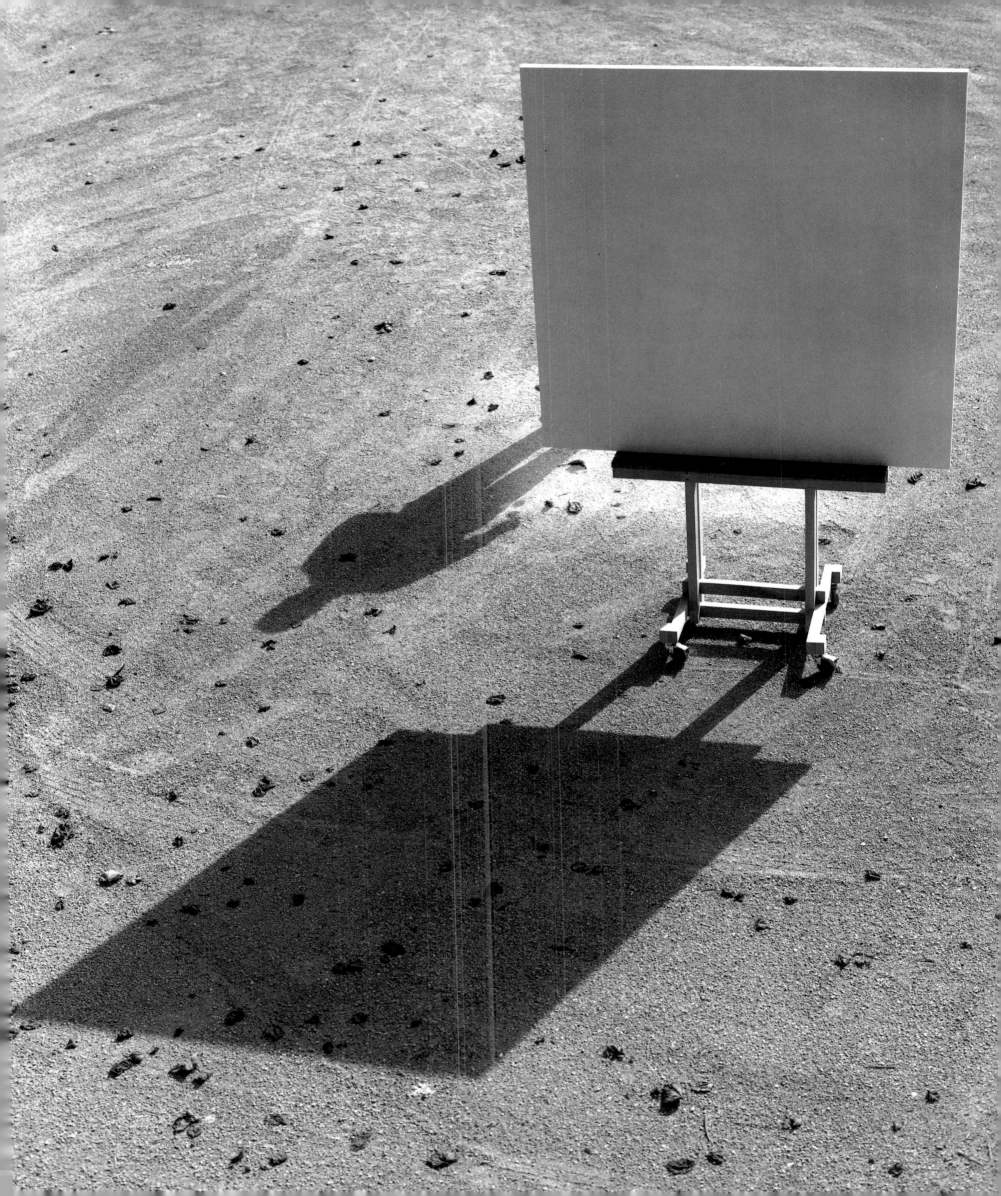

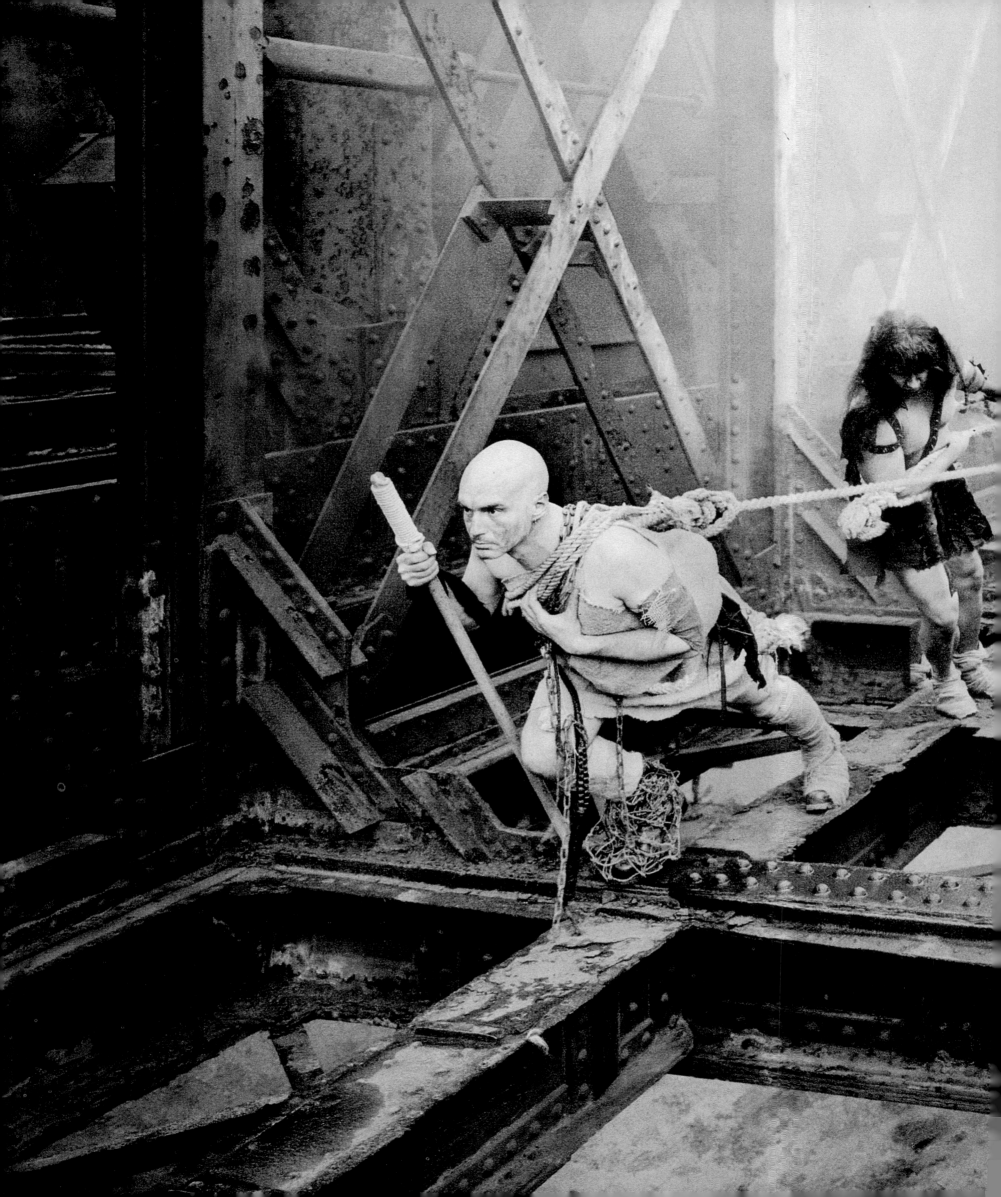

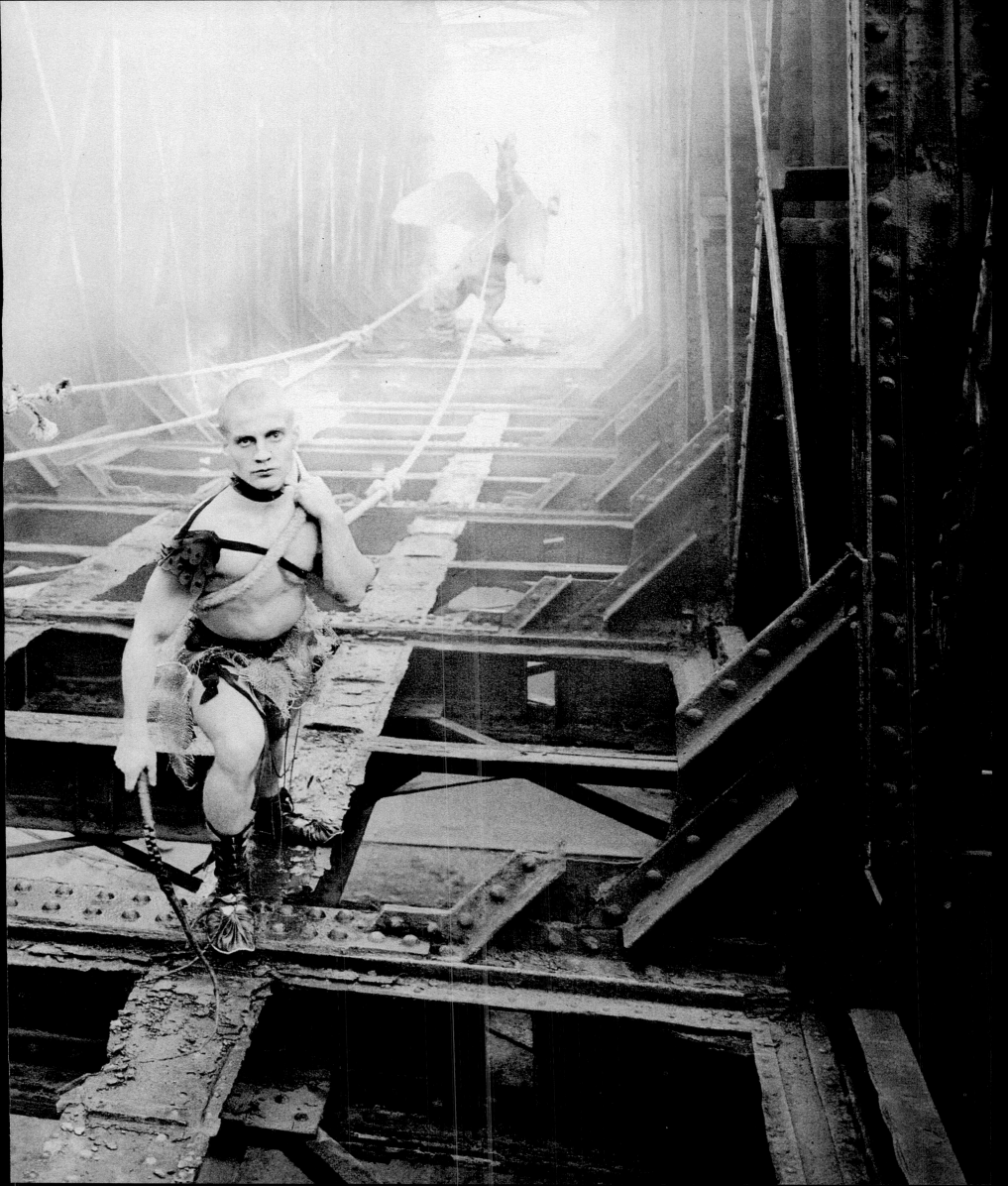

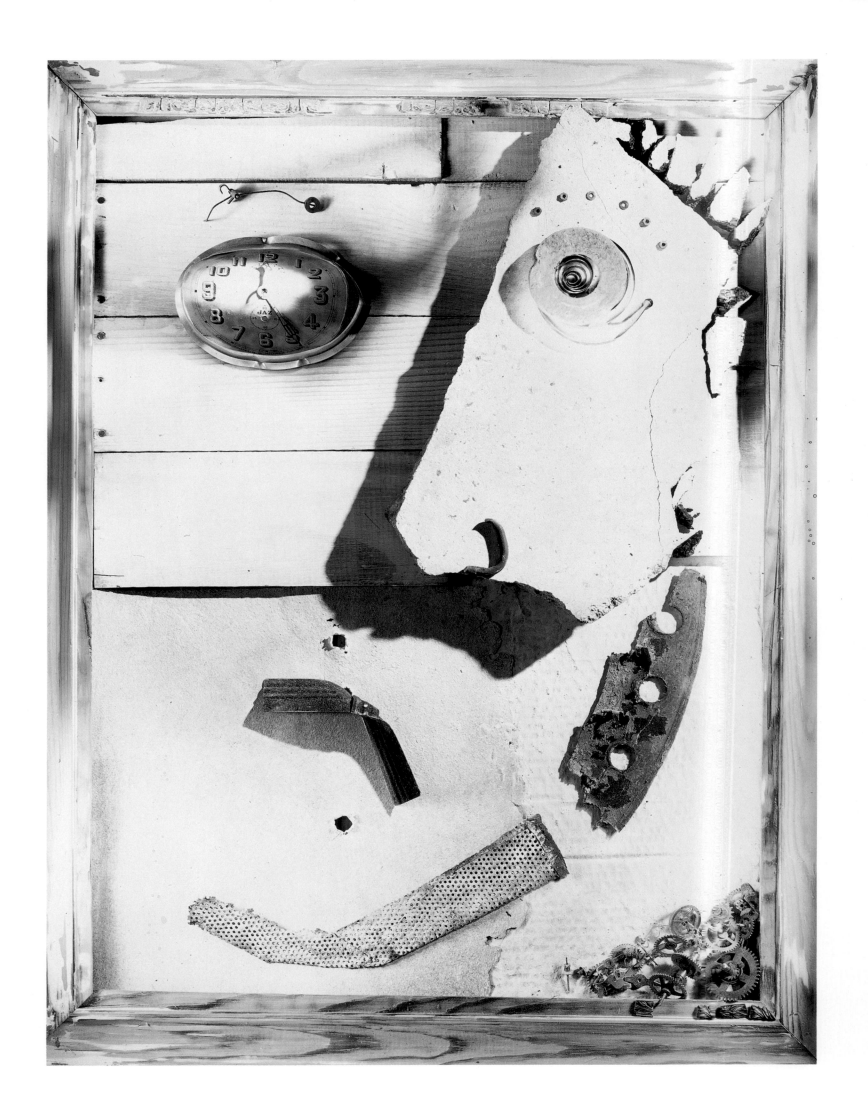

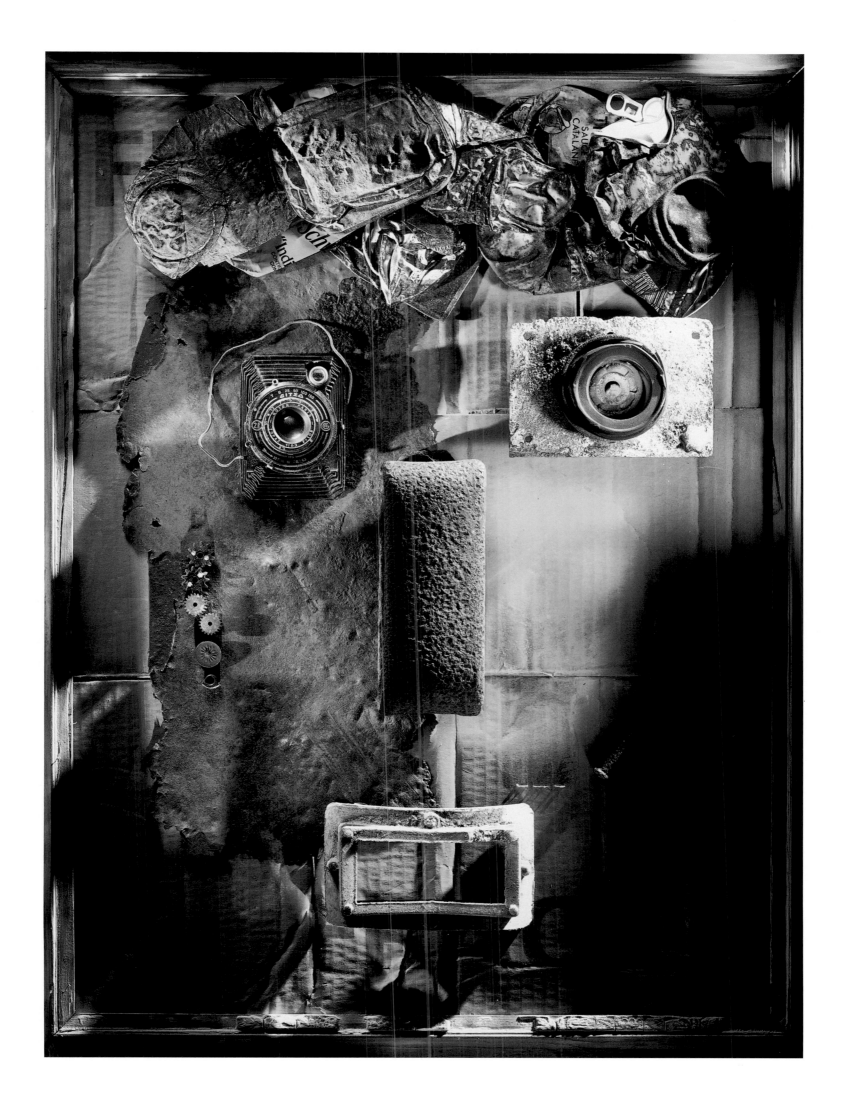

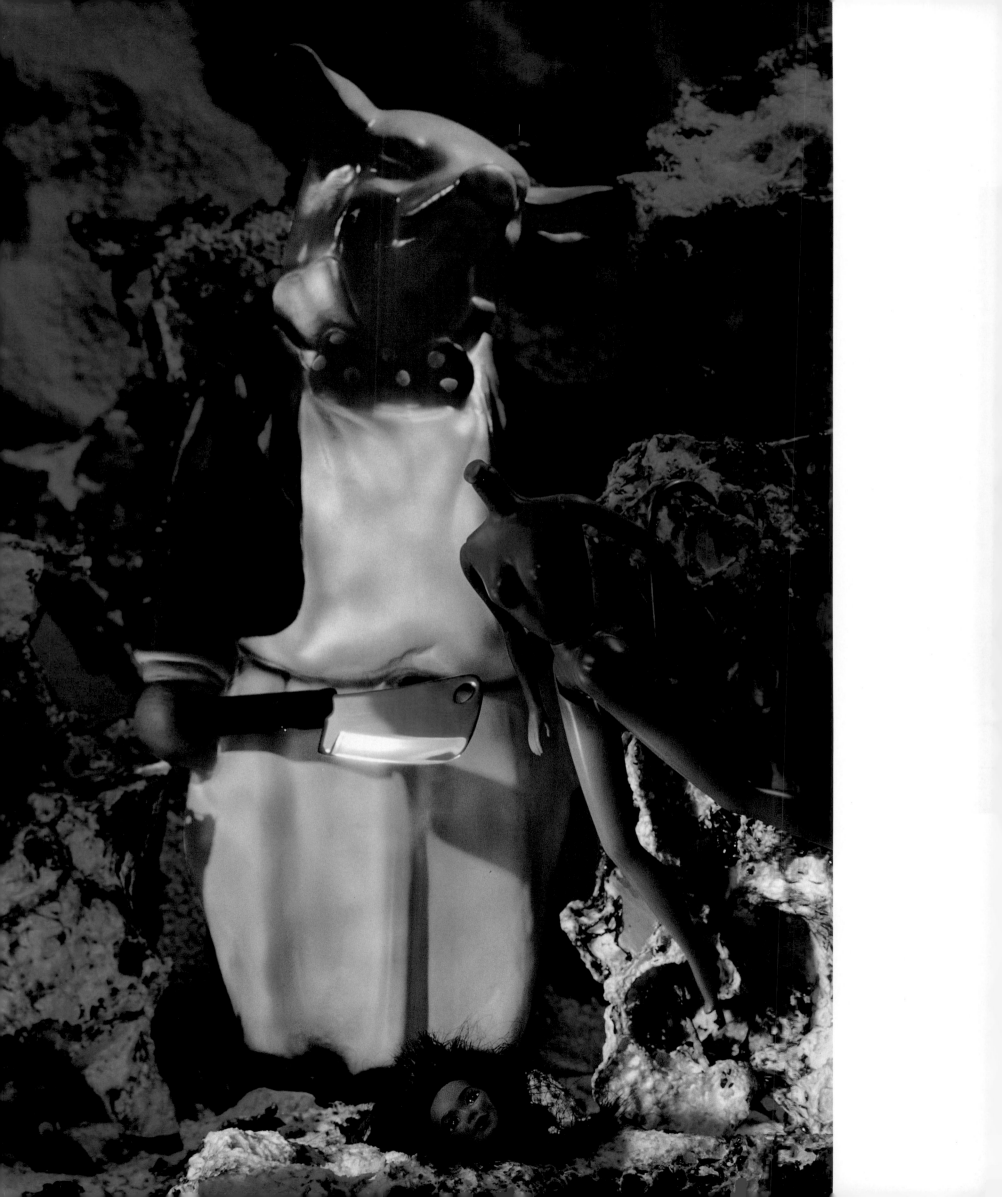

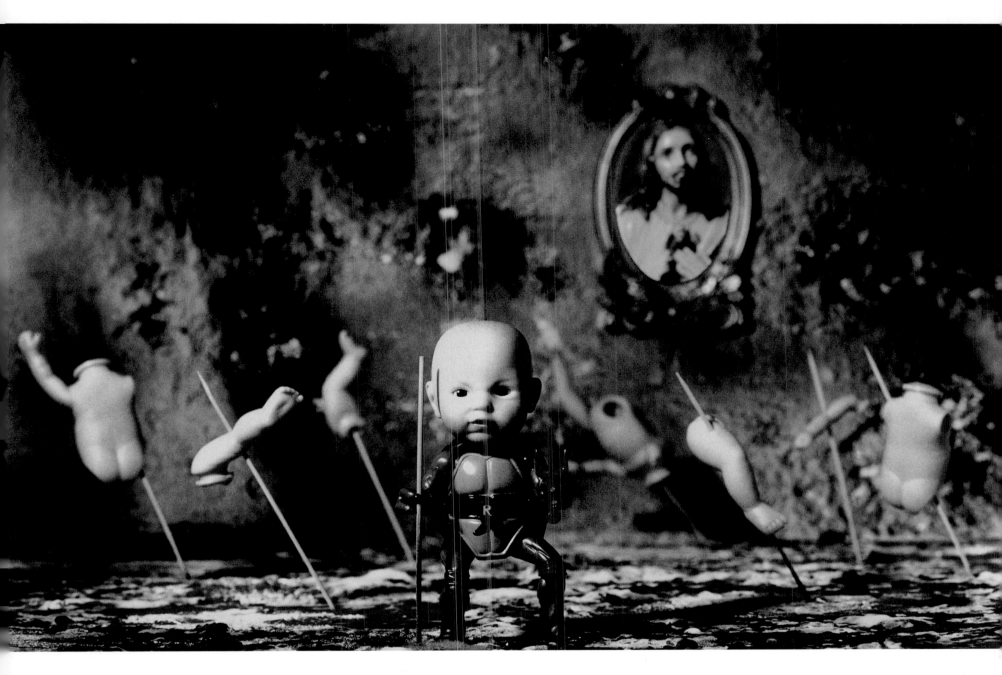

René Heitmüller

René Heitmüller

◁ Pascal Menard

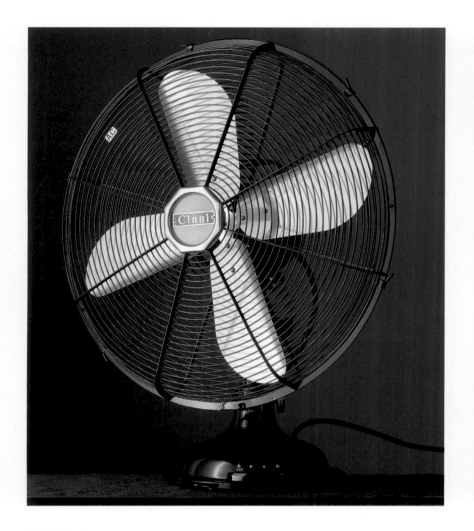

Detlef Odenhausen

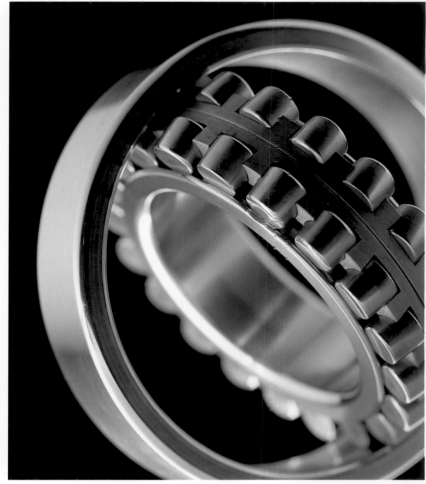

Detlef Odenhausen

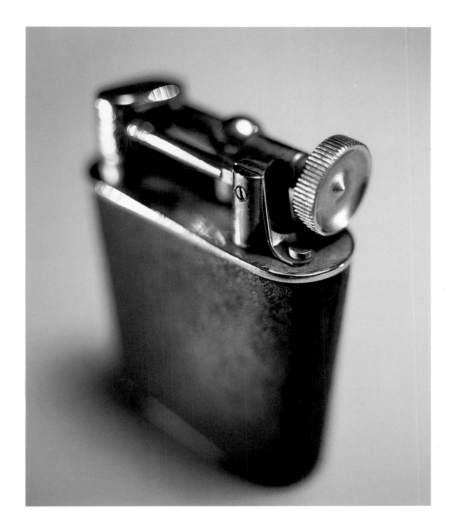

Nick Dolding

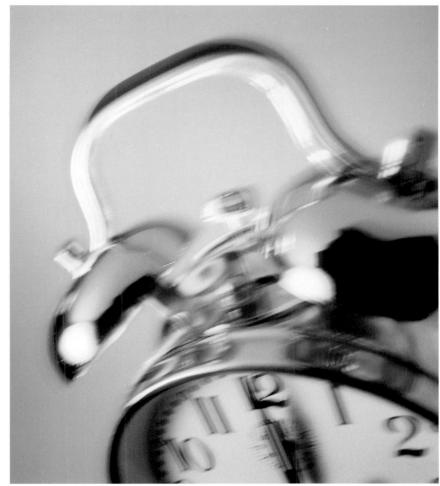

John R. Ward

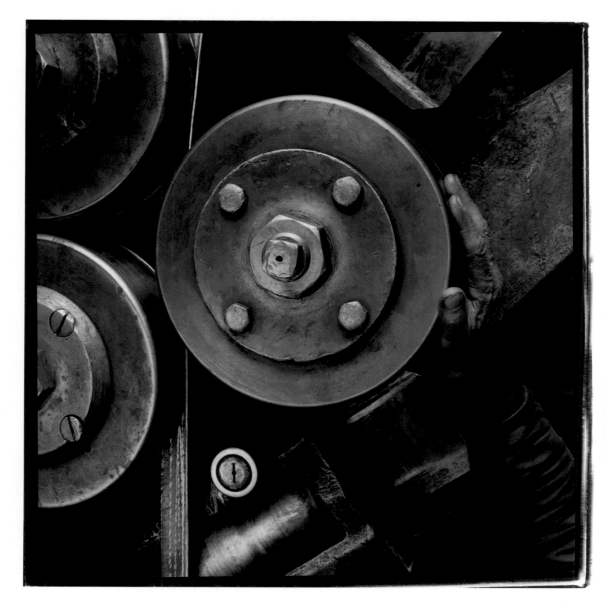

Dan Nelken

Alen MacWeeney

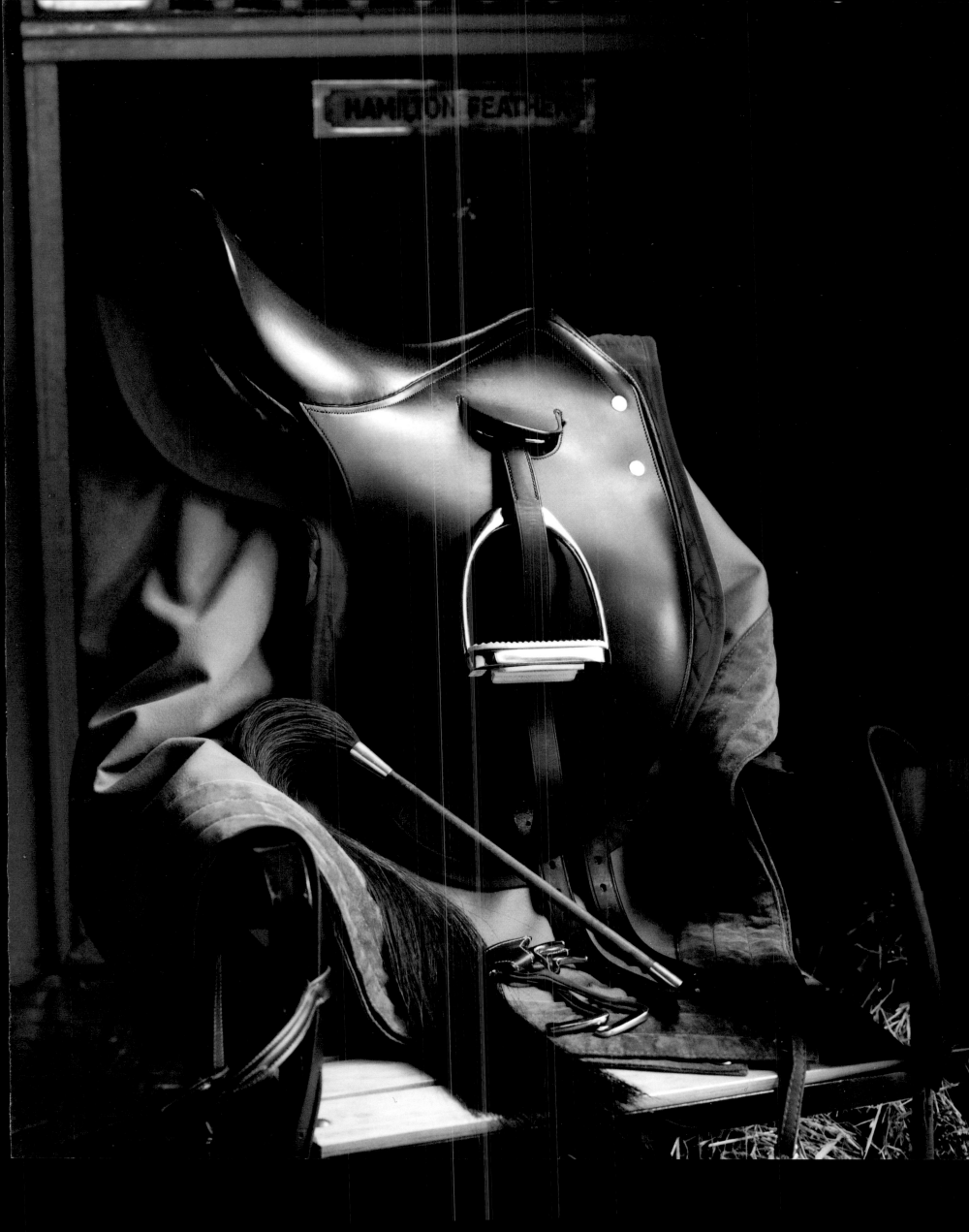

Photographers' Index

Adler, Peter (26)
Friedrichstrasse 44
10969 Berlin
Germany
Tel/Fax: 49-30-2517305

Antich, David Pau (272)
C/Saint Agusti 42
46600 Alzira (Valencia)
Spain
Tel : 34-6-2402480
Fax: 34-6-2400286

Arras, Klaus (204)
Hillerstrasse 15
50931 Koeln
Germany
Tel : 49-221-401344
Fax: 49-221-401226

Art Brewer Photographer (195)
25262 Mainsail Drive
Dana Point, CA 92629
U.S.A.
Tel : 1-714-6618930
Fax: 1-714-2482835

Aschermann, Frank (284)
Studio Frank Aschermann
Hoheluftchaussee 139
20253 Hamburg
Germany
Tel : 49-40-4223060
Fax: 49-40-4223070

Baer, Gordon (22)
18 East 4th Street
Suite 1007
Cincinnati, Ohio 45202
U.S.A.
Tel : 1-513-3814466
Fax: 1-513-3816188

Bartholomew, Larry (130/132/153)
Beate Work Represents
7916 Melrose Avenue, Ste. 2
Los Angeles, CA 90046
U.S.A.
Tel : 1-213-6535088
Fax: 1-213-6535089

Beer, Guenter (212/213)
Beer Photography
Putget 75
08023 Barcelona
Spain
Tel/Fax: 34-3-2120529

Bekker, Philip (217)
Philip Bekker Photography
5070 Trimble Road
Atlanta, GA 30342
U.S.A.
Tel: 1-404-8479777
HlPP://WWW.BEKKER.COM
BEKKER@MINDSPRING.COM

Berman, Howard (179/182)
Bronstein Berman Wills
38 Greene Street
New York, NY 10013
U.S.A.
Tel: 1-212-9252999
Fax: 1-212-9253799

Biela, Jordi Cubells I. (144-5/160-1)
C/Aribau 117, Pral. 1A
08036 Barcelona
Spain
Tel : 34-3-4536683
Fax: 34-3-4512251

Bogdan, Lisa (17)
Lisa Bogdan Photography
450 West 24th Street, Apt. #11A
New York, NY 10011
U.S.A.
Tel : 1-212-4630547
Fax: 1-212-3661715

Bradbury, Richard (111)
7A Langley Street
London WC2H 9JA
United Kingdom
Tel : 44-171-4976677
Fax: 44-171-4976688

Bronstein, Steve (223)
Bronstein Berman Wills
38 Greene Street
New York, NY 10013
U.S.A.
Tel : 1-212-9252999
Fax: 1-212-9253799

Buis, Fjodor Cyriel (63/228)
Studio Burgwal
Burgwal 69
2011 BC Haarlem
The Netherlands
Tel/Fax: 31-23-5366100

Burke, Adrian (188/189)
6 Willow Street
London EC2A 4BH
United Kingdom
Tel: 44-171-7393311

Campbell, Ian (206/277)
Westside Studio
33 Jefferson Avenue, Toronto
Ontario M6K 1Y3, Canada
Tel : 1-416-5351955
Fax: 1-416-5350118

Cataldo, Guido (286)
Guido Cataldo Fotografo
Via Giasona Del Maino 21
20146 Milano
Italy
Tel : 39-2-4982084
Fax: 39-2-48016971

Chamizo, Jesus Martin (290/291)
C/Gonzalez Sola 5
28029 Madrid
Spain
Tel : 34-1-3230562
Fax: 34-1-3230610

Chan, John (43)
11202 Pacific Drive
Malibu, CA 90265-2128
U.S.A.

Claus, Helmut (15/16/171)
Claus Photography
Braunstrasse 17
50933 Koeln
Germany
Tel : 49-221-9498420
Fax: 49-221-9498426

Clemens, Clint (124/127/257)
Clint Clemens Photography
P.O. Box 2439
6 Rachel's Lane
Duxbury, MA 02331
U.S.A.
Tel : 1-617-9349410
Fax: 1-617-9349409

Cohen, Serge (84/86/87/293)
3 Rue De Reims
75013 Paris
France
Fax: 33-1-45867531

Cohen, Stewart Charles (264/288)
Stewart Charles Cohen Photography
2401 South Ervay, Suite 206
Dallas, Texas 75215
U.S.A.
Tel : 1-214-4212186
Fax: 1-214-5650623

Cutler, Craig (33/131/192/256)
Craig Cutler Photography
628-30 Broadway, 4th Floor
New York, NY 10012
U.S.A.
Tel : 1-212-4732892
Fax: 1-212-4738305

Davoust, Dominique (222)
1 Hameau Les Gelinottes
DSFA 78170
La Celle Saint Cloud
France
Tel: 33-1-39696755

Dazeley, Peter (280/281)
The Studios
5 Heathmans Road
Parsons Green Fulham
London SW6 4TJ
United Kingdom
Tel : 44-171-7363171
Fax: 44-171-3718876

De Grove, Benny (27)
Fotostudio De Grove bvba
Zwijnaardesteenweg 28 A
9820 Merelbeke
Belgium
Tel : 32-9-2319616
Fax: 32-9-2319594

Dojc, Yuri (96/133)
28 Briar Hill Avenue, Toronto
Ontario M4R 1H6
Canada
Tel :1-416-5048081
Fax: 1-416-5048082

Dolding, Nick (301)
28/29 Great Sutton Street
London EC1V 0DS
United Kingdom
Tel : 44-171-4902454
Fax: 44-171-2513843

Dry, Tim (82)
Impresaria Photographic
101 Turmill Street
Farringdon, London EC1 5QP
United Kingdom
Tel : 44-171-6222301
Fax: 44-171-9781101

Donnelly, Simon (97)
Snap Photographic Productions
Junkando, Coleman Hill
Halesowen, West Midlands B63 2AL
United Kingdom
Tel/fax: 44-1384-637333

Dubois, Michel (139)
8 Rue Charlot
75003 Paris
France
Tel : 33-1-42724095
Fax: 33-1-42723956
Agents: Dominque Mornet &
Paule Friedland

Duka, Lonnie (164/176)
Duka Photography Inc.
352 Third Street Suite 304
Laguna Beach, CA 92651
U.S.A.
Tel : 1-714-4947057
Fax: 1-714-4972236

Eichhorst, Thorsten (78/79)
Holzmannstrasse 23
12099 Berlin
Germany
Tel/Fax: 49-30-6262671

Eisner, Sandra (174/227/238)
136 Tan Oak Drive
Milford, PA 18337
U.S.A.
Tel : 1-717-2964657
Fax: 1-717-2964658

Elbaz, Lorenzo (187)
Petrixol 5 Atico
08002 Barcelona
Spain
Tel: 34-3-3017431

Enfield, Jill (191/206/249)
211 East 18th Street, 2-T
New York, NY 10003
U.S.A.
Tel/Fax: 1-212-7773510

Ferri, Mark (120)
Mark Ferri Photography
463 Broome Street
New York, NY 10013
U.S.A.
Tel : 1-212-4311356
Fax: 1-212-2264959

Fischer, Dirk (139)
Agnestrasse 8
22301 Hamburg
Germany
Tel : 49-40-4804499
Fax: 49-40-4606108

Fisher, Jon (201)
Jon Fisher Photography Ltd
236 West 27th Street
New York, NY 10011
U.S.A.
Tel/Fax: 1-212-2066311

Fuis, Saša (35/170)
Sasa Fius Photographie
Simon-Meiser-Strasse 24
50733 Koeln
Germany
Tel : 49-221-723832
Fax: 49-221-446368

Food Foto Koeln (211)
Brigitte Krauth
Juergen Holz
Scheidtweiler Strasse 15
50933 Koeln
Germany
Tel : 49-221-5461832
Fax: 49-221-5461902

Foton Co., Ltd (40)
4F Jinnan-Watanabe Building
1-4-8 Jinnan Shibuya-Ku
Tokyo 150
Japan
Tel : 81-3-34619009
Fax: 81-3-34619006

Frahm, Klaus (214/224/225)
Bornsener Strasse 26 F
21039 Bornsen
Germany
Tel : 49-40-7207591
Fax: 49-40-7209764

Fraser, Ian (229/268)
Fraser Studio
Unit 15/4 Botley Works
Oxford 0X2 0LX
United Kingdom
Tel: 44-1865-250088

Freeman, Ed (64/199)
Ed Freeman Photography
912 East Third Street
Studio 304
Los Angeles, CA 90013
U.S.A.
Tel : 1-213-6873113
Fax: 1-213-6873104

Gamba, Mark (19/70/71/113/116/117)
Gamba Photography (220/239)
791 N.W. Trenton Avenue
Bend, OR 97701
U.S.A.
Tel : 1-541-3171000
Fax: 1-541-3171803

George, Fred (74/128/169)
Fred George Photography
40 West 27th Street, 11th Floor
New York, NY 10001
U.S.A.
Tel : 1-212-4813060
Fax: 1-212-4810966

Gisler, Mark (60/61)
Kastenseestrasse 44
81547 Muenchen
Germany
Tel/Fax: 49-89-69025

Goldsmith, Lynn (95)
241 West 36th Street, 7th Floor
New York, NY 10018
U.S.A.
Tel : 1-212-7364602
Fax: 1-212-6432916

Gray, Katie (172/173)
Sunstreak Productions, Inc.
350 Central Park West #B56
New York, NY 10025
U.S.A.
Tel : 1-212-6651481
Fax: 1-212-6651781

Gray, Mitchel (118/119/122)
Sunstreak Productions, Inc.
350 Central Park West #B56
New York, NY 10025
U.S.A.
Tel : 1-212-6651481
Fax: 1-212-6651781

Gwynn, Cat (99/168)
3815 Aloha Street
Los Angeles, CA 90027
U.S.A.
Tel/Fax: 1-213-6605354

Haase, Esther (138/152/158)
Marion Enste-Jaspers
Ackermannstrasse 21
22089 Hamburg
Germany
Tel : 49-40-222226
Fax: 49-40-221062

Haimann, Todd (18)
26 West 38th Street, 2nd Floor
New York, NY 10018
U.S.A.
Tel : 1-212-3910810
Fax: 1-212-7683775

Hamann, Horst (218/219)
Sabine E. Rieck Represents
Schollstrasse 11
82131 Gauting
Germany
Tel: 49-89-8505899

Hampton, Paul (52/98)
The Picture House (Glasgow)
Unit 3 The Quandrangle
Ruchill Street
Glasgow, G20 9PX
United Kingdom
Tel : 44-141-9480000
Fax: 44-141-9480012

Heidelauf, Christoph (210)
Christoph Heidelauf Photografie
Volmerswerther Strasse 53
40221 Duesseldorf
Germany
Tel : 49-211-308724
Fax: 49-211-3983366

Heitmüller, René (298/299)
The Beauty & The Beast
Le Helmersstraat 159 II
1054 DR Amsterdam
The Netherlands
Tel/Fax: 31-20-6834763

Hesser, Elke (53/142/151/155/157)
Elke Hesser Photographie
112 Bld. Rochechouart, Esc. F
75018 Paris
France
Tel : 33-1-42582413
Fax: 33-1-42582443

Hope, Christina (42)
Christina Hope Studio
2720 3rd Street South,
Jacksonville Beach, Florida 32250
U.S.A.
Tel : 1-904-2469689
Fax: 1-904-2467492

Horseman, Mike (53)
21 Yew Tree Road
Edgbaston, Birmingham B15 2LX
United Kingdom
Tel : 44-121-4408856
Fax: 44-121-4276933

Hughes, David (178)
David Hughes Photography
24 Fifth Avenue #324
New York, NY 10011
U.S.A.
Tel: 1-212-5058576

Husebye, Terry (137)
2325 Third Street, Studio 213
San Francisco, CA 94107
U.S.A.
Tel : 1-415-8640400
Fax: 1-415-8640479

Hunyady, Brooke (90/193)
Hunyady Photography Inc.
11 Third Avenue #2E
New York, NY 10003
U.S.A.
Tel : 1-212-7697986
Fax: 1-212-5056197

Iseli, Alfons (278/279/292)
Wiggermatte 5
6247 Scholz
Switzerland
Tel : 41-45-9801313
Fax: 41-45-9504434

Isarrualde, Marcelo (89)
Marcelo Isarrualde Photography
Rosellón 563, No. 5º 1ª
08026 Barcelona
Spain
Tel: 34-3-4364675
Fax: 34-3-2017025

Ivey, Richard (88)
Private View Photographers
26 Leverdale Road
London SE23 2TW
United Kingdom
Tel : 44-181-2911110
Fax : 44-181-2911557

Izu, Kenro (229)
Jean Conlon Represents
140 West 22nd Street
New York, NY 10011
U.S.A.
Tel : 1-212-9669897
Fax: 1-212-2559060

Jansen, Pascale (72/73)
Pascale Jansen Fotografie Koeln
Lukasstrasse 30
50823 Koeln
Germany
Tel/Fax: 49-221-5101550

Janssens, Alain (246)
Rue Bonne Nouvelle 72
4000 Liege
Belgium
Tel: 32-41-276791

Jaeger, Michael (102)
Luegallee 13
40545 Duesseldorf
Germany
Tel : 49-211-553035
Fax: 49-211-555213

Jell, Barry (230/231)
Barry Jell Productions
69 Blythe Road
London W14
United Kingdom
Tel: 44-171-6038796

Kawachi, Yutaka (202)
Yutaka Kawachi Studio, Inc.
33 West 17th Street, 2nd Floor
New York, NY 10011
U.S.A.
Tel : 1-212-9294825
Fax: 1-212-6271462

Kempke, Det (158/162)
152 West 26th Street
New York, NY 10001
U.S.A.
Tel : 1-212-7410762
Fax: 1-212 6339235

Klee, Jutta (10)
Marion Enste-Jaspers
Ackermannstrasse 21
22089 Hamburg
Germany
Tel : 49-40-222226
Fax: 49-40-221062

Knoblich, Karin (10/53/138)
Agent: G.Debus
Paulinenstrasse 15
20359 Hamburg
Germany
Tel: 49-40-310710

Koetter, Manfred (12)
Manfred Koetter Photography
Hanauer Landstrasse 186-198
6000 Frankfurt Main
Germany
Tel : 49-69-496525
Fax: 49-69-4950759

Kohanim, Parish (276)
Parish Kohanim Studio Inc.
1130 West Peachtree Street
N.W. Atlanta, Georgia 30309
U.S.A.
Tel : 1-404-8920099
Fax: 1-404-8920156

Kohlberg, Karin (32/93)
Karin Kohlberg Photography
34 White Street
New York, NY 10013
U.S.A.
Tel: 1-212-9660485

Kojima, Tak (147-149/184/185)
135 West 26th Street 10B
New York, NY 10001
U.S.A.
Tel/Fax: 1-212-2432243

Kremer, Michael (23/24/52/53)
c/o Vogelsanger & Partner
Osterwaldstrasse 10
Haus 24
80805 Muenchen
Germany
Tel : 49-89-3617126
Fax: 49-89-3618385

Kurtenbach, Martin (125)
Tondernstrasse 46
50825 Koeln
Germany
Tel: 49-221-551595

Lang, Rob (221)
Rob Lang Photography
1659 Ocean Front Walk
Santa Monica, CA 90401
U.S.A.
Tel: 1-310-3191929

Lanpher, Keith (247)
Lanpher Productions Inc.
865 Monticello Avenue
Norfolk, VA 23510
U.S.A.
Tel: 1-804-6273051

MacWeeney, Alen (66-69/136/162)
Alen MacWeeney Inc. (303)
171 First Avenue
New York, NY 10003
U.S.A.
Tel : 1-212-4732500
Fax: 1-212-4732250

Malmström, Eric (43/45)
Ström Photography
2400 Virginia Avenue N.W.
C 419, Washington DC 20037
U.S.A.
Tel: 1-202-4293742
Fax: 1-202-5042465

Mandakis, Nik (62)
Foto Futura
93 Baptist Street
Redfern Sydney
Australia
Tel : 61-2-8413754
Fax: 61-2-3193208

Marsel, Steve (20/21/269)
Steve Marsel Studio
215 First Street
Cambridge, MA 02142
U.S.A.
Tel : 1-617-5474445
Fax: 1-617-5479685

May, Dale (28/29)
Dale May Photography
47 South 5th Street
Brooklyn, NY 11211
U.S.A.
Tel/Fax: 1-718-7823329

McDonald, Jock (25/63)
Jock McDonald Photography
46 Gilbert Street
San Francisco, CA 94103
U.S.A.
Tel : 1-415-6210492
Fax: 1-415-6210601

Medilek, Peter (30/31)
Claus & Associates
354 Broome Street #4
New York, NY 10013
U.S.A.
Tel: 1-212-2749263
Fax: 1-212-2748953

Menard, Pascal (296/297)
301 Rue De Belleville
75019 Paris
France
Tel: 33-1-42401135

Michael, Philip (233/235/240/241/287)
Philip Michael Photography
421 N. 23rd Street
Allentown, PA 18104
U.S.A.
Tel: 1-610-8207674

Miles, Jonnie (8/53)
Jonnie Miles Photography
309 West 99th Street, #3B1
New York, NY 10025
U.S.A.
Tel: 1-212-8657956

Millard, Robert (52/85)
Robert Millard Photography
1435 Gardena Avenue
Studio 10, Glendale CA 91204
U.S.A.
Tel: 1-818-2474700

Miller, Karen (13/82/83)
Karen Miller Photography
& Hand Coloring
312 Nevice Way
Venice, CA 90291
U.S.A.
Tel : 1-310-8275921
Fax: 1-310-8272412

Moreau, Jocelyn (92)
Jocelyn Moreau Fotografie
Oosterhovtlaan 7
2012 RA Haarlem
The Netherlands
Tel: 31-23-5470647

Morini, Stefano (253)
Stefano Morini Photography
Pza. Unversidad, 4, 2º
08007 Barcelona
Spain
Tel : 34-93-4151664
Fax: 34-93-4534247

Morrison, John (134/135/140/141)
Westside Studio
33 Jefferson Avenue
Toronto, Ontario M6K 1Y3
Canada
Tel: 1-416-5351955
Fax: 1-416-5350118

Mueller, Eva (143)
16 Warren Street #2
New York, NY 10007
U.S.A.
Tel: 1-212-6081227

Mui, Kai H. (112/123/150/174/175/262)
Mui & Gray
210 E. Lombard Street, Suite 301
Baltimore, MO 21202
U.S.A.
Tel : 1-410-8371112
Fax: 1-410-8377060

Nat, Dottsie Dorothy (234)
7126 Leader Street
Houston, TX 77074-3424
U.S.A.
Tel: 1-713-7843416

Nelker, Dan (100/103/166/167/302)
Dan Nelken Studio Inc.
43 West 27th Street
New York, NY 10001
U.S.A.
Tel : 1-212-5327471
Fax: 1-212-5329381

Neumann, Peter (252)
30 East 20th Street
New York, NY 10003
U.S.A.
Tel : 1-212-4209538
Fax: 1-212-4201140

Nicoll, Bruce (52)
Impresaria Photographic
101 Turmill Street
Farringdon, London EC1 5QP
United Kingdom
Tel : 44-171-6222301
Fax: 44-171-9781101

Nielsen, Anne (175)
Anne Nielsen Photography
288 West 12th Street
New York, NY 10014
U.S.A.
Tel/Fax: 1-212-4630712

Nordmann, Klaus-Peter (75/81)
Klaus-Peter Nordmann Photografie
Weissenburgstrasse 8
65183 Wiesbaden
Germany
Tel : 49-611-409369
Fax: 49-611-407602

Northrup, Michael (285)
Strobophoto Design Studio
2350 Eutaw Place
Baltimore, MO 21217
U.S.A.
Tel/Fax: 1-410-6694705

Odenhausen, Detlef (300)
Dianastrasse 25
40223 Duesseldorf
Germany
Tel : 49-211-9179010
Fax: 49-211-9179040

O'Toole, Terence (101/273)
Terence O'Toole Images
14238 North 12th Street
Phoenix, Arizona 85022-4403
U.S.A.
Tel: 1-602-7897845

Overbeeke, Aernout (216/226/250/251)
Aernout Overbeeke Fotograaf
Coen Cuserhof 39
2012 G2 Haarlem
The Netherlands
Tel : 31-23-5324000
Fax: 31-23-5320323

Paterson, David (249)
David Paterson Photography
88 Cavendish Road
London SW12 0DF
United Kingdom
Tel : 44-181-6732414
Fax: 44-181-6759197

Pearson, John (236)
John Pearson Photography/Video
1343 Sacramento St.
Berkeley, CA 94702
U.S.A.
Tel: 1-510-5257553

Peringer, Brenda (94)
80 Barrington Road
London N8 8QX
United Kingdom
Tel: 44-181-2926582

Pieterse, Anno (65/274)
Anno Pieterse Fotografie
Burgenster Vening, Heineszlaan 123
1063 AX Amsterdam
The Netherlands
Tel : 31-20-6146535
Fax: 31-20-6149373

Pobyjpicz, Peter (114/115/126)
Agent: Dagmar Staudenmaier
Prinzenstrasse 50
80639 Muenchen
Germany
Tel : 49-89-173348
Fax: 49-89-173961

Powers, David (52)
2699 18th Street
San Francisco, CA 94110
U.S.A.
Tel : 1-415-6417766
Fax: 1-415-6418822

Rausser, Stephanie (46/47/177/200)
4053 Harlan, #203
Emeryville, CA 94608
U.S.A.
Tel : 1-510-6549470
Fax: 1-510-6011570

Rebmann, Klaus-Dieter (266/267)
Wiesenstrasse 74
70794 Filderstadt
Germany
Tel : 49-711-7089545
Fax: 49-711-702013

Renders, Aatjan (289)
Prinsengracht 860
1017 JN Amsterdam
The Netherlands
Tel/Fax: 31-20-6201699

Rieder & Walsh Photography (36/91)
424 North Craig Street
Pittsburg, Pennsylvania 15213
U.S.A.
Tel : 1-412-6211268
Fax: 1-412-6219030

Rossi, Guido Alberto (198/235/237)
The Image Bank Italia
Via Terraggio No. 17
20123 Milano
Italy
Tel : 39-2-874693
Fax: 39-2-8057739

Rumpf, Friedrich K. (54/55/196/197)
Vorbirgsstrasse 64
53119 Bonn 1
Germany
Tel : 49-228-652171
Fax: 49-228-633389

Rudolph, Kuno (181/294-5)
Starck, Thomas (254/263)
Potsdamer Platz Photo Studio
Koethener Strasse 38
10963 Berlin
Germany
Tel : 49-30-2616027
Fax: 49-30-2641338

Schmauch, Oliver (76/77)
Suelzgurtel 65
50937 Koeln
Germany
Tel : 49-221-542466
Fax: 49-221-9498426

Schlegelmilch, Rainer (258-9/260-1)
Gustav-Freytag Strasse 34
60320 Frankfurt Main
Germany
Tel : 49-69-561734
Fax: 49-69-5604238

Schulzki, Jürgen (34)
Fotografie Elsner/Schulzki
Hermann-Loens-Strasse 7
51469 Bergisch-Gladbach
Germany
Tel : 49-2202-50941
Fax: 49-2202-56720

Schulz, Max (41/44)
Max Schulz Studio
Mintarder Strasse 210
45481 Mulheim/Ruhr.
Germany
Tel : 49-208-482203
Fax: 49-208-483196

Silverman, Jay (121)
Jay Silverman Productions
920 North Citrus Avenue
Hollywood, CA 90038-2402
U.S.A.
Tel : 1-213-4666030
Fax: 1-213-4667139

Smith, Rodney (154/156/163)
Rodney Smith Ltd
P. O. Box 48
Snedens Landing
Palisades, NY 10964
U.S.A.
Tel : 1-914-3593814
Fax: 1-914-3598408

Stempell, Ruprecht (76/77)
Aachener Strasse 348
50933 Koeln
Germany
Tel : 49-221-542466
Fax: 49-221-9498426

Stewart, Holly (206)
Holly Stewart Photography
370 4th Street
San Francisco, CA 94107
U.S.A.
Tel : 1-415-7771233
Fax: 1-415-7772997

Stringfellow, Kim (50/51)
Kim Stringfellow Photography
564 Mission #657
San Francisco, CA 94105
U.S.A.
Tel/Fax: 1-415-8646475

Strobel, Peter (209)
Strobel Photodesign AWI
Herbigstrasse 9
50825 Koeln
Germany
Tel : 49-221-5502727
Fax: 49-221-5505204

Tang, Ringo (11/186)
G/F 31 Robinson Road
Hong Kong
Tel : 852-25215185
Fax: 852-28685456

Tenneson, Joyce (48/49)
114 West 27th Street, 9th Floor
New York, NY 10001
U.S.A.
Tel : 1-212-7419371
Fax: 1-212-6753378

Thijssen, André (frontispiece)
Binnenkadijk 315
1018 AX Amsterdam
The Netherlands
Tel : 31-20-6270013
Fax: 31-20-6384582

Thoma, Benno (38/39)
Benno Thoma Photographie
Beatrix Strasse 81
7511 KP, Enschede
The Netherlands
Tel/Fax: 31-23-4327476

Toy, Jo Ann (80)
67 Sullivan Street, #H
New York, NY 10012
U.S.A.
Tel : 1-212-9690744
Fax: 1-212-2749246

Tracy, Janis (190/207)
Janis Tracy Photography Inc.
213 West Institute Place
Chicago, IL 60610
U.S.A.
Tel : 1-312-7877166
Fax: 1-312-7871262

Trent, Brad (14/104/106-110)
33 Greenwich Avenue
New York, NY 10014
U.S.A.
Tel : 1-212-6272147
Fax: 1-212-6272323

Vanbecelaere, Johan (205/208)
Vanbecelaere Photography
Broekstraat 22
1831 Machelen-Diegen
Belgium
Tel : 32-2-7211797
Fax: 32-2-7255418

Vasilev, Jacko (56-59/180/194)
Stara Zagora 6003
Stacen 4
Bulgaria
Tel: 359-56643/042

Vogt, Christian (37)
Augustinergasse 3
4051 Basel
Switzerland
Tel : 41-61-2714600
Fax: 41-61-2714606

Ward, John R. (301)
65 Shakespeare Road
London W7 1LU
United Kingdom
Tel : 44-181-5791325
Fax: 44-181-7239984

Wark, Jim (232/234/248)
Airphoto
5 Bellita Drive
Pueblo CO 81001
U.S.A.
Tel/Fax: 1-719-5451051

Weber, Peter (282/283)
Peter Weber Fotograf
Auenstrasse 28
80469 Muenchen
Germany
Tel : 49-89-2010472
Fax: 49-89-20239057

Wexel, Dirk Olaf (206)
Marion Enste-Jaspers
Ackermannstrasse 21
22089 Hamburg
Germany
Tel : 49-40-222226
Fax: 49-40-221062

Winter, Conny J. (146/265)
Tuttlinger Strasse 68
70619 Stutgart
Germany
Tel : 49-711-471673
Fax: 49-711-4780120

Wirtz, Manfred (23/242-245)
Bruggstraat 4
1141 BB Monnickendam
The Netherlands
Tel : 31-299-655953
Fax: 31-299-652441

Wood, David (Dr.) (159)
David Wood Foto Studio
127 West 22nd Street
New York, NY 10011
U.S.A.
Tel : 1-212-6757696
Fax: 1-212-6752178

Yani Photography (270/271)
W.G. Plein 35
1054 RA Amsterdam
The Netherlands
Tel: 31-20-6552273

CALL FOR ENTRIES

Should you be interested in being included in the Index, we would ask you to send us a representative selection of your recent work in the form of transparencies or photographs suitable for reproduction, to enable us to select works we wish to use in the publication. **The deadline for entries for the 1997 Index is 15 April 1997.** We will, of course, also require all the relevant information which will accompany each work, e.g. title, year, client, etc. Please do not send us originals. The publication of your work in the Index will be free of charge to you. Your name and address will be listed in the book. We would ask you to sign and return the contract along with your submission for the publication to us at the address below.

TERMS AND CONDITIONS FOR PUBLICATION OF MATERIALS SUPPLIED TO THE PUBLISHER BY THE ARTIST FOR INCLUSION IN THE INDEX.

1. The Artist grants and assigns the Publisher (Page One Publishing Pte Ltd) the right to publish the work submitted by the artist in the Index without limitation in quantity and in any size and for an unlimited period of time.

2. The Publisher has the right to have the published Index sold in any country, without geographical limitation. The right to publish the work is non-exclusive.

3. The Publisher may refuse to reproduce any submitted entry, transparency or photograph, which he feels is unsuitable for publication in the Index.

4. The Publisher will not be responsible for printing discrepancies, for damage to or loss of any material supplied, howsoever this may arise, nor for any delay in publishing, or omission to publish any accepted submission.

5. Submitted material will become the property of the Publisher. It may be returned to the Artist on demand and at the expense of the Artist.

6. The Artist represents and warrants that he is the sole and exclusive proprietor of all materials submitted by him to the Publisher, whether transparencies, photographs, copies or other, and that the inclusion of these in the Index will not infringe upon any existing copyright or other proprietary right; he further guarantees that these materials will not contain matter which is objectionable, obscene, defamatory, or in breach of the peace and good morals of any other law or regulation.

7. The Artist further guarantees that he shall hold the Publisher harmless against any claim against the Publisher by a third party arising out of the materials submitted by him to the Publisher.

8. Notwithstanding the acceptance of material for incorporation in the Index, the Publisher reserves the right, at any time, not to publish, to discontinue publication, or to modify it (e.g. enlarge or reduce in size, bleed edges, use details, cut out). The Publisher rejects all responsibility for the non-appearance of documents or reproduction, whatever the cause might be.

9. The materials may only be used for Index publications and any advertisement, brochure or other printed matter produced specifically for the purpose of promoting the sale of these publications.

✂ -

PLEASE FILL OUT AND ATTACH TO EACH ENTRY.

Title of image:

Art Director:

Designer:

Illustrator, Photographer, Stylist

Agency, Studio:

Client, Publisher:

Description of assignment/other information:

Signature:
I hereby grant Page One Publishing Pte Ltd non-exclusive permission for use of the submitted material, for which I have full reproduction rights.

Agreed by (Artist): Countersigned by (Publisher):
 Page One Publishing Pte Ltd

Name:

Address:

Date:

Könemann Verlagsgesellschaft mbH, attn.: Mary Connolly, Bonner Straße 126, D-50968 Köln, Germany

EINLADUNG ZUR TEILNAHME

Sollten Sie daran interessiert sein, in den Index aufgenommen zu werden, bitten wir Sie, uns eine repräsentative Auswahl Ihrer letzten Arbeiten in Form von reproduktionsfähigen Diapositiven oder Fotos zu übersenden, damit wir diejenigen Arbeiten auswählen können, die wir in der Publikation verwenden möchten. **Letzter Einsendetermin für den Index 1997 ist der 15. April 1997.** Wir benötigen natürlich auch alle relevanten Informationen im Zusammenhang mit den einzelnen Arbeiten, z.B. Titel, Jahr, Kunde u.s.w. Bitte schicken Sie uns keine Originale. Die Veröffentlichung Ihrer Arbeiten im Index ist für Sie kostenlos. Ihr Name und Ihre Anschrift werden im Buch genannt. Bitte unterzeichnen Sie den Vertrag und reichen Sie ihn zusammen mit Ihrem Bildmaterial an die unten angegebene Adresse ein.

BESTIMMUNGEN UND BEDINGUNGEN ZUR VERÖFFENTLICHUNG VON MATERIALIEN, DIE DER KÜNSTLER DEM HERAUSGEBER ZUR AUFNAHME IN DEN INDEX ZUR VERFÜGUNG GESTELLT HAT.

1. Der Künstler gewährt dem Herausgeber (Page One Publishing Pte Ltd) und überträgt auf diesen das Recht zur Veröffentlichung der von ihm eingereichten Arbeiten im Index, und zwar ohne mengenmäßige Beschränkung, in jeder beliebigen Größe und auf unbegrenzte Zeit.

2. Der Herausgeber ist berechtigt, den veröffentlichten Index in jedem beliebigen Land – ohne geographische Einschränkung – verkaufen zu lassen. Das Recht zur Veröffentlichung der Arbeiten ist nicht ausschließlich.

3. Der Herausgeber kann die Reproduktion eingereichter Arbeiten (Diapositive oder Fotos) ablehnen, wenn er der Meinung ist, daß diese sich nicht für eine Veröffentlichung im Index eignen.

4. Der Herausgeber haftet nicht für auf den Druck zurückzuführende Abweichungen, für Schäden an oder Verlust von eingereichten Materialien (gleichgültig auf welche Weise diese entstehen), für Verzögerungen bei der Veröffentlichung oder die Unterlassung der Veröffentlichung angenommener Einsendungen.

5. Eingereichte Materialien gehen in das Eigentum des Herausgebers über. Sie können auf Anfrage und auf Kosten des Künstlers an diesen zurückgesandt werden.

6. Der Künstler erklärt und garantiert, daß er der einzige und ausschließliche Eigentümer aller durch ihn an den Herausgeber gesandten Materialien ist,

und zwar unabhängig davon, ob es sich bei diesen Materialien um Diapositive, Fotografien, Kopien oder sonstige Materialien handelt, und daß durch die Aufnahme derselben in den Index keinerlei bestehendes Copyright oder sonstiges Eigentumsrecht verletzt wird; weiterhin garantiert er, daß diese Materialien nichts enthalten, was anstößig, obszön oder beleidigend ist bzw. die öffentliche Sicherheit gefährdet oder gegen die sittlichen Grundsätze sonstiger Gesetze oder Vorschriften verstößt.

7. Darüber hinaus garantiert der Künstler, daß er den Herausgeber von allen durch einen Dritten an ihn gerichteten Ansprüchen freistellt, soweit letztere auf den dem Herausgeber durch den Künstler überlassenen Materialien beruhen.

8. Der Herausgeber behält sich das Recht vor, unbeschadet der Annahme von Materialien zur Einbeziehung in den Index zu jedem beliebigen Zeitpunkt keine Veröffentlichung vorzunehmen bzw. die Veröffentlichung einzustellen oder sie abzuändern (z.B. Vergrößerung oder Verkleinerung, Beschnitt, Verwendung von Ausschnitten und Freistellungen). Unabhängig vom Grund für das Nichterscheinen von Dokumenten oder Reproduktionen lehnt der Herausgeber jede Haftung für das Nichterscheinen derselben ab.

9. Die Materialien dürfen ausschließlich für Index-Publikationen und Werbeanzeigen, Broschüren oder sonstige Drucksachen verwendet werden, die speziell zum Zwecke der Verkaufsförderung für diese Publikationen hergestellt werden.

BITTE AUSFÜLLEN UND AN JEDE EINGESANDTE ARBEIT HEFTEN.

Bildtitel:

Art Director:

Designer:

Illustrator, Fotograf, Stylist:

Agentur, Studio:

Kunde, Herausgeber:

Beschreibung des Auftrags/sonstige Informationen:

Unterschrift:

Hiermit erteile ich Page One Publishing Pte Ltd die nicht ausschließliche Genehmigung zur Verwendung der eingereichten Materialien, für die ich über alle Reproduktionsrechte verfüge.

Einverstanden (Künstler): Gegengezeichnet durch (Herausgeber): Page One Publishing Pte Ltd

Name:

Anschrift:

Datum:

Könemann Verlagsgesellschaft mbH, attn.: Mary Connolly, Bonner Straße 126, D-50968 Köln, Germany

DEMANDE DE PARTICIPATION

Si vous êtes intéressé par la figuration de vos œuvres dans l'index, nous vous prions de nous envoyer une sélection représentative des plus récentes sous forme de diapositives ou de photographies faciles à reproduire pour nous permettre de sélectionner les ouvrages que nous aimerions utiliser dans la publication. **La date limite d'inscription pour l'index 1997 est le 15 avril 1997.** Il est évident que nous aurons également besoin de toutes les informations importantes spécifiques à chacune des œuvres, par ex. le titre, l'année, le client, etc. Nous vous prions de ne pas nous envoyer d'originaux. La publication de votre œuvre dans l'index sera gratuite. Votre nom et votre adresse seront indiqués dans le livre. Nous vous prions de nous retourner le contrat signé avec votre œuvre soumise.

MODALITES DE PUBLICATION D'OUVRAGES FOURNIS PAR L'ARTISTE A L'EDITEUR EN VUE DE SON INSERTION DANS L'INDEX.

1. L'artiste octroie et cède à l'éditeur (Page One Publishing Pte Ltd) le droit de publier dans l'index l'œuvre soumise par lui-même sans aucune restriction quant à la quantité et la taille et pour une période illimitée.

2. L'éditeur a le droit de vente de l'index publié dans n'importe quel pays, sans aucune limitation géographique. Le droit de publier l'œuvre est un droit non-exclusif.

3. L'éditeur peut refuser de reproduire une œuvre soumise, diapositive ou photographie, s'il la juge inappropriée à la publication dans l'index.

4. L'éditeur ne sera responsable ni d'éventuels défauts d'impression, endommagement ou perte du matériel remis, ni d'un retard de publication ou de l'omission de la publication d'une œuvre acceptée.

5. Le matériel soumis deviendra la propriété de l'éditeur. Il pourra être renvoyé à l'artiste sur sa demande et à ses frais.

6. L'artiste déclare et garantit être le propriétaire unique et exclusif de tout le matériel soumis par lui-même à l'éditeur, qu'il s'agisse de diapositives, photographies, copies ou autres, et que son inclusion dans l'index n'enfreindra pas de droit d'auteur déjà existant ou autre droit de propriété; il garantit d'autre part que ce matériel ne contient aucun sujet choquant, obscène, diffamatoire ou portant atteinte à l'ordre public et à la bonne moralité de toute loi ou réglementation.

7. L'artiste garantit en outre qu'il tiendra l'éditeur à couvert contre toute plainte portée contre celui-ci par une tierce personne suite au matériel remis par lui-même à l'éditeur.

8. Malgré l'acceptation du matériel pour son enregistrement dans l'index, l'éditeur se réserve à tout instant le droit de ne pas procéder à la publication, d'interrompre la publication ou de la modifier (par ex. agrandissement ou réduction, changement du pourtour, utilisation de détails, découpe de certaines parties). L'éditeur rejette toute responsabilité pour la non-parution de documents ou de reproductions, quelle qu'en soit la raison.

9. Le matériel remis ne pourra être utilisé qu'à des fins de publication dans l'index, à des fins publicitaires, pour une brochure ou autre imprimé spécialement réalisé dans le but de promouvoir la vente de ces publications.

A REMPLIR ET ATTACHER A CHAQUE ŒUVRE SOUMISE.

Titre:

Directeur artistique:

Créateur:

Illustrateur, photographe, styliste:

Agence, atelier:

Client, éditeur:

Description de la cession des droits et obligations/Autres informations:

Signature:

Par la présente, je soussigné accorde à l'éditeur One Publishing Pte Ltd l'autorisation non-exclusive d'user du matériel soumis pour lequel je suis seul détenteur des droits de reproduction.

Approuvé par (artiste):

Contresigné par (éditeur):
Page One Publishing Pte Ltd

Nom:

Adresse:

Date:

Könemann Verlagsgesellschaft mbH, attn.: Mary Connolly, Bonner Straße 126, D-50968 Köln, Germany

INVITACION A PARTICIPAR

Si le interesa ser incluido en nuestro índice, envíenos una selección representativa de sus trabajos más recientes, ya sea en forma de diapositivas, o como fotografías aptas para reproducir, de tal modo que podamos seleccionar sus trabajos para emplearlos en nuestra publicación. **La fecha límite para el registro en el directorio de 1997 es el 15 de abril de 1997.** Para tal fin precisamos, por supuesto, la información más destacada sobre cada trabajo, por ejemplo, el año, el cliente, etc. Por favor no nos envíe originales. La publicación de sus trabajos en el directorio será totalmente gratuita para Ud. Su nombre y dirección serán listados en el libro. Posteriormente le solicitaremos que firme y nos remita de vuelta el contrato con el material suministrado.

TÉRMINOS Y CONDICIONES PARA LA PUBLICACIÓN DE MATERIALES SUMINISTRADOS POR EL ARTISTA AL EDITOR PARA SER INCLUIDOS EN EL DIRECTORIO (INDEX).

1. El artista concede y adjudica al editor (Page One Publishing Pte Ltd) los derechos para publicar en el directorio los trabajos suministrados por el artista, sin limitación de cantidad ni de tamaño y por un período indefinido de tiempo.

2. El editor tiene el derecho de venta del directorio en cualquier país, sin limitación geográfica. El derecho a la publicación del trabajo es de no exclusividad.

3. El editor rehusará reproducir cualquier trabajo, diapositiva o fotografía autorizadas que considere no conveniente para su inclusión en el directorio.

4. El editor no será responsable de discrepancias en la impresión, de la pérdida o del daño del material suministrado, sin importar la causa, como tampoco de cualquier demora en la publicación, o de omitir la publicación de cualquier trabajo propuesto y aceptado.

5. El material que haya sido autorizado se convertirá en propiedad del editor. Dicho material podrá ser devuelto a solicitud y por cuenta del artista.

6. El artista declara y garantiza que es el único y exclusivo propietario de todos los materiales suministrados por su parte al editor, ya se trate de diapositivas, fotografías, copias u otros, y que la inclusión de éstos en el directorio no infringirá derechos de autor existentes o propiedad intelectual alguna. Además, el artista garantiza que dicho material no incluirá temas censurables, obscenos, difamatorios o que vayan en contra de la moral y de la paz o de cualquier ley o regulación.

7. El artista garantiza, además, la inmunidad del editor en caso de reclamo por parte de terceros contra el editor, que se presente a causa del material autorizado al editor por el artista.

8. No obstante la aceptación del material para su inclusión en el directorio, el editor se reserva el derecho de, en cualquier momento, no publicar, suspender la publicación o de modificarla (p. ej. aumentando o reduciendo el tamaño, los márgenes, utilizando detalles o fragmentos). El editor no asume responsabilidad alguna por la no aparición de documentos o por la reproducción, cualquiera que sea la causa para ello.

9. Los materiales sólo podrán ser utilizados para publicarse en el directorio, o en anuncios, folletos u otros medios impresos producidos específicamente con el fin de promover la venta de estas publicaciones.

POR FAVOR, RELLENAR Y PEGAR EN CADA TRABAJO ENVIADO.

Título:

Director artístico:

Diseñador:

Ilustrador, fotógrafo, estilista:

Agencia, estudio:

Cliente, editor:

Descripción de la cesión de derechos y obligaciones/ otras informaciones:

Firma:

Por la presente concedo a Page One Publishing Pte Ltd autorización no exclusiva para utilizar el material propuesto, sobre el cual poseo los plenos derechos de reproducción.

Aprobado por (artista): Refrendado por (el editor):
 Page One Publishing Pte Ltd

Nombre:

Dirección:

Fecha:

Könemann Verlagsgesellschaft mbH, attn.: Mary Connolly, Bonner Straße 126, D-50968 Köln, Germany